1/8
D.

Dode Patterson'
from Pat - Christmas 1975'

The Seeing Hand

A Treasury of Great Master Drawings

An Alexis Gregory Book

The Seeing Hand

A Treasury of Great Master Drawings

by Colin Eisler

New York University, Institute of Fine Arts

HARPER & ROW, PUBLISHERS

New York, Evanston, San Francisco, London

Dedicated to my daughter Rachel

THE SEEING HAND:
A TREASURY OF GREAT MASTER DRAWINGS

Copyright © 1975 by Edita S.A., Lausanne.
The majority of illustrative material is drawn
from Fabbri's series "I Disegni dei Maestri" © 1970
et "Arte moderna" © 1967

FIRST EDITION

ISBN: 0-06-011143-7

LIBRARY OF CONGRESS CATALOG CARD NUMBER: 74-1804

Book design by Massimo Vignelli

Contents

Introduction

Art is when one and one make three. Drawing is when the magic begins—and sometimes ends. With a single stroke, light is separated from dark, and space and scale are evoked from a void. In the beginning of all the arts lies this graphic act by pen, pencil, brush, or chisel with which, and from which, all else flows. As line bends to follow form, the re-creation of nature can give the artist a god-like role, as if re-experiencing Genesis. That sudden miraculous moment when art becomes illusion is never more vividly experienced than in the act of drawing.

Drawings are the bone and muscle of art, the often fascinating and in themselves eloquent preparatory solutions that underlie the finished surface. Line can be playful, willful, or almost uncontrolled, as well as rigidly within the master's command and direction. The subjective quality of much recent draughtsmanship recalls Montaigne's speculation about whether he played with his cat, or she with him. Whether illustrating David's songs for the *Utrecht Psalter* in the ninth century or creating sublime linear parallels to Dante's *Divine Comedy* a few hundred years later, supreme masters of the most deliberately restricted graphic means such as Botticelli opened the door to stirring revelations—line leading to light. Drawing's great strength lies in this inference of light through dark, as the draughtsman illuminates from within and without, his achievement verging on the mystical.

Line has many lives. Enclosing form by continuous containment, it can assume the precise, fixed character of a die or cameo. As it is worked into the shape of its model, line becomes a pliable means, like wrought iron or twisted wire, conforming to its object. Lines may break and scatter like waves over a rock, to define form with extraordinary proficiency in shifting cascades. The great master of manuscript illumination who drew the scenes inspired by King David's songs for the *Utrecht Psalter* converted the solid flesh of Old Testament imagery into a shimmering, almost impressionistic linear stream-of-consciousness. Hundreds of short lines, like tadpoles or the dots and dashes of Morse code, wriggle or tap out the Biblical harpist's myriad images in fluent magnetic currents or vectors. Other masters choose a freer line that seems to define itself as it goes along, adding a unique spontaneity to the graphic process.

As a series of conventions and abbreviations to communicate the artist's thoughts and perceptions, drawing formulas can change quite rapidly and radically—even within three generations and in a single culture, as evidenced in the shift from Goltzius' elegant, engraving-like whorls to Buytewech's more free-wheeling, loopy lines to Rembrandt's bold, deceptively abandoned slashes of reed pen. Most masters adopt a shorthand style to lay out the bare bones of their plot. Rubens, especially in his early period, practiced such a personal script. A trailing, weedy line that seemed unassertive and deliberately self-effacing, it gave the artist's thoughts "maximum visibility," a stimulating freedom to evaluate the perceptual and aesthetic problems raised or solved. Like terse entries in a diary, drawings sometimes seem to be jottings from the artist's "coloring book". Such hurried initial sketches may share the alphabet-like character of ideographs, as is often the case in Oriental or Expressionist art, where substance becomes graphic symbol.

Placement of the forms on the page, *mise en pages*, is a major yet elusive aspect of drawing in the complex relationship between what you see and what you don't, a subtle way of defining and animating the page.

The lines the artist sets down should endow the blank areas with a complementary life, assisting and extending the graphic expression. Rembrandt is a striking master of this art of intervals. Acquaintance with Oriental art may have contributed to his audacious exploitation of absence—of suggestive blank space—as well as presence for achieving linear and emotional resonance. In his sensitive, superbly controlled drawings, a single line can capture a snowbound landscape or a puzzled facial expression, vibrating like a stringed instrument. Rembrandt possessed a collection of exotic musical instruments, and themes relating to musical sound, such as the Biblical account of David, played a compelling role in his art. It may be more than coincidence that so many of the greatest draughtsmen were also keen musicians (Leonardo and Raphael, Delacroix and Ingres) or were known to be fond of music, such as Watteau and Matisse. Because of this perhaps, their own graphic music lingers in the mind.

Throughout the history of art, drawing has fulfilled a variety of purposes, both practical and aesthetic. Art manuals, for professional and amateur use, have existed from classical antiquity. The famed thirteenth-century manuscript by the architect Villard de Honnecourt was introduced with the observation that "In this book can be found good advice upon the art of drawing as geometry directs and teaches it". Villard's models are shown as if seen through a superimposed grid, and such a schematic, mechanical approach is sensed even in his sketch of a lion, despite this medieval drawing instructor's notation that the animal was "drawn from life". These early texts were really compilations of motifs and patternbooks; their many little illustrations, or *exempla*, were didactic copies of copies of copies going far back into the past.

A more realistic approach is seen in the Northern European model books of the later fourteenth and fifteenth centuries. Essentially catalogues, these assemblages of pictorial elements were kept by painters, sculptors, and craftsmen to remove much of the speculation and uncertainty from commissions, so that their patrons could have a sneak preview, on a small scale, of the intended appearance of the finished work and possibly direct the artist to modify it in various ways. Plants and animals, still life, physiognomical types, architectural details, and, later, classical motifs and other decorative accessories were all made available in drawn form, to select a final array for inclusion in a fresco, panel painting, tapestry, relief, or other project.

Often these patternbook entries were drawn on stamp-size tinted sheets of paper, set four or more to the page on wooden mounts, and then kept within small square storage boxes. Others were drawn directly on thin panels of wood, to be shown to the patron in this crushproof format. These tiny drawings were often very highly finished, in silverpoint or heightened with white, to provide as convincing an indication of the future work as possible. Their small size, due mainly to the costliness of paper, also allowed for convenient portability. The artist then utilized such little drawings for gathering and enlarging the details in the completed project. The high price of paper also contributed to development of elaborate preparatory drawing on the panel surface itself, as seen in Jan van Eyck's *Saint Barbara*, so exquisitely rendered that either artist or patron decided to keep it in its uncolored state.

Similarly, when planning frescoes, artists often drew directly on the wall itself as a guide for rapid painting on the wet plaster. As paper became cheaper, scaled drawings known as cartoons, in the same proportions (and sometimes even full size) as the paintings or tapestries for which they were made, were often prepared. Among the finest of these are Raphael's series for *The Acts of the Apostles* (Victoria and Albert Museum, London) and for his *School of Athens* in the Pinacoteca Ambrosiana, Milan.

Printed drawing manuals, with elaborately engraved plates to instruct the reader in anatomy, the laws of perspective, and the secrets of physiognomy, were widely available from the sixteenth century on. Produced in quantity, these books which promised to initiate the reader into a mastery of chiaroscuro in a few easy lessons are among the earliest and most revealing of "how to" publications.

The full force of drawing as creative magic is first found in the wall art of prehistoric caves with their superimposed profiles capturing enduring shadows of reality. Perpetually defined by its source, as a permanent record of the light displaced by its form, the powerful attraction of the profile extends from caveman art to the mythic origins of classical art. Discovery of the profile was viewed as the discovery of painting itself in a tale told by Pliny (*Natural History*, XXVI, 15), about a Corinthian maiden who drew her lover's profile on the wall by candlelight in order to gaze on his lineaments when he was not in sight. Early Greek painting, like so much of the Egyptian art that came before it, was founded on the outline—black figures against a red ground and, later red figures on black. Line created both tension and harmony and was suspended between movement and repose, with every stroke contributing to the vibrant goal of balancing the static and the active.

With the increasing sophistication of later Greek art and patronage came a special taste for the monochromatic, rather analogous to the "Less is more" minimal esthetic of our recent past. The true test of the artist's ability became how convincingly illusionistic an image he could create with the least possible coloristic means, by a highly subtle play of light and dark or by line alone. To satisfy this delight in *grisaille*, color was renounced in favor of delicate pictorial effect. Even closer to modern views of drawing are the Picasso-like outlines of figures on the white *lekythoi*, the slender Greek funerary vases on which the pale unglazed surface, like a sheet of paper, provided an atmospheric ground for line to come to life.

Drawings in the contemporary sense of the term have not survived from the Middle Ages. There are existing handmade maps, builders' guides, manuscript illuminations, and even random, spontaneous notations in the backs and margins of books; but few of these have the experimental, autobiographical or experiential quality of "works in progress" we now associate—perhaps wrongly—with the Western graphic tradition. The concept of the work of art as something resulting from a mutable process, a selective creation open to change by individual modification, was not then so popular as it is today. Style, technique, and even theology did change, of course, but this trinity of faith and appearance was an indivisible "given," with the assertion of personal taste and perception being perhaps less venerated than these qualities have since become. At a time when God was felt everywhere, and not only "in the details," the artist was expected to delineate absolute rather than relative truths.

The medieval world was a milieu of predetermined systems in which renderings were done more for replication than for discovery. Medieval artists' drawings—at least those few still known today—tend to be scrupulously confined within the divine diagram of God's will, or else its demonic opposition in such Romanesque vistas of pre-Bosch horror as those which unfold in the *Guthlac Roll* (British Museum, London). Later, in the fourteenth century, there were very large drawings made on textiles (e.g., the *Parement de Narbonne* in the Louvre), mock altarpieces in shades of gray wash prepared for Lenten observance. These give some evidence of the artist's extensive training in a graphic approach, although no comparable works have survived to document parallel studio practices of the time.

Sketchbook in hand, the thirteenth-century master Cimabue is described by Vasari as making a radical break with the hieratic art of Byzantium by drawing direct from nature. A still more significant step toward free observation was Giotto's. Vasari, writing two centuries later, linked this new style to drawing, telling a slightly dubious tale that as a shepherd the young master was "always drawing something from nature, or representing the fancies which came into his head, on flat stones on the ground or on sand, so much so that he was attracted to the art of design by natural inclination". Cimabue supposedly came upon Giotto drawing his sheep from life with a roughly pointed stone upon a smooth rock surface, "although he had never had any master but Nature". Giotto's one-man academy quickly brought forth the most sophisticated artist in the West, who later manifested his excellence by drawing the abstract with the same assurance as the natural: in another traditional account, when a messenger asked for a sign of his skill to bring to the Pope, Giotto "took a sheet of paper and a red pencil, pressed his arm to his side to make a compass of it, and then, produced a circle so perfect in every particular that it was a marvel to see".

The Craftsman's Handbook, written about 1400 by the Tuscan artist Cennino Cennini, urges the artist to draw from the model, with special attention to light and form: "Using a model, start to copy the easiest possible subjects to get your hand in; and run the stylus over the little panel so lightly that you can hardly make out what you first start to do: strengthening your strokes little by little, going back many times to produce the shadows. And the darker you want to make the shadows in the accents, the more times you go back to them; and so, conversely, go back over the reliefs only a few times".

Since the Early Renaissance, drawing has been viewed as perhaps the foremost sign of the artist's strength, his virtuosity. Without the support and blandishments (sometimes even the disguise) of color, the rigorous restraints of line can truly indicate the measure of an artist's gifts. In his widely read and diligently emulated Renaissance handbook *The Courtier*, Castiglione observed: "I would discuss another matter which I consider to be of great importance . . . this is a knowledge of how to draw and an acquaintance with the art of painting itself. . . . Do not marvel if I require this accomplishment, which perhaps nowadays may seem mechanical and ill-suited to a gentleman, for I recall reading that the ancients, especially throughout Greece, required boys of gentle birth to learn painting in school, as a decorous and necessary thing, and admitted it to first rank among the liberal arts; then by public edict they prohibited the teaching of it to slaves."

Line, with its single-minded austerity so admirably suited to spiritual and ascetic medieval imagery, was on its way out in the later Middle Ages. With the growing demand for greater verisimilitude, illusionism required more modulated transitions from light to dark, increased subtlety of modeling, and more dramatic, persuasive differentiation of texture. By drawing after ancient statuary, artists came closer to the sophisticated accomplishments of classical antiquity. Working in the first third of the fifteenth century and active in Venice, Florence, Rome, and many other areas, Gentile da Fabriano brought with him a new command of the classical achievement as adapted to Christian subjects and captured in hundreds of drawings made by him and members of his large itinerant studio, including the gifted Pisanello.

The only known drawings by the supreme painter of the Early Renaissance, Masaccio, are those still buried beneath his frescoes in the preparatory *sinopie*. Similar sketches by his senior partner Masolino have been uncovered, and some of these show a fleeting, impressionistic line—just what one would expect from these early masters of light and motion in space.

The greatest group of drawings surviving from the mid-fifteenth century are found in a splendid notebook of Jacopo Bellini; now divided between the British Museum and the Louvre, these magnificent studies are rendered in graphite, silverpoint, and pen. His romantic evocations of classical imagery and his stagelike perspective settings for Christian subjects furnish an unrivaled pageant of the unique scope of Jacopo's mind and art. His innovations were carried to still greater heights by his son Giovanni and his son-in-law Andrea Mantegna.

Uccello's prismatic vision is preserved in many perspective studies whose dramatically isolated *actes de présence* seem to say so much more than they show. Paradoxically, there is about his uncannily tangible studies for goblets and headdresses also something spectral and immaterial. Despite their contribution to the systematic conquest of illusionism, they still convey something of the fugitive and fleeting nature of actuality.

Drawing, or *disegno*, has had many aspects in the Italian use of the term. First it refers to a mastery of the outline or profile, as stated by Piero della Francesca: "By drawing we mean the profiles and the contours which are contained in the thing". And this linear definition depended on a profound command of the intricate language of proportion, the measured "means," or modules, of ideal form so necessary for absolute security in its representation. Piero's own drawings of this kind (his only graphic works to survive) present in an almost mystical fashion this rational coordination of line and eye in seeking a measure-for-measure reconstruction of the perfect being.

For Leonardo, the cosmic artist, every aspect of life was studied in encyclopedic, Aristotelian fashion—explored through description and dissection, by physical and optical analysis. His pen or pencil was at once a surgeon's scapel and sculptor's chisel, a mirror, telescope, camera, computer, and laser beam. His drawings are the videotapes of a recording eye whose curiosity and ingenuity remain forever a marvel.

Drawing's innate powers of suggestion and inference, its intriguing anticipation of elaborate presentations to come, provided perhaps the ideal medium for this most gifted of artists. Happily, probably more of Leonardo's drawings survive than those of any other major artist of his

generation. Master of many techniques, Leonardo brought both new objectivity and new subjectivity to drawing, as he presented his astonishing dreams with the persuasiveness of a documentary. Leonardo's line and light and shade seem to emanate from his models, in a sort of metaphysical photography, as if a function of their very metabolism. No other artist possessed such reciprocity between drawing and writing; with him the visual and the verbal were as interchangeable as his left and right hands, both equally oriented toward lasting discovery through description, keen analysis through observation. Comparing the artist's line to the poet's, he wrote: "Now have you never thought about how poets compose their verse? They do not trouble to trace beautiful letters, nor do they mind crossing out lines to make them better".

Raphael's balanced, perfectly ordered art, evident in his drawings as well as his paintings, left little room for successful imitation. His forceful assistant Giulio Romano may have been more important in determining the character of subsequent drawing modes. In a manner that is sometimes startlingly direct and extremely decorative, he dismissed subtlety for expressive realism. With his distinctive lusty variant of Raphael's classicism, Giulio contributed to the emergent Northern styles in the mid-sixteenth century. Then, in the late sixteenth century, Barocci's new pastel colorism and lyrical nature studies opened up further graphic frontiers.

In Venice, drawing was an intrinsic part of the painting process, rather than a separate exercise as in Florence. The Venetians, like their nineteenth-century admirers the Impressionists, found the application of paint to canvas to be as close to drawing as they often cared to come, being by inclination reluctant to sort out line from light and color. Pastel provided an important exception to this rejection of *disegno* and meticulous preliminary design. This most luminous of graphic means was brilliantly employed by Tintoretto in a series of drawings, many of which were appropriately based on reductions after Michelangelo's best-known sculptures. Another leading and highly influential Venetian artist, Veronese, had a vast output of drawings, from Rembrandt-like small figure studies in brown washes to a silvery Watteauesque world—superbly finished independent sheets, verging on miniatures but retaining a sufficient sense of themselves to avoid that tiny trap.

While no drawing survives as undeniably from Giorgione's hand—perhaps the most elusive Renaissance master—his vision and technique are no doubt reflected in the works of his follower, the Venetian Domenico Campagnola. Giorgione's images seem as if viewed through hazy scrims, against a landscape backdrop set within a diaphanous mesh spun by the artist's myriad hatchings. This subtlest of techniques allows for unusually delicate tonal modulations.

The Renaissance artist saw himself occupying a very special role, as the agent of *disegno*, the Italian word signifying both "drawing" and "design"—each impossible without the other. He was the earthly vehicle for the divine image, the ideal form seen in his mind's eye (*disegno interno*) in a moment of transcendental inspiration and communion. Endowed with special mastery of technique and enjoying the full force of his artistic powers (*virtus*), this human agent was elevated by a guiding spirit (*genius*) that allowed him to materialize his miraculous, visionary insights. "We are all draughtsmen in the eyes of the Lord," wrote the sixteenth-century painter Federico Zuccari, "all of us have

an inner idea in whatever art or science we are concerned with, but a transposition of interior design into externalized form is the special gift of the artist". Zuccari saw *disegno* as the vital core of all art; as God manifested His divine self in the Trinity, so did *disegno interno* in painting, sculpture, and architecture.

The other side of this supernatural creative coin is the draughtsman as master of the black arts of drawing and printmaking, paralyzed by brooding inadequacy and despair, blocked in the desire to communicate his insights through his art. This special spiritual affliction of the artist—*melancholia*—provides a recurring tragic threat in the *oeuvre* of such great masters of line as Leonardo, Parmigianino, Rembrandt, Salvator Rosa, Watteau, Hogarth, and Munch.

Dürer, whose bleak *Melancholia I* (engraved in 1514) brought this haunting image to definitive form, exemplified the modern draughtsman. With an almost clinical objectivity, as in his ailing *Self-Portrait*, he broke away with shattering candor from the resigned "All's right in God's world" attitude of the medieval craftsman. Such piercing works herald the lonely agonies of the Reformation conscience.

From the late 1520's on, Mannerist art, so intimately involved with complex ideas of grace and elegant formal abstraction, was drawn to graphic formulas. The first true artistic academies sprang from this style, devoted to a suave reconciliation between the classical legacy and newly realized decorative subtleties. The first elaborately grounded center for artists, the Florentine Accademia del Disegno, was founded in 1563 under ducal patronage and furnished the model for the French Academy in the next century.

Early draughtsmanship on the highest level had often sprung from goldsmiths' practice and from engraving. Pollaiuolo, Verrocchio, Schongauer, Ghirlandajo, and Dürer, among many others, all began their careers close to those of craftsmen in precious metals; their art never lost the sinuous, finespun quality of the engraved line. Sculptor's chisel and engraver's tool alike contributed an unusually plastic aspect to draughtsmanship; Michelangelo's drawn figures often seem defined by finely chiseled hatching. This webbed, net-like formula was continued by many of the great draughtsmen/master printmakers: Gossaert, Lucas van Leyden, Van Heemskerck, and others.

An old, yet new, graphic language was devised at the end of the sixteenth century under the leadership of Hendrick Goltzius, the dean of the painters' guild and director of the Haarlem Academy. This duality of medieval and Renaissance roles also characterizes his draughtsmanship. Using his pen like a jet-propelled burin, he incised across the page a series of intricately ordered parallel lines, often achieved by dots comparable to those known as "flick work," which were made on the engraved surface of a metal plate with the end of an engraver's tool. Goltzius' very schematic, brilliantly drawn works make it seem as if the subject were actually rendered by some extraordinarily complex and sensitive mechanical process, under the inspiration of the highly evolved engravings of Dürer and Lucas von Leyden. The most successful of these drawings are like images reflected on the surface of a bubble, with an almost surrealistic sense of mirror image. Goltzius' style foreshadows that of various artists whose energy was generally directed to print production, such genial seventeenth-century figures as Jacques Callot, Stefano della Bella, Claude Mellan, Wenzel Hollar, and others.

Toward the end of the sixteenth century, in the highly varied *oeuvre* of the Bolognese master Annibale Carracci, a broadly assertive graphic style was created, with a marked sense of the momentary and the particular. This new tendency launched Western art on a broader course than ever before. Annibale, his brother Agostino, his cousin Lodovico, and their followers freed themselves from the inhibitions of classical perfection and idealization, yet without any compensatory return to the encyclopedic catalogues of minutiae typical of the late Middle Ages. Using reed pen and chalk boldly and descriptively, the Carracci, especially Annibale, transcribed carefully what they saw before them, but were no longer impelled to cast it slavishly within the aesthetic formulas of the great masters of the past—be they those of ancient Greece and Rome or Raphael. Modification through tradition *did* take place, but it involved many mansions: such gifted, imaginative eclecticism became in itself an audacious creative act. Annibale Carracci could be called, in spirit, the first great Northern draughtsman of the Baroque, for his exuberant observation, together with the art of the major masters he so discerningly drew upon as sources, provided the basis for Rubens' and Rembrandt's freely drawn worlds.

Rubens, whose life-style as well as art was largely modeled on Giulio Romano's, liked to "improve" the many master drawings he owned by adding white heightening to increase their sculptural effect. Northern realism provided a powerful undercurrent in his art, so that this great Flemish master bridged not only North and South but also past and present in his singularly authoritative, vigorous graphism. His brilliant young associate Van Dyck went one step further, in perfecting a curious, shorthand-like graphic technique of eloquent economy and great elegance. Without these Flemish Baroque achievements, which straddled the classical legacy and the local highly detailed descriptive tradition, Rembrandt's splendid pages could never have been drawn.

Rembrandt the draughtsman should not be separated from Rembrandt the etcher. Whether working with the needle, scratching through the wax layer to prepare some 400 plates for etching and printing, or with the variety of graphic means he employed for at least several thousand drawings (over 1,400 have survived), the artist often used his *oeuvre* in both graphic techniques toward the same goals: to see a subject as a fragmentary detail, a close-up study; to evolve preliminary compositions or figure groupings; or to prepare complete, highly finished individual works, as gifts or for sale. So much of his graphism is devoted to Biblical subjects—about half of all his drawings—that it might almost be said he rewrote the Bible in drawing, recalling too the traditional belief that the author of the vivid Gospel of Saint Luke had himself been an artist.

Unlike earlier masters who often seemed to vary their very style of graphism according to the formal character of their subjects, Rembrandt applied many techniques to the same subjects, so that both dogs and goddesses, winter landscapes and portrait studies, shared equally in the incomparable draughtsman's extensive spectrum of techniques. It was as if the artist played a diversity of focal lengths and spotlights on the same subject in different renderings, in order to bring out new levels and dimensions of cognition. Such subtle choice extended even to the papers and inks the Dutch master employed, using Japanese as well as Western media in a wide variety of textures and colors.

Though drawing was especially important and abundant in the seventeenth century, some of that era's greatest painters (including Frans Hals, Vermeer, and Velázquez) left few if any securely documented drawings. All of these master painters seem to have thought instinctively with the brush rather than with pencil or pen. Caravaggio, whose *oeuvre* is of such significance for the seventeenth century, has not left behind a single known drawing. Unlike their prolific contemporary draughtsman Rembrandt, none of these artists were active as teachers. Perhaps this lack of involvement with academic instruction, together with their pure painterly intuition, made the exercise of demonstrative or preliminary line unnecessary. Working in Titian's splendid afterglow, some Baroque artists may have judged painting as creative prowess only where line and color were released simultaneously, achieved with free-flowing inspiration and without the studious Florentine accent on preconceived design expressed in draughtsmanship—a pictorial scheme *in nucleo* to be systematically enlarged and colored.

Almost as much an "architect" and "sculptor" as draughtsman, colorist, and painter, Poussin deployed form and light with a stoical severity or lyrical grace in his classical works. Living in Italy, the French master became more Roman than the Romans, but happily never lost the love for luminous landscape and romantic emotion that pervaded his Gallic past. Whether blocking out a figure composition or recording the Italian countryside, Poussin seldom pushed graphism beyond first or second thoughts; his drawings, all small-scale and deliberately tentative, refused to become finished substitutes for the ever-monumental painting. Nonetheless, Poussin's drawings show an unusually powerful capacity to communicate color quality even in the restricted terms of ink on paper. His virtuoso use of brown and black ink washes achieved a unique chromatic richness and suggestiveness.

Claude Lorrain, in addition to keeping patternbooks of stock figure types to insert in his prefabricated and somewhat stagey vistas, combined this dependable repertory company with exquisite backdrops to produce probably thousands of handsome if repetitive canvases.

Staffage, decoratively filling out a landscape with people, animals, or other picturesque props, was an important concern for many masters from the sixteenth century onward, when communication of natural setting became more and more a primary consideration and the narrative subject matter gradually secondary. Artists kept drawn anthologies of figure groupings and themes, clusters of grazing sheep and cattle, an obstinate goat, or ruddy peasants and boatmen, all counted on to "hold down" a landscape and evoke receding space by their diminishing scale and to emphasize the proportions of the scene.

Besides these "theme banks" of pictorial raw materials, Claude—as productive an artist as he had been a pastry cook—maintained a *Liber Veritatis* (British Museum, London) to document his paintings by reproducing them by hand on miniature scale, thus protecting himself against his many facile imitators. Even more beautiful documentation is found in the tiny, scintilllating pencil renderings Gabriel de Saint-Aubin sketched in the margins of eighteenth-century auction catalogues to certify just which work had been sold.

More than any other period, the eighteenth century was dedicated to enlightened comfort, to a private pleasure that compensated for the top-heavy and passé formality of preceding epochs. Upholstery,

porcelain, radical advances in diet and medical care, the development of such personal arts as letter writing, and improvement in travel, leading to the era of the Grand Tour, all encouraged a reasonable delight in the small-scale, the convenient, and the diverting. To participate in life in a more intimate, confidential manner with a maximum of personal enjoyment became the social ideal. This, then, was the time of the "little master" rather than the Grand Manner. Hundreds of artists in this period restricted their output to drawings, including watercolors, pastels, and little paintings in tempera or oil suitable for the modest dimensions of contemporary dwellings. Thinking small, the artists now displayed a more personal and humanly scaled art in the decades that fall between the great academic official styles characterizing the reigns of King Louis XIV and Emperor Napoleon I.

Drawings were now framed and could be viewed on a salon wall without being dwarfed by some massive masterpiece in oils. It was a century happy to see itself on an approachable scale, as mirrored in the small paintings of Longhi depicting the contemporary Venetian scene or the rich genre records drawn throughout Western Europe, all showing a life that increasingly rejected the grandiose and ceremonial pomp for the personal and even cosy.

The enlightened perspectives of the eighteenth century were especially sympathetic to drawing, described in 1708 by Roger de Piles as "*l'organe de nôtre pensées*". A few years later, Watteau's drawings were characterized by a friend as "thoughts in sanguine". Toward the middle of the century, the largest single drawing campaign in Western history was undertaken to prepare the thousands of illustrations for Diderot's *Encyclopédie*, in which all the aspects of technology in every known craft and manufacture were presented with an unprecedented clarity.

Before the invention of photography, drawing was of critical importance in many fields, essential to the communication of nonverbal data, as it still is in such fields as medicine and mechanical repairs, where only the artist through his understanding of an operation can convey what the camera is unable to see and record. Without meticulous graphic skills, how could a map be made, a military campaign be charted, or a manufacturing process be explained and patented? Until the Industrial Revolution, almost all men of means constantly made decisions concerning the physical appearance of their world. Drawing allowed the patron to communicate most facilely and effectively with his architect, armorer, jeweler, cabinetmaker, tailor and wigmaker, landscape gardener, carriage builder, silversmith, or porcelain maker—to say nothing of his surgeon, aide-de-camp, road builder, ironworker, and the many other skilled professionals and craftsmen his pampered existence required to make life comfortable and magnificent.

Watteau, Fragonard, and Daumier continued Rembrandt's austere yet eloquent graphic expression. Watteau's art often reflects the dependency of his generation upon earlier Dutch, Flemish, and Italian models. The Netherlandish artists' later fusion of Italian classical breadth and the characteristic Northern particularity enabled the French master to leave the grandiose, often constricting tradition of the Baroque academy for a more intimate art of quiet sensitivity. Watteau's many drawings, lovingly reproduced in print form under the direction of the gifted Jean de Jullienne, circulated throughout Western culture and achieved the widest distribution of an artist's graphic *oeuvre* yet known.

Prophetic of both the glaciers and fires of Neoclassicism and Romanticism, Piranesi's virtuoso drawings re-created ancient Rome with dramatic archaeological flair, and then the artist went on to invent his chilling, fantastic prisons of the mind. In England of this time, a sudden flurry of almost Baroque proportions led to the airy, inventive draughtsmanship of Gainsborough and Rowlandson, with their imaginative, more extroverted return to Rubens' art—analogous to Fragonard's revival in France of aspects of the Dutch and Flemish masters' art.

Before the Neoclassic period, when "pure" line was again judged to be the finest expression of art, the serpentine line was seen by Hogarth to be the true basis of beauty, in his *Anatomy of Beauty*. This view was carried on by other eighteenth-century aesthetes and theoreticians such as George Cumberland, with his "chaste outline." These ideas may have been based on a belief that from the very beginning of art the profile, with its severity and exactitude, best conveyed the essence of a subject without undue elaboration. With the excavations at Pompeii and the revived interest in antiquity, the austere line of the classical vase painter once more came to the fore. So appropriate to reproduction in other decorative media (e.g., Wedgewood plaquettes, Adam stucco ceilings, Clodion reliefs), the pure profile is often found in works by artists of the late eighteenth and the early nineteenth century. The austere graphism of Flaxman was often based on classical motifs, and William Blake copied from High Renaissance engravings for his mystical, simplistic watercolor compositions.

The Neo-Primitive masters of the early nineteenth century also shunned the illusionistic chiaroscuro of the academy in favor of a purist profile, close to fifteenth-century art both north and south of the Alps. Sharp linear definition was equated with truth, while highly developed manipulation of light and shade was seen as seduction, an artistic straying from the straight-and-narrow of the Good, the True, and the Beautiful. Certainly the ravishing, smoky modeling of a Correggio, a Leonardo, or later a Prud'hon spoke more clearly of carnal knowledge and illicit desire than did the more abstract outlines of pre-Renaissance art or of Italian Mannerism. The deliberately "primitive" line of Ingres, Runge, Friedrich, and others provided a finely wrought tracing which the viewer himself was to flesh out.

This rigorously ascetic style was subject to rapid reversal in the hands of other artists, with renewed delight in more sensuous Leonardesque surfaces apparent in the *sfumato* contours of Prud'hon's well-endowed nudes; a perverse pleasure in the superbly anatomical, cannibalistic agonies of Géricault; or the delectable shudders induced by the eerie fantasies of Humbert de Superville and Fuseli. Respite from such sensual or imaginative extremes soon came, however, with the rather bourgeois idealism of the mid-nineteenth-century academy, its tenets dictated by the older Ingres and Thomas Couture. By the 1850's, drawing again received especially diligent attention; secure draughtsmanship was recognized by Ingres as constituting three-quarters of painting and its essential preparation. Polite attention to detail, sentimental morality, and rigid decorum were the rules of the day, in a time when only the exotic was allowed to be quite human and relaxed.

Delacroix, a prolific diarist and writer on art, used the process of drawing to contemplate and absorb what he saw, without necessarily planning to "use" his copious sketches for other finished works. His

appreciation and assimilation of past art was so profound that Delacroix's resulting works transcended the mere derivative and made a valid independent statement.

The puritanism of the Nazarenes, a group of German Catholic artists active in Rome and Munich, and of their English (and less pure) followers, the Pre-Raphaelites, led to an important revival of Early Renaissance style. Members of this self-consciously purifying movement renounced the "godless classicism" of their academic teachers for an art which, in every sense of the word, was fundamentalist. The more eclectic Pre-Raphaelites' strange fusion of archaism, faith, and thinly veiled eroticism led to liberating new perspectives. Poets as well as painters, the English artists conveyed close ties between word and graphic line that gave them a fresher, more original authority.

The seemingly impossible dream of an art both real in representation and ideal in goal was, in a sense, accomplished by Courbet and the Barbizon school—and most vividly in the moving graphic works of Jean François Millet, whose vigorous draughtsmanship and profound humanity provided the model for Vincent van Gogh's emotional response to the ordinary in life. Next, shortly after mid-century, the boldly innovational economies and modernist rejection of meticulously devised illusionism so strikingly evident in Manet's forceful, painterly drawing style led to a flowering of rapid, spontaneous graphic techniques which captured light and space.

Though firmly grounded in the legacy of the past, Degas' drawings like his paintings took on the challenge of the present, sensitive to the gradual influence of Japanese art, with its sharp perspectives and audacious approach to space, as well as to the accidental marvels revealed by the camera eye. Both of these new influences combined to break the confining conventions of the academy. His great personal gifts and sensibility joined with a classical assurance were to establish the groundwork for several succeeding generations of draughtsmen—including Seurat and Gauguin, who were eager to follow Degas' way with charcoal, pastel, pencil, silverpoint, and monotype.

Then, near the end of the century, bored with photographic accuracy, the too-predictable solutions of the academy, and the relentlessly anecdotal school of Düsseldorf, some artists found a novel path to graphic beauty in the bold and inspired reportage of Toulouse-Lautrec. Others about this time, such as Vuillard and Bonnard, pursued a subtle new vision of the quiet pleasures of domesticity that came to be called Intimism.

Just as a Renaissance sculptor—Michelangelo—had generated an important new graphic style for rendering the nude, so did the greatest sculptor of the nineteenth century, Rodin, evolve a new technique for the same purpose. The French master, sculpting during the rise of Impressionism, sought the fastest way to record an instantaneous impression of a natural sequence of poses. His studio was continually filled with models, nude and draped, who were encouraged to move about at will, ignoring the restrictions of academic pose. When the artist saw a body attitude or gesture he wished to preserve, he set it down with swift pencil lines and suggestive pools of pale watercolor. In these sketches, Rodin devised what amounts to a language of graphic abbreviations, a swift and evocative way to transcribe the moving bodies before him in a kind of softly visual "dance notation".

Inability or deliberate refusal to continue the conventions of nineteenth-century academic drawing led Cézanne to invent a distinctive personal drawing manner, by which patches of pencil shading or watercolor registered form in a modernist fashion rooted in Manet's art. Dematerializing his subject, as if recorded with a sort of detached photosensitivity, Cézanne used drawing as an objective anchor for arresting the path of light, so that its transitory yet form-defining passage could be recollected. Into this single-mindedly original manner was fused a certain classical vigor that recalled the seventeenth-century art the Provençal master so admired.

In the late nineteenth century, with the revival of a medieval guild approach in the Arts and Crafts movement as well as the organic profusion of Art Nouveau, sinuous line ruled supreme. In the hands of William Morris, Beardsley, Klimt, or Hoffmann, line told the whole story in a fashion at once austere and mysterious, reserved and abandoned. Line seemed to indulge in a new condition of surging autonomy, as if circumscribing and creating form through some inherent, independent volition, an inexplicable power beyond conscious artistic intent. This same undulating contour appeared conspicuously in the art of the Symbolists and the Nabis, as well as with searing emotional release in the work of Munch.

Originating in decorative style, the ever-increasing force of line, expanding its dominion to include the major as well as the "minor" arts, became marked near the end of the century as certain painters reacted against the momentary, form-dissolving optical perception of Impressionism to seek a new affirmation of the plane and volume. Accompanying this new linear assertion in England, Belgium, and Germany was a revival of early printing techniques, especially the woodcut, in a complex nostalgia for the Middle Ages, as well as for Oriental mysticism as transported to the West in print form.

Matisse may be the greatest draughtsman and painter of this century. In breaking with the recent past of his own Fauvist phase to recapture the Golden Age in his personally devised homage to classicism, he seems to deal only with what he sees directly before him; yet his art is rarely simplistic or materialistic. The best of his superbly economical graphic works suggest that there can be no other way to see or draw than in his timeless manner. In his modern-day "Venetian" hands, black assumes an unparalleled richness and suggestive power.

Picasso's "Magical Mystery Tour" through the history of art—a dazzling series of "instant styles" hatching one another in an unending cascade of *tours de force*—lasted to the very end of his long life. The Catalan master's virtuosity and unfailing inventiveness have left us thousands of drawings knowingly embracing a staggering range of styles, from El Greco and Velázquez to Puvis de Chavannes and Lautrec, on through the successive phases of Cubism—then back to classicism again, in a never-ending, always fertile cycle. Their vivacious energy and intelligence span naturalistic animal studies, primitivizing figures, classically elegant portraits and mythological themes, shrewd burlesques of the past, Art Deco figures and still lifes of monumental poise. Like many other draughtsmen—from Degas and Lautrec to Calder—Picasso was attracted to the exceptional life of the circus, where he envisioned himself as ringmaster, acrobat, and animal trainer putting the artistic past through his brilliantly conceived graphic paces.

The Russian master Kandinsky, partly inspired by Matisse, pushed the expressive power of line further than it had ever been directed beyond cognitive reference. His swirling drawings furnished a point of departure for much of the stream-of-consciousness graphism of Dalí, Matta, Ernst, Tanguy, Gorky, Pollock, and many others. Kandinsky's line is often set down to capture spiritual states, creating a sort of soul picture. He strives to represent an inspired state of being in which the artist, almost like a Navajo sand painter or a cave painter, is guided by spiritual forces to evolve a new alphabet or hieroglyphic system for conveying this mysterious new consciousness. This highly personal graphic symbolism was later to be continued in a more fanciful, less doctrinaire vein in the work of the "little master" Paul Klee.

Within a few years after these deeply subjective, almost biological connotations of line were being explored by Kandinsky with the Blaue Reiter and Brücke groups in Germany, a rigorous new scientism, marked by an academic scrutiny of the supposed intrinsic properties of line, was developing at the Bauhaus. This occured after the First World War, at a time when so many of the masters of Expressionism (Marc and Schiele, among others) had been killed in battle or by disease. In the hands of Moholy-Nagy, Albers, Le Corbusier, Ozenfant, and Schlemmer, line was the perfect vehicle for the new purism, so strongly opposed to the organic, ecstatic art of Expressionism. Instead, these postwar masters, highly aware of industrial technology, treated line with mathematical, clinical care in investigating its qualities as applied to geometric shapes, or examining organic forms through the intermediary of pure geometry.

Astonishing breakthroughs in the sciences (X-rays, cinematography, mechanical innovations in automative and aeronautic design and dynamics) had challenging new implications for the graphic artist, in his art as well as his daily existence. Cubism, Futurism, and Surrealism were all partly motivated by the artist's exploration of new dimensions of spatial, technological, or psychological experience. When the magical new transfers of image are examined by De Chirico, all aspects of creativity become animated, even partly mechanized, in such vivid communion that the artist himself becomes model and his model, in turn, artist. Artist and medium, ends and means, cause and effect, again become one and the same in Dalí's "automatic drawing," where Pollock-like squiggles, as if without the artist's conscious intervention, seem to document themselves as they go along. Such exercises in complex caprice, further exemplified in the diverting series of multi-authorship, the *Cadavre Exquis*, and in the telling whimsies of Duchamp, typify the new artistic exploitation of the unconscious, which often resulted in outrageous yet meaningful juxtapositions in this drawing out of a post-Freudian inner design.

Drawing, so long relegated to the Beaux-Arts nostalgia alley, has in recent decades returned almost to the prominence it formerly enjoyed in the heyday of the academy. Neo-Expressionism, Surrealism, Minimal Art, and and the many manifestations of the New Realism all depend on an overtly graphic approach as a major element in the completed, as well as the preliminary, picture. Comic-strip dialogue has been enlarged to a new significance, together with the long-familiar imagery, in this new commitment to drawing. Words as lines, and lines as words, often presented in an utterly impersonal simulation of mechanical type, have reappeared with an intensity recalling the great draughtsmen-calligraphers of the past. The inimitable force of black on white and the initiatory, singular eloquence of the graphic act are sometimes felt, ironically, most strongly in just those current-day tendencies which proclaim themselves in the most outwardly nihilistic attitude toward ikon and idea. Moreover, in "hand-making" its new mirrors of actuality, the New Realism is reasserting the continuing dominance of the painter-draughtsman, with his unique powers of intellect and choice, in reclaiming some of that visual realm temporarily captured by photography.

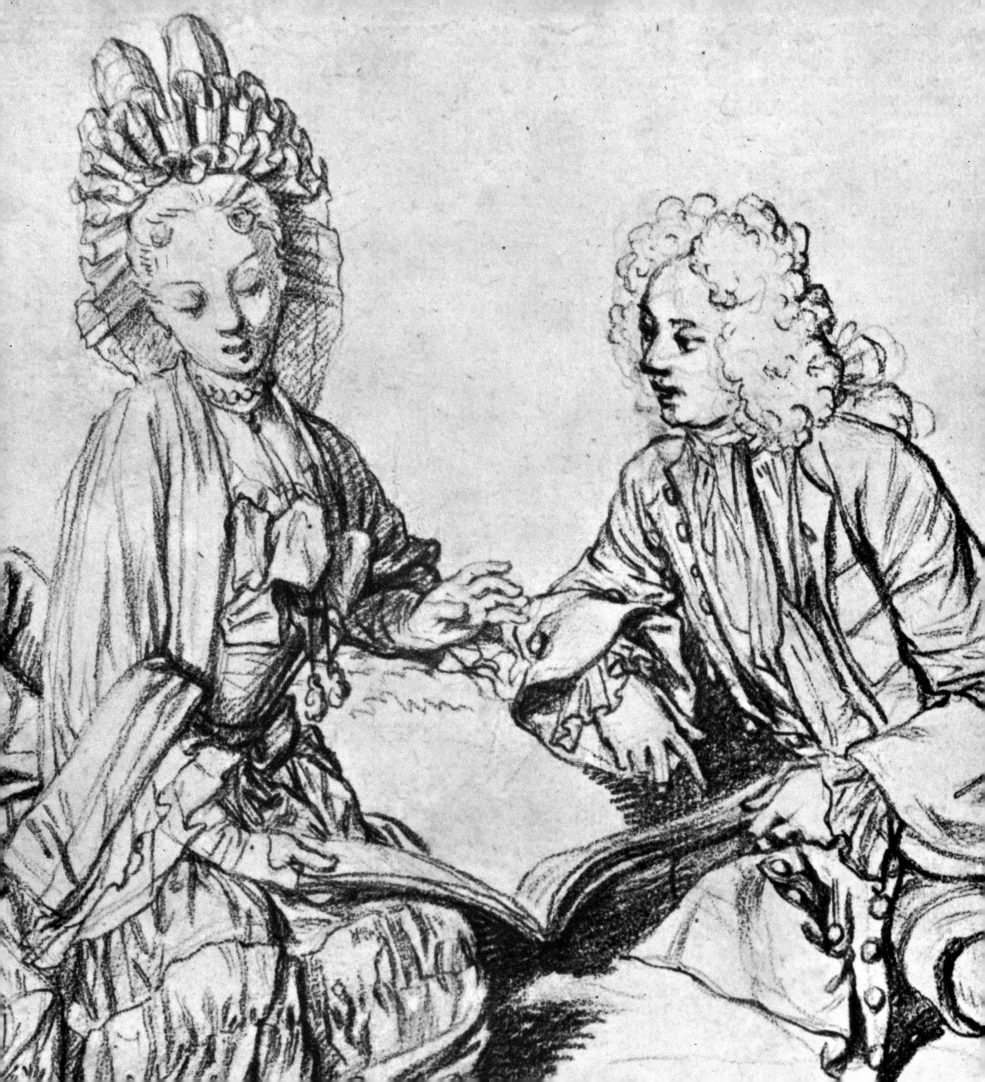

Portraits

Portraiture is the artist's trump card: his efforts alone can present and aggrandize the lineaments of power for posterity. Alexander the Great would be much less so without his noble, stirring image handed down through the ages in monuments of antiquity. Napoleon's spurt of fame might have trickled into oblivion but for his flair as publicist, for visual propaganda. Freud agreed with Ovid that nothing was more interesting than the way one looks; Narcissus, quite literally drowning in his own beauty, became the legend of the origin of art, answering the quest for the eternalized mirror image. The portrait can be a love object, sacred image, sign of imperial authority, symbol of familial continuity, key to immortality, something to keep creditors and servants in their place—and, admittedly rarely, all six at the same time. Until very recent times, the fashionable painter of likenesses was very much the richest of artists. Through his dazzling renderings, Thomas Lawrence, a baker's son, earned enough money to accumulate what must have been the greatest collection of drawings since Leopoldo de' Medici.

Though portraits survive on manuscripts, among the earliest portrait drawings are those by Pisanello, often designs for commemorative medals in the antique style. Here regal authority is presented with that most hieratic, authoritarian portrait formula—the profile. Immutable, remote from the spectator, the profile rarely fails in its icon-like function, providing instant recognition but never familiarity. The bust is another major early portrait convention—significantly, also sculptural in format. Jan van Eyck's silverpoint rendering of Cardinal Albergati is the first such drawing, remarkable for its intimate, yet almost topographical scrutiny of features. The engaged three-quarter view is almost like a plaster cast, complete with notations in the artist's hand specifying the subtlest variations of the sitter's skin color.

Later fifteenth-century Italian artists joined the Netherlandish sense of the specific as revealed by Eyckian luminosity with the more classical economy of Pisanello. Bellini, Mantegna, and Raphael were all especially adept masters of powerful, revealing portraiture in which the sitter seems to realize himself by indirection. Only the gentlest reminder of Roman Republican portraiture is felt just below the surface of these master's works to indicate their Italian origin.

Leonardo's infinite subtlety—beyond any historical or stylistic categorization—brings to each image a curiously genetic sense of evolutionary magic, as though retracing the origins of man from the distant past. His intense concern with physiognomy (like that of Grünewald), with the relationship between character and appearance as indicated by the correspondence between human and animal features, gave all his works a special dimension of mystical resonance.

Leonardo's only real rival in haunting, delicate yet forceful portraiture is Grünewald. Seemingly smoked onto the paper, without any overt indication of the artist's manipulation of his medium, Grünewald's portraits emerge from the page in strangely evocative fashion—as if the longer one looked, the more pronounced the image might become, like a gradually developing negative. Dürer, though incomparable in his graphic virtuosity and expertise, lacked Grünewald's bizarre psychological penetration. A moving portrayal of the young artist's mother, made some two months before her death and deservedly among the best-known of Dürer's portraits, shows an aged, ailing woman with the pitiless clarity and clinical detail one might reserve for rendering a rock formation.

Portraits

Gentler, with a consistently more flattering, aristocratic orientation, is the draughtsmanship of Hans Holbein the Younger, with its frequent skilled use of colored chalks. The German master was hired by his noble patron to prepare portraits of prospective wives. This role of royal "cameraman" was a major function of all court artists. They were frequently engaged on quasi-diplomatic missions and enjoyed impressive titles and payments for their major contribution to marriage arrangements.

Jan Gossaert's highly finished rendering of Christian II of Denmark was probably a preparatory study for an engraving that would make the ruler's image still better known. The elaborate triumphal arch used as a framing device proudly asserts his regal status. Another image of nobility, Antoine Caron's *Duke of Alençon*, shows how imposing and authoritative even a small equestrian portrait can be. The subdued coloring makes the sheet that much more elegant in its aristocratic restraint.

Toward the end of the sixteenth century a new richness of coloristic effect and vivacity, first suggested in Cranach's work, was achieved by Hendrick Goltzius in his telling likeness of the great Flemish Renaissance sculptor Giambologna. The Netherlandish draughtsman, probably influenced by the adroit colorism of such major Italian masters as Barocci, anticipated the finest expressions of Baroque portraiture, such as Bernini's dazzling *Agostino Mascardi*.

Less peripheral, among regional centers, to the major Baroque trends in Italy was the art of late sixteenth- and seventeenth-century Bologna, with its naturally grand orientation, combining Venetian, Tuscan, and Roman sources. Annibale Carracci's *Page of Sketches with a Self-Portrait on an Easel* reveals the breadth and power of the Bolognese Baroque school, as well as its special liveliness in such touches as the painter's pets tucked in beneath his easel. Another noteworthy Bolognese portrait, of less artistic than historical distinction, is Carlo Maratta's *Padre Resta*. The sitter was an important collector of drawings, whose huge albums preserved many of the splendors of the draughtsman's art now found in the world's finest drawing collections. With its rich, full forms and warm, animated spirit, Guercino's *Cardinal Bernardino Spada* shows that great painter and draftsman at his expansive best, carrying on the magnificent tradition of the Carracci, which persisted in Bologna long after that illustrious family had died out.

Usually associated with imperial splendor, the Baroque should also be related to the burgeoning Netherlandish bourgeoisie, who indulged themselves with the attributes of aristocracy. Cumulatively the greatest single body of fine portrait drawings stems from this time and place, depicting a populace unusually drawn to its own image, in portraits made at bargain prices by the many gifted Northern draughtsmen. This superabundance of excellent renderings may also be due to the popularity of the highly finished portrait drawing as an economical substitute for a costly canvas. Appealing to thrifty puritan instincts, the austerity of a small portrait in black-and-white would lessen the possibility of accusations of vanity.

The popularity of engraved portraits also led to the production of extremely carefully rendered preparatory drawings by Mellan and Nanteuil in France. Some Italian masters such as Leone Leoni restricted their output almost exclusively to small, almost miniature portraits, possibly done at a single sitting. These images share some of the intensity (and possibly the low price) of daguerreotypes two centuries later.

Portraits

Rubens and Rembrandt, so different in faith and outlook, both derived pleasure from delineating those they loved. Both drew their women, children, servants, pets, framemakers and gilders, and fellow artists, with a sense of affectionate haste, capturing the convivial moment with camera-like speed but without cliché. Sometimes these quick studies were referred to in canvases or etchings, but more often than not they remained a graphic *carpe diem*, mirroring a moment, a woman's gaze, a child's touching concentration, or a friend's bemused equanimity.

French masters of the eighteenth century saw themselves as rightful heirs to the enlightened art of the Netherlands, thus continuing the Gallic tradition of assimilating the feats of artists to the north. A new interest in the small-scale, the apartment rather than the palace, now made framed portrait drawings "carry" as independent works of art. Many of the Little Masters of the Rococo produced artfully casual works. Matted in Mariette blue or on the elaborate mounts by Glomy, pastels by Chardin, Liotard, or Latour, wash drawings by Carmontelle, Glomy, or Boilly, and the stirring studies in *trois-crayons* by Watteau or in sanguine by Greuze had a special vitality and pertinence to the décor in which they were found. Providing a spontaneous, vivacious image of host or hostess and freed from the more self-seeking aspects of portraiture on a larger scale, such little portraits were left to casual discovery rather than imposition.

Many of the greatest portrait painters of the eighteenth and early nineteenth centuries made few—and sometimes no—drawings of their sitters. Largillière, Walther, Reynolds, Gainsborough, and Lawrence spent little time as limners. Quick workers, they painted directly from a sitter whose time was even more valuable than theirs. Among the loveliest of all portrait drawings are Ingres's early works in graphite. Reflecting the happiest aspects of the Neoclassical tradition, a handsome asceticism and crystalline clarity, these pages of rich tourists in the early 1800's provided Ingres with pocket money during the years when he was attached to the French Academy in Rome. Some of his group drawings, such as *Lucien Bonaparte and His Family*, included as many as mine sitters. Though hating portraiture, which he deemed unworthy of his Olympian gifts, Ingres worked in this genre most brilliantly throughout his lifetime, creating works that will be memorable long after his campy allegories gather dust.

German artists such as Rünge and Friedrich, working in a moment of unusual spiritual ferment, produced portraits rooted in Biedermeyer authority but betraying a compelling intensity, physiognomies battling between pained reason and Romantic pangs. Orthodoxy offered a way out for the German artist converts to Catholicism known as the Nazarenes, who drew themselves as medieval craftsmen, yearning for the blessed anonymity of the guilds. Their English followers, the Pre-Raphaelites, reviving the techniques of the Middle Ages, made exquisite portraits in silverpoint. Poets as well as painters, freed from the dreary *ut pictura poesis* or the *paragone*, Rossetti and Ruskin also wrote portraits. Many of Rossetti's were based on photographs of his beautiful mistresses.

Between the first years of *la belle époque* and the last of *l'Art Nouveau* belongs a group of dashing portraitists whose vapid elegance and seemingly effortless virtuosity enhanced or assured the social position or ambition of their sitters. Bonnat, Chase, Sargent, Boldini, Helleu, Zorn, Dewing, and Zuloaga managed to deliver portraits in

Portraits

which almost all their sitters look "to the manner born," thus provided with a partial passport to the Bottin Mondain or Social Register. Other master draughtsmen such as Degas, Whistler, Toulouse-Lautrec, and Augustus John, alien to the goals of society portraiture, reflected the real goods of an innate aristocracy, whether the sitter be musician, actor, gypsy, or maharajah.

The Expressionists, breaking with much of the stolidly classical art of the late nineteenth century, sought to rip the polite façade from fashionable physiognomy, showing both the outer and inner man. Predominantly German and Austrian, these artists employed an emotional, stirring technique in which line and *chiaroscuro* reflected the uncertainties and conflicts of the generation that was to be divided between victims and survivors of the First World War. Kokoschka, Nolde, and Kirchner, successful above all in the graphic arts, drew people in a manner involving both the primitive and the medieval, illuminated by Matisse's essential contribution to the art of their day (and ours).

Picasso as portraitist almost always represents that modern master at his very peak throughout all the *-isms* and periods. Forced to draw from the model as individual rather than the model as theory, the Catalan master's monumental intelligence, greatest of his gifts, goes to the heart of the matter, revealing his sitter from within and without by using the almost scalpel-like power of pen or pencil. Profoundly classical, Matisse eschewed such inner analyses and restricted his role as portraitist to showing what he saw rather than what he knew.

One of the very few esteemed twentieth-century artists to restrict his *œuvre* to the human face and figure, Modigliani's fine portraits might be described as drawing to exclusion, reducing likeness to hieroglyph. Vuillard, consistently electing the minor over the major key in his very rare studies, has made some of the loveliest twentieth-century portraits, as the sitter's personality seems to guide the artist's hand in an artless art without ego. Giacometti, like Degas, often restricted portraiture to members of his family, communicating man's quintessential isolation, alone in a crowd of existential conflicts.

Seeing people as things as well as faces—anthologies of attributes, machines designed for and defined by life—later twentieth-century portraiture has employed the abstract, the organic, and the ridiculous to communicate the often contradictory experience of "being oneself", transcending the accidental, physical limitations of place, time, and anatomy. Dreams and fears, symbols and stages were all variously and dexterously employed by the Futurists, Surrealists, and their followers to delineate portraits as vividly accurate as possible.

Some modern draughtsmen have believed in letting the likeness speak for itself. Dix, Dickinson, the Albrights, Derain, Balthus, and Schad bent their graphic energies to subordination of their selves, to an almost excessively objective scrutiny of their sitter, who seems to imprint his gestures on the drawn page with a "Look, no hands" intensity, in a new academy of the recent past.

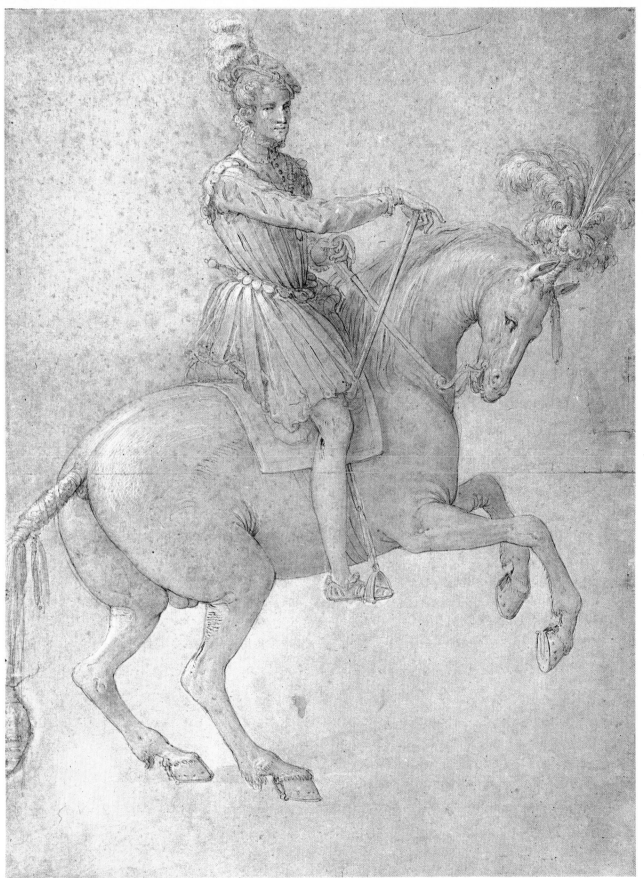

Antoine Caron
Beauvais c. 1525 - Paris 1599

The Duke of Àlençon.
Chantilly, Musée Condé. Pen, bister, and white lead highlights ; 19 ½ × 14 ½ in. (49 × 36.5 cm).

Provenance : Colls. Lenoir ; Stafford House ; Duc d'Aumale.

Bibliography : Dimier, 1925, II, no. 1317 ; Ehrmann, 1955, p. 36.

Sinuous yet strong, Caron's exquisite draughtsmanship is rooted in Primaticcio's drawing technique : long a resident at Fontainebleau, that Italian mannerist master had perfected this subtle distinctive combination of delicate shading and soft white highlights. The elegant mien of the aristocratic horseman — a favorite suitor of Elizabeth I of France — is rivaled by that of his splendid steed, caught in a pose as languidly affected as that of his rider.

1

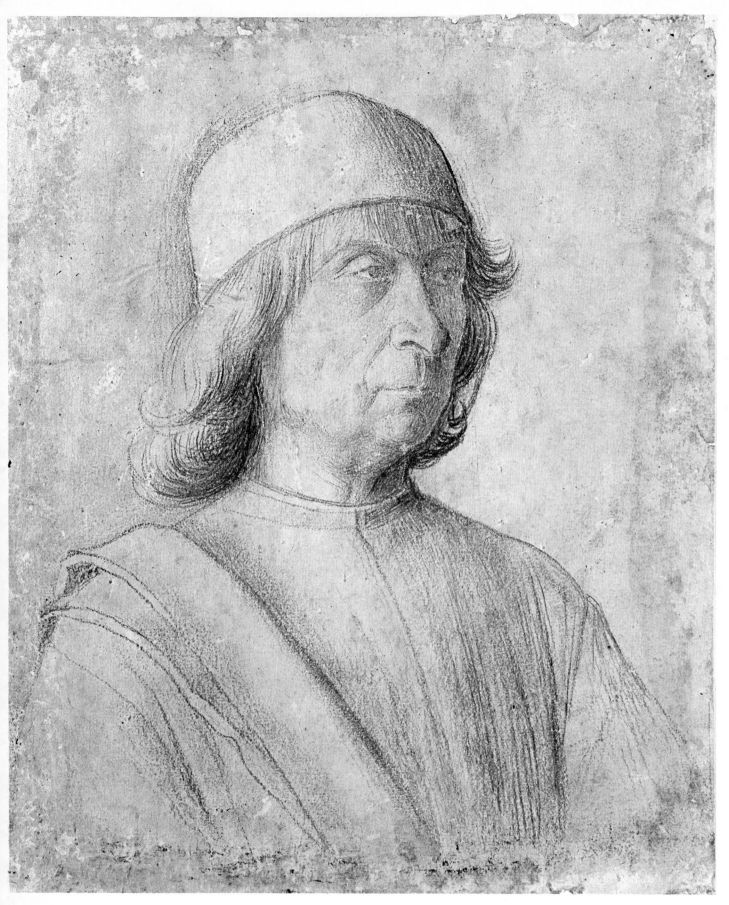

Giovanni Bellini (attrib.)
Venice 1426/30? - 1516

Gentile Bellini.
West Berlin, Staatliche Museen, no. 5170. Black lead pencil on yellowish paper ; 9¼ × 7¾ in. (23 × 19.5 cm).

Bibliography : Tietze, 1944, no. A261 ; F. Gibbons, *Art Bulletin,* 1963, p. 54.

Here the more celebrated younger of the artist brothers has immortalized his less gifted sibling Gentile, in a format that seems almost as if it were drawn after some fifteenth-century Florentine bust. Previously long identified as Gentile's self-portrait, this work was reattributed by the Tietzes to Giovanni Bellini, of whom no securely identified drawings survive. A self-portrait is included in *The Procession of the Cross* (Venice, Accademia), which Gentile completed in 1496, and in other group scenes. To the fundamental Quattrocento concern for abstract form, Giovanni adds the luminous effect and particularity of Jan van Eyck, as found in the latter's Cardinal Albergati portrait.

2

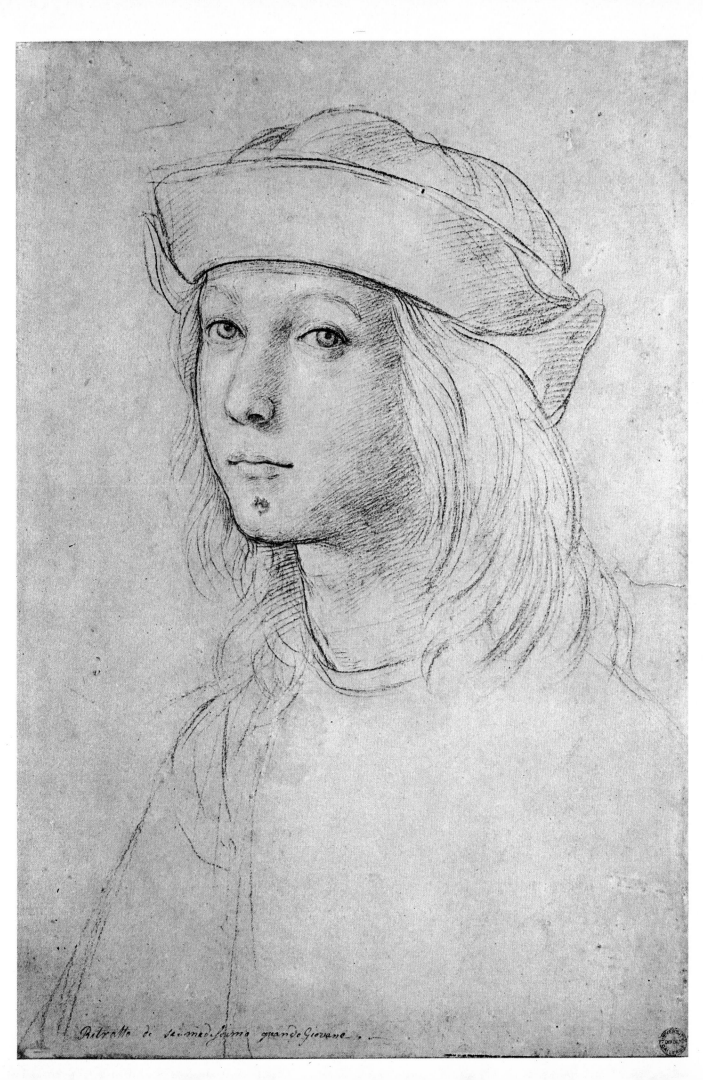

Ritratto di semedsismo quando Giovane

Raphael (Raffaello Sanzio)
Urbino 1483 - Rome 1520

Head of a Young Man.
Oxford, Ashmolean Museum, no. 515.
Black chalk with white lead highlights ;
15¼ × 10½ in. (38.1 × 26.1 cm).

Provenance : Colls. Wicar ; Ottley ;
Harmann ; Woodburn.

Bibliography : Fischel, 1913 - 41,
no. 1 ; Parker, 1956, no. 515.

Rather than being a youthful self-portrait, as it was once identified, this beautiful drawing is more likely Raphael's delineation of a handsome and alert Florentine youth. It dates from the artist's first residence in that city. The style and technique are influenced by those of such Leonardo followers as Lorenzo di Credi and the Ghirlandajo workshop. Consummate works such as this make it clear why Raphael was regarded as a demigod during his lifetime and all but beatified after his death.

3

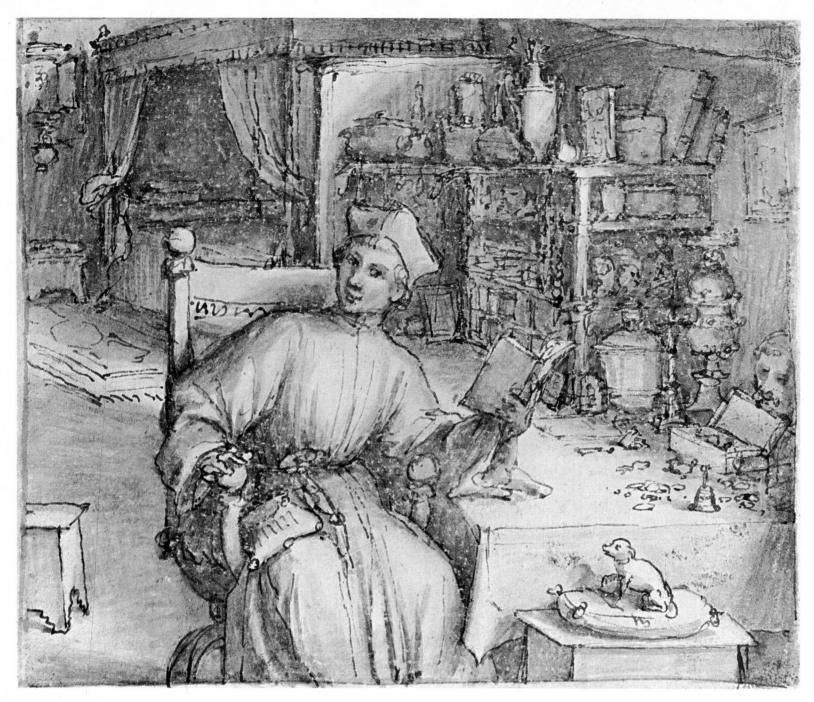

Lorenzo Lotto
Venice c. 1480 - Loreto 1556

4

A Monk in His Study,
c. 1539. London, British Museum,
no. 1951.2.8.34. Brush and brown ink ;
6½ × 8 in. (16.2 × 19.8 cm).

Bibliography : Popham, 1951, p. 72 ;
Pouncey, 1964, p. 15.

A humanist cleric, seated in his com-
fortable chamber and surrounded by an
interesting jumble of books, bronzes,
and antiquities, is shown with pleasant
candor in an invitingly informal interior.
For one so known as a master of highly
finished, technically and conceptually
exquisite painting, Lotto's draughtsmanship
as evidenced here is very different in
its relaxed, expressive manner and
fragmented line, its style harking back
to that of Carpaccio and forward to
Buytewech and the new masters of
early-seventeenth-century genre in the
Netherlands. Pouncey dates this genial,
revealing study of a cleric about 1539.

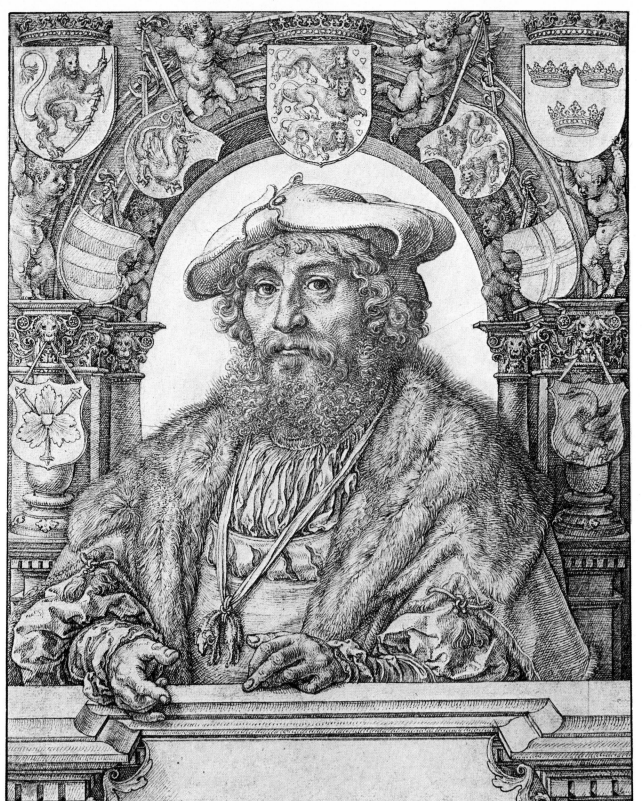

Jan Gossaert (Mabuse)
Maubeuge c. 1478 - Antwerp 1532/36 ?

Christian II of Denmark.
Paris, Institut Néerlandais, Coll.
F. Lugt. Pen and bister of two colors ;
10 ¾ × 8½ in. (26.7 × 21.5 cm).

Provenance : Colls. Schneider de Creuzot
(Paris sale, April 6, 1876, no. 73) ;
Faure Lepage (Paris sale, November 16,
1936).

Bibliography : Friedländer, p. 95 ; *Jan
Gossaert genaamd Mabuse,* 1965,
no. 65.

Probably done as a study for an engraving, Gossaert's elaborate and highly
finished drawing shows the exiled King
of Denmark in relatively modest garb.
Christian II was given refuge by the
artist's patron, Adolf of Burgundy.
Only the encircling Order of the Golden
Fleece and the triumphal arch (added
after the artist had finished drawing his
sitter from life) bearing the king's and
queen's armorial insignia indicate his
regal status. Though the conventional
arch and portrait bust format belong to
the Renaissance, Gossaert's essentially
Gothic spirit emerges preeminent.

5

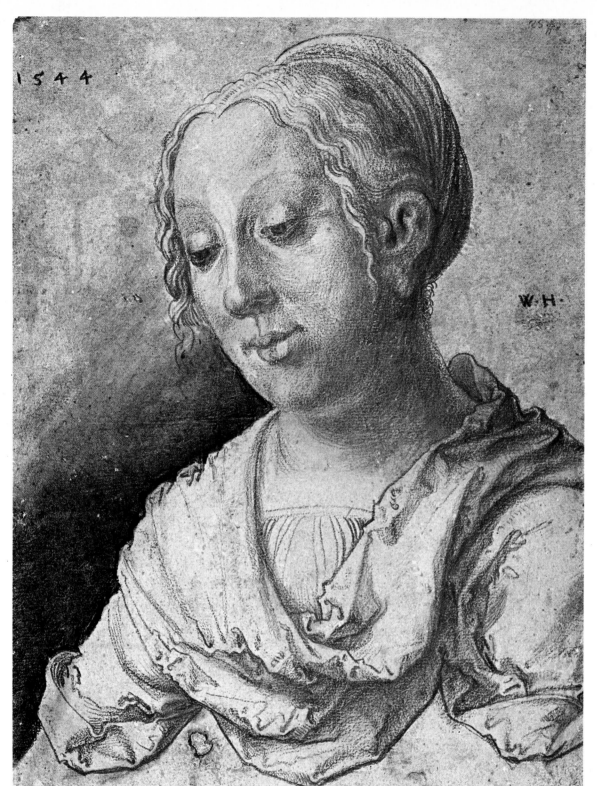

1544

W.H.

Wolf Huber
Feldkirch 1480/90 - Passau 1553

Bust of a Young Woman, 1544.
Vienna, Albertina, no. 3016. Red chalk,
with background of gray wash added by
a later hand ; 9¼ × 7¼ in.
(23.3 × 18.2 cm). Signed at right
margin with artist's monogram :
"W.H."

Bibliography : Weinberger, 1930,
p. 203 ; Tietze-Benesch, 1933,
no. 289 ; Heinzle, 1953, fig. 67.

The latest in date of Huber's major
known drawings, this impressive study
suggests his growing interest in Italian
art. The softness of the facial modeling
and the hazy suggestion of a surrounding
ambient recall the qualities of Venetian
style in this period. Only the drapery,
with its expressively patterned Gothic
wrinkles, suggests the painter's
response to the art of Grünewald.

6

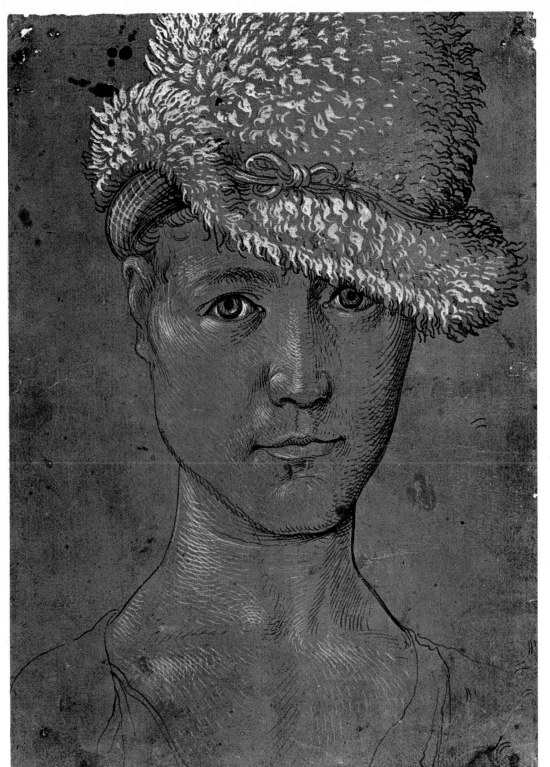

Hans Baldung-Grien

Gmünd (Swabia) 1484/85 - Strasbourg 1545

Self-Portrait.

Basel, Kunstmuseum, no. U. VI. 36.
Pen and ink on prepared grayish-green
paper, with gouache highlights;
8¾ × 6⅜ in. (22 × 15.9 cm).

Bibliography : Koch, 1941, p. 23, no. 7 ;
Oettinger-Knappe, 1963, no. 13 ; Fritz,
1961, no. 15.

The swaggering young Baldung-Grien,
with his assured, almost challenging
countenance, is obviously pleased by
what he sees in his mirror — jaunty
expensive hat, crossed eyes, and all. As
witnessed here, the predilection for the
color green of young Meister Baldung
caused his workshop companions to
give him the more descriptive name
Baldung-Grien (" green "). He, along
with Urs Graf and Nikolaus (Manuel)
Deutsch, belonged to a unique gene-
ration of artist-adventurers, whose
devil-may-care *œuvre* is animated by
pulsating violence and a fierce, spell-
binding eroticism. Their technique
brings to mind that of their great
Northern compatriot Dürer.

7

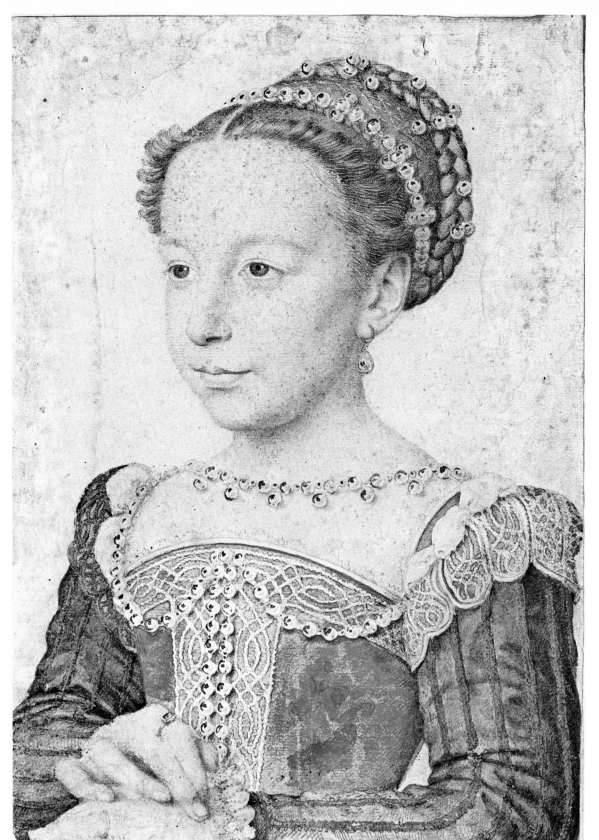

François Clouet
Tours c. 1516/20 - Paris 1572

Marguerite of France as a Child, c. 1560.

Chantilly, Musée Condé. Black lead pencil, red chalk, with touches of watercolor and gold ; 13 ½ × 9 ¼ in. (33.5 × 23 cm).

Provenance : Colls. Reiset ; Duc d'Aumale.

Bibliography : Moreau-Nélaton, 1910, no. 42 ; Dimier, 1925, II, no. 464.

Drawn about 1560, this study of the young queen-to-be of Henry of Navarre is unusually finished in execution for Clouet ; perhaps some of its extensive coloring was added at a later date. The princess is posed in the Flemish style, to the waist and with both hands visible, very likely in reflection of the Netherlandish origin of her portraitist. Although pearls are seen in many portraits of this period, they are not often included in such abundance as accessories for children, and may here signify the sitter's name — Marguerite meaning "pearl".

8

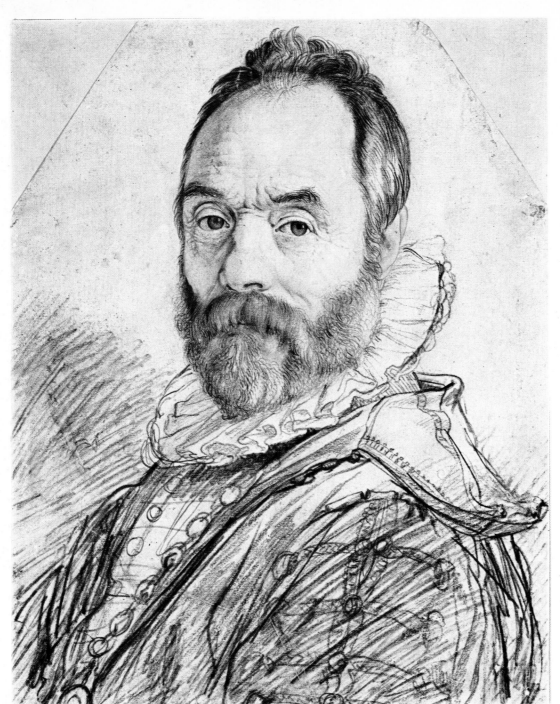

Hendrick Goltzius
Mühlbrecht-Venlo 1558 - Haarlem 1616

Giambologna, 1591.
Haarlem, Teylers Museum, Mappe N, no. 72. Charcoal, red chalk, and wash in tones of reddish- and greenish-brown; 14¾ × 12 in. (37 × 30 cm).

Bibliography : Reznicek, 1961, p. 86, no. 263.

The Flemish artist Jean de Boulogne, long the leading sculptor of Tuscany (where he was known as Giambologna), is here portrayed by the Dutch painter and engraver Goltzius, whose Haarlem Academy nurtured the Northern Baroque. This portrait was executed in August of 1591, while Goltzius was in Florence, just before his return to the Netherlands. The inscription on the back reads : *"Giouan de Bolonia Beelthoower tot florencen gheconterf. H. Goltius 1591."*

9

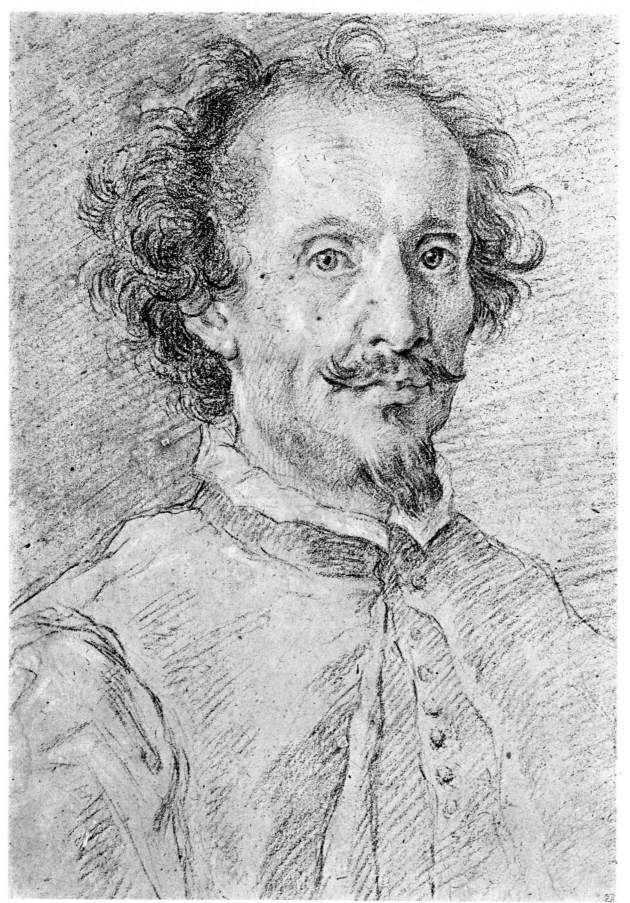

Gian Lorenzo Bernini
Naples 1598 - Rome 1680

Portrait of Agostino Mascardi,
c. 1630.
Paris, École des Beaux-Arts, no. 435.
Black, red, and white chalks;
10½ × 7¾ in. (26 × 15.9 cm).

Provenance : Coll. Armand Valton.

Bibliography : W. Vitzthum, *Il Barocco a Roma* (I Disegni dei Maestri), Milan, 1971, p. 85.

As imbued with life as are his famed marble busts, Bernini's drawing of his noted literary contemporary Mascardi (1590 - 1640), who also enjoyed Barberini patronage and worked in Rome during the pontificate of Urban VIII, shows the baroque painter-sculptor-architect at the peak of his creative powers, about 1630. Bernini *was* the baroque, and further eloquent testimony of his many-sided genius is found in this vital likeness of his friend. Inscribed on the back is *"Augustinus Mascardus eques L. Bernini delineavit".*

10

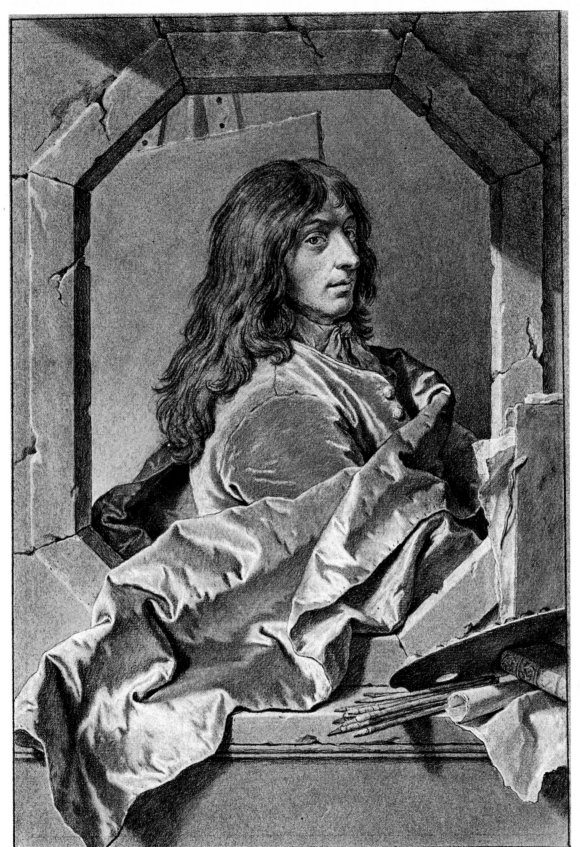

Hyacinthe Rigaud
Perpignan 1659 - Paris 1743

Portrait of the Painter Sébastien Bourdon.

Frankfurt, Städelsches Kunstinstitut, no. 1067. Black chalk with white highlights on blue paper ; 15 × 10½ in. (37.7 × 26.4 cm).

Provenance : Colls. De Jullienne (sale of 1767, no. 768) ; Staedel.

Bibliography : Demonts, 1909, p. 270.

Framed in a stone-cut octagon, Bourdon's draped effigy is meant to convey the triumph of his art over time. The painter's attributes — palette and brushes — rest on the outer ledge of the frame ; his easel is seen within, and his splendid silk cape thrusts out toward the viewer like a victorious banner. Executed in *grisaille*, this brilliantly illusionistic posthumous portrait of Poussin's gifted follower Sébastien Bourdon (1616 - 1671) became well known, since it was engraved by Laurent Cars as his *morceau de reception* for the French Academy in 1733.

11

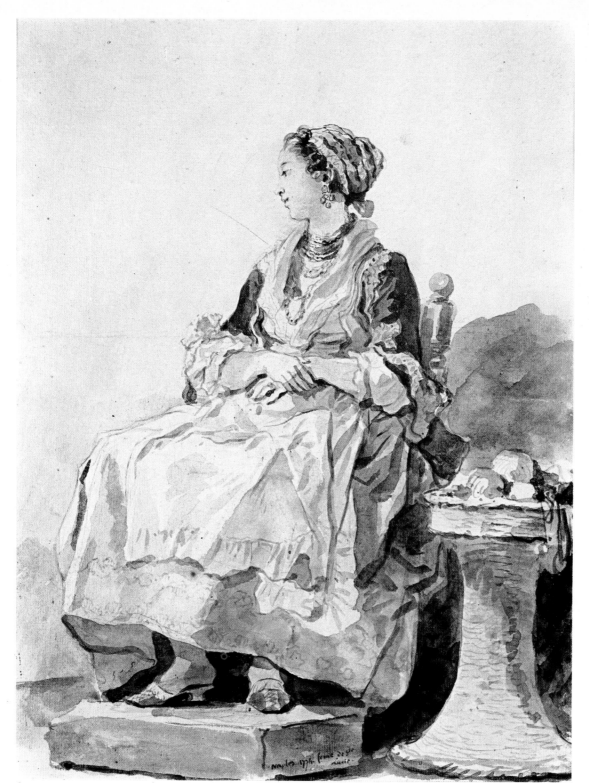

Jean Honoré Fragonard
Grasse 1732 - Paris 1806

Seated Woman, 1774.
Frankfurt, Städelsches Kunstinstitut,
no. 1104. Black chalk and brown wash;
14½ × 11¼ in. (36.2 × 28.1 cm).

Bibliography: *Handzeichnungen alter
Meister im Städelschen Kunstinstitut,*
1913, XIII, pl. 4; Ananoff, 1961,
I, no. 181.

As if captured in a moment of quiet
relaxation during her workday, a beau-
tifully dignified peasant girl from Santa
Lucia, in Campania, is show in an
effortless classical pose, with a wicker
basket at her side like some ancient
Roman household altar. This charming
work was drawn near Naples in 1774,
as part of a series of local folk types
made during Fragonard's second Italian
journey. It is inscribed in ink:
"Naples 1774 femme de Ste. Lucie."

12

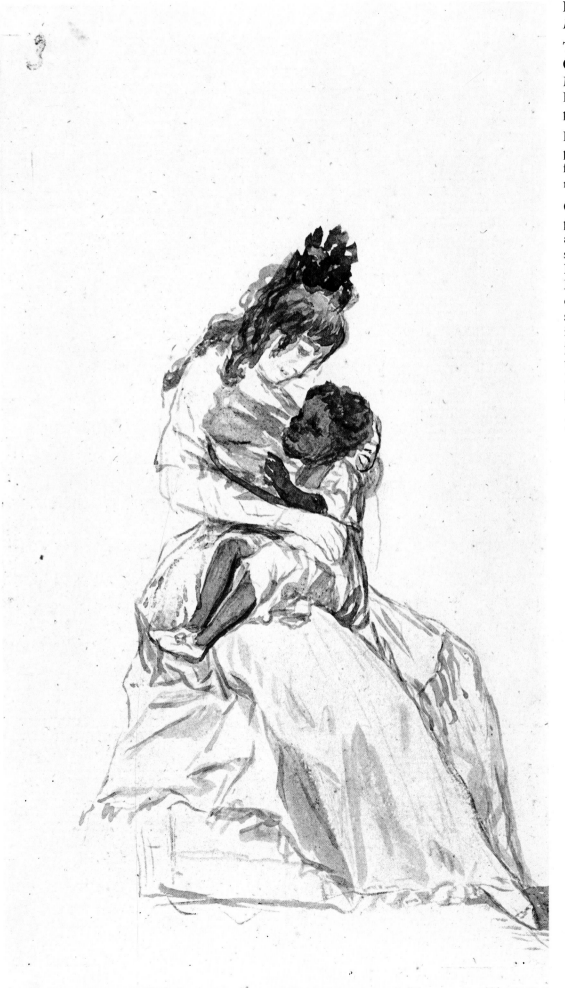

Francisco José de Goya
Fuente de Todos 1746 - Bordeaux 1828

The Duchess of Alba with the Child Maria de la Luz.
Madrid, Museo del Prado, no. 426.
Brush and brown ink on yellowish paper; 6½ × 3½ in. (16.5 × 9 cm).

Bibliography : Sánchez Cantón, 1928, p. 12 ; López Rey, 1953, I, p. 17, II, fig. 5 ; Sánchez Cantón, 1954, II, no. 221.

Caught in a curiously Madonna-like pose — possibly intended as both ironic and charitable by the artist friend of the sitter — Goya's beloved, the worldly Duchess of Alba, is shown cuddling Maria de la Luz, a dwarf and the daughter of a slave. This tender, small-scale brush drawing is on a page belonging to an album devoted to Goya's journey to Andalusia with the recently widowed, childless young duchess in 1797 — biographical data that may give this study an added poignance.

13

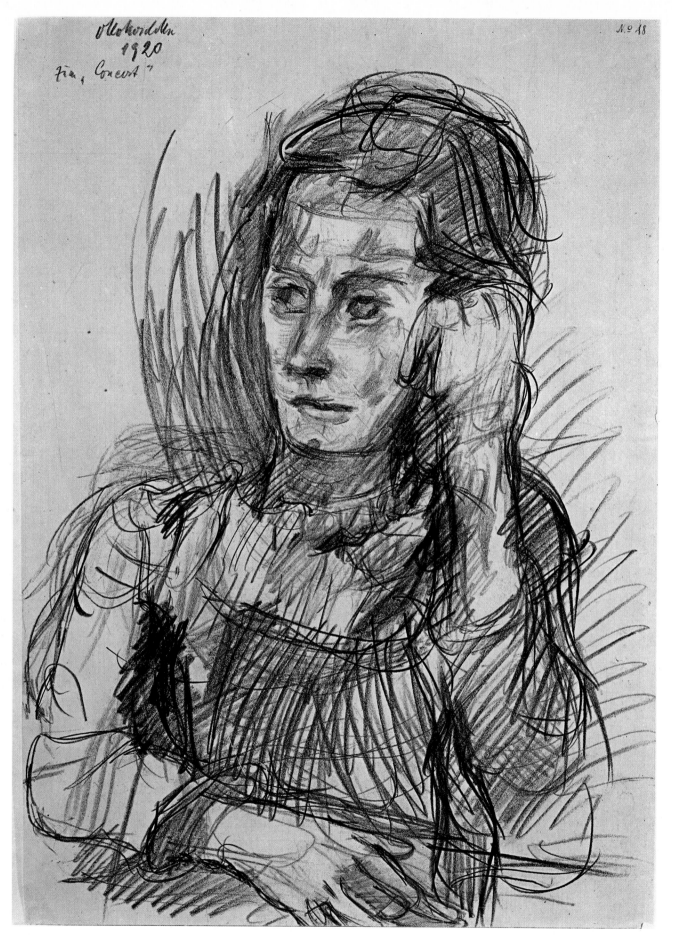

Oskar Kokoschka
Poechlarn 1886 -

Study for "The Concert", 1920.
Stuttgart, Coll. Willy Hahn. Black
crayon ; 27 × 19½ in.
(67.5 × 48.7 cm).

Bibliography : *Oskar Kokoschka,
Aquarelle und Zeichnungen Aus-
stellung zum 80. Geburtstag,*
Stuttgart, 1966, no. 60, p. 64 (exhi-
bition catalogue).

Seemingly expressionistic in its vigo-
rous succession of strokes, yet essen-
tially classical just below its agitated
surface, this figure study is typical of
Kokoschka's early portraiture. Inspired
by the technical qualities of the litho-
grapher's crayon, the artist enlivened
this preparatory study for a larger work
entitled *The Concert* with the waxy
line characteristic of that medium.
Signed and dated at the upper left, it
also bears the notation *"für 'Concert' "*.

14

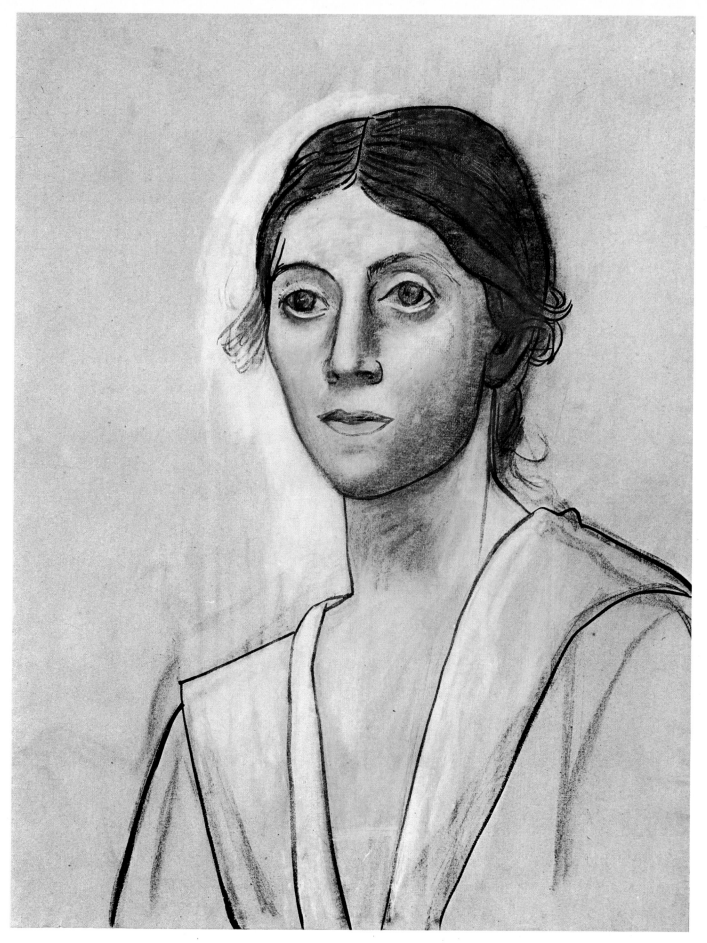

Pablo Picasso
Málaga 1881 - Mougins 1973

Portrait of Olga, 1920.
Formerly in the artist's personal collection. Charcoal, ink, and pastels ; 19¼ × 25⅛ in. (48.2 × 62.8 cm).

Bibliography : Russoli, 1971, p. 84.

Drawn after the artist's Italian tour with Diaghilev's Ballet Russe in 1917, this work portrays Picasso's first wife Olga Koklova, a ballerina in that company, for which the Catalan artist prepared costume and set designs. A deliberately neoclassic veneer is laid over the recent structural discoveries of Cubism, so in evidence in much of Picasso's other work of this phase — possibly injected as an ironic allusion to Olga's reputed conventionality.

15

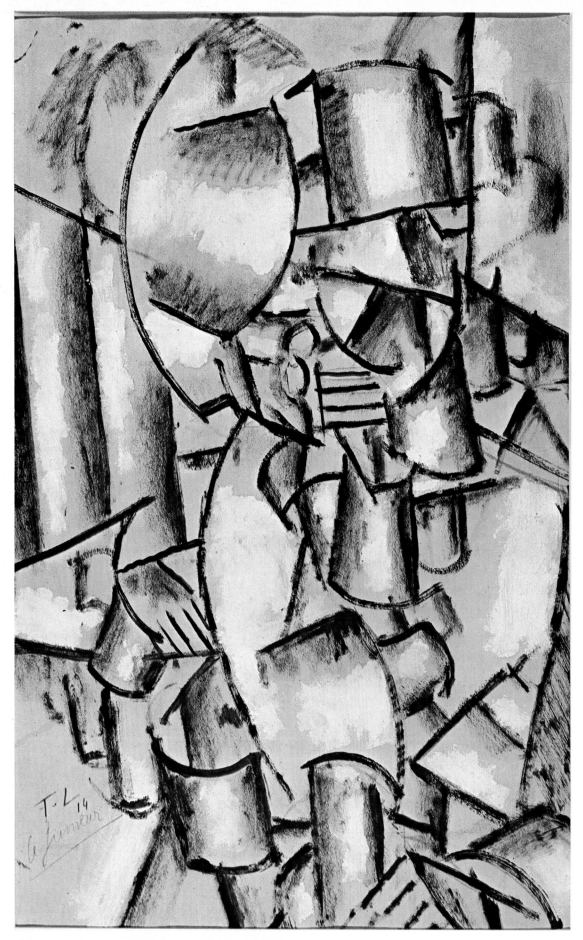

Fernand Léger
Argentan (Orne) 1881 - Gif-sur-Yvette 1955

The Smoker, 1914.
Paris, Coll. Simone Frigerio. Charcoal, ink, and white gouache; 24¾ × 16 in. (62 × 40 cm). Inscribed in lower-left corner: *"F. L. 14 le fumeur."*

Bibliography: Russoli, 1971, p. 82.

Working within the Cubist vocabulary, Léger here demonstrates his persistent concern with mass and motion, already manifest in his *Ballets mécaniques.* In *The Smoker,* a Cubist approach is extended to suggest the dynamism, complex rhythms, and hectic pace of modern industrial life. In Léger's later work, clearly defined and self-enclosed geometrical units were combined with more recognizable figural elements and attributes than are apparent in the more unstable visual interplay — one might say, flux — of lines, planes, and ambivalent geometric masses seen in this abstract "portrait".

16

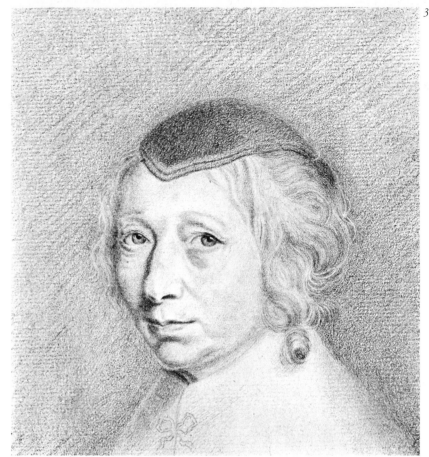

Gentile Bellini F. 1
Venice c. 1429 - 1507

Turkish Woman.
London, British Museum,
no. P. P. I. 20. Pen and India
ink ; 8 ½ × 7 in.
(21.4 × 17.6 cm).

Federico Zuccari F. 2
*Sant'Agnolo in Vado 1540/41 -
Rome 1609*

Head of a Woman.
Besançon, Ecole des Beaux-
Arts, no. 3152. Black and red
chalk ; 6 ¼ × 4 ¾ in.
(15.5 × 12 cm).

Mathias Grünewald F. 4
*Würzburg c. 1470/80 - Halle-
an-der-Saale 1528*

Woman Laughing.
Paris, Musée du Louvre, Inv.
no. 18.588. Black chalk, on
yellowish paper ; 8 × 5 ⅞ in.
(20.1 × 14.7 cm).

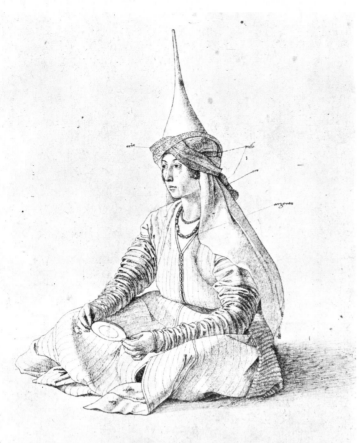

2.

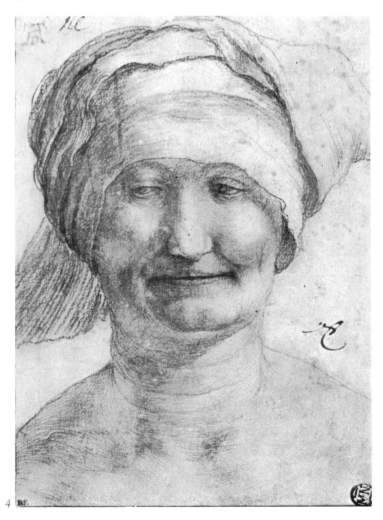

4

Robert Nanteuil F. 3
Reims 1623 - Paris 1678

Madame Bouthillier (née Marie de Bragelogne).
Florence, Uffizi, no. 14359F.
Black pencil ; 5 ¾ × 5 ½ in.
(14.6 × 13.9 cm).

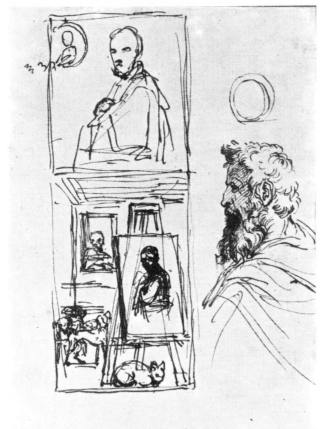

5

Annibale Carracci F. 5
Bologna 1560 - Rome 1609

Page of Sketches with a Study for a Self-Portrait.
Windsor, Royal Library, no. 1984
(by courtesy of Her Majesty Queen Elizabeth II). Pen and ink ;
9 ¾ × 7 ¼ in. (24.5 × 18 cm).

Diego Velazquez F. 6
Seville 1599 - Madrid 1660

Cardinal Borgia.
Madrid, Real Academia de Bellas Artes de San Fernando, no. 72. Black pencil on yellowed white paper ;
7 ½ × 4 ¾ in. (18.6 × 11.7 cm)

Guercino F. 7
(Giovanni Francesco Barbieri)
Cento 1591 - Bologna 1666

Cardinal Bernardino Spada.
Haarlem, Teylers Museum, no. H. 103.
Pen and ink, with watercolor ;
14 ⅛ × 8 in. (35.3 × 19.9 cm).

Anton van Dyck F. 8
Antwerp 1599 - Blackfriars (London) 1641

Hendrick van Balen.
Chatsworth, Devonshire Coll., no. 998.
Charcoal ; 9 ½ × 8 in. (24 × 19.8 cm).

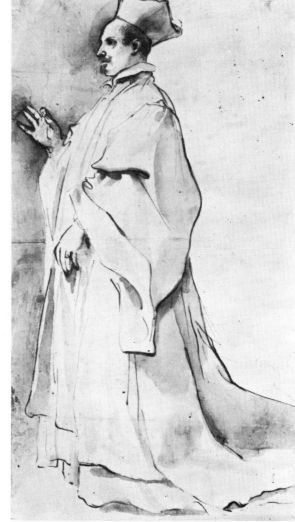

7

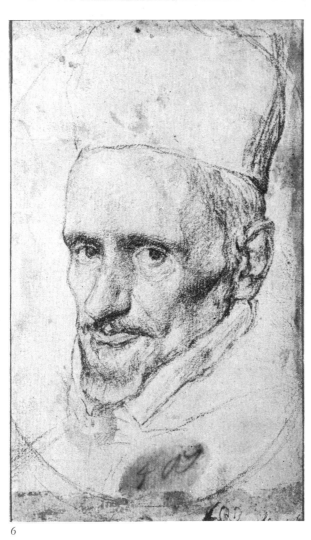

6

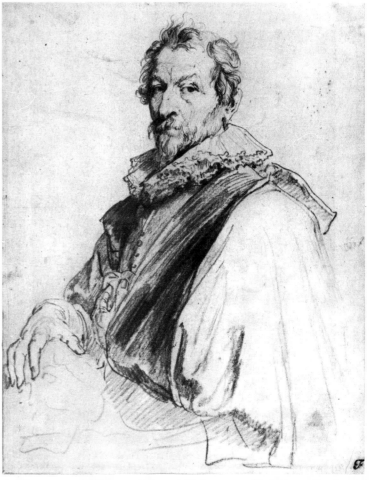

8

Bernard Picart F. 9
Paris 1673 - Amsterdam 1733

**Pair of Figures for a
"Fête Galante".**
Oxford, Ashmolean Museum.
Red chalk ; 7 ¾ × 11 ¾ in.
(19.3 × 29.5 cm).

Raymond La Fage F. 10
Lille 1656 - Lyon 1684 ?

Self-Portrait.
Windsor, Royal Library,
no. 6185 (by courtesy of Her
Majesty Queen Elizabeth II).
Pen and ink, with bister and
blue-gray watercolor ;
7 ¾ × 10 ⅜ in.
(19.4 × 26.1 cm).

Martin Freminet F. 11
Paris 1567 - 1619

Portrait of a Young Man.
Vienna, Albertina, no. 11.770.
Red chalk, with pen and
bister ; 9 ⅛ × 7 ⅜ in.
(22.9 × 18.5 cm).

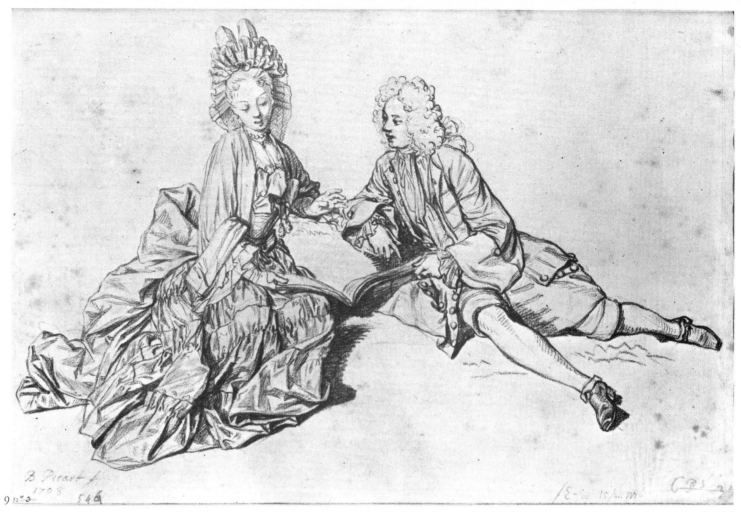

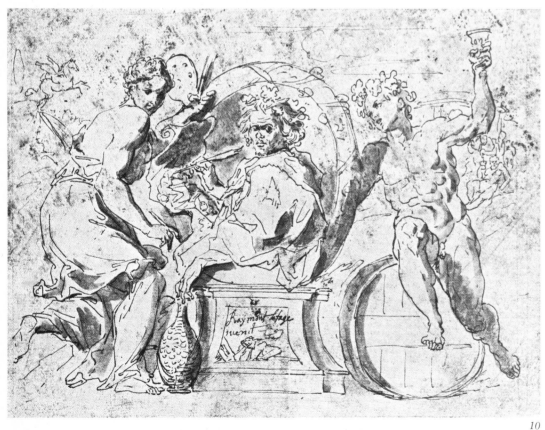

10

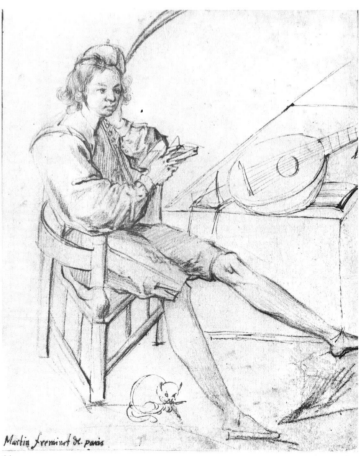

11

Albrecht Dürer F. 12
Nürnberg 1471 - 1528

Portrait of the Artist's Mother.
West Berlin, Staatliche Museen, no. 1877. Black chalk ; 16⅞ × 12⅛ in. (42.1 × 30.3 cm).

Jan Lievens F. 13
Leiden 1607 - Amsterdam 1674

Portrait of Jan Vos.
Frankfurt-am-Main, Städelsches Kunstinstitut, no. 836. Black chalk ; 12⅞ × 10⅛ in. (32.2 × 25.3 cm).

Giorgio Vasari F. 14
Arezzo 1511 - Florence 1574

Seated Figure in Renaissance Costume.
New York, Pierpont Morgan Library no. 1965.6. Black crayon ; 11¼ × 7¾ in. (28.7 × 20.2 cm)

Diego Velazquez F. 15
Seville 1599 - Madrid 1660

Girl's Head.
Madrid, Biblioteca Nacional. Black crayon on blue paper ; 5¾ × 4½ in. (15.0 × 11.7 cm).

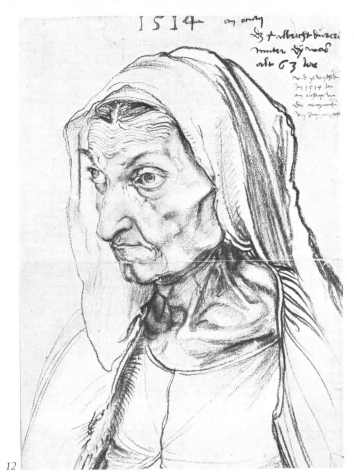

12

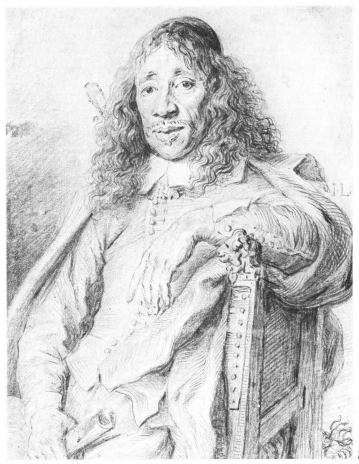

13

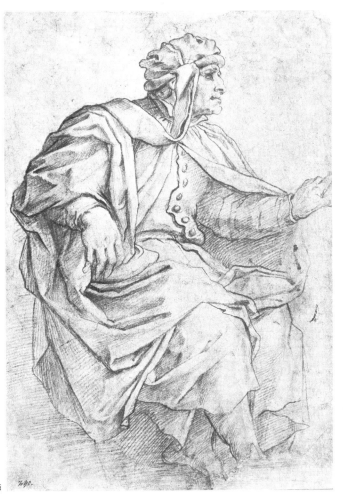

14

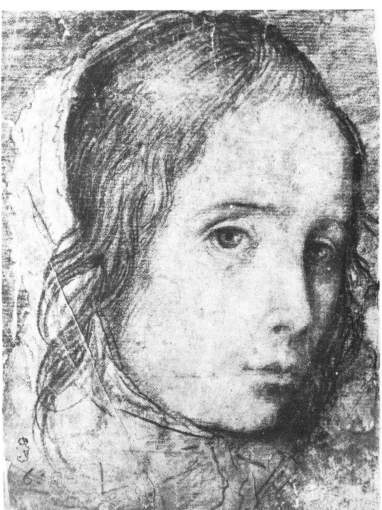

15

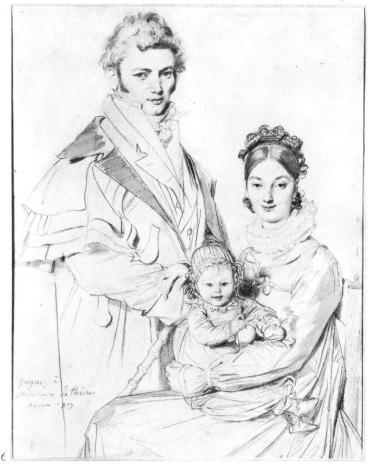

16

17

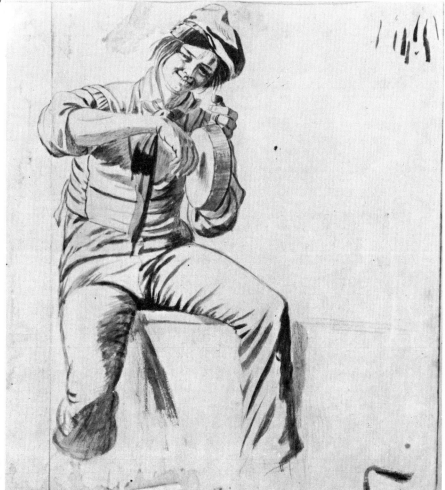

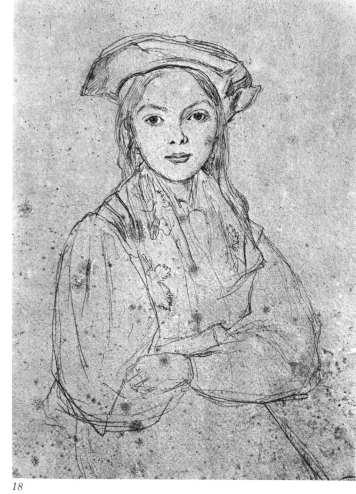

18

Jean-Auguste-Dominique Ingres
Montauban 1780 - Paris 1867

The Guillon-Lethière Family.
Boston, Museum of Fine Arts F. 16

George Caleb Bingham F. 17
Charlottesville (Va.) 1811 -
Kansas City (Mo.) 1879

Young Man Beating Rhythm.
St. Louis (Missouri), St. Louis Mer-
cantile Library Association. Pencil,
ink and wash ; 10¼ × 9½ in.
(26.6 × 24.1 cm).

Camille Corot F. 18
Paris 1796 - 1875

Girl with a Cap.
Lille, Palais des Beaux-Arts,
no. PL-1181. Graphite pencil ;
11½ × 8⅞ in. (29 × 22.2 cm).

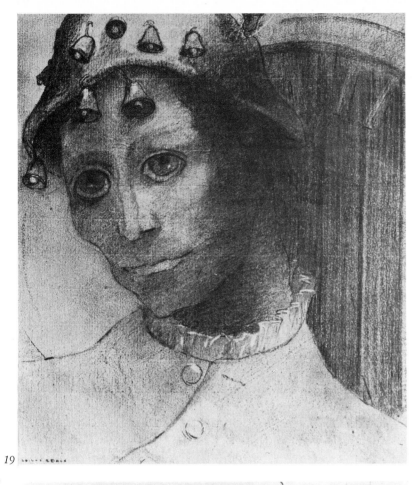

19

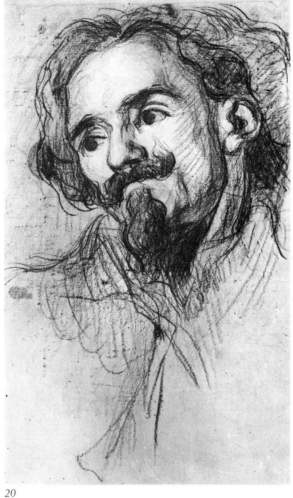

20

Odilon Redon F. 19
Bordeaux 1840 - Paris 1916

Folly.
Paris, Coll. Claude-Roger Marx.
Charcoal on beige tinted paper ;
14 ⅜ × 12 ⅜ in. (36 × 31 cm).

Paul Cézanne F. 20
Aix-en-Provence 1839 - 1906

Achille Emperaire.
Paris, Musée du Louvre,
no. RF-31.778. Charcoal and lead
pencil ; 19 ¼ × 12 ¼ in.
(48.4 × 30.5 cm).

Ernst Ludwig Kirchner F. 21
Aschaffenburg 1880 - Davos 1938

**Self-portrait under the
Influence of Morphine.**
Kassel, Staatliche Kunstsammlungen.
Pencil, pen and ink ; 15 ¼ × 20 in.
(38 × 50 cm).

Paul Klee F. 22
*Münchenbuchsee (Bern) 1879 -
Muralto (Locarno) 1940*

**Self-Portrait '' Junger Mann
ausruhend''.**
Bern, Coll. Rolf Bürgi. Ink wash ;
5 ⅝ × 8 in. (14 × 20 cm).

21

22

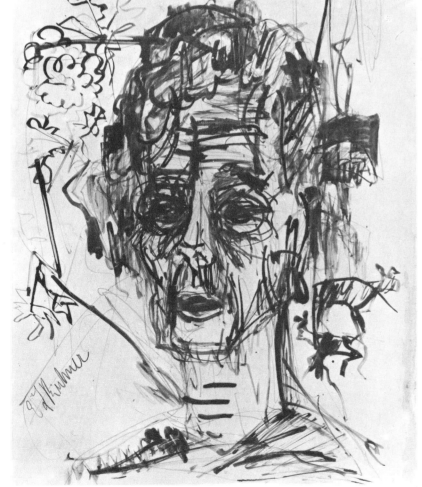

Landscape

Of all subjects, landscape lends itself most readily to drawing. The basic shape and pale color of the page provide a window through which a view is seen, given space and light by implication. Scant linear suggestions can be extended or echoed to present field or forest, city or seascape. Starting with Pisanello's castles in the air—among the first-known independent landscape studies—draughtsmen have let their lines reverberate with almost Oriental economy, spanning the near and the far. Sparse linear indications in the *sinopie*, or preparatory drawings, for frescoes show how effective a grasp the masters of the late Middle Ages had on the projection of nature, even though it often occupied a very minor role in their art. Relegated to the background of narrative scenes, landscape enjoyed an almost "underground" function, filling the space between the dragon, the princess, and the rescuing saint in scenes of Gothic imagination. Often a single tree or flower, already rendered in a patternbook, was required to symbolize a whole landscape, and the draughtsman's close scrutiny of such forms gave them special valence and authority.

Map-like, topographical studies were prepared in the fourteenth and early fifteenth centuries, but only with Pollaiuolo's and Leonardo's lovingly descriptive drawings of the Arno valley did landscape first come into its own. A new sense of the wanton power of nature, divorced from the designs of God or man, is first felt in these Tuscan renderings of the river, whose abstract, "nonobjective" flow evoked a freedom of artistic expression that has characterized landscape drawings over the last five centuries.

The very impersonality of an essentially people-free genre makes it supremely irrelevant whether man or prospect please the viewer and allows the draughtsman a unique opportunity to exercise his unfettered imagination. In reacting rapidly to often vast surroundings, the draughtsman was often forced to create certain linear conventions to communicate the essentials of a perhaps highly complex view. Fra Bartolommeo's notebooks show the eloquent abbreviations used by the artist in the early sixteenth century to record a series of wooded peaks and valleys to be included in the backgrounds of his devotional subjects. These album pages, like those of Bellini earlier, formed a sort of topographic blood bank to enliven the scenic context of the Gospel as seen by this master.

Dürer and the artists of the Danubian school, often working on colored papers and employing gouache and watercolor as well as reed pen, brush, and colored chalks, produced a mystical revelation of Nature, shown as if drawing its own portrait, with great intimacy and in stirring silence, almost as if it remained unseen and undisturbed by the artist himself.

A more microscopic yet cosmic view of natural phenomena, first evidenced in Northern manuscript illuminations of the early fifteenth century and the art of Jan van Eyck, is first known in drawn form in the *oeuvre* of Pieter Breugel and Stinemolen. Their arresting descriptions of the Alps, often drawn on the artist's way to Italy (as were so many of Dürer's landscapes), seem like lunar photography in the intricacy of their *chiaroscuro*, with mountains rising magically from the paper like a negative developing in the darkroom.

Venice, always making the best of both cultural worlds—Northern and Southern—produced landscapes of unrivaled lyrical beauty, which join the illusionistic gifts and particularity of the North to a Latin sense of the Arcadian. The short,

Landscape

flickering, almost pointillist strokes of Giorgione, Campagnola, and Titian created an ideal world, eternally bathed in flatteringly hazy light, and established the romantic attitude to landscape that was to be shared by such great seventeenth- and eighteenth-century draughtsmen as Rubens and Watteau, whose first and greatest love these Venetian Renaissance masterworks remained.

Expressionistic fires are first seen in the landscapes of later-sixteenth-century Urbino, Bologna, and Rome. Federico Barocci, in drawings of unparalleled loveliness, captured the *Tempest*-like qualities of fields and vines, woods and shrubs, with a rich colorism (including exquisite use of chalks) that points toward the French and Flemish masters of the Baroque era. The Carracci, working with reed pens, created a new sense of urgency in an almost reluctant vision of Nature—again, as if it were writing itself into reality, much like Rembrandt's etchings and drawings. Domenichino and Guercino combined an inventive, private examination of the natural world with a bravura approach of broad brushwork and bold washes, producing freshly harmonious studies rather than a contradiction in terms.

Grandeur, classical authority and a heroic orchestration of all the elements of nature toward an almost operatic approach, is found in the major landscape masters of the Baroque, active about the middle of the seventeenth century. Poussin, following Domenichino, brought a certain Gallic rigor to Italian splendor that resulted in nature drawings of matchless grace and beauty. As absolute statements of divine authority whether peopled by Mercury or Moses, these works shared a pantheistic grandeur with the greatest achievements of classical antiquity. Claude often worked in the brown washes favored by his Netherlandish contemporaries also living in Rome. For all the stagey monotony of the bulk of his *oeuvre*, like flats for uninspired operas, Claude could break away from the boredom of his too-predictable formulas to produce landscape studies of radiant loveliness.

As canvases seemed to get larger and larger, machine-like in their plotty over elaboration, artists sought and found respite in the privacy of their landscape drawings, many of them made without an eye to any future utility, but rather as materializations of a personal world or retreat. Nowhere is this more strongly felt than in the landscape drawings and sketches of Rubens and Rembrandt, whose quietly limned insights provided a meditative refuge from the sometimes bombastic requirements of their patrons. The tiny views by Callot and Hollar, Elsheimer, and Silvestre provided welcome counterpoint to the relentlessly "bigger is better" esthetic of the Baroque, and thus have long been treasured by collectors and artists alike. Chinese and Japanese paintings, as well as Indian manuscript illuminations, intrigued Western artists as trade with the Far West increased, and their influence brought a new modesty and austerity to European renderings.

With the advent of the eighteenth-century Grand Tour, Northern aristocrats went south and Italian masters came north, in an exchange that brought a new element of the souvenir to the *oeuvre* of many Italian artists such as the Ricci, Guardi, Tiepolo, and Bellotto and to such Frenchmen as Fragonard, Hubert Robert, and Ingres. Small-scale drawings of favorite squares and monuments, in characteristic views, provided needed bread-and-butter for their creators, since such graphic keepsakes were now sought throughout the West. The Enlightenment cut Nature down to man-sized proportions within a manageable dream of intelligent pleasure. Land-

Landscape

scape now took a decorative backseat to the endless amorous picnics and fêtes; it provided an outdoor livingroom, a kind of carless drive-in where dark as well as light contributed to the convenient pursuit of earthly delights. The world became a well-tended garden, of cultivatedly encyclopedic proportions.

Seeds of picturesque terror and sublime revelation, leading to the pictorial principles of late-eighteenth- and early-nineteenth-century landscape, were first sown by Salvator Rosa and Guercino in the Baroque and were followed by Piranesi's dramatic evocations of the grandeur that was Rome. Surprising fear and fearful surprise lurked below the surface of much of the gayest eighteenth-century art, brought out of light-hearted *boiserie* into the dark woods of fantasy by Goya, Cozens, and Géricault. Reasoned Neoclassicism had little interest in an unpopulated natural scene, but its Romantic countercurrent, marked by a renewed religiosity and nationalism, revived the Gothic landscape of the *Chanson de Roland*, the Rhine journey and Alpine crossing, with an implicit theology that appealed to Nazarene and Pre-Raphaelite alike.

Literary vistas, peopled with supernumeraries of the operatic stage in the spirit of Claude, re-entered the landscape scene in the sketches of Turner and Bonington. Pre- and post-Darwinian doubt and discontinuity of faith and force led also to exotic explorations of Morocco, Egypt, and even more distant lands—Delacroix and later Klee in Morocco, Lafarge and Gauguin in the South Seas, among others. These new territories liberated the artist from an exhausted conventional ambience and the played-out terrestrial allegories of the recent past.

The unprecedented objectivity of the camera eye, mirroring and freezing an infinite variety of topography with startling clarity and a new way of looking, provided further challenge and stimulus to the limner of landscape. Following Ruskin's fanatical lead, the artist explored such new pictorial frontiers as Africa, South America, and the Far West, presented in their new destiny as lands first caught by the artist's graphic re-creation. Whether searching the flaming mysteries of the Forest of Fontainebleau at sunset, watching the moon rising over the Hudson's impressive Palisades, or surveying the harsh, ceaseless battle between man and ocean in Maine or Bermuda, the masters of the mid- and late nineteenth century involved themselves intensely in the land and seascape, often drawn under agonizing conditions. During roughly the same years, the Dürer-like detail of Millet's flowers was combined with the almost Surrealist abandon latent in the painstaking "specificity" of Ruskin's rocks and waterfalls.

A sunnier aspect of photographic vision is found in the rapidly executed landscapes of the Impressionists and their followers, which were dashed off with an incomparable sense of the moment, before the natural light changed, as if the artist himself were some chemical agent instantaneously developing his image from within the paper.

With Symbolism and Expressionism in the late nineteenth and the early twentieth century, the draughtsman became more and more a prophet, isolating and intensifying the emotional and spiritual significance of dramatic detail or seizing upon a sudden manifestation within landscape to which he felt uniquely attuned. Beginning with such varied graphic sources as Gustave Doré and Grandeville, Van Gogh and Munch delineated coal mines and beach scenes that somehow disturbingly conveyed the interior topography of human experience.

Landscape

Equally passionate but less cognitive landscape were realized by Kandinsky and his followers in Scandinavia, France, and Germany. Their cerebral, mystical exploration of space and color in drawings and watercolors elicits a suggestive power that challenges acres of Turner's glowing, inherently representational canvases. New landscapes of the mind, with ambiguous interpenetrations of organic and inorganic, renouncing long-standing animal, vegetable, and mineral dichotomies in favor of a drawing moved by and with all three, are found in the Surrealist works of Max Ernst, Matta, and Yves Tanguy. A distinct automatism continues the psychological landscape in the Kafka-like visions of Paul Klee and in the obsessively impersonal, mechanistic fantasies of the Futurists. Now seemingly self-propelled, the pen or pencil was set free by the Dadaists and Dali, by Pollock and *art informel*, to delineate its own abstract world. In all these works topography apparently realizes itself, with the artist being almost a bystander who frees the inner world in a transfiguration that is almost Danubian in its mystical abandon, calling to mind the luminous landscapes of Huber and Altdorfer centuries earlier.

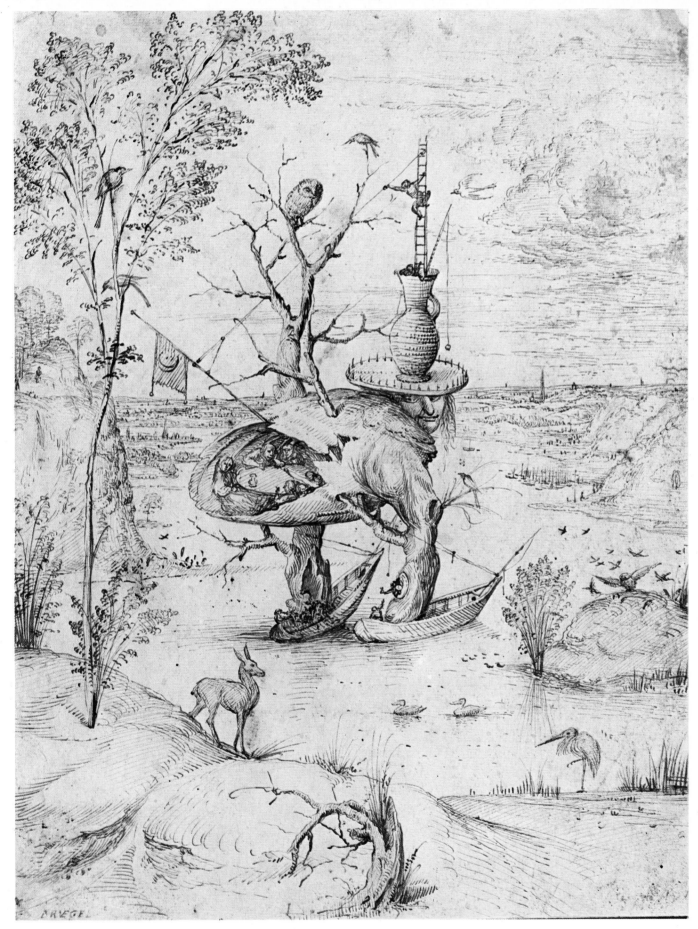

Hieronymus Bosch
Bois-le-Duc (Brabant) c. 1450 - 1516

Fantastic Landscape.
Vienna, Albertina, no. 7876. Pen and bister ink ; 11⅛ × 8⅜ in. (27.7 × 21.1 cm). Signed spuriously in lower-left corner at a later date : *"Bruegel."*

Bibliography : Benesch, 1964, no. 125.

Without its central personification of earthly evil and decay — the fantastic humanoid tree which also appears in Bosch's celebrated triptych *The Garden of Earthly Delights* (Madrid, Prado) — this landscape would be of striking naturalism. But moralist first and naturalist second, Bosch blocks this precocious view with a visual sermon on his subject : earthly corruption. The artist seems to surprise even himself with the sudden, tender intrusion of charming animal studies scattered throughout his marshy landscape, on an often minute scale. Their very presence moderates Bosch's fanciful, but basically bleak reflection on the inherent evil of nature and of mankind.

1

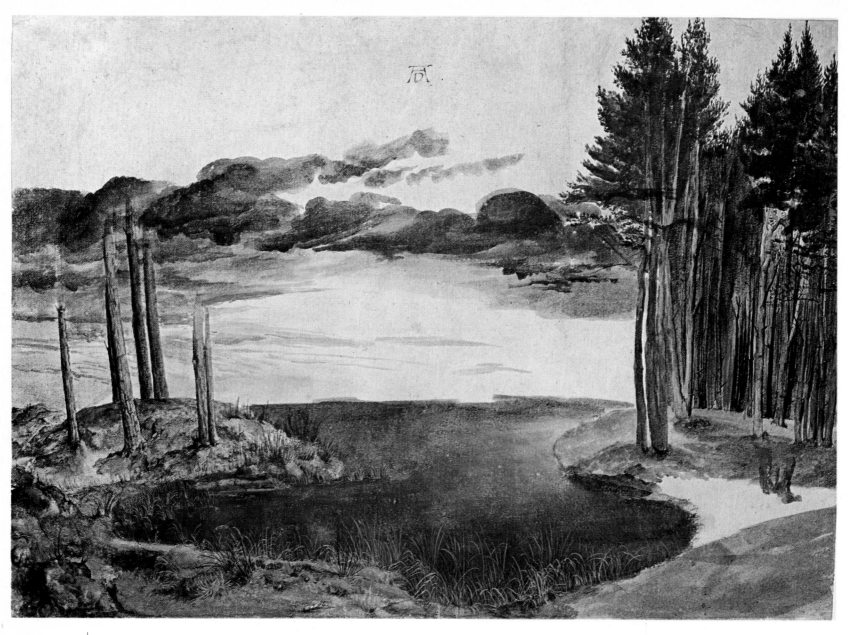

Albrecht Dürer
Nürnberg 1471 - 1528

2

Lake by a Wood, c. 1495-1497.
London, British Museum, no. 5218.167.
Watercolor and gouache ; 10½ × 12 in.
(26.2 × 37.4). Inscribed with artist's
monogram at top center.

Bibliography : Flechsig, 1931, II,
p. 137 ; Winkler, 1939, no. 114 ;
Panofsky, 1948, no. 1387 ; Winkler,
1957, p. 86.

Of unprecedented freshness, such water-
colors exemplify the other side of Dürer's
art. So different in rendering from his
rigorously detailed works in black-and-
white, their free-flowing spontaneity
lies at the opposite pole in style and
attitude from his better-known prints
and drawings. Executed in the environs
of Nürnberg shortly after his first Italian
journey, these engaging early works
show an immediate response to nature
characteristic of Dürer's youth. The
foreground is done with astonishingly
fine detail, probably with the very tip
of the artist's brush, whereas the hazy
sky and background are washed in with
more sweeping strokes. The evidently
unfinished clump of trees at the left
adds to the romantic, deserted air of
this edge of a woodland.

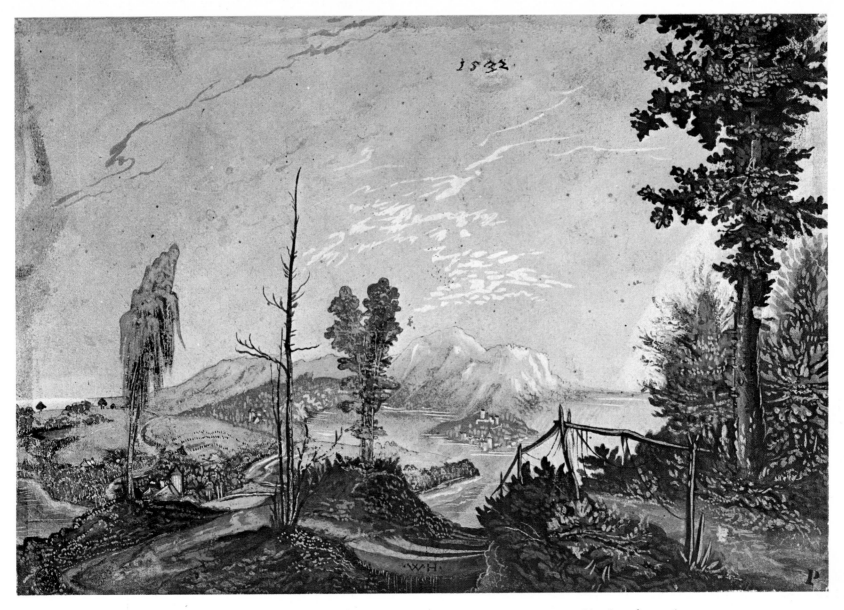

Wolf Huber
Feldkirch c. 1480/90 - Passau 1553

3

Alpine Foothills, 1522.
West Berlin, Staatliche Museen,
no. 2061. Brush, watercolor, and goua-
che ; 8⅜ × 12¼ in. (21.1 × 30.6 cm).
Signed with artist's monogram at bottom
center ; inscribed with altered date
(1532) at top center.

Bibliography : Friedländer-Bock 1921,
p. 56 ; Weinberger, 1930, pp. 168,
228 ; Heinzle, no. 91.

Dramatic in its combination of strongly
outlined dark trees in the foreground
and a soft-focus alpine view in the dis-
tance, Huber's rosy-hued landscape
suggests a supernatural transfiguration.
Some sudden event, an apocalyptic
sunset or sunrise, has left its luminous
mark on the artist's mind and work.
Artists of the Danubian school often
invested the natural world with a vision-
ary, pantheistic quality that went well
beyond the confines of conventional
Christian faith.

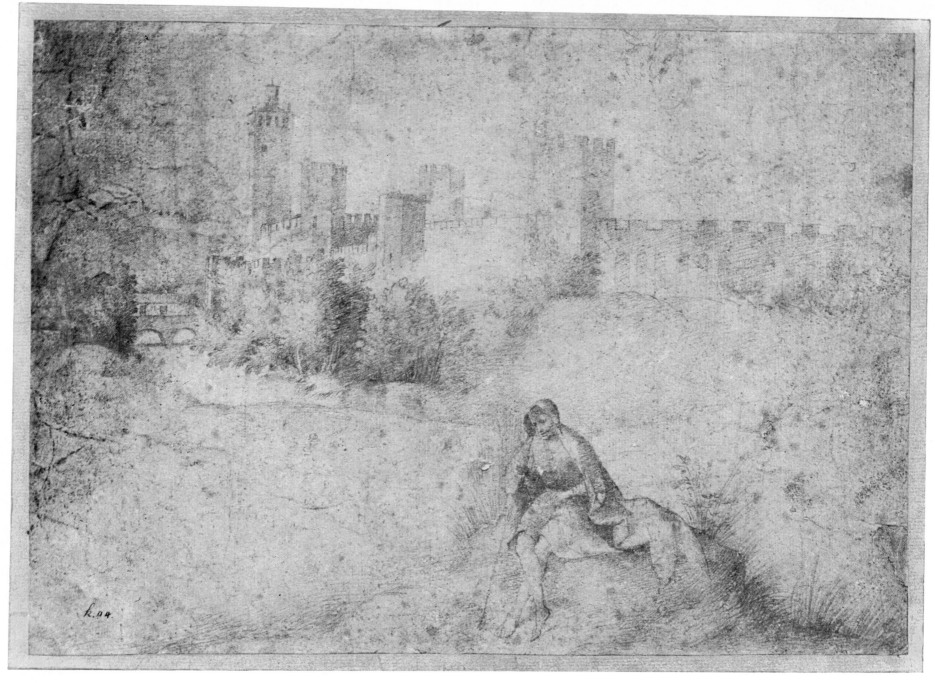

Giorgione (Giorgio da Castel-franco)

Castelfranco 1477 ? - Venice 1510

4

View of Castelfranco.

Rotterdam, Museum Boymans-van Beuningen, Cat. no. 485. Red chalk ; 8½ × 11⅝ in. (20.3 × 29 cm).

Provenance : Coll. Resta.

Bibliography : Hadeln, 1925, fig. 3 ; Tietze, 1944, no. 709.

This is one of the very few drawings generally accepted to be by the Venetian master's hand, with its background so similar to his painting *The Tempest* (Venice, Accademia) and its foreground figure so like those in his *Sunset* (London, National Gallery). A medieval walled town, presumably the artist's native Castelfranco del Veneto, is seen behind a pensive shepherd seated on a knoll. Short, shimmering parallel strokes define both voids and solids and carry light across or around forms through their presence or absence. A complex, elusive relationship between figure and landscape is found in many of Giorgione's works. Perhaps no other artist ever conveyed such a sense of " more than meets the eye " as Giorgione, whose placid scenes mysteriously intimate some event that has just occurred or is about to happen, modifying forms as if from within rather than without.

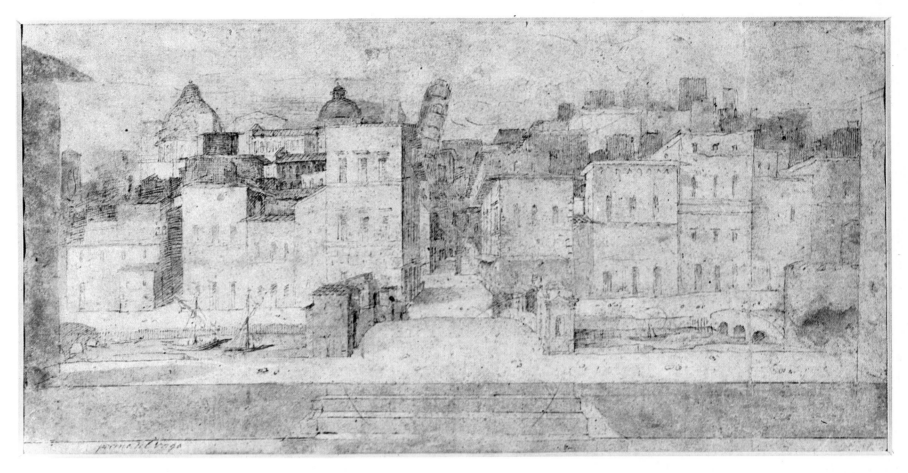

Domenico Beccafumi (Domenico di Pace)
Valdibiena c. 1484/86 - Siena 1551

5

View of Pisa.
London, Coll. John Pope-Hennessy.
Pen and ink, with brownish wash and
touches of rose watercolor ;
7⅜ × 15½ in. (18.4 × 38.7 cm).

Bibliography : Sanminiatelli, 1967,
p. 153 ; Pope-Hennessy, 1943, p. 65.

Beccafumi often stayed in Pisa, espe-
cially during 1539, when this drawing
may have been executed. (The former
attribution to Perino del Vaga visible
at the lower left of the drawing is
incorrect.) Arranged conspicuously
parallel to the spectator, Beccafumi's
artfully symmetrical view of Pisa as
seen from along the Arno may have
functioned as a scenic cityscape for some
Renaissance theatrical fête : leaning
toward its central thoroughfare is the
famous tower, with the domes of the
Cathedral and the Baptistery seen to
the left. The delicate coloring and
lucidly defined masses of the buildings
call to mind Corot's muted Italian views
of three centuries later.

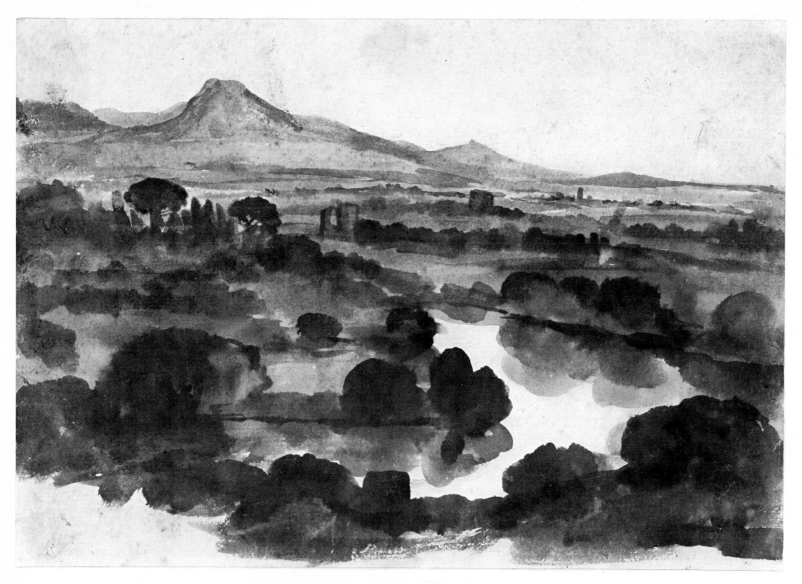

Claude Gellée (Le Lorrain)
Chamagne (Nancy) 1600 - Rome 1682

6

View of a Lake near Rome,
c. 1640.
London, British Museum, no. 007.212.
Bister wash ; 7⅜ × 10¾ in.
(18.5 × 26.8 cm).

Provenance : Coll. Richard Payne
Knight.

Bibliography : Vallery-Radot, 1953,
pl. 76 ; Roethlisberger, 1968, no. 356.

Washed in with broad brushstrokes,
this Roman landscape points to the art
of the eighteenth century in its spare,
dramatic communication of the pic-
turesque. Almost Oriental in its austere
exploitation of contrast between ground
and brushwork, Claude's scenery is a
view of absolute classical grandeur. The
serpentine river seems to play a lyrical
duet with the jutting profiles of the
distant heights in the countryside. Cer-
tainly this is among the most beautiful
of some 1,200 known drawings by
Claude — most of them studies for his
evocative, idyllic, painted landscapes.

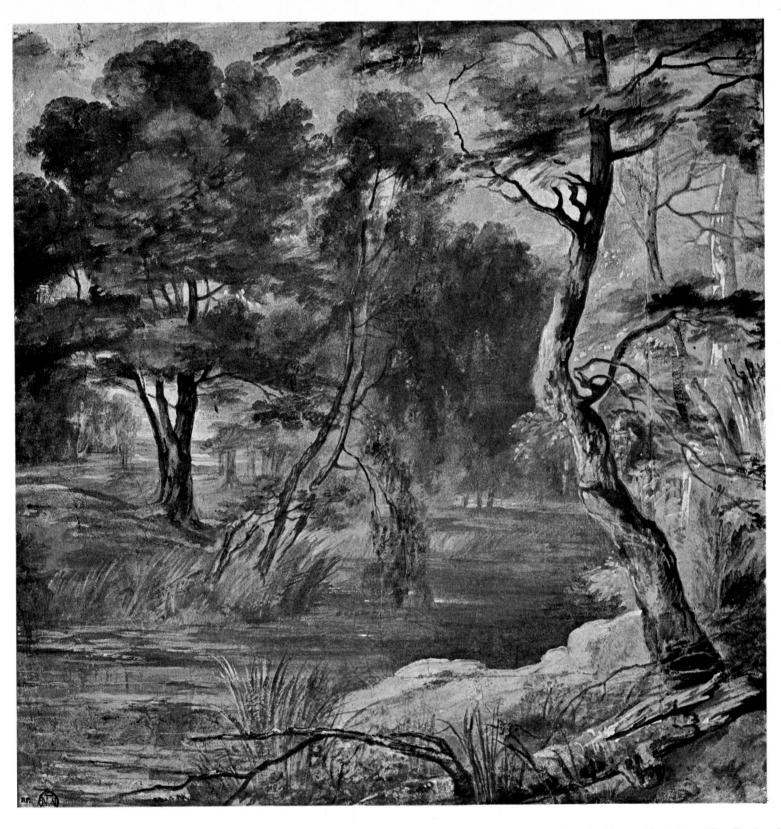

Jacques Fouquières
Antwerp (?) c. 1590 - Paris 1659

7

Woodland Stream.
Paris, Musée du Louvre, Inv.
no. 19.970. Brush, watercolor, and
gouache ; 15 ¼ × 15 ⅛ in.
(38.1 × 37.7 cm).

Provenance : Coll. Mariette.

Bibliography : Stechow, 1948, pl. IX ;
Lugt, 1949, I, no. 662 ; Méjanès, 1967,
no. 176.

Little known today, this Franco-Flemish
painter to the French king was a master
of landscape studies, in the tradition of
Federico Barocci. Breaking away from
the intricate Mannerism of his teacher,
the Flemish painter Gillis van Conninx-
loo, Fouquières — like Rubens — con-
ceived his art in the bright major keys
of baroque orchestration. His romantic,
freely drawn and imaginatively colored
woodland scenes, though probably
meant as studies for backgrounds in
paintings (like comparable sketches by

Van Dyck, who was nine years his
junior), call to mind the independent
landscape renderings that were so
widespread in the nineteenth century.

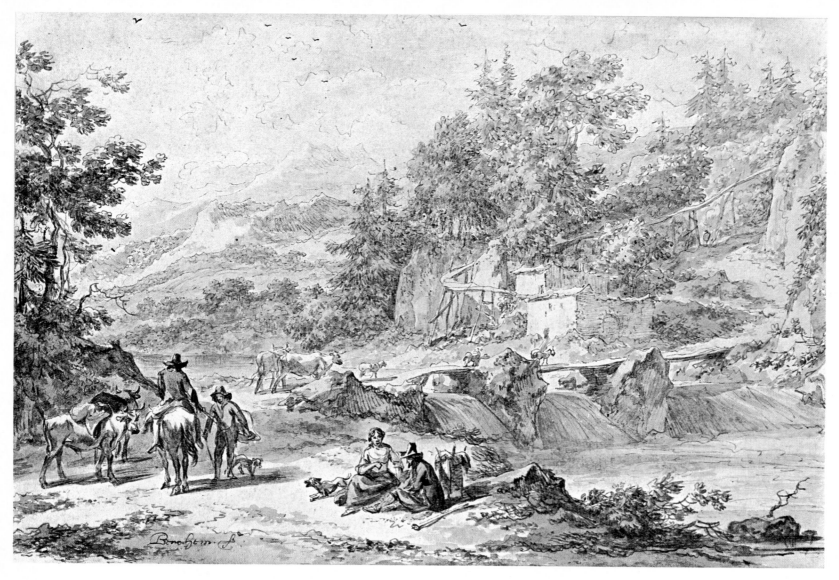

Claes Berchem
Haarlem 1620 - Amsterdam 1683

8

Mountain Landscape with a Bridge.
London, British Museum, Berchem no. 20. Pen and bister ink, with watercolor ; 6 × 9 in. (15 × 22.6 cm). Signed at lower left : *"Berchem f. "*

Provenance : Colls. Reynolds ; Dimsdale ; Holford ; Salting.

Bibliography : Von Sick, 1930, p. 62, no. 226.

Pendant to *Italian Peasants at a Ford* (British Museum, Berchem no. 21), this drawing was done during or just after the artist's second Italian journey (c. 1653-1655). So like Tiepolo in its crisp, vivacious linework and soft wash shadows, Berchem's gay and informal rendering anticipates the rippling decorative qualities of the Rococo. The effervescent humor enlivening both figures and natural setting in studies such as these, with their frank pursuit of a delicious lightweight manner, begins the new genre of the *capriccio,* which was to be a major comic element in eighteenth-century art.

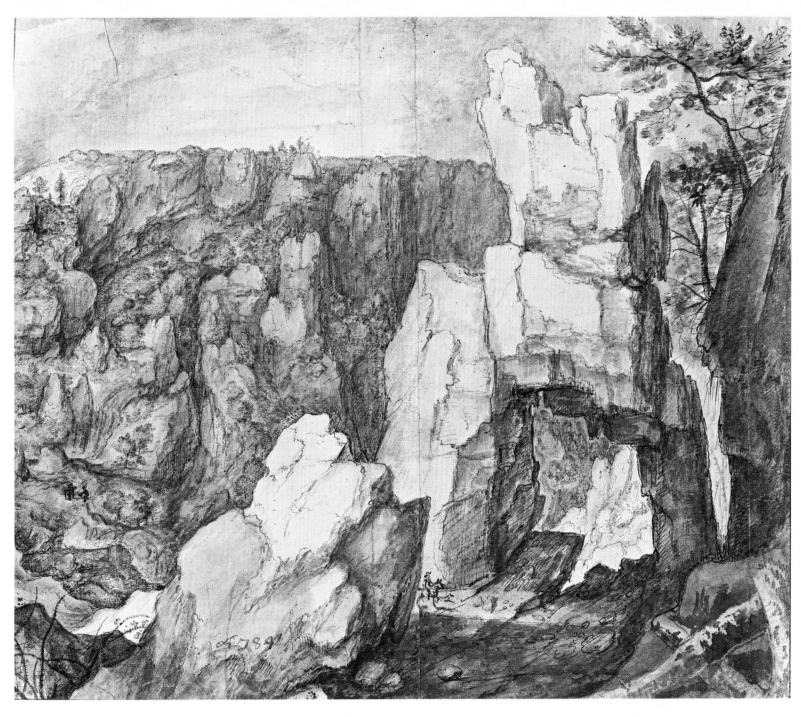

Roelandt Savery
Courtrai 1576 - Utrecht 1639

9

Mountain Landscape.
Leningrad, The Hermitage, no. 15103 (acquired 1924). Pen and bister ink, with watercolor; 11¾ × 13¾ in. (29.5 × 34.5 cm).

Provenance : Coll. I. I. Beckij ; Akademija Chudozestv (Leningrad).

Bibliography : Dobroklonskij, 1965, no. 29 (erroneously attributed to Lucas van Uden).

Savery's curious combination of a sense for topographical accuracy with a rich vein of picturesque fantasy led the way away from the precise, medievalizing renderings of Bruegel toward a more spontaneous, interpretive approach to landscape. This tendency opened Northern landscape art to new classical currents from Italy. Best known for his exotic "Peaceable Kingdoms," which brought together the newly discovered fauna of both the Far East and the remote West, Savery was also capable of creating eerily poetic landscapes that pointed toward the greatest works in this genre — the art of Hercules Seghers.

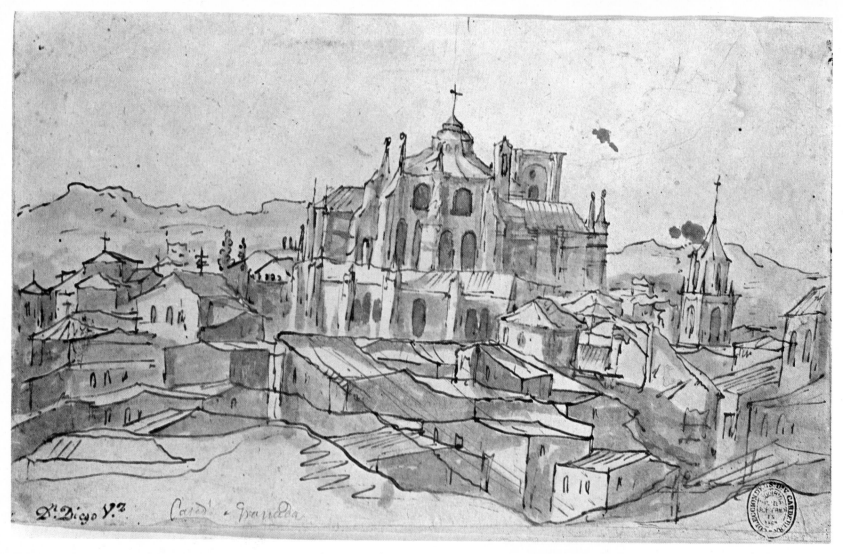

Diego Velázquez (attrib.)
Seville 1599 - Madrid 1660

10

The Cathedral of Granada,
c. 1629.
Madrid, Biblioteca Nacional, no. 500.
Pen and ink, with bister tempera wash,
on yellowish paper ; 7⅜ × 12⅜ in.
(18.5 × 31 cm). Inscribed at lower
left : *"Dn Diego Vz Cated1. Granada."*

Bibliography : Barcia, 1906, no. 500 ;
Sánchez Cantón, 1930, III, 223 ;
Velázquez y lo Velazqueño, 1960-1961,
no. 183 ; López-Rey, 1964, no. 638 ;
Vey - De Salas, 1965, p. 261.

Vibrantly luminous in rendering, this
drawing may indeed be by that greatest
master of light in action, Diego Veláz-
quez. Few drawings associated with his
name survive, and with one exception
(a Borgia portrait in the Pierpont Morgan
Library, New York) there is little
scholarly agreement about their
authorship. Velàzquez is known to have
been in Granada at the end of 1629, on
his way to Málaga, the port of embark-
ation for his first trip to Italy.
While none of the Spanish master's
landscape paintings or landscape details
correspond to this scene, that does not
preclude his having sketched it as a
travel record just before leaving for his
momentous confrontation with the new
art of the Baroque in Italy.

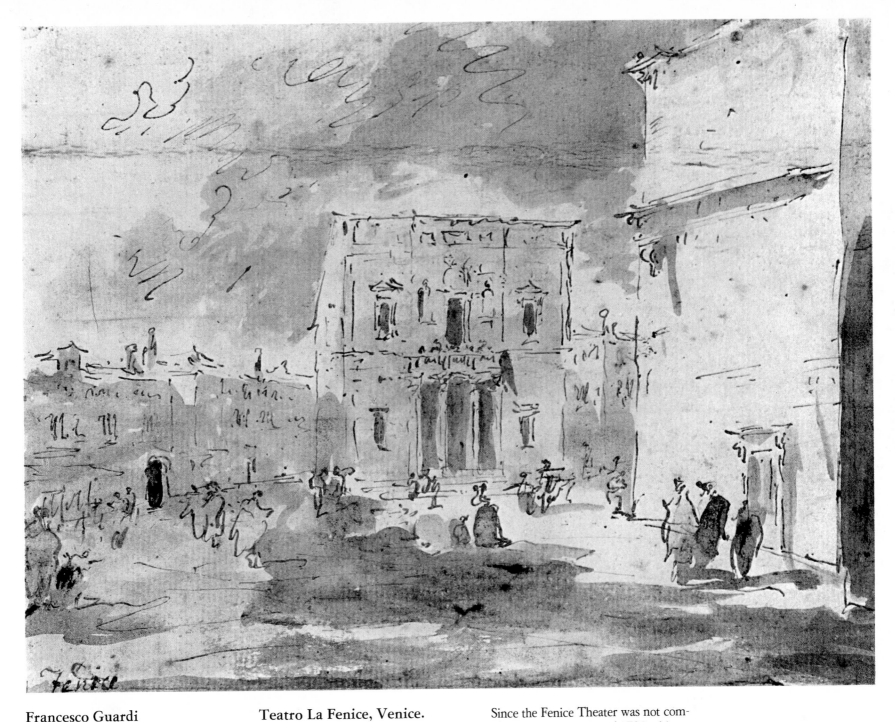

Francesco Guardi
Venice 1712 - 1793

11

Teatro La Fenice, Venice.
Venice, Museo Civico Correr, no. 724.
Pen and sepia ink, brush and gray wash ;
7¾ × 10⅛ in. (19.5 × 25.4 cm).
Inscribed in lower-left corner : *"Fenice. "*

Provenance : Coll. Correr.

Bibliography : Pallucchini, 1943, p. 49,
no. 87 ; Pignatti, 1967, fig. LXVII.

Since the Fenice Theater was not completed until the spring of 1792, this drawing must be among Guardi's last, made during his final year of life. Even in his most cursory manner, Guardi's fugitive lines communicate the dramatic air of a "happening" that characterized almost any Venetian event, be it no more than a casual gathering of people in a piazza. It seems appropriate that this spectral, unusually cerebral study, with its highly mobile, almost ghostly line, should have come just before the artist's death in Venice in 1793.

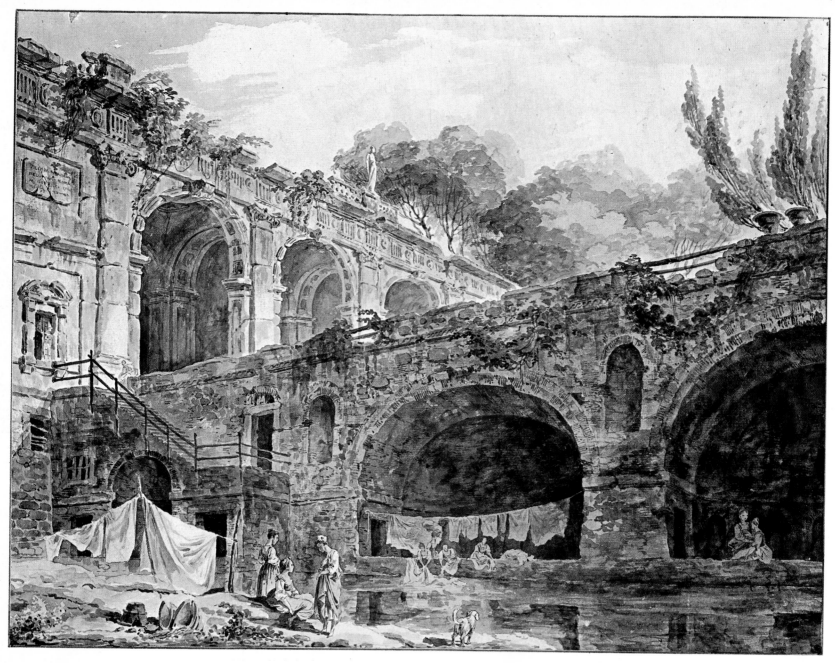

Hubert Robert
Paris 1733 - 1808

12

Villa Madama.

Vienna, Albertina, no. 12.431. Pen and
brown ink, with watercolor, over a
black chalk sketch; 13¾ × 18¼ in.
(34.5 × 45.5 cm). Inscribed on plaque
at the upper left: " *Villa Madama deli-
neavit Romae. H. Robert. 1760.* "

Provenance : Coll. Mariette (Paris sale
1775).

Bibliography : Loukomski-De Nolhac,
1930 ; *Exposition Hubert Robert*, 1933,
no. 117 ; *Amis et Contemporains de
P.J. Mariette*, Paris, 1967, no. 265.

In the summer of 1760, Robert traveled
through the Roman Campagna with the
Abbé de Saint-Non and Fragonard. The
crumbling Renaissance grandeur of
Raphael's Villa Madama in Rome, with
its great gardens reduced to use as laun-
dries, is shown here in operetta fashion,
as though the washerwomen might at
any moment burst into *bel canto* to the
beat of the dog's tail. The rococo friv-
olity of these genre figures contrasts
with the powerful, Piranesi-influenced
perspective of the intersecting arcaded
foundation and the white marble loggia
above, as part of the new picturesque
esthetic in painting. This splendid draw-
ing was bought by Mariette with its
pendant, *The Fountain of Villa Sac-
chetti* (Albertina collection) ; they were
later engraved (1778) by F. Janinet.

François-Marius Granet
Aix-en-Provence 1775 - 1849

13

Fog along the Seine, 1843.
Paris, Musée du Louvre. Inv.
no. 26.858. Watercolor over traces of
lead pencil ; 7 ¼ × 11 ¾ in.
(18 × 29.5 cm). Inscribed at lower
right : *"Paris le 18 janv. 1843."*

Provenance : Bequeathed by the artist
to the Louvre in 1850.

Bibliography : *François-Marius Granet,*
Paris, 1960 (Louvre catalogue).

Beginning in 1799, Granet worked in
David's atelier and, together with
Ingres and Girodet, lived in the nearby
Capuchin monastery. Between 1802 and
1819, he traveled and studied in Italy,
mostly in Rome. Continuing in the best
French and English watercolor tradi-
tion, Granet brushes in the water, a
ghostly bridge, and the banks of the
Seine in a diaphanous manner that is
often wrongly viewed as the monopoly
of Turner (his exact contemporary) or
the Impressionists afterward. A delight-
ful, little-known master, Granet was
a close friend of Delacroix and a pro-
minent artistic figure in his day, when
he was better known for his dramati-
cally presented romantic and historical
subjects than for the rather more modest,
sensitive studies like this.

John Ruskin
London 1819 - Brantwood (Coniston) 1900

Rock Formation at Glenfinlas, 1853.

Oxford, Ashmolean Museum. Ink and watercolor; 19 × 13 in. (48.2 × 33 cm).

Bibliography: P. H. Walton, *The Drawings of John Ruskin,* Oxford, 1972, p. 82, no. 58.

Ruskin was a student of geology and collected minerals diligently. Despite his professed desire for a faithful, disinterested transcription of nature, Ruskin's surface realism is infused with an almost hysterical sublimation of passion as read into leaf and rock. This exquisite *grisaille* rendering thus becomes a disquietingly personal statement, the very antithesis of the writer-artist's stated objectives. In his innumerable sketches, Ruskin portrayed nature painstakingly — rocks, glaciers, trees, flowers, shells, and cloud formations — nearly all its components except the human figure. Here the rock mirrors the man behind the rock, just as Glenfinlas lies locked in its own embrace.

14

Joseph Mallord William Turner
London 1775 - Chelsea 1851

15

Glacier at Chamounix, with Blair's Hut, 1808.
London, British Museum. Watercolor ; 12⅝ × 19 in. (31.5 × 47.5 cm).

Bibliography : P. Oppé, *Catalogue of the Exhibition of Watercolours of Turner, Cox, and de Wint...,* London, 1925, p. 21, no. 9.

At the end of the eighteenth century, artists throughout Europe occupied themselves with producing Alpine views. Rising above and beyond the turmoil of such world-shaking events as the American and French revolutions, these massive mountains represented a world of timelessness, a primordial nature beyond change, and reinforced the esthetic of the sublime with a glacial strength. Turner's view of nature, with its fragile yet convincing correlation between art and actuality, presents a topographic image of great brilliance. Like Leonardo's lunar valleys in the Quattrocento, the human dimension has vanished into space, as suggested here by Turner's Alpine vista. Though related to Romantic perspectives, in their strangely objective vision, Turner's cosmic views presage the new scientific authority of Darwin and Humboldt.

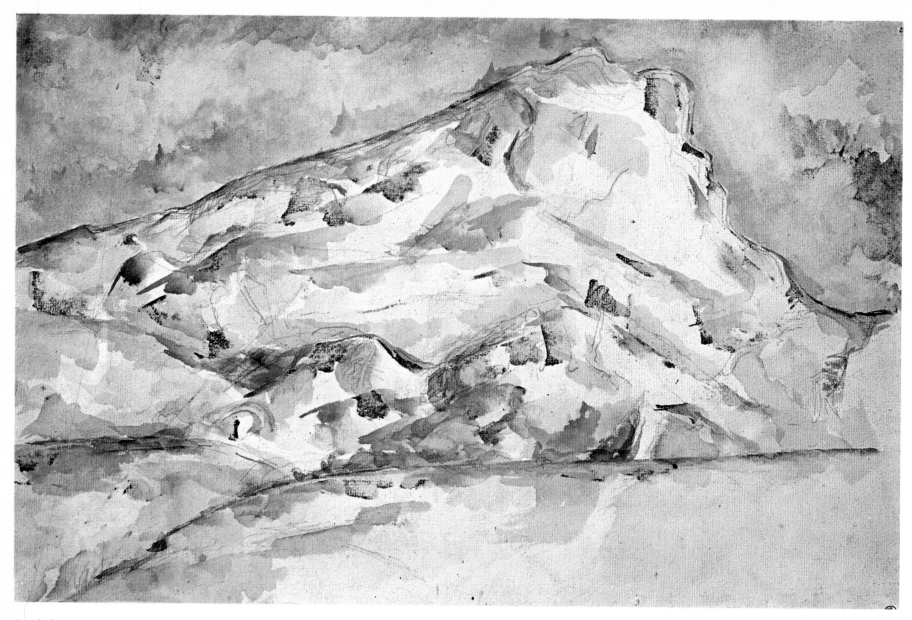

Paul Cézanne
Aix-en-Provence 1839 - 1906

16

Mont Sainte-Victoire, c. 1900.
Paris, Musée du Louvre, Inv. no. RF
31.171 (acquired 1959). Watercolor
over traces of graphite pencil ;
12 ½ × 19 ⅛ in. (31.1 × 47.9 cm).

Bibliography : Venturi, 1936, I,
no. 1562.

Ever since the mid-fifteenth century,
with the art of Quarton, this mountain
has presented a singular natural monu-
mentality to painters of the Provençal
landscape. The subject of Cézanne's
endless scrutiny in drawings, water-
color, and oils from about 1890 on,
Mont Saint-Victoire indicates the
artist's striving for an absolute, geometric
understanding of nature, from its roots
to its peaks. The austere, prismatic
rendering and pale, faceted color of this
study look forward to the landscape
analyses of Cubism a decade later.

John Marin
Rutherford (N. J.) 1870 - Cape Split (Me.) 1953

17

Quoddy Head, Off the Maine Coast, 1933.
Washington, D. C., Phillips Collection. Watercolor; 15⅜ × 21¾ in. (38.4 × 54.4 cm). Signed and dated in lower-right corner: *"Marin 33."*

Bibliography: *John Marin, Paintings and Watercolors from the Phillips Collection,* New York, 1967, no. 19 (exhibition catalogue).

Brisk reevocations of Whistler's works in their incisive linearism, Marin's watercolors reflect his early experience as an etcher. Maine's clear light and powerful surf brought a special energy to this artist's *œuvre,* just as it also lent to that of Homer, Hartley, and Avery. By an inventive, dynamic integration of his framing devices with pictorial content, Marin enlivened an essentially conservative art. With the exception of some views of New York City and very rare figure pieces, the artist concentrated on his loving depictions of the constantly changing conditions of sea and sky, in their ceaseless rhythmic interplay with the rocky shores and woods of Maine.

Lyonel Feininger
New York 1871 - 1956

18

Ostsee, 1931.
Campione d'Italia, Coll. R. N. Ketterer.
India ink and watercolor ; 11¼ × 18 in.
(28 × 45 cm). Signed and dated at
bottom : *"Feininger - Ostsee - 1931. "*

Bibliography : R. N. Ketterer, *Lyonel
Feininger Gemälde, Aquarelle, Zeich-
nungen, Graphik, 19??.*

In this elegant seascape, reduced to a
brittle, graph-like linear pattern stem-
ming from Cubist and Futurist innovat-
ions, with adroit touches of chilly color
Feininger re-creates the look, feel, and
almost the sound of the cold Ostsee.
Approaching the cinematic in its proj-
ection, this scene recalls the artist's
early involvement with communications
media during his lucrative career as a
comic-strip illustrator, before his teach-
ing days at the Weimar Bauhaus with
Gropius, Klee, and Moholy-Nagy. Like
Klee's fanciful visions, but with a more
realistic bent, Feininger's images often
achieved a delicate fusion of Cubist
formal analysis with Expressionist
emotion and symbolism.

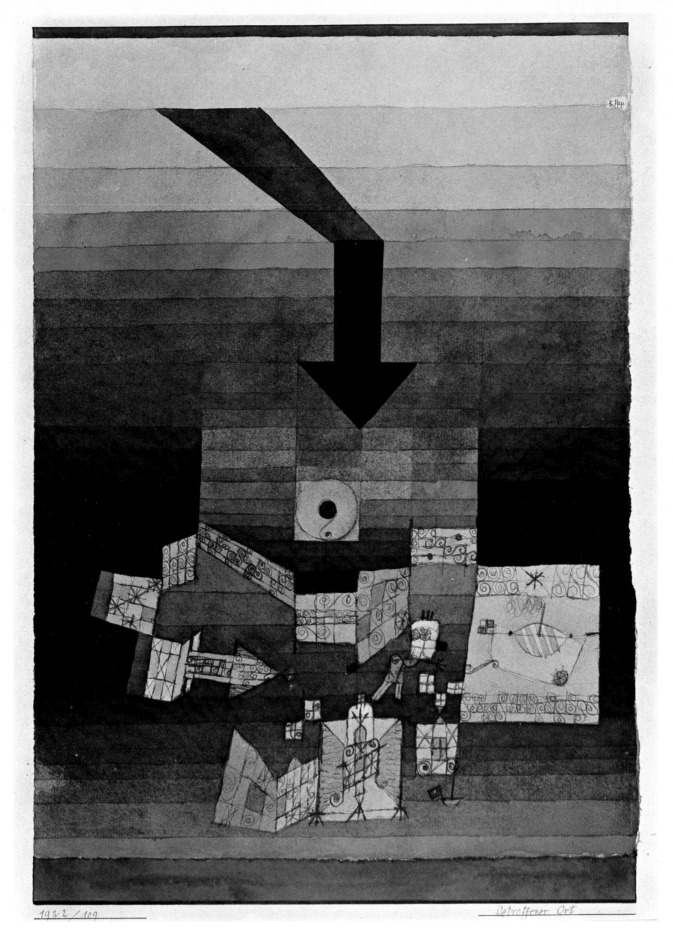

1922/109 Betroffener Ort

Paul Klee
Münchenbuchsee (Bern) 1879 - Muralto (Locarno) 1940

Doomed Place, 1922.
Bern, Kunstmuseum (Paul Klee Stiftung). Pen, ink, and watercolor ; 13 × 9¼ in. (32.7 × 23 cm). Signed at upper right : *"Klee."* Inscribed below : *"1922/109 — Betroffener Ort. "*

Bibliography : *Paul Klee Ausstellung in Verbindung mit der Paul Klee Stiftung,* Bern, 1956, p. 17, no. 38 (exhibition catalogue).

Essentially secretive, Klee's art is a code, a gathering of personal hieroglyphs, written in a series of private allusions whose meaning is sometimes illuminated by their mercifully legible captions inscribed in the artist's hand. Here, a huge, ominous black arrow snakes from the skies like a lightning bolt toward an exposed, defenseless locale below. The innocent aspect of its target seems only to heighten the sense of impending disaster. Like Steinberg, Klee allows his drawing to write, intuitively bridging the verbal and the visual with a series of silent, enigmatic, yet somehow eloquent signs.

19

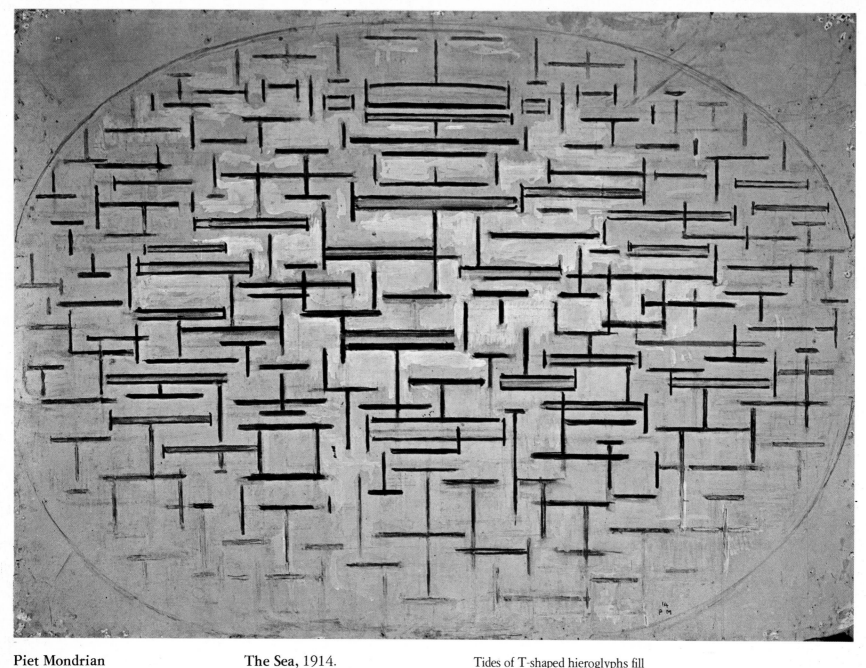

Piet Mondrian
Amersfoort 1872 - New York 1944

20

The Sea, 1914.
Venice, Peggy Guggenheim Foundation. Charcoal and gouache ;
35 ¾ × 48 ¾ in. (90 × 123 cm).
Signed and dated at lower right :
"14 P M. "

Bibliography : P. Guggenheim (ed.),
Art of This Century, New York, 1942,
p. 54 ; M. Seuphor, *Piet Mondrian :
Life and Work,* London, 1957, pp. 114,
120, 424, no. 392.

Tides of T-shaped hieroglyphs fill
Mondrian's cosmic oval. Confined
within a rectangle, his compositional
scheme recalls the classical circle in a
square. The modern Dutch master's
calm, clear approach is his birthright.
After partaking of Cubist currents
encountered in Paris, Mondrian drew *The
Sea* on his return to Holland, just before
an increasingly linear, abstract approach
took over in his art, a tendency giving
eloquent testimony to urban inhumanity.
The beautiful, stylized *Sea* with its
organic, enveloping curve brings to a
close the perfect circle of Mondrian's
progressively abstracted nature studies.

Leonardo da Vinci F. 1
Vinci 1452 - Amboise 1519

Landscape.
Windsor, Royal Library, no. 12399
(by permission of Her Majesty Queen
Elizabeth II). Pen and ink, on yellowish
paper ; $4 \times 5\,^7/_8$ in. (10×14.7 cm).

Fra' Bartolommeo (Baccio della
Porta)
Florence 1475 - 1517

**View of the Church and Square
of the Annunziata.** F. 2
Florence, Uffizi, no. 45P. Pen and ink ;
$12 \times 11.^1/_2$ in (30×28.5 cm).

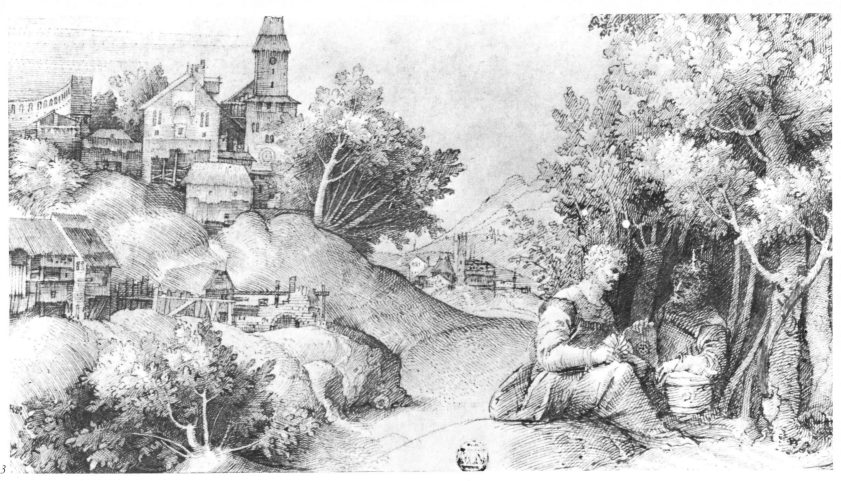

3

Giulio Campagnola F. 3
Padua 1482 - after 1515

Landscape with Figures.
Paris, Musée du Louvre,
no. 4648. Pen and brush,
brown ink ; 5 1/4 × 10 1/4 in.
(13.3 × 25.7 cm).

Guercino (Giovanni F. 4
Francesco Barbieri)
Cento 1591 - Bologna 1666

Landscape with Volcano.
New York, Coll. Janos Scholz.
Brush and brown wash, on
blue paper ; 10 1/4 × 14 7/8 in.
(25.8 × 37.2 cm).

4

Albrecht Dürer F. 5
Nürnberg 1471 - 1528
The Port of Antwerp.
Vienna, Albertina, no. 3165. Pen and
ink ; 8½ × 11¼ in.
(21.3 × 28.3 cm).

Wolf Huber F. 6
Feldkirch c. 1480/90 - Passau 1553
Landscape with Pollarded Trees.
Nürnberg, Germanisches National-
museum, no. H. 218. Pen and brown
ink ; 5 × 8¼ in. (12.7 × 20.6 cm).

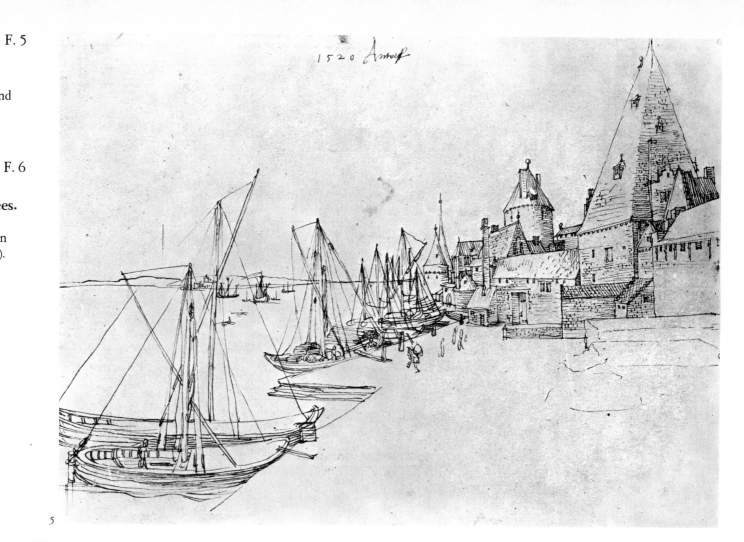

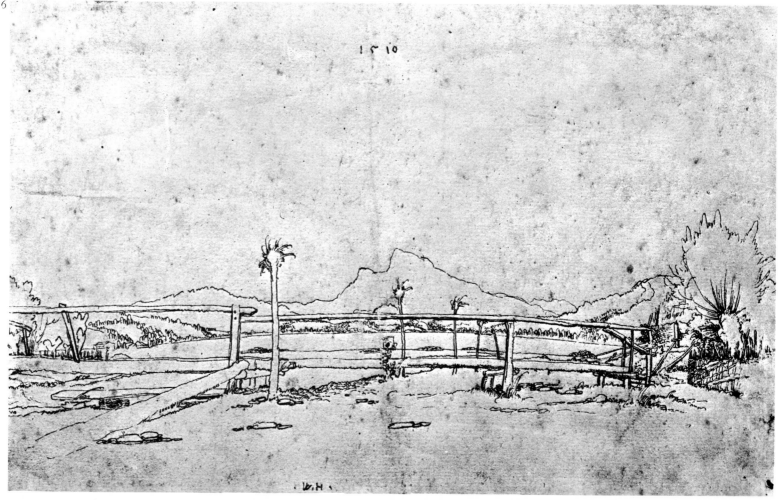

Erhard Altdorfer F. 7

Regensburg c. 1485 - Schwerin 1561/62

Hilly Landscape Near a Bay.
Vienna, Albertina, no. 17.546. Pen
and brown ink ; 8 ¼ × 12 ½ in.
(20.6 × 31.1 cm).

Pieter Bruegel the Elder F. 8

Breda c. 1525/30 - Brussels 1569

**Mountain Landscape
(Waltersburg).**
Brunswick (Me.), Bowdoin College
Museum. Pen and ink ;
10 ⅜ × 12 ½ in. (25.9 × 31.3 cm).

Niklaus (Manuel) Deutsch F. 9

Bern c. 1484 - 1530

Rocky Landscape.
Basel, Kunstmuseum, no. U.S. 19.
Pen and ink ; 11 ¼ × 8 ¼ in.
(28.2 × 20.5 cm).

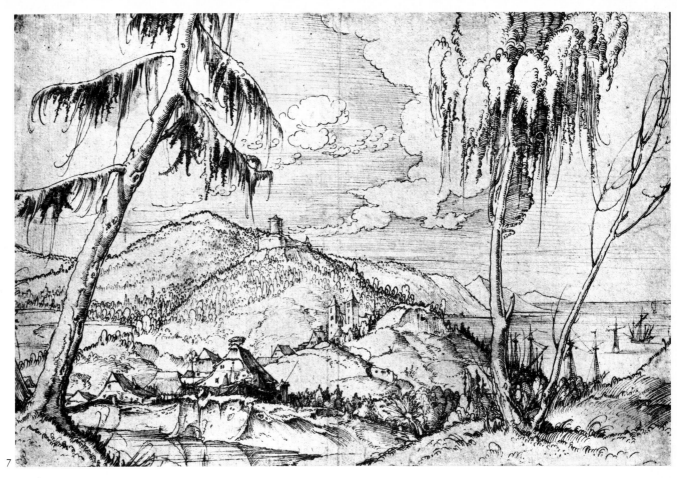

7

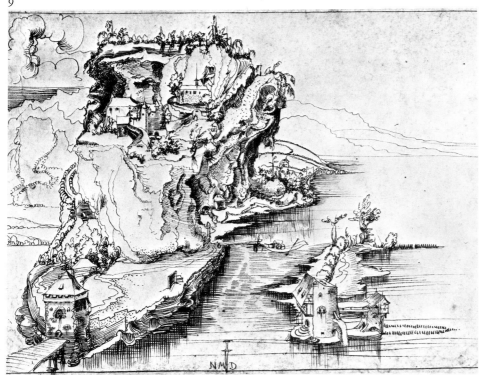

9

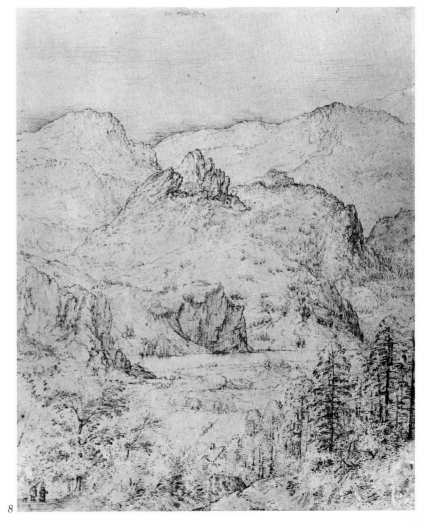

8

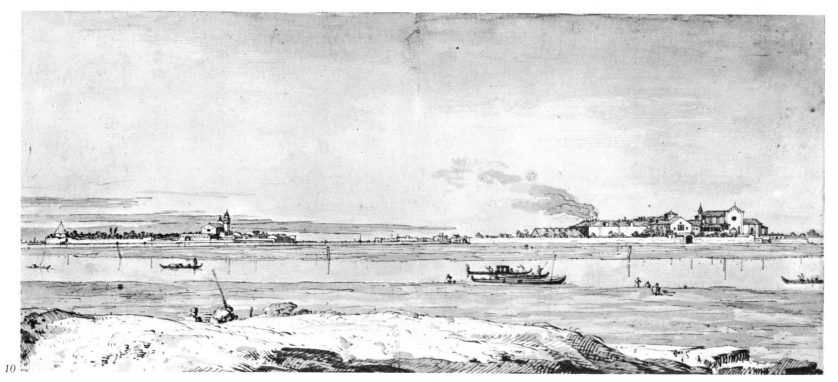

10

11

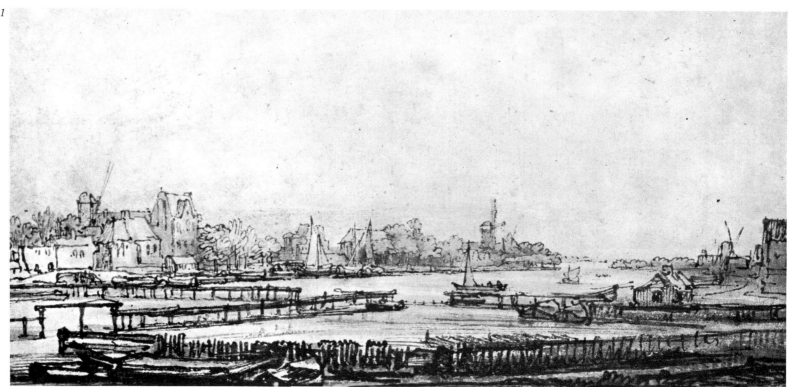

Canaletto (Giovanni Antonio
Canal)
Venice 1697 - 1768

**View of Sant'Elena with the
Certosa.** F. 10
Windsor, Royal Library, no. 7488
(by permission of Her Majesty Queen
Elizabeth II). Pencil, pen and brown
ink, brush and gray ink ;
6 ¼ × 14 in. (15.5 × 35.2 cm).

Rembrandt Harmensz. Van Rijn
Leiden 1609 - Amsterdam 1669

**View of the Amstel from a Ram-
part near Blauwbrouk,** F. 11
c. 1647 - 50. Washington, D. C.,
National Gallery of Art, Rosenwald
Coll. Pen and ink, with bister wash ;
3 ½ × 7 ½ in. (9 × 18.6 cm).

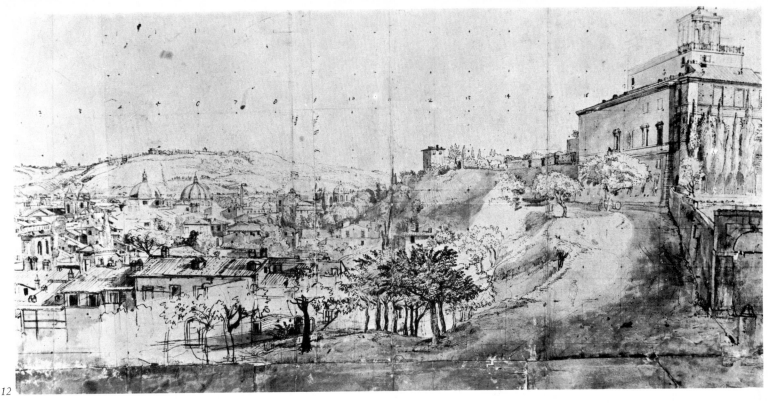

12

Gaspar van Wittel
(Gaspare Vanvitelli) F. 12
Amersfoort 1653/55 - Rome 1736

**View of Rome with Villa Medici
and Monte Mario.**
Naples, Museo Nazionale di San
Martino, no. 4065/5. Charcoal, pen,
and watercolor; 19 ½ × 36 ¾ in.
(49 × 92 cm).

Peter Paul Rubens F. 13
*Siegen (Westphalia) 1577 -
Antwerp 1640*

A Country Lane.
Cambridge (Eng.), Fitzwilliam Museum,
Inv. no. 2178. Pen, brush, and brown
ink, with traces of black-chalk preli-
minary drawing; 12 ½ × 16 ⅛ in.
(31.3 × 40.3 cm).

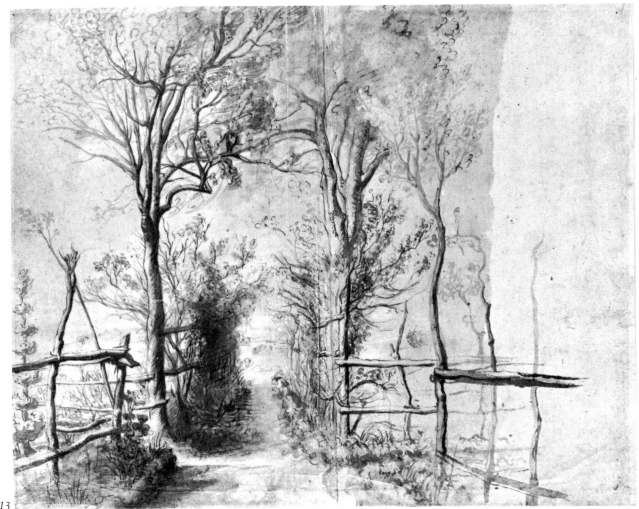

13

Jan Van der Heyden F. 14
Gorinchem (South Holland) 1637 -
Amsterdam 1712

Ruined Warehouse with
Brewers' Barrels.
Amsterdam, Rijksprentenkabinet,
no. A347. Chalk with wash ;
9 1/4 × 13 in. (23 × 32.4 cm).

François Boucher F. 15
Paris 1703 - 1770

A Farmyard.
New Haven, Yale University Art
Gallery (Everett V. Meeks and Paul
Mellon Fund). Black chalk with white
highlights, on blue paper ;
13 3/4 × 19 1/4 in. (34.6 × 48 cm).

Richard Parkes Bonington F. 16
Arnold (Nottingham) 1802 -
London 1828

Church of St. Wulfran, Abbéville
1818. Paris, Musée du Louvre, Inv.
no. RF 809. Pencil ; 9 5/8 × 7 1/8 in.
(24 × 18 cm).

Charles Meryon F. 17
Paris 1821 - Saint-Maurice
(Charenton) 1868

The Pont-au-Change, Paris.
Williamstown (Mass.), Sterling and
Francine Clark Art Institute, Cat.
no. 253. Pencil on tracing paper ;
6 7/8 × 13 1/8 in (17.2 × 32.8 cm).

John Ruskin F. 18
London 1819 - Brantwood
(Coniston) 1900

Piazza delle Erbe, Verona, 1841.
Oxford, Ashmolean Museum. Pencil
and watercolor ; 13 1/2 × 19 1/4 in.
(34 × 48.2 cm).

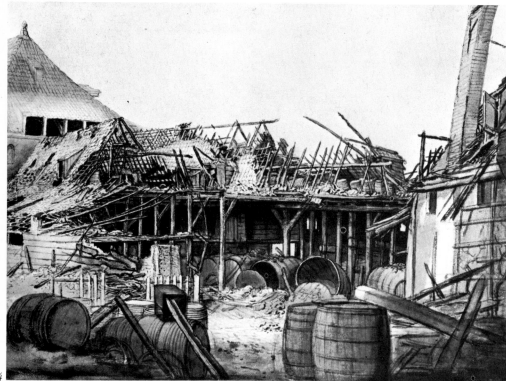

14

16

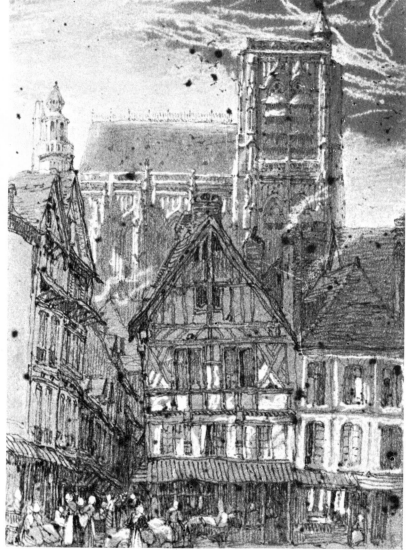

15

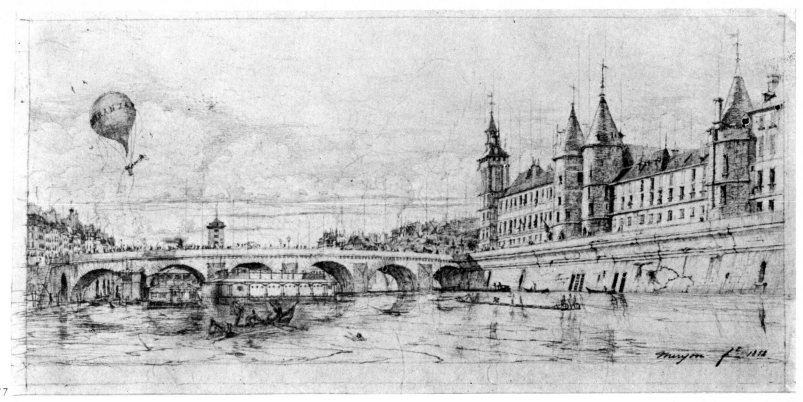

17

18

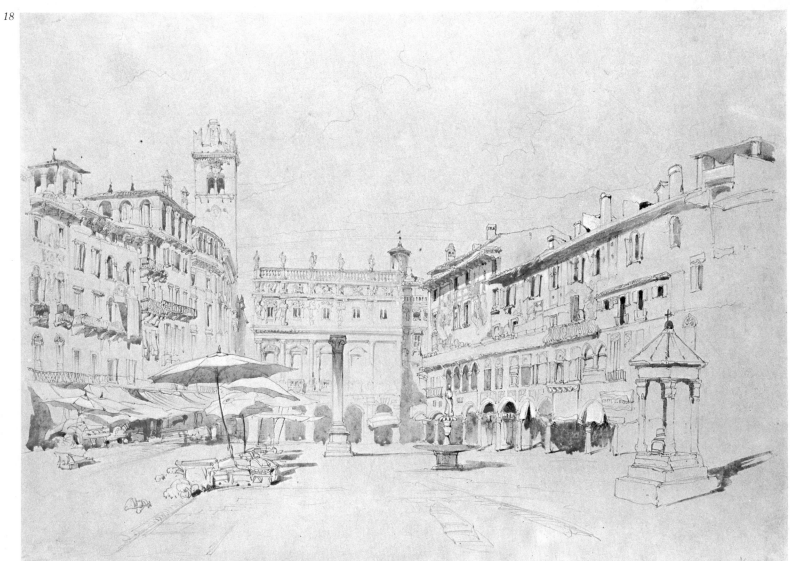

Johannes Thorn Prikker F. 19
The Hague 1868 - Cologne 1932

Les Xhorres, 1901.
Otterlo, Rijksmuseum Kröller-Müller.
Chalk ; 22 ½ × 18 ½ in.
(56.2 × 46.2 cm).

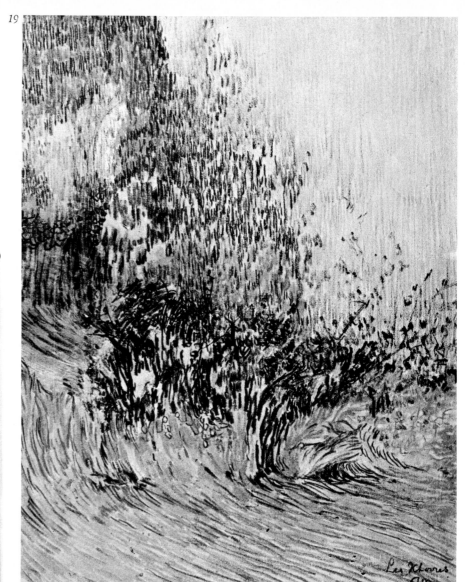

20

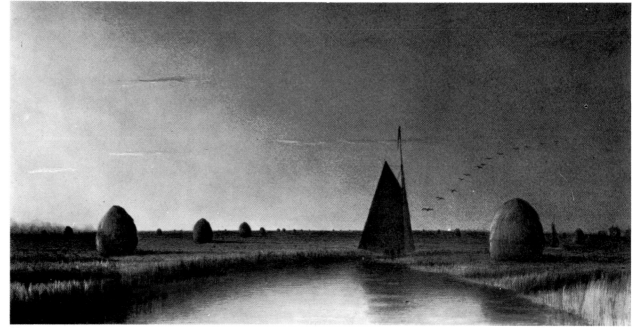

Thomas Moran F. 20
*Bolton (Lancashire) 1837 - Santa
Barbara (Calif.) 1926*

Spanish Peak, Colorado, 1901.
New York, Cooper-Hewitt Museum.
Pencil and gray wash ; 9 ⅞ × 14 ⅛ in.
(24.8 × 35.4 cm).

Martin Johnson Heade F. 21
*Lumberville (Pa.) 1819 - St. Augustine
(Fla.) 1904*

Twilight, Salt Marshes.
Boston, Museum of Fine Arts, Karolik
Coll. Acc. no. 52.1615. Charcoal,
white and colored chalks ;
11 × 21 ⅝ in. (27.5 × 54.1 cm).

21

22

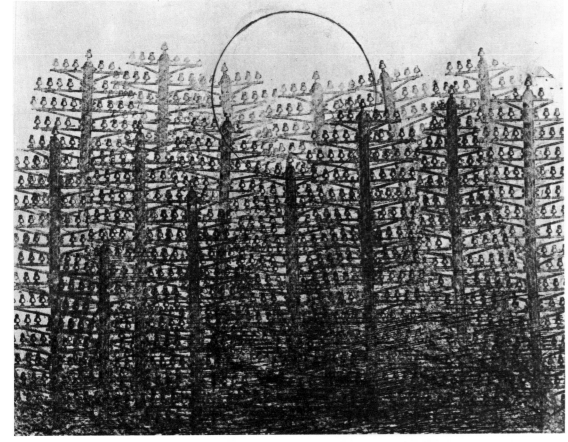

23

24

Vincent van Gogh F. 22
Zundert (Brabant) 1853 - Auvers-sur-Oise 1890

Washerwomen Along the Canal, 1888.
Otterlo, Rijksmuseum Kröller-Müller, no. F. 1444. Reed pen and India ink ; 12 ½ × 9 ½ in. (31.5 × 24 cm).

Max Ernst F. 23
Brühl (near Cologne) 1891
Forest and Sun, 1925.
New York, Museum of Modern Art (gift of Mme Helena Rubinstein). Frottage in black ; 7 ⅞ × 10 ¾ in. (19.7 × 26.9 cm).

Paul Klee F. 24
Münchenbuchsee (Bern) 1879 - Muralto (Locarno) 1940

Playful Water.
Bern, Klee Gesellschaft. Pencil ; 7 ⅛ × 9 ⅝ in. (18 × 24 cm).

Lord Clark delineated the two major categories of the unclad figure. The first, stripped, unidealized, bereft of protective coloration and ill-prepared for exposure, is simply *naked*. The second, happy at home or abroad in its own well-fitting skin, overdressed in more than a leaf or two, is *nude*, its beauty confirmed and possibly even enhanced by exhibition. Nudity is an ideal state, the native dress of Paradise, uniting the True, the Good, and the Beautiful. Nakedness isn't and doesn't. Open to scrutiny, with nothing to hide, the nude personifies Truth—known, confusingly, as the "naked" truth. Often faintly impersonal, the nude is beyond mortality; its perfect resolution of spirit and flesh bespeaks eternal bliss, an absolute statement of fully realized potential. The distance of the canonical nude is due to its esthetic yet Frankenstein-like assemblage, as in that too-oft-told tale of Apelles in search of female perfection: the greedy painter selected a limb from here and a breast from there to manufacture Wonder Woman. Presumably, perfect men were easier to come by. The pagan knew that the nearer my gods to thee, the less need be worn. The Christian could only be shown naked in the beginning, at birth and baptism, and in the end, when his soul departed to its eternal reward—a babe once more, borne up or down, in angelic or demonic embrace. Almost every pose taken by the nude had been discovered in classical antiquity, until the nineteenth century, when Romanticism, photography, and psychology, each in its own successive ways, broke with the gorgeous clichés of Greece and Rome.

The would-be romantic ducal centers of the International Style—Verona, Ferrara, Milan, and Mantua—maintained the fictions of a chivalric age, with their court artists, such as Gentile da Fabriano, copying classical motifs and turning a Diana into a damsel-in-distress.

Academic Florence, succumbing to the Neoplatonic masculine mystique, saw the nude as athletic messenger of eternal strength and grace. Pollaiuolo's gladiators, Signorelli's muscle men, and Michelangelo's *ignudi*, like the first art of the Greeks, all showed ideal nude beauty as man's, not woman's. Possibly style and propriety entered into their drawing, since the studios forbade women as models and used youths instead. Concern with sharp linear definition, with the beauty of the wire-like profile, also favored man over woman. Leonardo's lovely women are always something else—sphinx and swan and beardless boy, spiraling into one another's beauties, always becoming but never quite being. Leonardo's heroic model, static within a square and active in a circle, conforms to Vitruvian man, relating human proportions to the mysteries of numerical ratios and linking man to the grand design of the harmony of the spheres. The mathematics of flesh and blood becomes a mirror and microcosm of divine order.

Chained to the magic of numbers, Dürer also sought significance in the ratio of head size to body size, finger lengths and kneecaps, thereby devising his ideal man and woman, startling in their ugly inhumanity. His stereometric drawings, resembling Michelangelo's blocking out of sculptured form within the chunk of marble, are far more evocative of whatever wonder may be found in the facts of scale, the sublime reason of ratio in the anatomy of man.

Correggio and Parmigianino, both from Parma—the former perfecting a short, rather plump and very sensuous model, the latter an elongated, aristocratic and more formal beauty—established the two major types of womanly loveliness in the first

third of the sixteenth century. The first, less classical than the second, was always to be found in a naturalistic, unintellectual art. The second, more mannered, literally as well as figuratively highbrow, is linked to an elegant, courtly style lingering from the time of Francis I to Napoleon I.

With the Carracci of Bologna came a new loosening up and naturalism. The Mannerist nude, with its twisting lyricism, looked almost Gothic compared with the abundant ease and verisimilitude of the Emilian masters, who modeled themselves more upon the demigods of Venetian art, with their shimmering yet plausible flesh. Eclectic in their intelligent use of the best of everything, the Bolognese helped themselves to Raphael's classical assurance and quiet perfection, to Titian's radiance, to Michelangelo's vigorous presence. With Domenichino's figural mastery, and that of Lanfranco and Poussin, the achievements of the High Renaissance and of the late sixteenth and the early seventeenth century were brought into focus. Now the glories of Velázquez's nudes and those of Rubens and Rembrandt could burn brightly.

After the seventeenth century, the undressed figure was afforded an utterly different role: frankly sensuous and decoratively domestic or relentlessly, often meretriciously allegorical, never failing to stand for Something, when it would have been far more appealing sitting or lying down—and thus standing for *itself*.

Boucher's nudes, male and female, are based, respectively, on single models. His Correggiesque budding nymphets enjoy the individuality of a Rockette, all drawn after the lineaments of Louison O'Murphy or her sister's. Assiduously dumb, with bedroom eyes and rouged bottom, the calculated sex-object of her day, Louison just had to be the royal mistress, and so she was. Highly finished drawings of this dimpled darling, toying with bow and arrow (Diana) or with a pigeon or two nestling in the nicest of warm places (Venus), were carefully copied in reproductive prints. The cover girls and centerfolds of the eighteenth century, these were certainly the most popular and among the earliest of drawing facsimiles.

There really can be too much of a good thing. Even Louison's naked truth began to bore, and France yearned for a more reserved, dignified beauty, which came in with the new bloodless linear austerity of the Neoclassical style, first established in Flaxman's and Blake's England. For Blake, the poet of the Bible, Dante, Shakespeare, and Milton were essentially the same, manifestations of that uncommon denominator, divine genius; thus his nudes are similarly clothed in Michaelangelesque flesh, drawn and tinted in pale watercolors to give them the quality of the *dramatis personae* of a simplified Seicento stained-glass window, faded by the London fog.

The beautifully Neoclassical mode, with its relentless deindividuation, is best seen in Canova's huge marble rendering of Napoleon in the buff. Perhaps three times life-size and now in the possession of the Emperor's captor's heirs at Apsley House, this colossus has all the corporeality of a fortune cookie. Contemporary drawings like Pru'dhon's revive Leonardesque *sfumato*, with the flesh becoming marble or the marble becoming flesh, in a graphic round-trip ticket of titillating transfer from mortality to eternity and back and. . . .

Byronic—but without his wit or hokum—Géricault's fearless line is primarily virile; its beauty lies in force, not surrender. Intoxicated, infatuated, obsessed, possessed by every aspect of corporeal existence, Géricault studied the expressions of the insane, made endless anatomical dissections and drawings, and depicted severed

heads and feet and cut-up limbs with the same positive detachment that others confer on baskets of apples. Géricault's love of violence and death freed him from the eternal present of classical nudes, releasing a new level of intransigent physicality. His major laboratory for a new atlas of the body was provided by contemporary accounts of the raft bearing fugitives from the shipwreck of the *Medusa*, whose survival may have been due to cannibalism. Géricault's graphic re-creation of great tragedy performed on a very small stage, where life banked on death, brought new perspective to the body's meaning, drawn with unprecedented genius. The overwhelming power of his hundreds of drawings of the *dramatis personae* of the celebrated raft, prepared for the vast canvas now in the Louvre, is still felt among major masters of the present—found in Francis Bacon's *oeuvre*, for instance, where the mortal gymnastics of love and hate are fused in a single ghastly blur of passionately mutual decimation.

Photography dealt a blow to both the naked and the nude. Daguerre's recording devil showed most people to look so much worse than one dared think. The unblinking objectivity of the camera was utterly uninformed by the subliminal memory of a physical Golden Age that modified most earlier unclothed depictions no matter how much their draughtsmen prided themselves on their objectivity. "There but for the grace of God go I" stilled the pen and calmed the pencil's most clinical detachment. Before photography, the classicizing nude was a hope; after the revelations of the camera eye, that hope became a lie.

"Academies" is the cataloguer's name for drawings from the nude that were prepared as part of an artist's training, in a school where a model would be studied and drawn at leisure, usually in a classical pose. These works can be found since the later sixteenth century as ever more official instruction in the arts was taken away from the studio apprenticeship and given over to the larger state- or privately sponsored schooling. In the late nineteenth century, when all leading masters of the Salon such as Baudry, Gérome, and Cabanel were splendid draughtsmen, their brilliant highly finished Academies were almost impossible to tell apart. Possibly the post-photographic era may have had its eyes opened to such an impersonal yet exhaustive comprehension of what they saw before them, together with the rigorously unimaginative demands of their curriculum: that young artists not only could but should (from their teachers' viewpoint) suppress any inkling of individuality—the artistic icing on the basic cake—demonstrating their often apallingly impersonal virtuosity.

Among the last masters to revolutionize the nude was the Austrian Klimt, whose drawings of women achieved a lyrical force independent of antique conventions. Founded upon a new literature of life, drummer to a different sexual awakening, Klimt and his models are beyond the pious or impious sentimentalities of *innocente* or *femme fatale*. Ecstatically abandoned, yet always themselves, these women are superior to their mates, whose superficial musculature is a sort of organic corseting, a vestigial bulwark hiding the little man within. Narcissists without pools, Klimt's models find their reflection in the artist's eye or page, lost and found in a world of erotic reverie where "two's a crowd."

Promethean in his genesis of life in clay, Rodin created an unparalleled world for, by, of, from, and with the nude. Working in a studio surrounded by undressed models of enough variation in age, type, and sex to produce a microcosm of the human condition, the Protean master drew thousands of pencil studies and water-

colors that are cinematic in their sense of speed, continuity, and multiplicity. Unequalled for their throw-away immediacy—like conceptual Polaroids taken by the mind, not the hand—these strange images are almost beyond art, in a category of their own, paradoxical in their immateriality, like the Holy Shroud or Veronica's Veil. Perhaps only the sculptor whose works were so stunningly realistic he was constantly accused of casting from life could have had the speed and vision to dash off these graphic streams-of-figural-consciousness, poured and drawn on the paper in blobs of watercolor and rather nasty little pencil lines.

Near the end of the century, the German master Hans von Marees and the great Parisian Puvis de Chavannes approached the nude as abstract idea. The German's Herculean men are so dazzled by their own endowments that their idea is more "show" than "tell"; but Puvis's grave people, classical rather than Neoclassical, bespeak a new garden of earthly insights, illuminated from within and without. Moving slowly in a timeless age, beyond anecdote, these figures' heroic candor survives from primal, monumental innocence.

The acknowledged twentieth-century master of the nude is Matisse. Too much the instinctual creator to be intellectual, Matisse always knew where he was going. So why ask questions? He went to beauty—and this, more than anything else, was a beautiful woman, sometimes dressed, sometimes not. Like the Greek vase painter, Matisse cultivated a very small garden of form and vitality of line which was his for the drawing.

Among the very few twentieth-century masters who concentrated much of their efforts on the nude, Modigliani and Giacometti were both active as sculptors as well as painters; both were of Italian or Italo-Swiss origin, and both resided in Paris. The first, essentially a Neoclassical artist, specialized in highly simplified, extremely decorative forms, whose beautiful horizontal nudes are the Rokeby *Venus*, the *Josephine Bonaparte*, and the *Olympia* of our time. Working in an austere, linear style, Modigliani's drawings in pencil and pastels bridge the contrivances of Cubism and the Art Deco vogue, in a style that goes straight back to that master of the nude four centuries before, Parmigianino.

Giacometti, like that master anatomist-draughtsman of the late eighteenth century, Stubbs, explored the fiber of existence. Stubbs operated in the tradition of the anatomical theater, peeling back the skin, fat, and muscle and transcribing the texture and quality of each constituent of the body. Giacometti, instead, primarily a sculptor, made straight for the bones, drawing down to the armature, without losing that individual variation separating thee from me, just before and just beyond the grave.

That most violent and prodigal of cultures, America, has found a new return to beautiful drawings of the quiet nude, in the works of Diebenkorn, Oldenburg, and Segal, whose intimacy and sensitivity recall Bonnard's figure studies. Our real live Bouchers and Correggios—Harlow and Monroe—could not even survive the brief years of their beauty. These new drawings, loving rather than exploitative, may provide a silver lining.

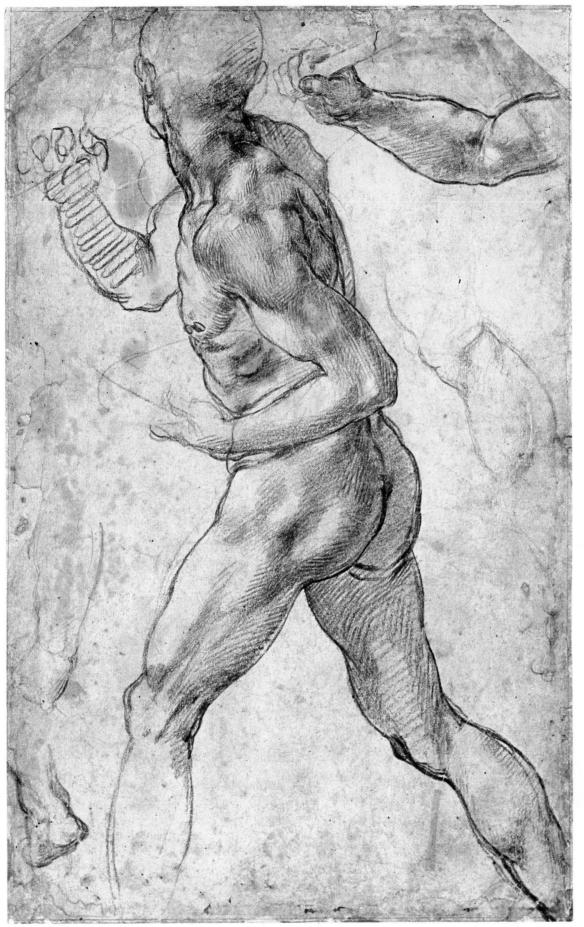

Michelangelo Buonarroti
Caprese 1475 - Rome 1564

Study of a Male Nude Turning Leftward.
Haarlem, Teylers Museum, no. 2.
Black lead pencil and stylus ;
16 ⅛ × 10 ⅜ in. (40.3 × 26 cm).

Provenance : Colls. of Queen Christina of Sweden ; Cardinal Azzolino ; Prince Odescalchi ; the Duke of Bracciano.

Bibliography : Berenson, 1938, no. 1464 ; De Tolnay, 1947, I. p. 219 ; 1949, II. p. 181 ; Dussler, 1959, no. 524 ; *Rotterdam Exhibition,* 1962, no. 78.

This powerful striding figure follows in Signorelli's footsteps. Whereas the older artist had only a surface understanding of anatomy, however, the younger genius was deeply experienced in that study and supremely capable of externalizing his new understanding of what makes motion. More carved than drawn, a beautiful young athlete is caught in an attitude of invigorating, unselfconscious physical exertion in this early example of Michelangelo's exaltation of manly strength. Although drawn from life, the figure is presented *all'antica —* recalling an ancient relief in its strenuous yet graceful pose.

1

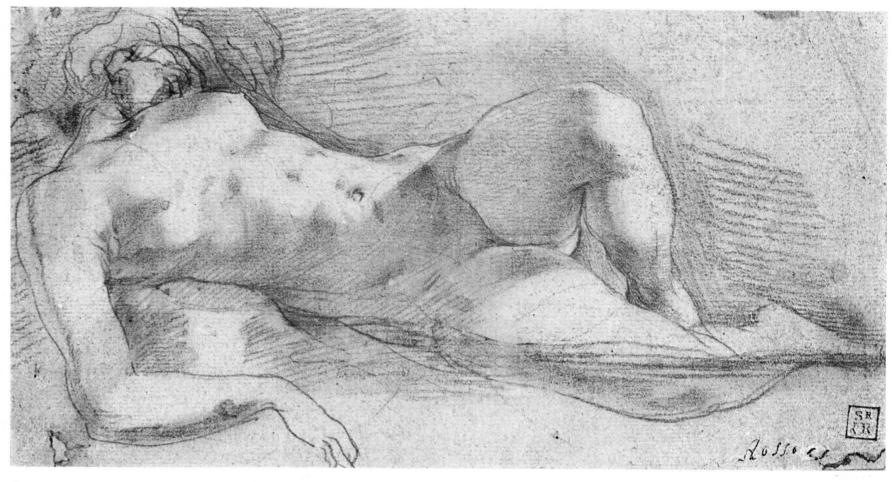

Rosso Fiorentino (Giovanni Battista di Jacopo)
Florence 1495 - Fontainebleau 1540

2

Study of a Reclining Nude.
London, British Museum, no. P. 5. 132. Red chalk, over faint preliminary drawing in black chalk ; 5 × 9 ¾ in. (12.6 × 24.4 cm). Signed in lower-right corner : *"Rosso."*

Provenance : Colls. Reynolds ; Richard Payne Knight.

Bibliography : Kusenberg, 1931, p. 142; Berenson, 1938, no. 2444 ; Barocchi, 1950, p. 226, no. 3 ; Carroll, 1966, pp. 176-177.

At the time of the Sack of Rome, Rosso's flight from that city may have been motivated as much by a desire to free himself from the oppressive, inhibiting effect of Michelangelo's incomparable genius as by the very human urge to escape the dangers of the invaded papal domains. This great, masterfully modeled nude study shows a curious fusion of the Florentine sculptor's colossal approach to the human body and a personal concern with luminous effects that either reflects or anticipates Rosso's Venetian sojourn before leaving for the court of the French king Francis I, where he was to evolve a new, independent and influential style.

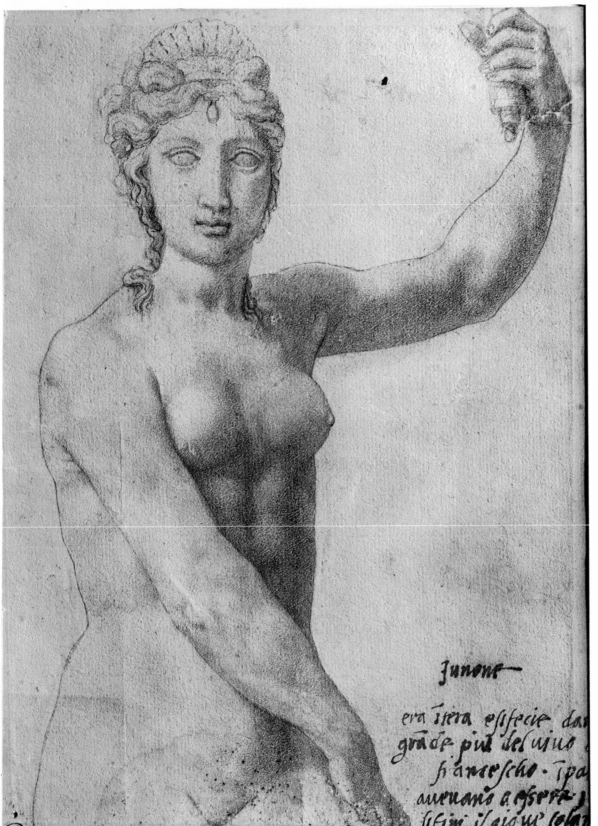

Benvenuto Cellini
Florence 1500 - 1571

Juno.
Paris, Musée du Louvre, no. 2740.
Black lead pencil ; 9 7/8 × 7 1/2 in.
(24.7 × 18.6 cm). Lengthy inscription
in lower-right corner.

Provenance : Coll. E. Jabach.

Bibliography : Popp, 1927 - 28, p. 11 ;
Camesasca, 1955, p. 39 ; Winner,
1968, fig. 1.

The goddess Juno's vacant, mask-like
visage is in curious contrast to her full-
bodied classical torso. Her pose is adap-
ted from a famous statue of antiquity,
the *Medici Venus.* Designed in the
1540's, the figure was meant for a
massive silver *torchère,* part of a series
of twelve life-sized gods and goddesses
serving to illuminate the great Gallery
of Francis I at Fontainebleau. The firm
contours, sculptural shading, and
relative coolness of the drawing are per-
haps graphic expressions of the metallic
medium for which the figure was desi-
gned by Cellini. The inscription at the
lower right alludes to this important
commission for the gifted Florentine
craftsman : *"Junone/ era i(n)tera e si
fecie d'ar(gento)/ gra(n) de piu del
vivo/ fransescho i(n) pa(rigi) avevano a
essere p(?)/ si fini il giove solam(ente)."*
(" Juno was a full-length figure made of
silver, larger than life-size ... only the
Jupiter [of this series] was finished.")

3

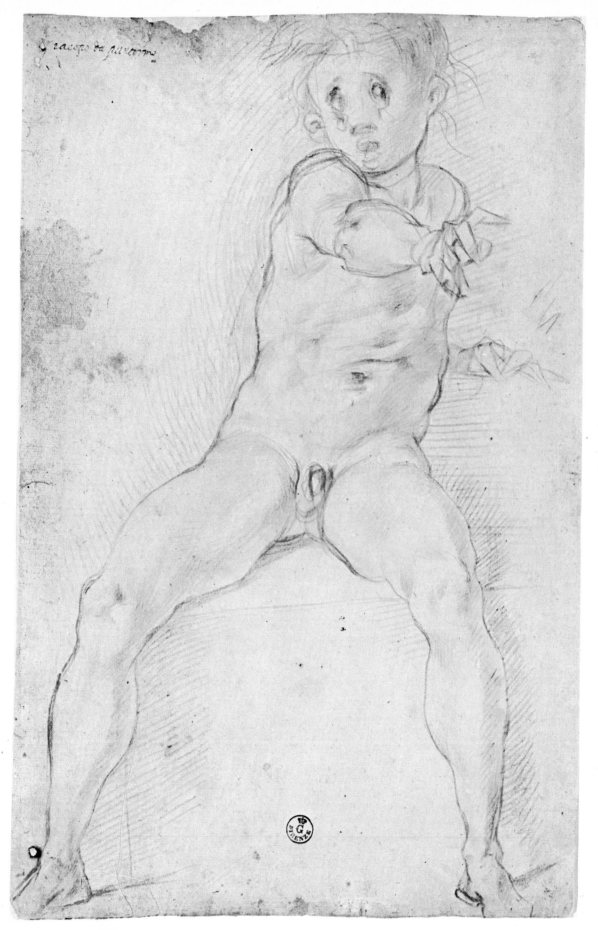

Pontormo (Jacopo Carucci)
Pontormo 1494 - Florence 1556/57

Nude Boy.
Florence, Uffizi, no. 6727 F. Red pencil over traces of black pencil ;
16 ¼ × 10 ⅛ in. (40.5 × 26.2 cm).
Signed in upper-left corner : *"Jacopo da Pontormo."*

Bibliography : Cox-Rearick, 1964, no. 143.

Animated yet melancholic, this curious and mysteriously agitated boy is a study for a figure in the lunette fresco of *Vertumnus and Pomona* for the great hall of the Villa Medici at Poggio a Caiano, painted by the young Pontormo in 1520-1521. His art is a fusion of Hellenistic delicacy and emotion with the uncertainties of an Age of Anxiety — a characteristic, often unsettling sensibility lying just below the graceful surface and elegant attenuations of Tuscan mannerism. Here the contour line, expressively varied from strong reinforcement to near-weightlessness, assumes notable significance.

4

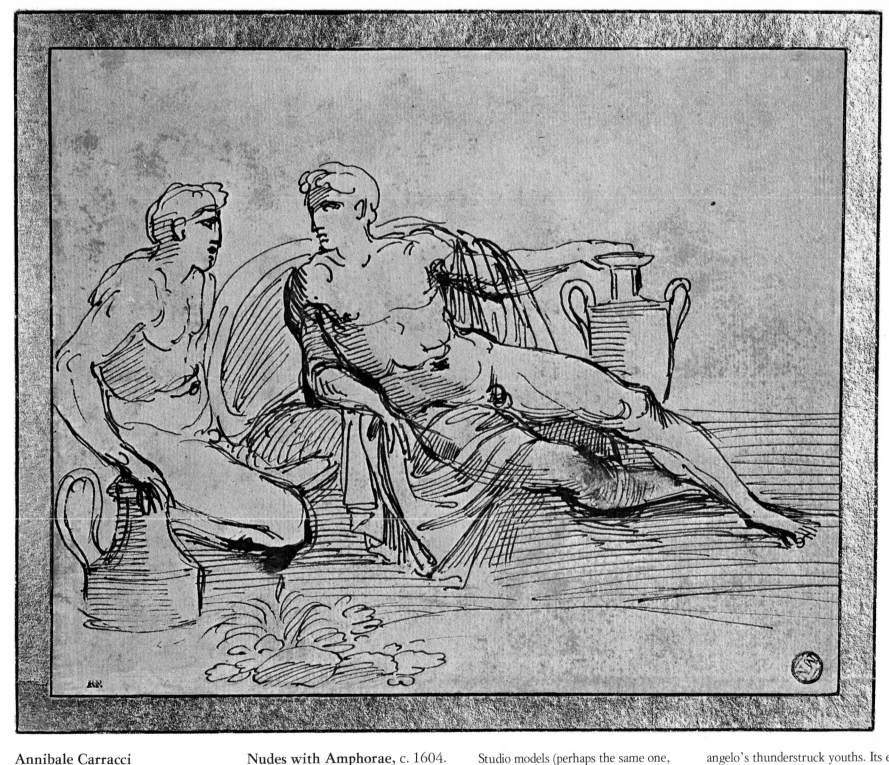

Annibale Carracci
Bologna 1560 - Rome 1609

5

Nudes with Amphorae, c. 1604.
Paris, Musée du Louvre, Inv. no. 7209.
Pen and ink ; 8 × 10⅛ in.
(20.1 × 25.3 cm).

Provenance : Coll. E. Jabach.

Bibliography : *Recueil Jabach,* 1754 ;
Martin, 1965, figs. 261-267.

Studio models (perhaps the same one,
seen in two variant attitudes) are posed
by the artist like ancient Roman river
gods, each resting a hand on a large
classically contoured vessel for holding
water, oil, or wine. Continuing the
technique of early-sixteenth-century
Tuscan masters, Annibale Carracci
seems almost to incise with a superb
economy rather than draw his sculptural
lines, giving us models reminiscent of
the *Ignudi* on the ceiling of the Sistine
Chapel, but substituting a more relaxed
and decorative classicism for the super-
human tensions animating Michel-

angelo's thunderstruck youths. Its elo-
quent yet strikingly "minimal" style
relates this study to the sketches pre-
pared by Annibale to be utilized by
studio assistants in the completion of
his greatest work, the frescoes of the
Galleria Farnese in Rome.

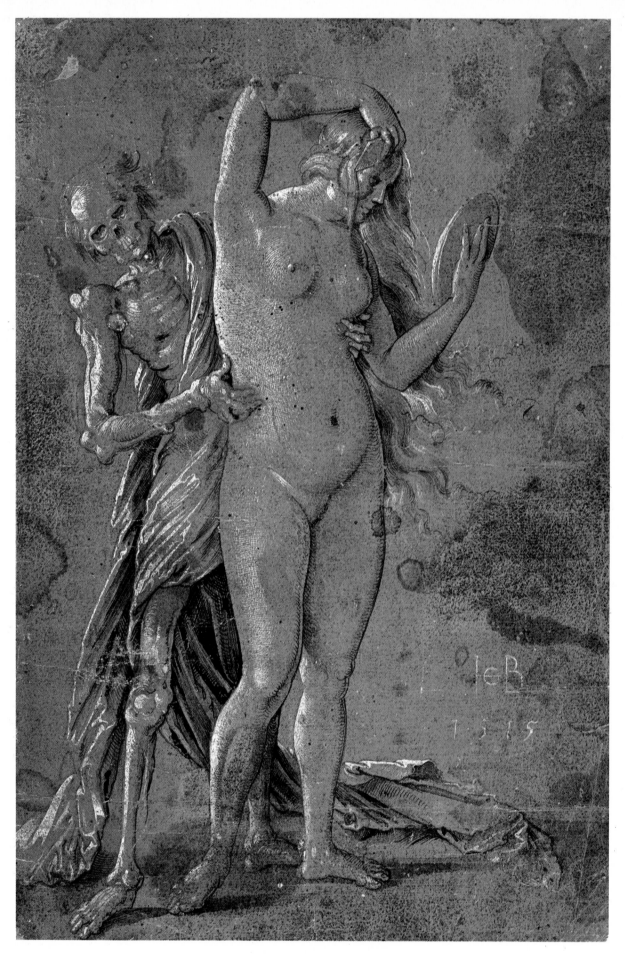

Hans Baldung-Grien
Gmünd (Swabia) 1484/85 - Strasbourg 1545

Death and the Woman, 1515.
West Berlin, Staatliche Museen, no. 4578. Pen and black ink, with white highlights, on brown paper; 12¼ × 8⅛ in. (30.6 × 20.4 cm). Inscribed with artist's monogram and dated at lower right: *"HG-B 1515."*

Bibliography: Térey, 1896, no. 28; Friedländer-Bock, 1921, p. 9; Koch, 1941, p. 32, no. 67.

Brilliant use of fine lines and hatching in black and white build up the form of Baldung-Grien's *Lumpen Venus,* seen while preening herself in the clutches of a horrifying personification of Death. Apparently oblivious to her ghastly fate, the statuesque naked beauty combs her hair as she seems to scrutinize her mirrored image with endless fascination. In this luridly titillating yet moralizing *vanitas,* Baldung-Grien combines a certain Venetian grandeur with Northern weightiness and Gothic particularity. It is as if he shares Death's gruesome delight in baring Beauty to the world at the very moment she is caught in h inevitable embrace.

6

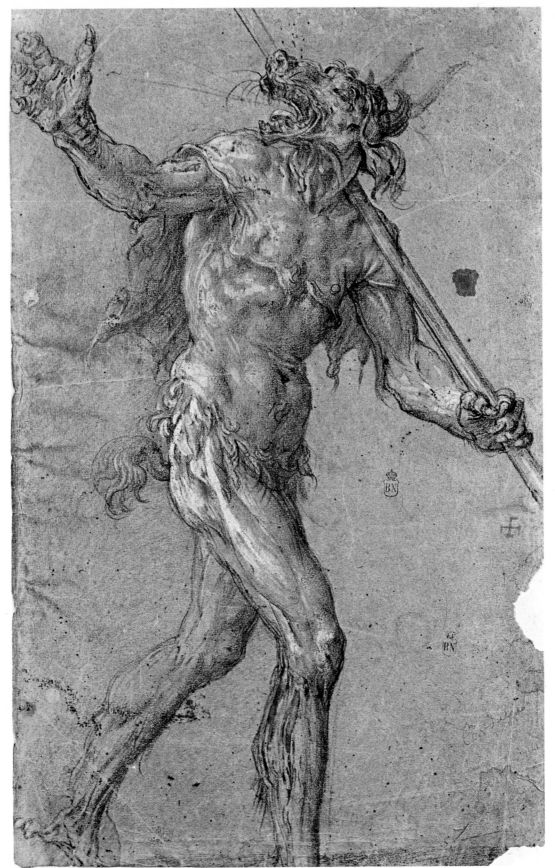

Vicente Carducho (Vincenzo Carducci)

Florence 1576/78 - Madrid 1638

Diabolical Figure, shortly before 1632.

Madrid, Biblioteca Nacional, no. 28. Black pencil, with touches of white gouache on grayish-blue paper; 16¼ × 10¾ in. (40.7 × 26.7 cm).

Bibliography : Barcia, 1906, no. 28 ; *Hamburg Exhibition,* 1966, no. 61.

Beastly man and manly beast, this devil is a study for the series painted by Carducho for the Charterhouse of Paular, near Madrid, between 1626 and 1632. Now in the Charterhouse of Miraflores in Burgos, the finished picture, signed and dated 1632, shows the Virgin freeing a Carthusian monk from diabolical temptation. Brought from Florence to Spain at a very early age, Carducho later traveled to the Netherlands and also visited Italy. Drawing style can well be a reflection of an artist's biography : in this case, it is Italian in tonality and figure treatment, but Northern in its grotesque Gothic abandon, recalling too the fantastic strain in Spanish art stemming from Bosch and other Dutch and Flemish influences.

7

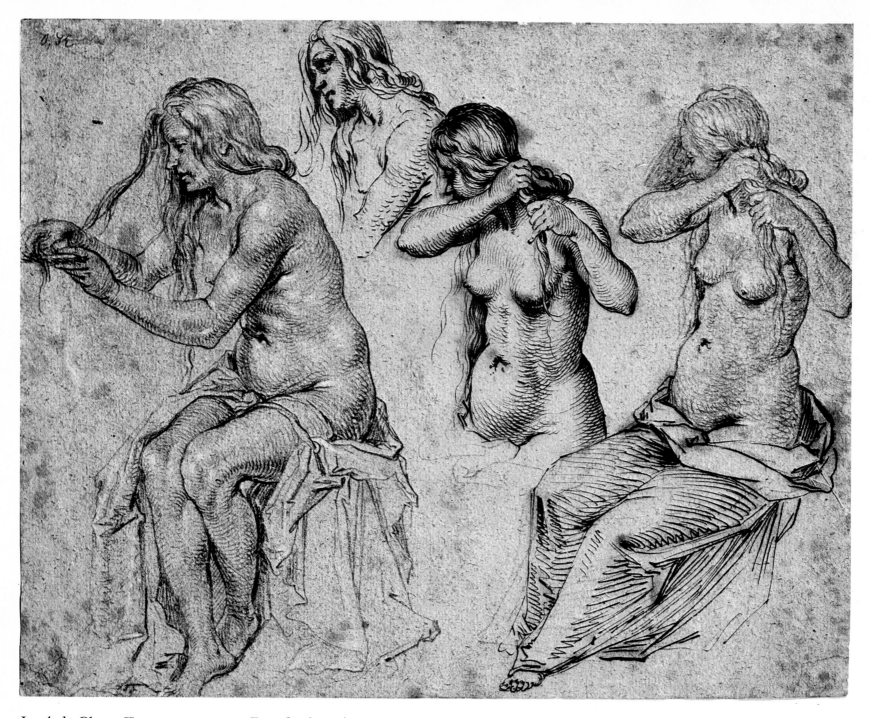

Jacob de Gheyn II
Antwerp 1565 - The Hague 1629

8

Four Studies of a Woman Braiding Her Hair.

Brussels, Musées Royaux des Beaux-Arts, no. 1346. Black chalk, pen and ink, and bister wash ; 10½ × 13⅜ in. (26.2 × 33.5 cm).

Provenance : Coll. De Grez.

Bibliography : Van Regteren Altena, 1936, p. 96 ; *Honderd Twintig Tekeningen ...* 1967, no. 83.

This graceful pose, recalling that of the *Venus Anadyomene,* rising from the sea and combing water from her hair, was often used by Venetian Renaissance masters. Active in the Haarlem Academy and one of the leading Northern European draughtsmen of the early seventeenth century, De Gheyn was markedly more classical in style than most Dutch artist in the succeeding decades. This drawing may have been a study for a Magdalen, and similar studies by De Gheyn are found in the Lugt Collection in Paris and in the museums of West Berlin (no. 5449) and Darmstadt (no. 408).

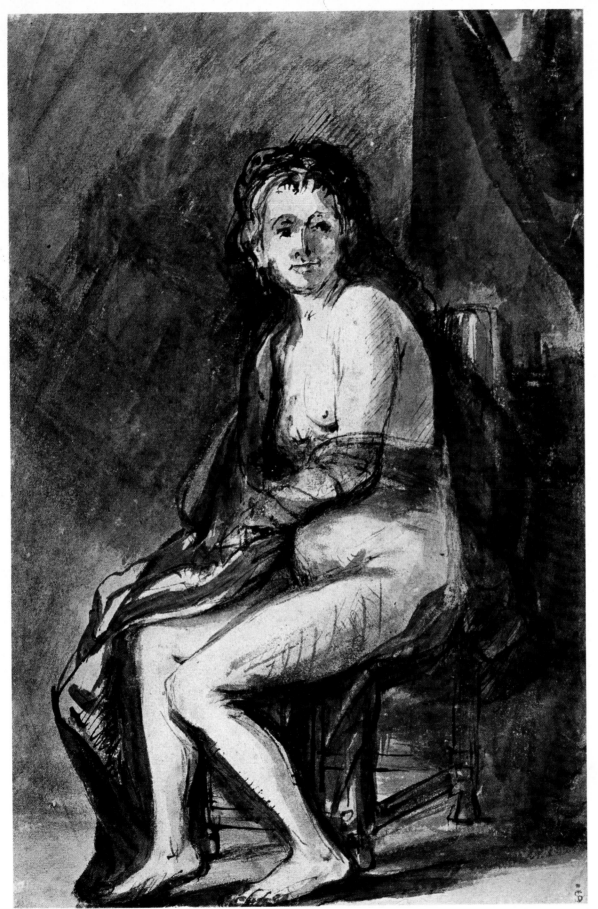

Rembrandt Harmensz. van Rijn
Leiden 1606 - Amsterdam 1669

Seated Nude.
Rotterdam, Museum Boymans-van Beuningen, no. R 2. Pen and brown ink, with bister wash and black chalk; 10⅝ × 7¾ in. (26.7 × 19.3 cm).

Provenance : Colls. Spencer ; W. Russell ; J. P. Heseltine ; F. Koenigs.

Bibliography : Benesch, 1957, V, no. 1144 ; Slive, 1965, I, no. 87.

Unusually lovely among Rembrandt's nudes, this figure study is close to those of the Late Renaissance. An avid collector of Italian prints and drawings, the great Dutch painter may well have selected this pose from a sheet in his possession, perhaps the work of some Venetian master. Suspicious of any royal road to beauty, for his Protestant conscience was wary of mindless artistic generalization, Rembrandt has here found a happy congruence of his own Northern culture and that of the Mediterranean past, creating this sympathetic image of the physical and spiritual essence of womanhood.

9

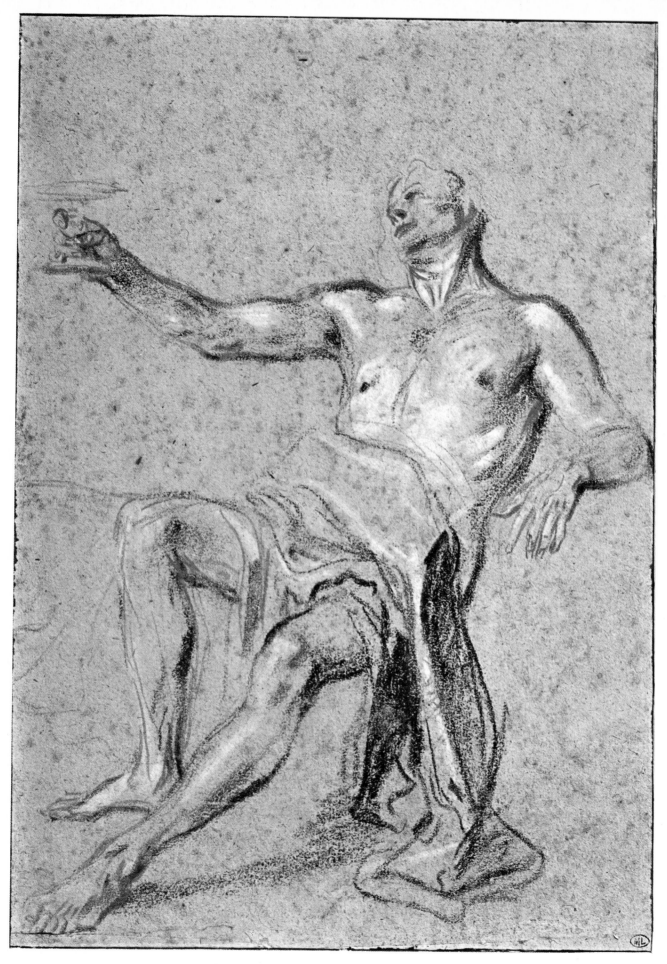

Jean-Antoine Watteau

Valenciennes 1684 - Nogent-sur-Marne 1721

Seated Bacchus Lifting a Cup.
Paris, Musée du Louvre, Inv. no. RF. 28.980 (Donation Walter Gay, 1938). Black and red chalk with white-lead heightening, on beige paper; 11¼ × 8 in. (28.1 × 20.2 cm).

Provenance : Coll. W. Gay ; Goncourt sale, Paris, 1897, no. 347.

Bibliography : *Exposition de Dessins de Maîtres Anciens,* 1879, no. 469 ; *Les Goncourt et Leur Temps,* 1946, no. 287 ; Parker-Mathey, 1957, I, no. 511 ; *Amis et Contemporains de P.-J. Mariette,* 1967, no. 17.

A polite version of the gross, wanton *Barberini Faun* (a popular, though much-restored, ancient Roman statue), Watteau's draped male model is posed as *Autumn* for his Four Seasons cycle, painted between 1712 and 1716, for the dining room of the painter's chief patron, Pierre Crozat. The latter's matchless drawing collection provided Watteau with the stylistic and technical basis for many of his own works. Other studies probably made for this figure, displaying the same vigorous, free modeling with line, are found in several American and British private collections. Some of the finished oval paintings in this series are now to be seen in Washington, D.C. *(Summer ;* National Gallery of Art), and in England, a more recently discovered and since destroyed, one *(Spring ;* see M. Levey, *The Burlington Magazine,* 1964, pp. 53-58).

10

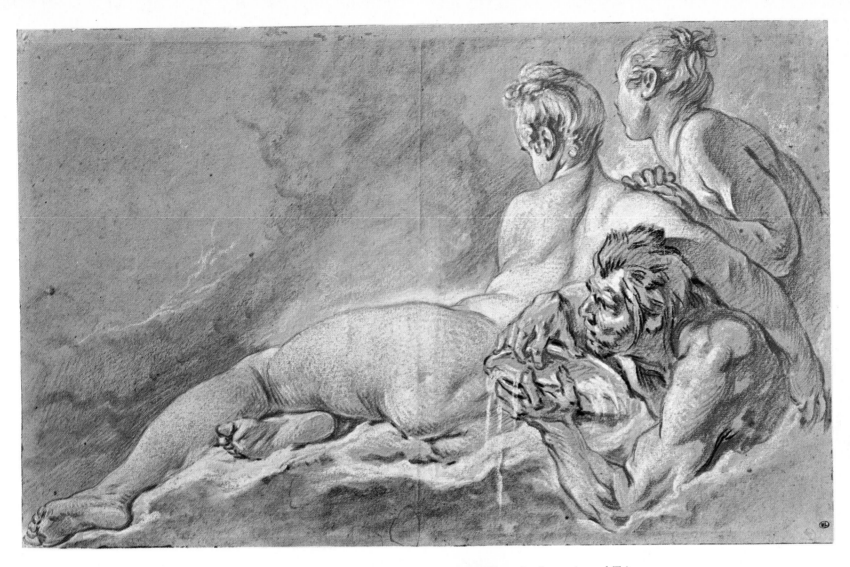

François Boucher
Paris 1703 - 1770

11

Naiads and Triton.
Paris, Musée du Louvre, Inv. no. RF.
29.327 (Donation G.E. Deligand, 1940).
Black and red chalk, with white-lead
highlights, on beige paper ;
11 ⅝ × 17 ⅛ in. (29.1 × 42.9 cm).

Bibliography : *L'Oeuvre Dessiné de
François Boucher,* 1966, no. 31 ;
Ananoff, 1966, I, no. 910 ; *Amis et
Contemporains de P.-J. Mariette,* 1967,
no. 56 ; *France in the Eighteenth Cen-
tury,* 1968, no. 92.

The pair of nymphs and Triton
portrayed here are adapted from classical
models, as first revived in monumental
pictorial form by Michelangelo in the
ceiling of the Sistine Chapel. To the
classical formula, Boucher added a
girlish sensuality, a Rococo dash and
grace calling on French seventeenth-
century sources that chase away any
vestige of symbolic meaning or high
seriousness from his glorious figural
fun. Boucher's decorative figures lend
themselves to almost infinite application
in *boiserie,* tapestry, and reliefs, being
conceived as enticing objects of eter-
nally alluring youth. Irresistibly attrac-
tive and cheerily unindividualized, they
are meant to be spared all the sorrows,
but none of the joys, of man.

Théodore Géricault
Rouen 1791 - Paris 1824

Standing Female Nude.
Rouen, Musée des Beaux-Arts. Brown
and indigo wash over traces of black
pencil ; 7⅛ × 5¼ in. (19.8 × 13 cm).
Verso bears a study of a *Warrior* in pen
and ink, with brown wash.

Provenance : Entered the collections of
the Rouen Museum prior to 1900.

Bibliography : Huyghe-Jaccottet, 1948,
pl. XX.

Except for its almost Cézannesque wash
rendering, this drawing is most inter-
esting for what it isn't — since it rep-
resents a quite atypical moment in
Géricault's *œuvre.* Here the artist almost
visibly relaxes ; his emotionally over-
wrought, incomparably personal art is
temporarily, almost therapeutically,
abandoned in a restful repetition of a
classical nude formula. Without such
secure roots in academic exercise as are
evident in this pose, the great French
artist might never have undertaken his
passionately clinical studies, in which
he walked the perilous line between
objectivity and madness with such
thrilling, shattering success.

12

Pierre-Paul Prud'hon
Cluny 1758 - Paris 1823

Standing Female Nude.
Paris, Musée du Louvre, Inv. no. RF. 31.196 (Donation Gourgaud, 1965). Black chalk with white-lead highlights, on blue paper ; 23 ¼ × 13 ½ in. (58 × 33.9 cm).

Provenance : Colls. Gourgaud ; Boisfremont ; Baroness Eva Gebhard.

Bibliography : *Exposition Prud'hon,* 1922, no. 222 ; Guiffrey, 1924, *Oeuvre,* no. 1128, p. 434 ; Sérullaz, 1966, pp. 96-97.

Prud'hon's model and his manner of depicting her call to mind Leonardo, in particular the latter artist's use of smoky shading, or *sfumato.* Resting her arms on a vaguely suggested studio prop, the model is caught in an Eve-like pose. The smooth marble sheen and firmly indicated contours of her body recall Cellini's generously proportioned classical *Juno* (Plate 3), but Prud'hon's nude is more romantic in her attitude and treatment, mingling the cool poise of Neoclassicism with a hint of the smoldering sentiment of the early nineteenth century.

13

Amedeo Modigliani
Livorno 1884 - Paris 1920

Caryatid, c. 1913 - 1915.
Paris, Musée du Petit Palais, Coll.
Girardin. Pastel and crayon ;
20 ⅞ × 19 in. (52.2 × 47.5 cm).
Signed in lower-right corner : *"Modigliani."*

Bibliography : A. Ceroni, *Amedeo Modigliani, Dessins et Sculptures,* Milan, 1965 ; F. Russoli, *Modigliani, Drawings and Sketches,* New York, 1969, p. XXV.

Art Deco in her deliciously superficial Cubism, this lovely caryatid seems more a stylish homage to Josephine Baker than to the studiously fragmented, primitivizing *Demoiselles d'Avignon.* Her sleek beauty and fluid pose recall the art of Brancusi, but without that modern master's rigorous purism of form. The young Modigliani's instinctive, happily uncomplicated classicism contributes to the lithe, coiled power of his unburdened figure, which in its ancient use was a load-bearing structural member. Here a gifted twentieth-century artist shows us an assured and original grasp of an antique, unimprovable figural formula. The resulting elegance is but a hair's breadth away from the chic simplistic streamlining of the 1930's.

14

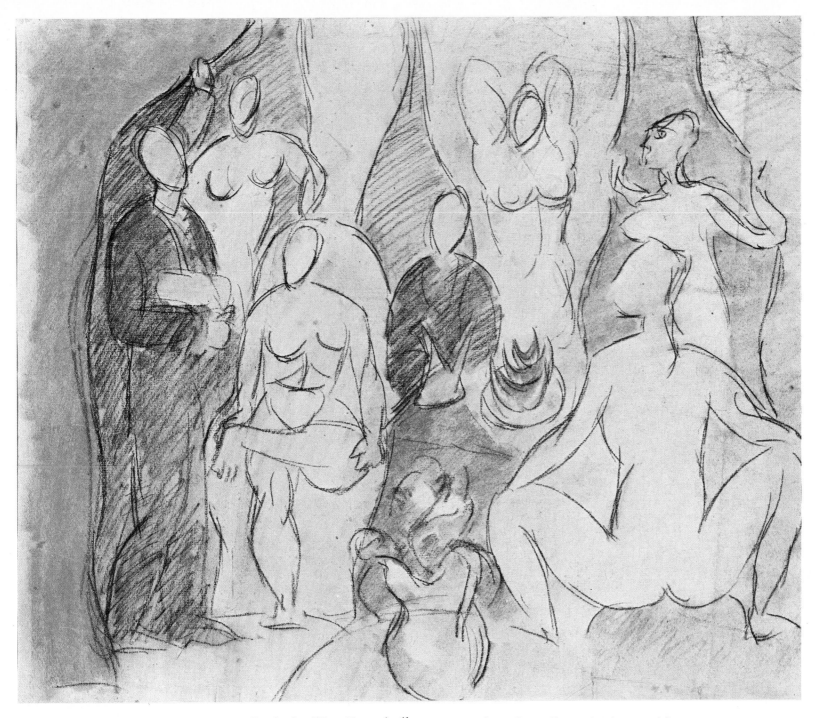

Pablo Picasso
Málaga 1881 - Mougins 1973

15

Study for "Les Demoiselles d'Avignon", 1906 - 1907.
Basel, Kunstmuseum, no. 1967. 106 (Gift of the artist). Black chalk and pastel ; 18 ¾ × 25 in. (47 × 62.5 cm).

Bibliography : Leymarie, 1967, p. 31.

According to Leymarie, the central figure in the composition is a sailor seated in a brothel and surrounded by its nude *demoiselles ;* the man entering at the left is identified as a student holding a skull. In the finished painting (New York, Museum of Modern Art), the men, the *memento mori,* and other *vanitas* still-life details are absent and the women have shifted from a Cézannesque style to the carved planes of African sculpture. Emerging from the tender, sweet-sour classicism of his Blue and Pink periods, Picasso is here seen moving toward a new structural fundamentalism — that relentless analysis of surface and mass which was early Cubism.

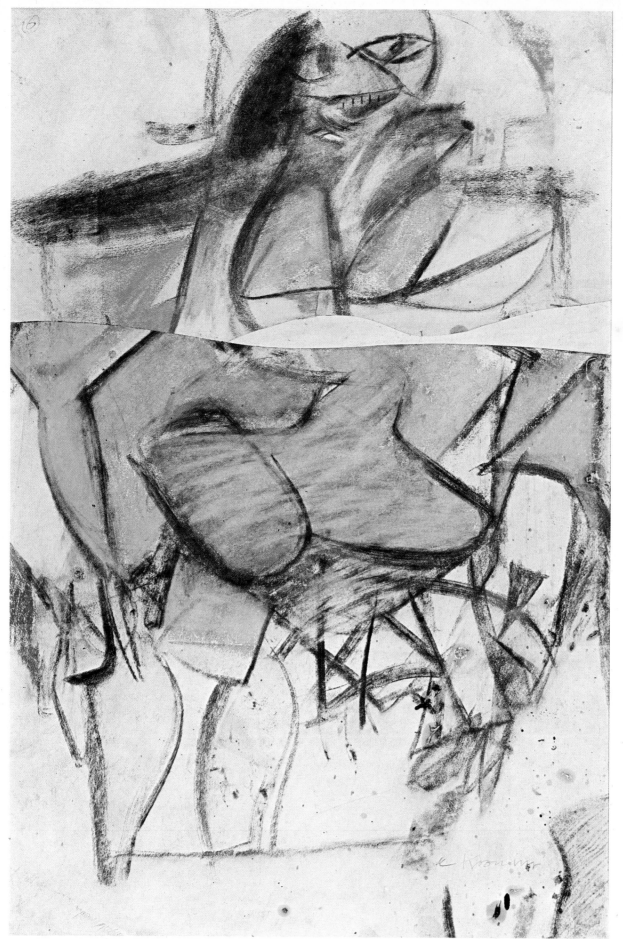

Willem de Kooning
Rotterdam 1904 -

Woman, c. 1952.
Paris, Centre National d'Art Contemporain. Crayons and charcoal, on paper mounted in two sections;
30 ½ × 22⅜ in. (76.2 × 55.9 cm).
Signed in lower-right corner: *"de Kooning."*

Provenance: Coll. Mr. and Mrs. Lee V. Eastman.

Bibliography: Hess. 1972, no. 63, p. 162.

By cutting apart a single drawing or several studies of the same model and then mounting just the upper and lower segments closer together on a backing sheet, De Kooning has literally eliminated the "middle man" — or woman — and somehow gained notably in force and expressive intensity through this almost surgical procedure. Like a modern Dutch "Old Master", De Kooning grasps certain essentials of the classical with some of the bold, confident independence that characterizes much of the *œuvre* of Frans Hals and Rembrandt. The American artist may also have drawn strength from the Northern Expressionist tradition in his unfliching confrontation of his own emotions, as well as in his dissection of those of his lacerated subject.

16

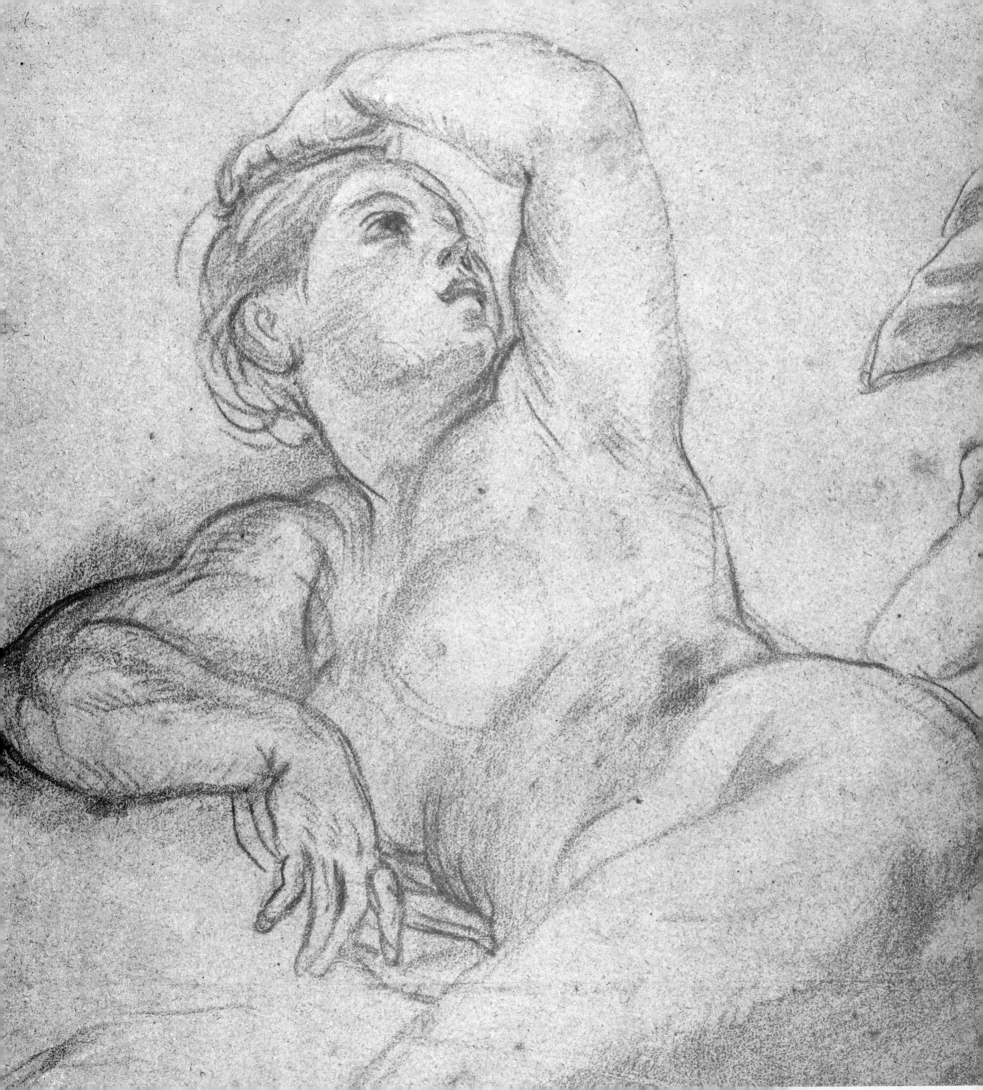

Leonardo da Vinci F. 1
Vinci 1452 - Amboise 1519

Male Figure within a Square and Circle. (Illustrations of Vitruvian Proportions).
Venice, Accademia. Pen and ink ; 13 ¾ × 10 ¼ in. (34.3 × 25.5 cm).

Raphael F. 2
Urbino 1483 - Rome 1520

Preliminary Study for the "The Disputa".
Frankfurt-am-Main, Städelsches Kunstinstitut, no. 379. Pen and ink ; 11 ¼ × 16 ⅝ in. (28 × 41.5 cm).

Carlo Maratta F. 3
Camerano 1625 - Rome 1713

Study for a Female Nude.
London, British Museum, no. 1874.8.8.42. Red and white chalk, on bluish paper ; 21 ⅝ × 16 ⅛ in. (54.2 × 40.3 cm).

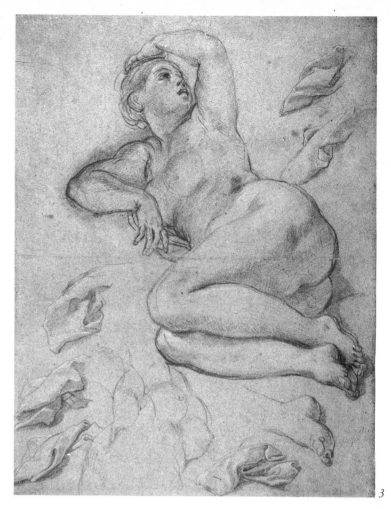

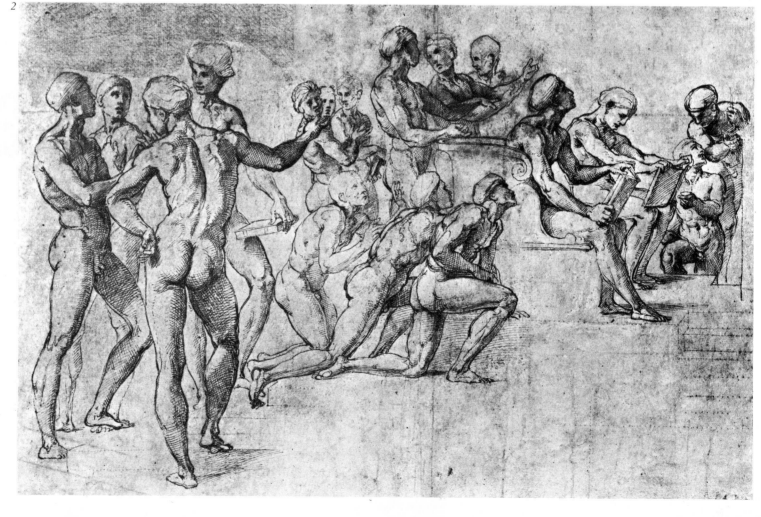

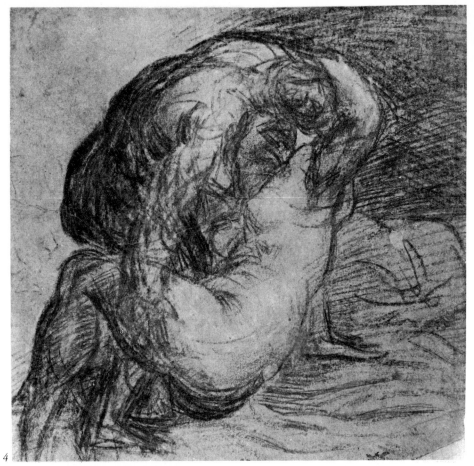

4

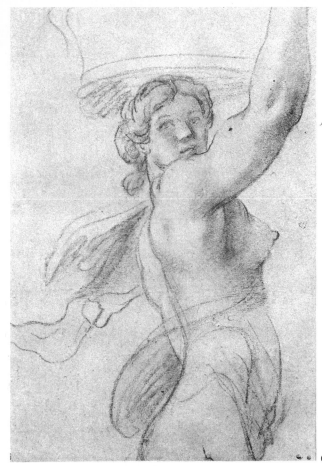

6

Titian (Tiziano Vecellio) F. 4
Pieve di Cadore c. 1488/90 -
Venice 1576

Jupiter and Io.
Cambridge (Eng.), Fitzwilliam Museum.
Black chalk, on bluish paper ;
9 × 10 ⅝ in. (22.5 × 26.5 cm).

Peter Paul Rubens F. 5
Siegen (Westphalia) 1577 -
Antwerp 1640

Male Nude Kneeling.
Paris, Musée du Louvre, Inv. no. 20218.
Black chalk, with stump and white
heightening, on yellowish paper ;
17 ⅛ × 21 ½ in. (42.8 × 53.9 cm).

Annibale Carracci F. 6
Bologna 1560 - Rome 1609

**Draped Woman Carrying a
Basket.**
Paris, Musée du Louvre, Inv.
no. RF. 610. Black and white chalk ;
17 × 11 ½ in. (42.6 × 28.7 cm).

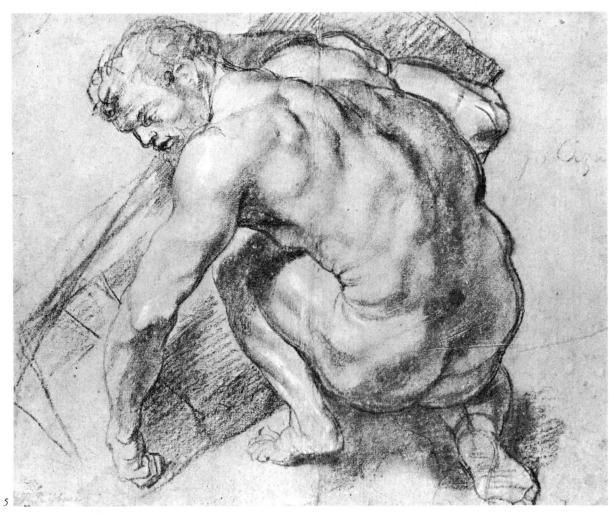

5

Baccio Bandinelli F. 7
Florence 1488/93 - 1560

Torso of Laocöon.
Florence, Uffizi, no. 14785. F. Red
chalk ; 11 ¼ × 8 ⅝ in.
(28.1 × 21.5 cm).

Domenico Beccafumi F. 8
(Domenico di Pace)
Valdibiena c. 1484/86 - Siena 1551
Seated Woman with Two Putti.
Paris, Musée du Louvre, Inv.
no. RF. 40. Pen and ink, with brown
wash ; 8 × 10 ½ in. (20.1 × 26.2 cm).

Guercino (Giovanni Francesco
Barbieri) F. 9
Cento 1591 - Bologna 1666
Woman Undressing.
London, British Museum. Pen and ink,
with wash.

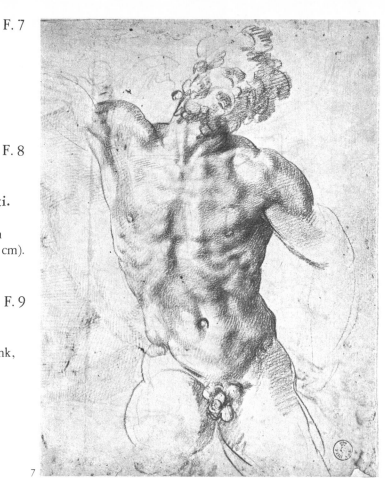

7

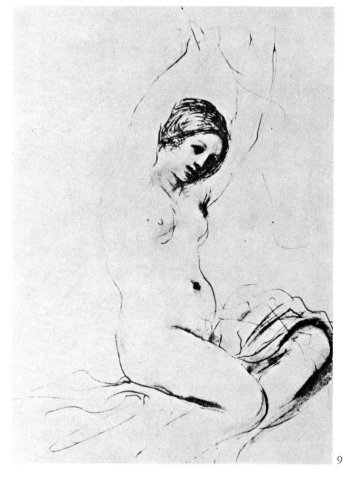

9

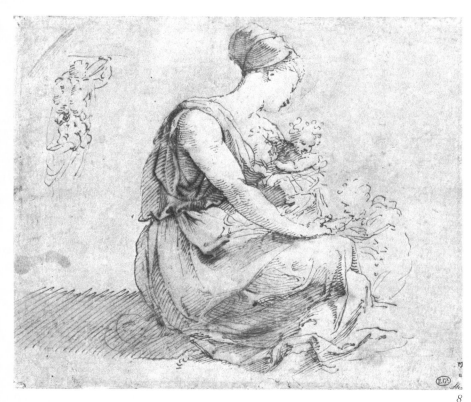

8

Charles Le Brun *Paris 1619 - 1690*

**Nude Woman Kneeling and
Holding a Baby.** F. 10
Paris, Musée du Louvre, Inv.
no. 27.824. Red chalk, with white-lead
highlights, on beige paper ;
11 ⅞ × 10 ⅞ in. (29.8 × 27.2 cm).

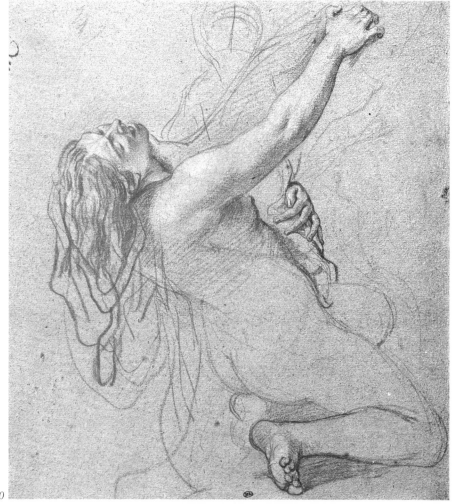

10

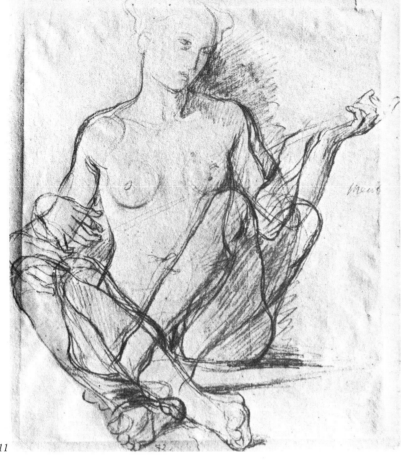

11

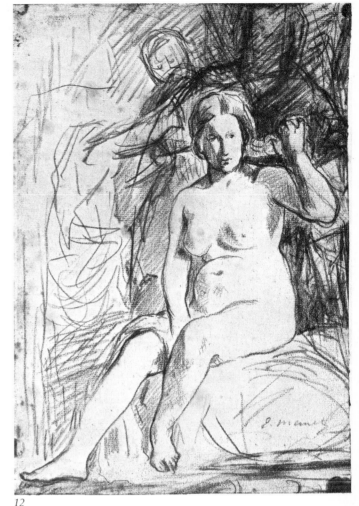

12

13

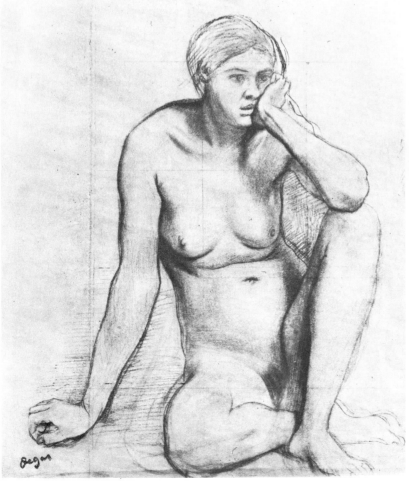

Jean-Auguste-Dominique Ingres
Montauban 1780 - Paris 1867

Study for an Odalisque. F. 11
Montauban, Musée Ingres,
no. 627.2032. Black chalk ;
9 ³⁄₈ × 8 in. (23.4 × 20.2 cm).

Edouard Manet F. 12
Paris 1832 - 1883

La Toilette.
Chicago, The Art Institute,
no. 1967. 30. Red chalk ;
11 ¹⁄₄ × 8 in. (28 × 20 cm).

Hilaire-Germain-Edgar Degas
Paris 1834 - 1917

Seated Nude Woman. F. 13
Paris, Musée du Louvre, Inv.
no. RF. 12.265. Black chalk with
stump, on beige paper ;
12 ³⁄₈ × 11 in. (31.1 × 27.6 cm).

Auguste Rodin F. 14
Paris 1840 - Meudon 1917

Three Crouching Women.
Philadelphia, Rodin Museum,
Pencil and watercolor ;
11 1/8 × 14 7/8 in.
(27.8 × 37.2 cm).

**James Abbott McNeill
Whistler** F. 15
Lowell (Mass.) 1834 - London 1903

**Studies on the Dances of Loïe
Fuller.**
Glasgow, University Art Coll.
(bequest of Birnie Philip).

Gustav Klimt F. 16
Baumgarten 1862 - Vienna 1918

**Two Studies of a Reclining
Woman.**
Zurich, Graphische Sammlung der
E. T. H., Inv. no. 1960/55. Pencil ;
22 × 14 1/2 in. (56.6 × 37 cm).

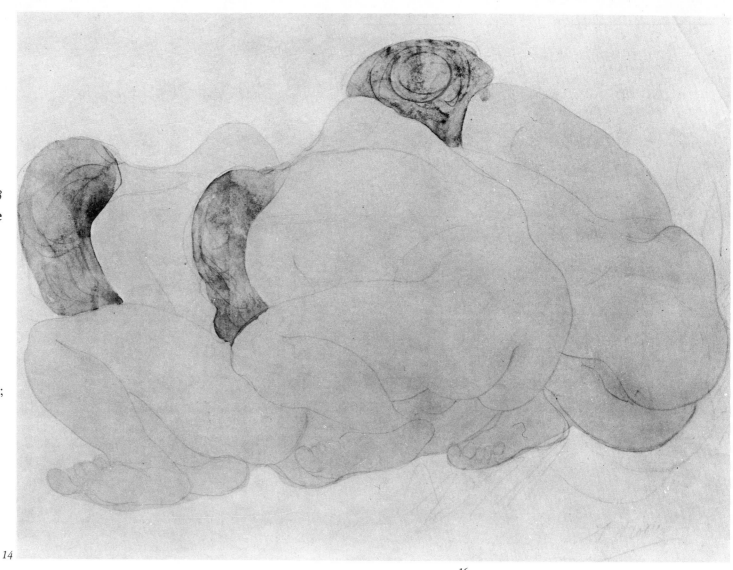

14

15

16

17

Henri Matisse F. 17
*Le Cateau-Cambrésis 1869 - Cimiez
(Nice) 1954*

**The Artist's Studio: Nude before
a Mirror.**
Paris, Private collection. Pen and ink.

Mary Cassatt F. 18
*Allegheny City (Pa.) 1845 - Château
Beaufresne (Beauvais) 1926*

Study for "The Coiffure", 1891.
Washington D. C., National Gallery
of Art, Rosenwald Coll., BrCR. 815.
Black crayon and pencil ; 15 ½ × 11 in.
(39.3 × 27.7 cm).

Claes Oldenburg F. 19
Stockholm 1929

Pat, Nude, Sleeping with Cat.
New York, Collection of the artist.
Black crayon ; 10 × 13 ¾ in.
(25 × 34.4 cm).

18

19

Animals

The artist's best friend may be his dog or cat, or any one of a host of other beasts animating his works. Dürer's great allegory of creativity, *Melancolia I*, has a large hound in the foreground, snoozing fitfully, to symbolize the restlessness and dreaming involved in making art. Uccello, Goltzius, Rembrandt, Hogarth, Oudry, and many other masters immortalized their pets in drawn and painted form.

Artists have studied animals in order to communicate human character, following the pseudo-Darwinian science of physiognomy, in which man's true nature was thought to be revealed by the animal features that were closest to his own, so that the lionlike were believed to be lionhearted, and the sheeplike sheepish. Greek mythology, unlike Judeo-Christian beliefs, made the creation of the animals a reciprocal proposition, for in the classical myths man often turned into beast as well. Even the gods might assume the guise of their four-footed friends to curry favor with some recalcitrant beauty.

Animals could be used to indicate speed or sloth, flight or flightiness, to represent a panorama of extensions of abstract concepts. Classical literature such as the Greek bestiary or a *Physiologus* or texts by Aratus imputed or discovered a reflection of the divine or prophetic in animal being or behavior that could lend a field mouse or an ant as much weight as an elephant. Emblem books and Biblical parables siezed upon an instant understanding of animal being through their physical traits to communicate ethical sentiments.

Before the nineteenth century, when so many pleasures of the rich became institutionalized and state-subsidized, zoos had been the private purlieus of the very wealthy, decorative enclaves within their vast gardens for courtly diversion. Prized animals from exotic places could indicate their imperial owners' worth and dominion or—like today's mainland Chinese pandas—might become diplomatic gifts of the first magnitude. The watchdog or the hunting dog, the stallion, the mousing cat, the diverting songbird, and glittering goldfish all played crucial roles in the survival or amusement of society until the twentieh century. For all its huge popularity, Disney's newly invented fauna captured but a fraction of man's earlier interest in animals in eras when they meant human survival, nurture, transportation, protection, and clothing.

Western draughtsmen were to lose for centuries the last traces of classical rendering after the illumination of the *Utrecht Psalter* (830-840), which still shared some of the luminism and vivacity of the best ancient art. Linear conventions, boxing in and walling out, turned the controlled accidents of Carolingian spontaneity into the frozen hieroglyphs of the Dark Ages, when even a marginal mouse seemed programmed by some Romanesque computer. Drawing a lion in the thirteenth century, Villard de Honnecourt stated that the beast was rendered from life; but the geometric, labyrinthine lines with which the lion is limned betray the rigid symmetry of medieval cosmology and rule out all the life-infusing accidents of the artist's hand.

No earlier fourteenth-century Western European animal studies survive, but if one is to judge by painting and manuscript illumination, model books and notebooks such as those later kept by Gentile da Fabriano and Pisanello must also have been prepared. Lombard masters of the early fifteenth century produced vivid studies of birds and deer, using free brushstrokes charged with watercolor, as well as silverpoint, to achieve an almost Oriental spontaneity. Rising interest in animal anatomy led to close studies of musculature and articulation, in a long tradition beginning with

Animals

Pisanello and culminating in George Stubbs' magnificent renderings of the anatomy of the horse in the latter half of the eighteenth century.

Leonardo's inspired patience, his impassioned scrutiny of minutiae, produced animal studies whose beauty and scientific importance reached unequalled heights. Aristotelian at heart, the Tuscan master sought to crack nature's code, to understand and conquer the large in the small, to achieve universal understanding through a blade of grass or the flight of a bird. Dürer, though a generation younger, seems more old-fashioned. His magically convincing rendering of a hare is closer to the mirror image of Van Eyck's art than to the driving spirit of intellectual inquiry which guided Leonardo's hand.

Florentine masters of the early sixteenth century seemed to take special delight in animal studies. Andrea del Sarto's monkey and Pontormo's dog, both destined to be repeated in fresco for major commissions, share an objective vision and vivacity that comes almost as comic relief after these artists' complex approach to man. Throughout that century, Mannerist masters could turn to the animal kingdom for freshness and freedom from the ennervating conventions of undulating grace. Parmigianino and his prize bitch, Ligozzi and his lobster, Goltzius' many affectionate studies of his dog, and Savery's dromedary—all show the draughtsman rejoicing in the intricacies of divine design, the handiwork of Creation. Still, bizarre nature has an intricacy and elegance outstripping even the artist's most inventive decorative and organic vocabulary, as exemplified by the Cartilaginous style, whose bone and cartilage-like elements are twisted into organic shapes.

Suddenly old-fashioned, all the refinements of the earlier sixteenth century were abandoned in favor of a splendid new affirmation of reality in its latter decades and in the seventeenth, in both the Catholic South and the Protestant North. This new naturalism is found in Rubens' lions, Rembrandt's elephants, and Fyt's hounds and in animals by the Carracci. Only Stefano della Bella's steeds, delineated with calligraphic dressage, defy the new naturalism of the Baroque. The same century that produced La Fontaine's *Fables* left another equally enduring repertory of animal themes in the prints made after Bloemaert's picturesquely drawn assemblages of shepherds and herders with their flocks of sheep and herds of goats and cattle. The Dutch master's infinitely applicable groups maintained their currency for centuries, as enthusiastically adapted by Boucher toward the mid-eighteenth as they were by the English masters of the nineteenth. Dutch artists active in seventeenth-century Italy as well as in the North, such as Berchem and Potter, working in washes and sanguine, produced brilliant animal studies later adapted by Fragonard.

Surprisingly, Claude Lorrain was an excellent *animalier*, and his notebook sketches of grazing goats have a frank rustic felicity very different from the labored Arcadia of his oils. Barlow's illustrations for Aesop show another felicitous *animalier* at work, whose vivacious animal studies led the way to those of Stubbs, Ward, and Landseer. Birds, almost by the acre, were cranked out by Hondecoeter and his busy studio, based on reference drawings whose particularity points to the fine-feathered *Birds of America* by Audubon and those of Gould.

The descriptive interests of the seventeenth and eighteenth centuries foreshadowed the split personality of the art of the late eighteenth and the early nineteenth century—both romantically classical and classically romantic—exemplified by

Animals

the drawings of Stubbs, in which the anatomy of the horse is explored with almost Leonardesque scientific intensity and precision. Yet many of Stubbs' painted horses, lions, and tigers also burn bright with the new romantic individualism.

Amusement, the enlightened objective of the eighteenth century, was sought and found in witty, ironic rooms where walls were decorated with monkey antics *(singeries)* based on hundreds of preliminary animal studies. Apes appear in tapestry, on walls and furniture, in salons that seem like two-dimensional monkey houses. Other, earlier rooms were filled by exotic birds and rustic subjects in which more decorous studies of animal life were worked into the design for living.

Delacroix and Géricault, both admirers of the brilliant British art of the eighteenth and early nineteenth centuries, followed the English lead in animal studies of unprecedented emotional impact. Their horses and lions share fiercely human passions, seething with a frustrated, anguished feeling more germane to the tormented *Jungle Book* of the Victorian Christian conscience than to the forest primeval. Even more than Stubbs, Géricault saw animal life as a microcosm, expressive of nature's splendor and unadulterated with human hypocrisy. Fierce cats and stoical Percherons were captured with all the intensity of their native being in pencil drawings done in France and England. Toulouse-Lautrec was attracted to the circus and prepared hundreds of studies of its life, some of them suggesting it is the animal that trains the rider, or that both are bound in a conspiracy of compliance between man and beast, caught in an unending *cirque*. Domestic pets such as cats, dogs, and ducks wander and waddle through the tame confines of Impressionism, as if engaged in deftly rendered dialogue between themselves or with their keepers.

German artists of the late nineteenth and early twentieth century were especially brilliant masters of the animal world. Orlik, Corinth, Lieberman, and Gaul all seemed to find a humor in animal informality that was increasingly absent in their own militaristic society. Paul Klee invented his own zoo, a Calder-like menagerie in its witty economy which bent lines to life. Franz Marc, killed in the First World War, used animals to convey both peaceable and unpeaceable kingdoms: his blue stallions verge on cliché in their Art Deco green pastures, while his mean tigers are disturbingly Hitlerian, with their shifty yet compelling stare and weirdly brilliantined forelocks.

Picasso, the greatest *animalier* of our century, could always count upon a novel path away from his own ideas when they became too *reçu* for the creator himself. Pink and blue-bottomed apes cut the cliché out of his Blue and Rose periods; desentimentalizing the scenes of picturesquely hungry mimes on the beach. Horses too busy to be anything but themselves take the idealized ephebe out of the youth who leads them. Studies for the great *Buffon* etching series show Picasso reveling in the infinite variety and character of animal life. Whereas Leonardo was busy gluing wings to salamanders and turning them into miniature dragons, Picasso saw each animal for what it was, rich in its own infinite variety. New appreciation for our dumb friends is found in Dubuffet's cows, stabled in a Lascaux revisited, and Miró's birds, rewired according to surreal specifications which mechanize the metaphors of sexuality.

Two contemporary American women, Landry and Bontecou, both drawn to the microcosmic life of the ant or of imagined insects, show how these minute extensions of animal life seem almost to draw themselves—as though the draughtsman's line, left to its own devices, can magically bring form to life.

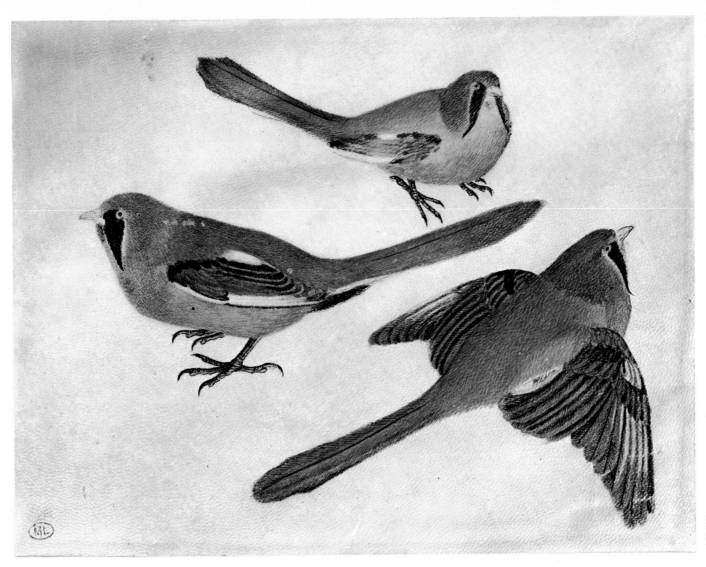

Unknown Lombard artist
First half of 15th century

Three Titmice.
Paris, Musée du Louvre, Inv. no. 2476.
Pen and ink with tempera, on vellum ;
4 ¾ × 6 ¼ in. (11.7 × 15.5 cm).

Provenance : Coll. Vallardi.

Bibliography : Venturi, 1896, p. 119 ;
Toesca, 1912, p. 448, note 1 ; Fossi
Todorow, 1966, no. 424.

The three titmice by this early-fifteenth-
century master, set down with the
subtly balanced informality of Oriental
art, show the most accomplished
exploitation of medium and technique.
The irregular vellum surface provides a
perfect foil for the brilliantly brushed-in
birds, which seem to alight upon or
take off from the page with convincing
freedom. Surprising in its charming
spontaneity and almost Impressionist
technique, this softly tinted page
reflects the largely lost heritage of early
secular art, which has been more sub-
ject to thoughtless destruction than
have artworks devoted to sacred images.
Sheets such as this, forming a cata-
logue-like repertory of motifs, were
subsequently adapted for use by masters
of fresco, panel painting, and manus-
cript illumination.

1

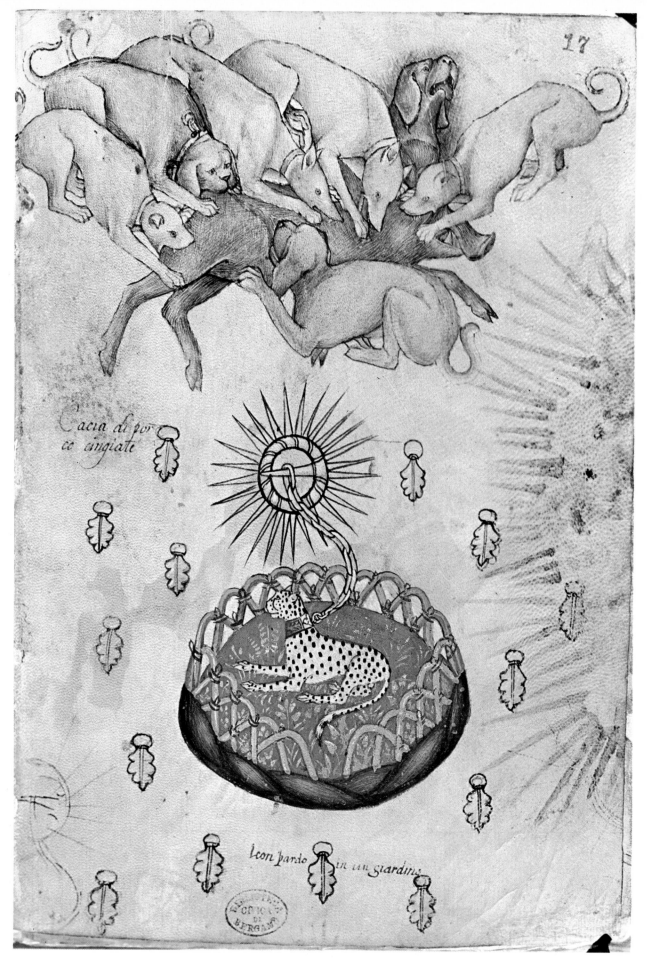

Cacia di porce cingiate

leon pardo in un giardino

Giovannino de' Grassi
Active in Milan 1389 - 1398

Leopard in a Garden and Boar Hunt.

Bergamo, Biblioteca Civica, Codex Δ VII. 14, fol. 17 recto. Pen and ink, with traces of silverpoint, white tempera, and watercolor on parchment; 10⅜ × 6⅞ in. (26 × 17.3 cm).

Provenance: Colls. Lotto; Sillano Licino; Tassi; Secco-Suardi.

Bibliography: Toesca, 1912, pp. 298-306; Van Schendel, 1938, p. 60; Scheller, 1963, p. 142, no. 21.

Forms similar to those shown in the hunt scene at the top of this page are found in that most splendid of late-medieval illuminated manuscripts, the *Trés Riches Heures* of the Duc de Berry (Chantilly). Presumably the draughtsman of this page, Giovannino de' Grassi, who is known to have been active primarily as an architect, modeled his page after a Northern European prototype, for future adaptation to some north Italian project. The collared leopard in a miniature garden, chained to a bold radial fixture suspended in the background, was probably a design for the back of a panel or for a heraldic page in a Book of Hours or other manuscript. The oak leaves decoratively disposed over the background very likely reflect a family motto or emblem relating to fortitude, since that tree is the attribute of both Zeus and Hercules.

2

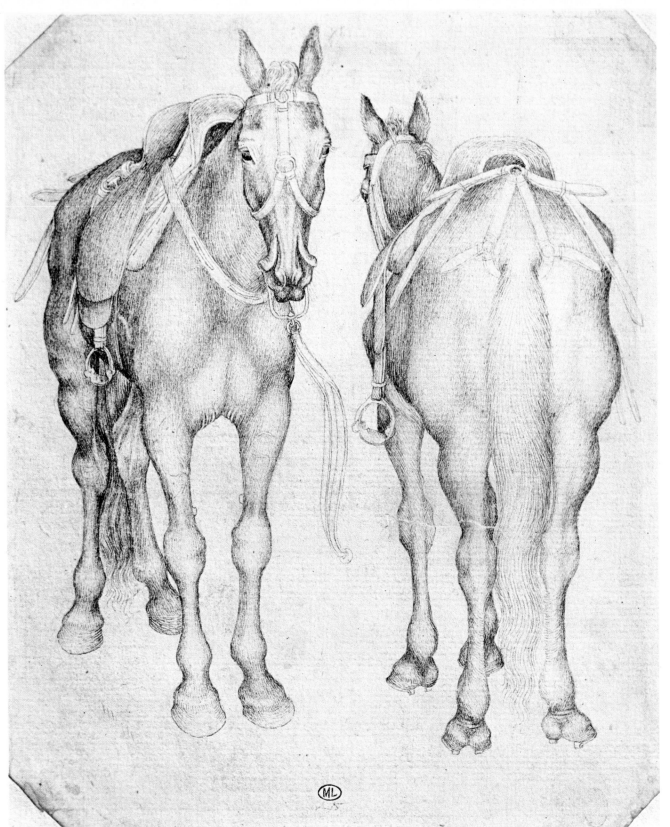

Pisanello (Antonio Pisano)
Pisa before c. 1395 - (?) 1455

Standing Harnessed Horses, in Front and Rear Views.

Paris, Musée du Louvre, Inv. no. 2468. Pen and ink, with traces of black chalk, on white paper ; 8 × 6⅝ in. (20 × 16.5 cm).

Provenance : Coll. Vallardi.

Bibliography : Venturi, 1896, p. 118 ; Degenhart, 1945, pp. 23-24 ; Fossi Todorow, 1966, no. 33.

Pisanello began his career in the workshop of Gentile da Fabriano, who seems to have kept many pets, including a remarkably aggressive and rambunctious monkey. Gentile's own major work — the Strozzi Altar of 1424, *The Adoration of the Magi* — includes a zoo-like variety of fauna. Some of these birds and beasts may have been painted by Pisanello, whose *œuvre* is also populated with both local and exotic animals that bring a certain Noah's Ark encyclopedism to his sacred and profane subjects. The war-horse and its trappings seen here, shown at once from front and back, are firmly established in space by the artist's ingenious simultaneous reversal. Renaissance masters counted on such cleverly unrepetitive repetitions to clarify the area and participants delineated in their newly rationalized, carefully constructed space. The great Florentine painter, sculptor, and engraver Pollaiuolo was especially adept at this device, and employed such reversed pairs in many of his major works.

3

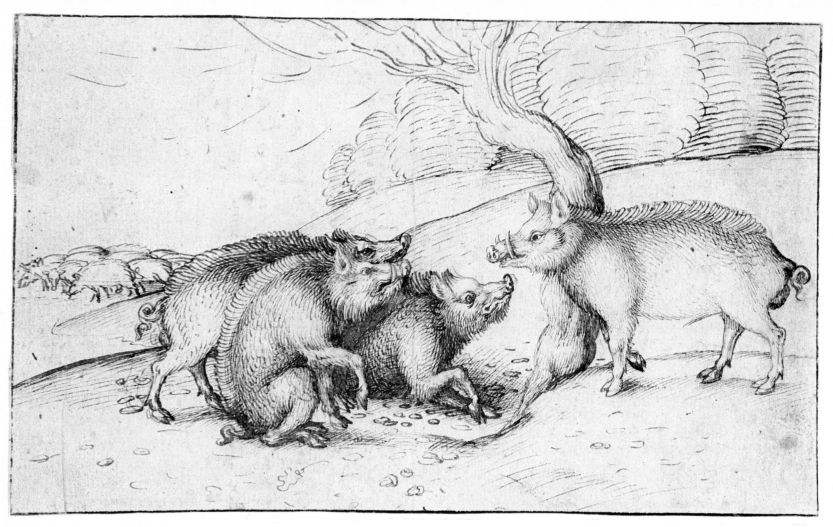

Martin Schongauer (attrib.)
Colmar c. 1445/50 - Breisach 1491

4

Family of Swine.
Hamburg, Kunsthalle, no. 23758. Pen
and brown ink ; 4 ½ × 7 ⅝ in.
(11.4 × 19.1 cm).

Bibliography : Rosenberg, 1923, p. 114;
Winzinger, 1962, no. 49.

Aesop-like in its wit and probable wis-
dom, this Orwellian drawing by Schon-
gauer or some member of his circle
shows one pig to be far and away the
equal of three. Such humorous, pro-
fane subjects were in considerable
demand during the late Middle Ages,
but few have survived. This scene may
have been meant as a book illustration
or a tavern decoration or for some other
informal setting. For such purposes, a
cheerily anecdotal theme like this jolly
fable of gluttony or some other
swinish, all-too-human vice would have
been particularly welcome.

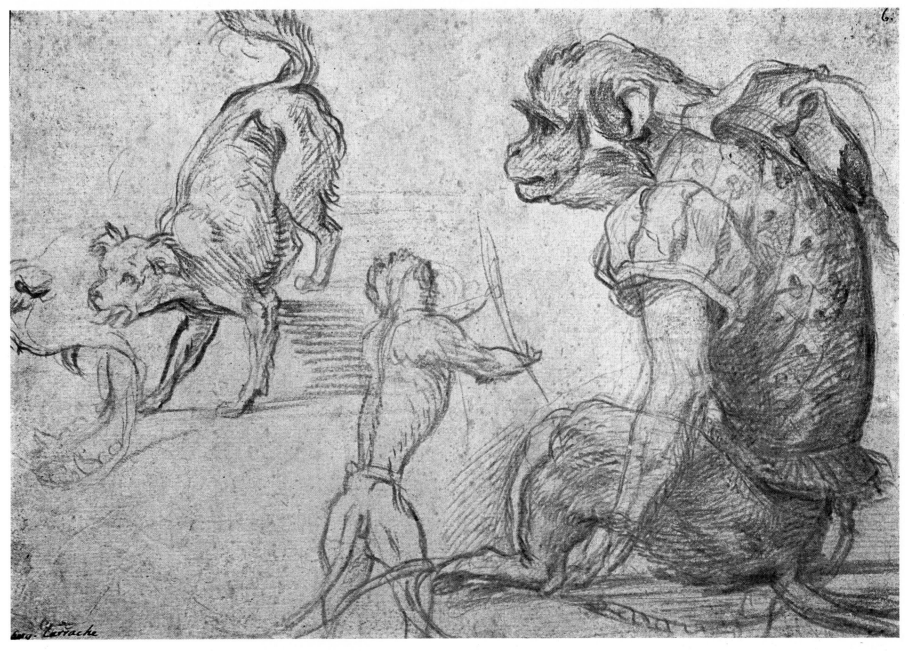

Andrea del Sarto
Florence 1486 - 1530/31

5

Studies of Various Animals.
Darmstadt, Hessisches Landesmuseum,
no. A.E. 1373. Red chalk ; 7 ¼ × 10 ½
in. (18 × 26.2 cm).

Provenance : Coll. Dalberg.

Bibliography : Berenson, 1938,
no. 55 G ; Freedberg, 1963, p. 102 ;
Shearman, 1965, p. 325.

Apes, used as satirical symbols of imitation and the painter's craft, are often mentioned as being in the possession of Florentine artists of Andrea del Sarto's generation. To the right, the artist's pet is profiled on a larger scale in fancy dress ; at the center, it is shown again, now stripped of its clownish finery but still restrained by a rope. A second pet, a dog barking as it trots down some steps, is also shown twice, with an enlarged closeup of its snarling muzzle lightly framing the artist's depiction of the whole animal. These animals were preparatory drawings for *The Tribute to Caesar* (frescoed in 1521 for the Villa Medici at Poggio a Caiano), which according to the tale was paid in the form of beasts. Andrea's choice of subject may refer to an event in the life of Lorenzo de' Medici, who was sent various North African and Near Eastern animals, including a giraffe, by the Sultan of Egypt.

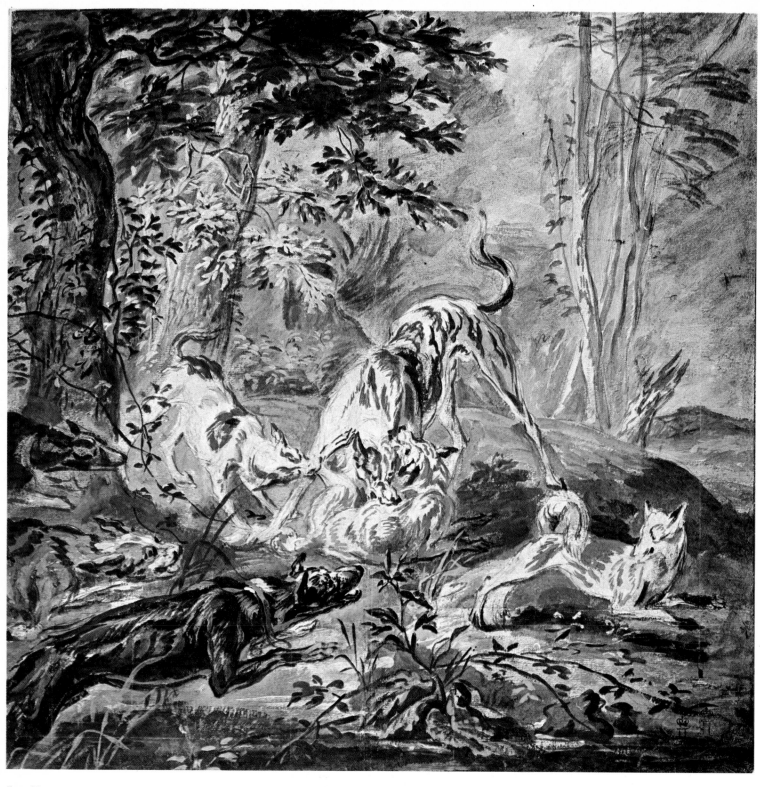

Jan Fyt
Antwerp 1611 - 1661

6

Dogs and Foxes.
Leningrad, The Hermitage, no. 3083.
Black chalk and gouache on yellowish
paper, squared off in chalk ;
20 3/8 × 20 3/4 in. (51 × 51.8 cm).

Provenance : Coll. Cobenzl (Brussels).

Bibliography : Dobroklonskij, 1955,
no. 737.

In the seventeenth century, vast can-
vases showing groups such as Fyt's
were produced in almost assembly-line
fashion to meet the insatiable demand
of European landowners and would-be
landowners for subjects reflecting the
aristocratic prerogative of the hunt,
which was pursued on their own sizable
game preserves. Ever since classical
antiquity, with its sizable Roman
household mosaics devoted to the motif
of the chase, that exclusively upper-
class subject had been hugely popular.

Tapestries or painted simulated tapes-
tries, like the one for which Fyt's deco-
rative scene was intended, endlessly
lined the walls, halls, and stairways of
drafty palaces, chateaux, and aristo-
cratic hunting lodges throughout Europe.

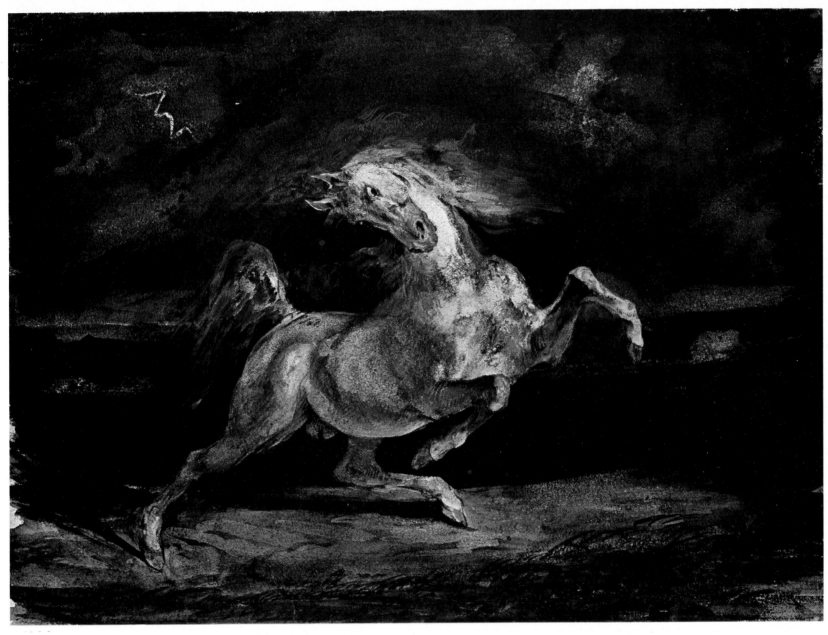

Eugène Delacroix
*Saint-Maurice (Charenton) 1798 -
Paris 1863*

7

Horse Frightened by a Storm,
1825-1828.
Budapest, National Museum of Fine
Arts. Watercolor ; 9⅜ × 12¾ in.
(23.5 × 32 cm). Signed at lower right :
"Eug. Delacroix."

Provenance : Coll. Paul von Majovsky.

Bibliography : Sérullaz, 1963, no. 70.

A force of nature conflicting with nature's majestic forces, Delacroix's rampant stallion, centaur-like in its fusion of animal and human qualities, paws the air in a contorted pose of Leonardesque dynamism. As if representing both the rider and the ridden, this demonic and emotion-taut beast appears to reflect the searing tensions of Romanticism. The intense early-nineteenth-century interest in the study of physiognomy is evident in this anthropomorphic horse, seen exercising its passions against a darkly dramatic sky. Almost as devoted to music as he was to painting, Delacroix shared the wide contemporary interest in musical dramas — possibly implied in the scenographic background here, which brings to mind a painted flat for some melodramatic opera of the period. Byron's passionate delineation of horses in his poems inspired many works of Delacroix and other French masters of his time. There may have been an English literary source for this sketch.

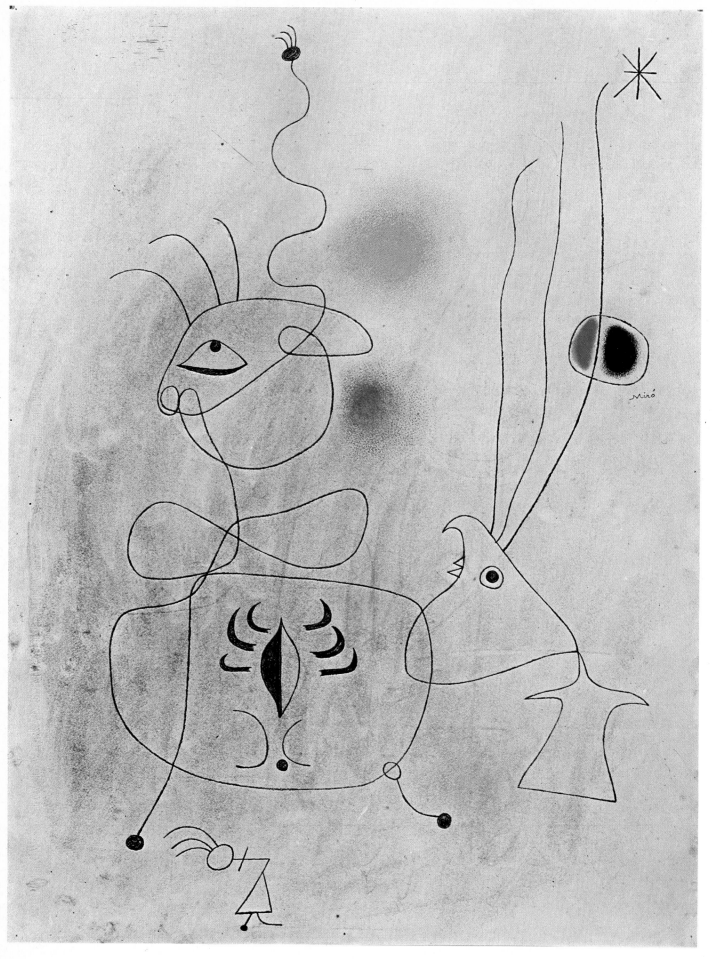

Joan Miró
Montroig (Catalonia) 1893 -

Woman, Bird, and Star, 1941.
Milan, Private collection. Watercolor;
19¼ × 25¼ in. (48 × 63 cm). Signed
at right margin : *"Miró."*

Bibliography : Russoli, 1971, p. 85.

Absorbed by animals throughout his
œuvre, Miró often delineates fantastic
zoomorphic forms to populate his own
wry commentary on the human con-
dition. Like Bosch's owls, the Catalan
master's calligraphic birds and strange
beasts, whether watchful or dormant,
in midair or underwater, personify
man's recurring drives, conscious and
subconscious. The very antithesis of
Descartes' reasoned "I think, therefore
I am", Miró's irrational — or perhaps
suprarational — graphic message frees
his blot-like, wittily drawn human
zoo to be the beasts they must.

8

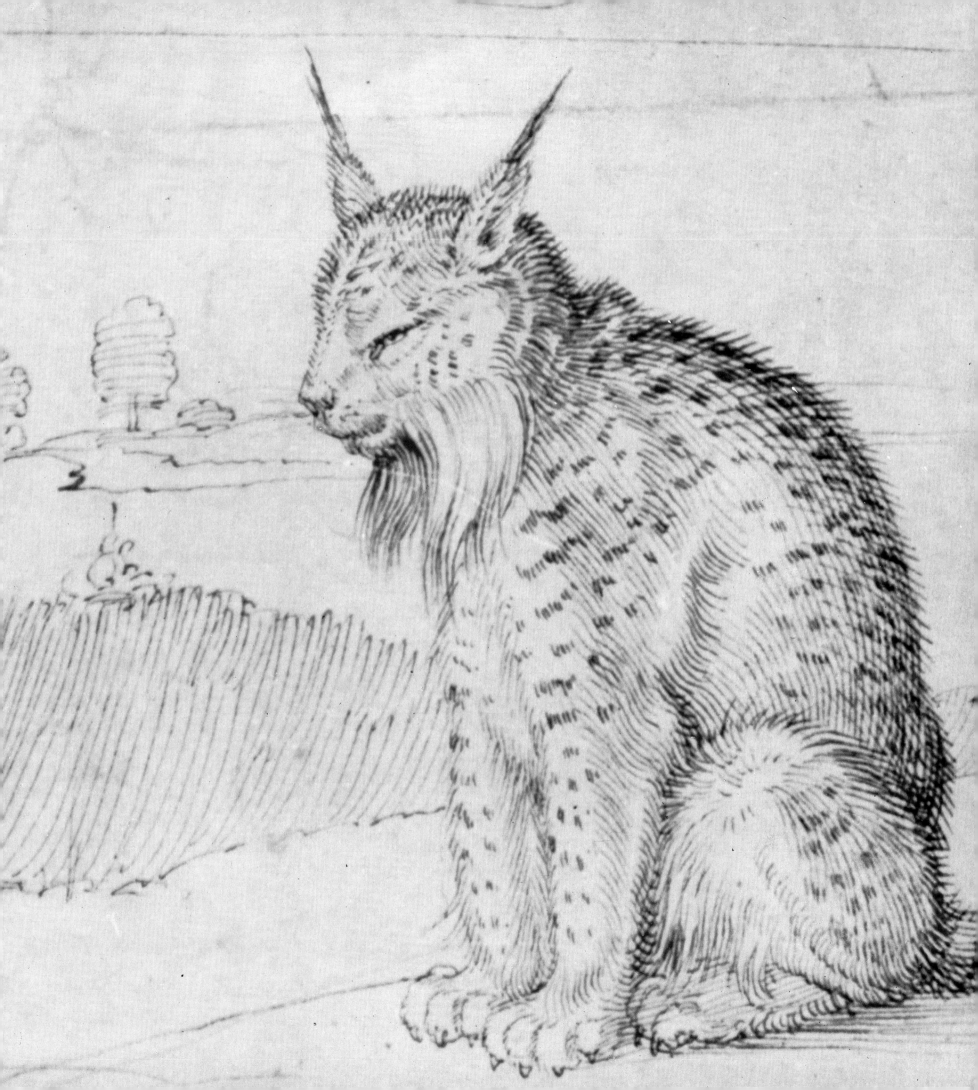

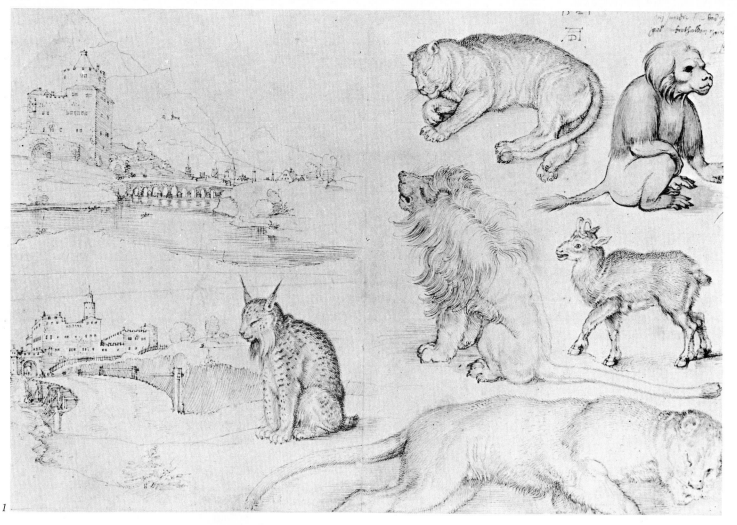

1

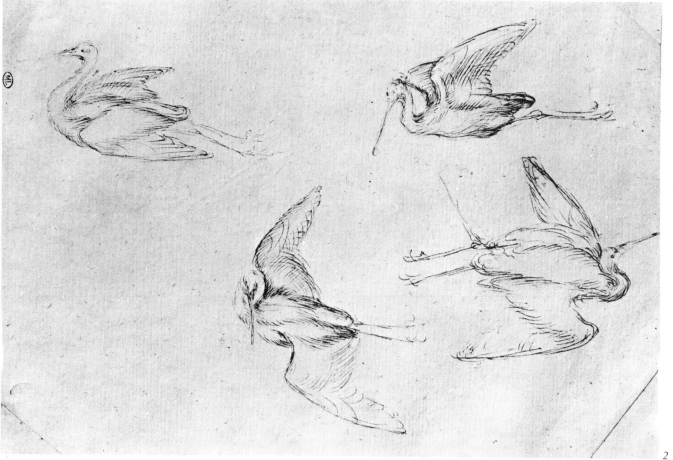

2

Albrecht Dürer F. 1
Nürnberg 1471 - 1528
Sheet of Animal Studies, 1521.
Williamstown (Mass.) Sterling and
Francine Clark Art Institute. Pen and
black ink, with blue-gray and rose
wash ; 10 ½ × 15 ⅞ in.
(26.4 × 39.7 cm).

Pisanello F. 2
c. Pisa 1395 - 1455 ?
Four Birds in Flight.
Paris, Louvre, Cabinet des Dessins.
Pen and ink on white paper ;
9 ½ × 6 ⅔ in. (24.6 × 17.0 cm).

Thomas Gainsborough F. 3
Sudbury (Suffolk) 1727 - London 1788

Studies of a Cat, c. 1765.
Amsterdam, Rijksmuseum. Black chalk
and stump and white chalk, on buff
paper ; 13 ¼ × 18 ¼ in.
(33.2 × 45.9 cm).

Giuseppe Cesari F. 4
Rome 1568 - 1640

The Dragon.
Berlin West, Staatliche Museen, no. 404.
Sanguine, black and white crayon on
brown paper ; 16 ⅔ × 10 ⅝ in.
(42.3 × 27.4 cm).

Théodore Géricault F. 5
Rouen 1791 - Paris 1824

Sketches of a Wild Striped Cat,
c. 1817 - 1818.
Cambridge (Mass.), Fogg Museum,
Harvard University. Pencil on cream-
colored paper ; 12 ¾ × 15 ⅞ in.
(31.9 × 39.8 cm).

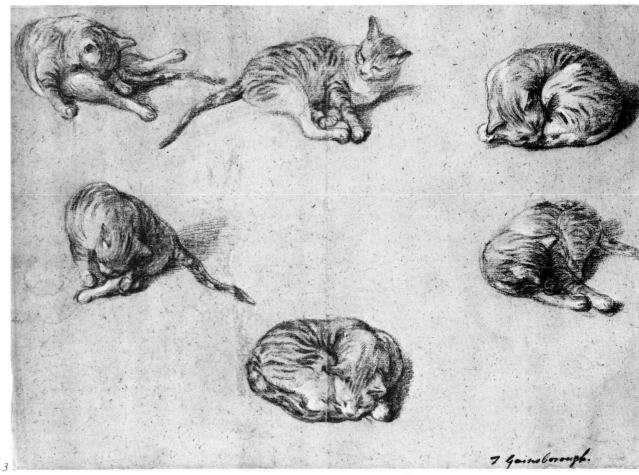

3

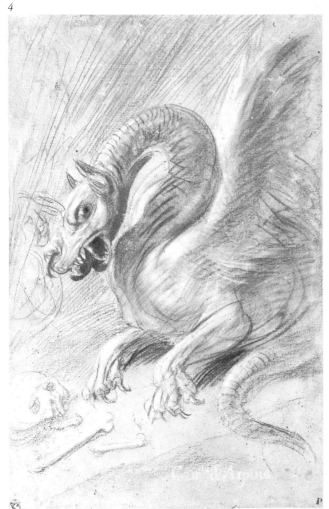

4

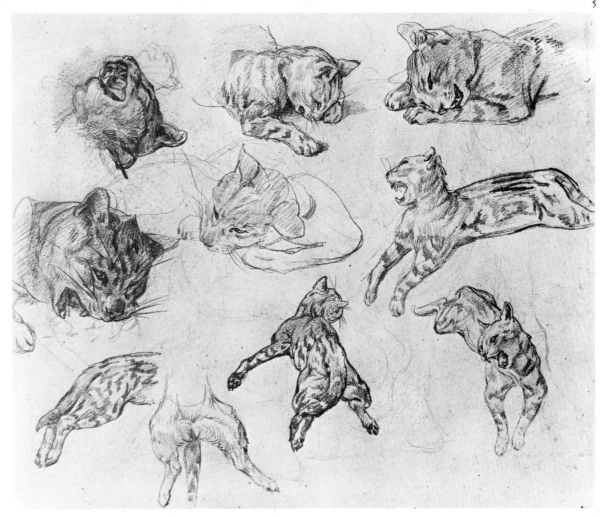

5

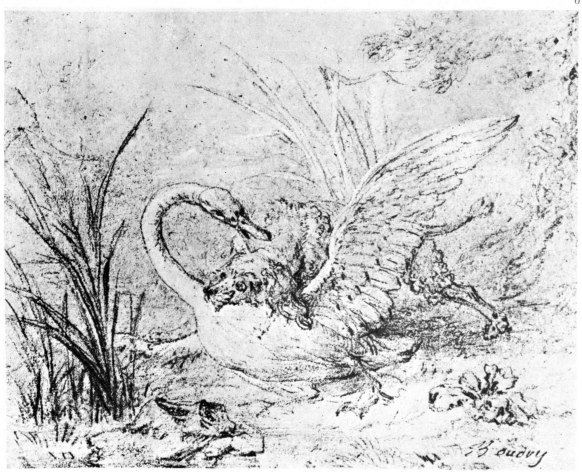

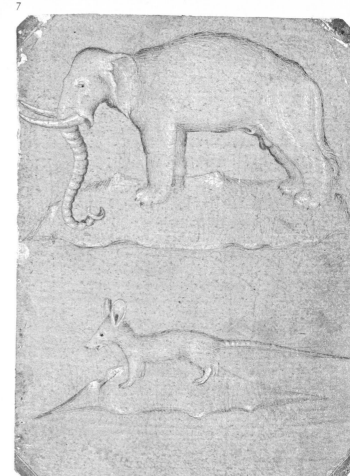

Jean-Baptiste Oudry F. 6
1686 - 1755

Dog Attacking a Swan.
Drawing authenticated but not cata-
logued.

School of Giovannino de' Grasse

Elephant and Mouse. F. 7
Venice, Gallerie dell'Accademia, no. 8.
Silverpoint, white lead on yellowish
paper ; 5 × 38 in. (13 × 97 cm).

Jacob de Gheyn II F. 8
Antwerp 1565 - The Hague 1629

Studies of a Field Mouse.
Amsterdam, Rijksprentenkabinet. Pen,
brush, and ink ; 5 1/8 × 7 1/4 in.
(12.8 × 18.1 cm).

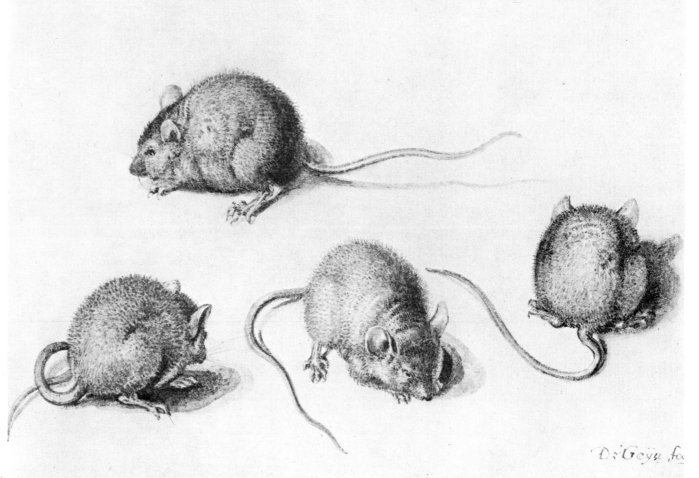

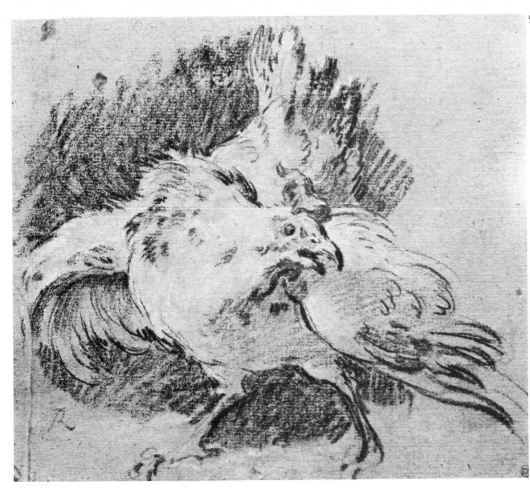

9

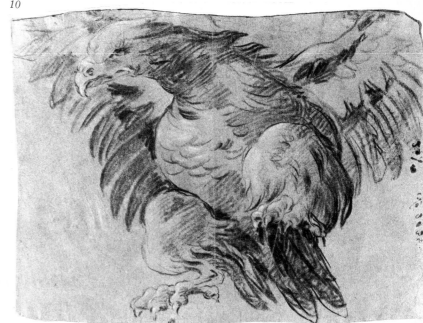

10

François Boucher F. 9
Paris 1703 - 1770

Study of a Rooster (for "Le Repos des Fermiers").
Stockholm, Nationalmuseum,
no. 2952/1863. Black, white, and red
chalk on brownish-gray paper;
6⅞ × 8 in. (17.2 × 20.2 cm).

Giovanni Battista Tiepolo F. 10
Venice 1696 - Madrid 1770

Study of an Eagle.
New York, Metropolitan Museum of
Art. Black crayon, heightened with
white chalk on blue-gray paper;
9¾ × 13¾ in. (24.7 × 34.7 cm).

Hieronymus Bosch F. 11
Bois-le-Duc (Brabant) c. 1450 - 1516

Owl's Nest.
Rotterdam, Museum Boymans-van
Beuningen. Pen with bister;
5⅝ × 7⅞ in. (14 × 19.6 cm).

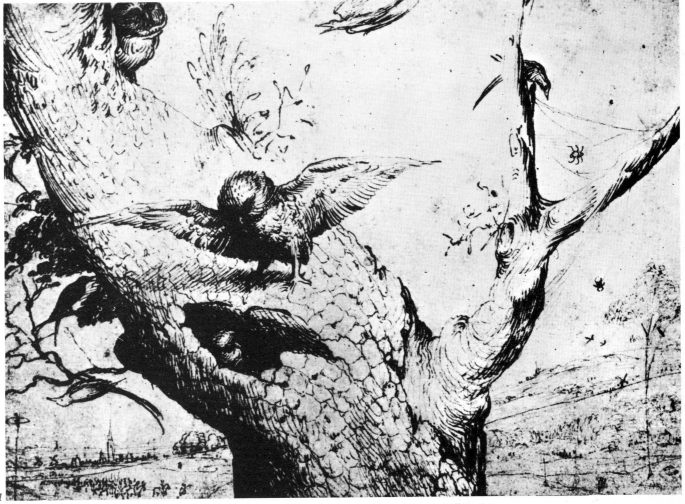

11

12

13

Thomas Nast F. 12
Landau (Ger.) 1840 - Guayaquil 1902

Tammany Tiger, 1872.
Andover (Mass.), Addison Gallery of
American Art, Phillips Academy.
Brush and ink ; 14 ½ × 21 ½ in.
(36.3 × 53.8 cm).

Jean Dubuffet F. 13
Le Havre 1901

Cow, 1954.
New York, Coll. Maxime Hermanos.
India ink with pen and brush ;
9 ¼ × 12 ⅜ in. (23 × 31 cm).

Alfred Sisley F. 14
Paris 1839 - Moret-sur-Loing 1899

The Goosegirl.
Paris, Louvre, Hugot Collection,
no. RF 31.844. Pastels.

14

15

16

Sarah Landry F. 16
Contemporary American illustrator

Bumblebee Colony Staking Out Abandoned Mouse Nest
(illustration for Edward O. Wilson, *The Insect Societies,* Belknap Press of Harvard University Press, Cambridge, Mass., copyright 1971 by the President and Fellows of Harvard College ; reprinted by permission of the publishers).
Collection of the artist. Pen and ink.

Baargeld F. 15
Alfred Grünewald (?) - Tirol (Austria) 1927

Beetles, 1920.
New York, Museum of Modern Art, Acq. no. 276.37. Pen and ink on tissue paper ; 11 ½ × 9 ¼ in. (28.8 × 23.1 cm).

Walt Disney Studio F. 17

Fantasia, "Pastoral" segment, c. 1939.
Pastels and pen and ink.

17

Allegory, Myth, and Fantasy

Legends from the unending lives of the pagan divinities and of the heroes and lesser beings in their midst furnish poetic accounts—the myths—explaining the How and Why of all aspects of actuality, originating in a long-lost When, through the passionate adventures of men-like gods and god-like men. With its mystical rationale, mythology appeals to the most basic human fears, hopes, and desires and provides immortal answers to mortal questions, eternally convincing since they are cast in all-too-human terms, with a pantheon of often jealous gods.

Myth is rooted in change, in metamorphoses: blood hardens into coral, tears of trees into amber; trees and flowers spring from the frustrated loves of the gods, or dead lovers are transformed into crystalline streams, and their natural beauty is a haunting souvenir of the human loveliness contributing to their genesis. The immortal into mortal, animal into vegetable, vegetable into mineral—a complex reversible cycle, with mutants arising along the wayside, results according to Ovid from the matchless matings and mismatings, adventures and misadventures, of the gods and men. One-eyed giants, three-headed dogs, winged horses, and monstrous women with snakes for hair populate the weird sideshow of mythology, as recorded with such singular beauty by Homer and Milton, Joyce and Graves, and Mozart, Wagner, and Richard Strauss. A cosmic fairy tale that abounds with the bizarre and erotic, it is a lyrical Grimm, an adult Andersen, a Kraft-Ebbing of how the gods do it. Mythology is humanistic science fiction: man as supermachine shuttling between heaven, earth, and the underworld.

Classical themes offered the highest and handsomest manifestation of secular man, ideally suited to the embellishment of luxurious objects for which Christian motifs might have been decidedly unsuitable, if not downright sacrilegious. Designs for Northern tapestries, paintings for Roman façades, and projects for painted Florentine hope chests (*cassone* or *forziere*), Burgundian battle tents and banners, decorative interior paneling, embroideries, silver reliefs, fancy salt cellars and cake boxes, painted circular wedding and birth salvers, papier-mâché, repoussé leather, splendid armor and harnesses—all these displayed mythological motifs by the late fifteenth and early sixteenth centuries. Mythology afforded a mutual visual language for the ages of chivalry and Humanism. The familiar damsel-in-distress and her liberator St. George reverted to their classical prototypes, Perseus and Andromeda.

In the first major postclassical era of the academy—the sixteenth century—and with the artist ever more concerned about his social and cultural standing, mythology provided an endless bounty of themes for gifted humanistic draughtsmen to devise elaborate programs involving all the arts, eventually leading to the first operas: Orazio Vecchi's *Amfiparnaso* (1594) and Jacopo Peri's *Eurydice* (1600). Each subsequent school and century have reexperienced antique themes; great artists from Poussin to Picasso have had their finest hours in uncovering the heritage of Ovid and Homer for successive generations.

Certain sixteenth-century allegorical scenes are so involved that one must study them with a contemporary emblem book in hand, a visual dictionary to define the symbolic components in the artist's vocabulary, to decode his message. A pomegranate means unity; a parrot, stoicism; a flaming vessel, sacrifice; a cracked pot or arrow or broken chain or bridge (along with about thirty other devices) symbolizes

death. The language of color symbolism must also be understood to decipher these elaborate visual puzzles. Indirect and multilevel, allegories are like courtly language —so carefully veiled, elegantly ambiguous, and obliquely expressed as to escape any consequences of quotation and misquotation alike. Such intricate visual communication was especially popular in the sixteenth century, when there was extraordinary fluidity of attitudes between Catholic and Protestant, orthodoxy and tolerance, art and iconoclasm.

The sum total of man's knowledge is almost exhausted in and by allegory, beginning with a fraudulent manuscript, the *Horus Apollo*. Supposedly a compilation of all the mystical wisdom of antiquity, this was later identified as largely a Renaissance forgery. Bringing together Horus, the hawk god of the ancient Egyptians, with Apollo, the classical divinity of art and healing, this madly esoteric manuscript made the rounds of Renaissance courts and was much used as a source of image and interpretation for centuries afterward.

Artistic creativity, always a central mystery of life, is a major subject of myth and allegory alike. Plato described the act of art as an essentially subversive, irrational, demonic moment. The artist, who abandons or is abandoned by the voice of reason, is infused with divine inspiration, by which the gods breathe a new understanding and apprehension into his being. In his ensuing trance-like state, the artist materializes in word or image the fruit of his ecstatic communication with divinity. *Furor poeticus*, as drawn in Raymond La Fage's self-portrait, for example, shows the artist as a Bacchic spirit, imbibing the Dionysian grape which will carry him beyond the human condition to extraordinary perceptions and understanding.

It is this "making visible"—the meaning of the Greek *phantasia*—which is the artist's greatest power and glory. A companion or rival of the divine, the draughtsman draws the unseen, renders the invisible visible. With a flick of the wrist, his pen or pencil or brush or chalk or silverpoint can turn line into image, capable of leading us to adventures beyond our ken or even our desire. Such is the artist's gift of fantasy, an enforced sharing of dreams which his imaginative powers make impervious to, while at the same time defined by, daylight. Whether Botticelli's sublime re-creation of the *Divine Comedy* or Walt Disney's "Ballet of the Elephants," fantasy is rooted in the literary and takes flight in the persuasion of the seen. Paraphrasing the Cartesian "I think, therefore I am," fantasy says "I am seen, therefore I exist."

Mercifully diverting borders in Books of Hours, teeming with diabolical or whimsical vignettes, and fanciful hidden carvings on church furniture with perverse metamorphoses of priest into pig (or perhaps vice versa) provided outlets for the artist's imagination in the late Middle Ages. Many such works of secular fancy were made, but few survive. Though "Nothing sacred" may seem the name of the game in the pungent satirical fantasies of Bosch and Rabelais, a kind of spiritual Monopoly was their true objective. Novel interpenetrations of sight and sound, of word and image, which reveled in the abundance of rediscovered antique sources lent new dimensions to imagination in the sixteenth and seventeenth centuries. Reborn, the robust gods of classical mythology frolicked in an endless Midsummer Night's Dream of mirth on all levels, from the cerebral burlesque of Mantegna and Dürer to the more carnal revelry of Rubens and Poussin.

Dreams, a staple of fantasy, were recharted by Raphael and Dürer, who adapted the abstruse literature of Neoplatonism in realizing the new secular mysteries of the Renaissance, dark visions stemming from the twin black arts of printmaking and alchemy. Melancholia, the tormented spirit in which the very nature of the artistic imagination is grounded, was caught in conflict between creativity and despair.

The *capriccio* and *schizzo*, the *bizzarria* and *grottesca*—though all these fantasy-laden types (like almost everything else) had antique origins and reemerged in Rome and Florence—were most wholeheartedly espoused in Venice, which had mercifully been spared a significant classical or Gothic past. Venetian humor as free-floating as the Dogana delighted in these slight yet penetrating vignettes, so theatrical in their decorative scenography. Generations of Venetian painters (most notably, the Tiepolos, Guardis, and Ricci) broke the bonds of conventional expectation in an art of adroit surprise, of witty illusionism and spatial improvisation, going well beyond the bounds of the *commedia dell'arte*, characterized by its endless familiar variations on predictable stereotypes.

Fantasy in art became both sublime and picturesque, as marked in the elegant shudders that Piranesi produced with his dramatic evocations of classical buildings in haunting decay or in his somber *Carceri* series. These last-named drawings and etchings are fantastically elaborated visions of the prisons of the mind, from which one can be freed by the power of imagination. Or, conversely, it may be the imagination which traps the soul in the horrific recesses of its labyrinthine gaols. The great Italian draughtsman's own life might well be given the operatic title of "A Venetian in Rome," he who brought to the reasoned order of antiquity the impassioned disorder of incipient Romanticism.

Fantastic art is an audacious encounter with the inexplicable—the latter term defined by Emerson as a conglomerate of "language, sleep, madness, dreams, beasts, sex." The Sphinx and Chimera of antiquity, the teeming diabolical populace of innumerable Last Judgments, the monstrous and monstrously punning mutants of Bosch, the melancholy black specters of Goya and Redon: all these terrifying visions arise from the same source described in the Spanish master's telling phrase, "The Sleep of Reason." Blake and Fuseli, and later Picasso, Miró, and Ernst, used the graphic arts to transcribe their turbulent nocturnes. Such widely disparate sources as Shakespeare's plays and Hitler's bombers, the sonorous cadences of the King James Bible, and Miltonic and Freudian mythology were to stimulate images of a splendid, mystical sexuality and richly aberrant passion, of demonic release and angelic recovery.

Goya's *The Sleep of Reason Produces Monsters*, from his *Caprichos* series (published in 1799), portrays the flight of the rational following upon the disasters of revolutions gone wrong. The artist, abandoning the deceptions of the Enlightenment, plunges into the world of darkness and demonology, releasing the floodgates of the black humors. Other artists, such as Fuseli, drawn to the "Gothick" world of Shakespeare and of Norse and Teutonic mythology, delineated the passions rather than the data of the Encyclopedia. They produced eerie depictions of the nightmare—the *Alpendruck*—along with renderings of the Alps themselves, in a curious contrast between nature at its highest and clearest and nature at its lowest and darkest.

More and more, the nostalgic became the focal point of fantasy, a yearning for the "good olde days" that never were, those Ages of Gold and of Faith, longingly

Allegory, Myth, and Fantasy

documented once more through the artistic imagination. Neoclassic, Nazarene, Pre-Raphaelite, Academic, Symbolist—all these movements cast the artist as cinemagician, producing endless silent operas, fantasies of law and order, truth and purity, of newly found, innocent lands where the natives didn't even know how to sin properly.

The rational mind, aspiring to a new objectivity, a reconstruction of matter without anecdote, led to the new fantasy of Cubism, wherein the artist revealed the unseen inner reality by smashing the pictorial atom to re-create, in two dimensions, all aspects of seen and unseen alike. The ostensibly objective analysis of movement that inspired the Futurists at times went off in the direction of imaginative fantasy in some of their most poetic works.

Also in this era spanning the *fin de siècle* and the Weimar Republic, the inscrutable West produced that most enchanting, elusive master of fantasy, Paul Klee. Almost painfully didactic, Klee "explained" his art and work in such utterly mystifying terms that he brought new validity to the old injunction never to apologize or explain. In doing so, he created an exclusively personal world of allusions and emotions. Though his vocabulary at times overlaps that of Dada and Surrealism, its wit is more guileless, a private wisdom more in the beguilingly innocent spirit of the child in Andersen's tale *The Emperor's New Clothes* than Duchamp and Miró's desire *pour épater le bourgeois* ("shock the squares").

Artistic fantasy has been greatly eclipsed by recent reality; Jules Verne's wildest dreams have now been conventionalized through modern technology. In the decades between the expounding of the Oedipus complex and the double heart transplant, myth, allegory, and fantasy have been analyzed and banalized. Surrealism may have sounded that last squeak of the speculative needed for art as imaginative exploration. Thrice-thwarted (by patronage lag, by the obsolescence of the classical academy, and by the crippling limitations of "good taste" and old wars), some of the most intelligent, imaginative masters of this century such as Max Ernst and Joan Miró turned to pictorial iconoclasm, to that art of questions rather than answers known as Dada. It stressed the corrupt sentimentalization of Art, Value, and Originality in the droll revelations of its "ready-mades," mass-produced items selected with devilishly keen wit, then signed and exhibited per se as works of art. First, last, and always a sucker for ingenuity, America fell madly in love with Dada's all-alchemical sweetheart. Enduring romance conducted mostly in the environs of Hollywood.

Like some antibourgeois philosopher-scribe of hermetic lore, Marcel Duchamp evolved his own world of visual references, in an ingenious, almost alchemical manner. This graphic conjurer compiled arcane personal notebooks of psychic know-how, never avowing whether they were drawn in self- or in universal deprecation. But it took the Belgian Magritte to unveil the deceptively serene but meaningful fantasies of the bourgeoisie, in meticulous Memling-like images of borderline monotony. His finely sharpened pencil delineates startling visionary apertures to madness, where infinitely expanding Eyckian apples lead to an illusion of domestic paradise regained, a weirdly precise world of Buñuelian decorum.

Ultimately, art is the "trip" affirming the right to assert ourselves through exercise of the imagination. Allegory and fantasy expand both vehicle and license for the expression of individual validity as sentient being, creating another tiny stitch in that greatest myth of all—the sense of time.

Pisanello (Antonio Pisano)
Pisa before c. 1395 - (?) 1455

Allegory of Lust.
Vienna, Albertina, no. 24018 recto.
Pen and bister on reddish paper;
5¼ × 6 in. (12.9 × 15.2 cm).

Provenance : Colls. Moscardo ; Grassi ;
J. Goldmann.

Bibliography : Degenhart, 1945, pp. 24,
31, 54, 72 ; Fossi Todorow, 1966 no. 1.

Reveling in her undraped beauty, flow-
ing tresses, and globular floral head-
ress, this languid reclining nude can
be identified as the vice Luxuria by the
rabbit at her feet and her high-fashion
demeanor, so elegantly and affectedly
oblivious to her extravagant endow-
ments. Such figure types were drawn
from the carvings on classical sarco-
phagi, but their identifying attributes
were added from Christian literature —
in this case to embody the deadly sin
of lust. The sleek proportions of this
sophisticated temptress place her in that
most courtly of periods, the era of the
International Style, when the Late
Gothic manner was first tinged with an
appreciation for the arts of ancient
Greece and Rome.

1

Francesco Primaticcio
Bologna c. 1504 - Paris 1570

2

Hercules and Omphale, c. 1535.
Vienna, Albertina, no. 69. Pen and
ink, with bister wash ; 11½ × 17⅞ in.
(28.5 × 44.7 cm).

Bibliography : Dimier, 1900, no. 151 ;
Dimier, 1928, pl. VIII ; Barocchi, 1951,
p. 211 ; Lebègue, 1960, p. 303.

This drawing belongs to a series of
Hercules frescoes that once adorned a
portico of the Porte Dorée at Fontaine-
bleau. Sold into slavery to the Lydian
queen Omphale, Hercules falls so much
under her sway that he assumes her
sexual identity and garb, as well as her
labors, spinning while she, in turn,
dons his lionskin. The bewitched hero's
effeminate guise — calling to mind
nothing so much as Francis I in drag —
is reinforced by the daintily crooked
little finger of his right hand, which
appears in ludicrous contrast to his
other, club-wielding and Michelange-
lesque hand. The drawing is filled with
sexual *double entendre,* in this favorite
scene of classical burlesque from Ovid's
Fasti (II, 6, 3). Primaticcio's sinuous,
chryselephantine gifts of draughtsman-
ship are particularly well suited to this
scene, in which force and fallibility are
rendered with laughing ripples of line.

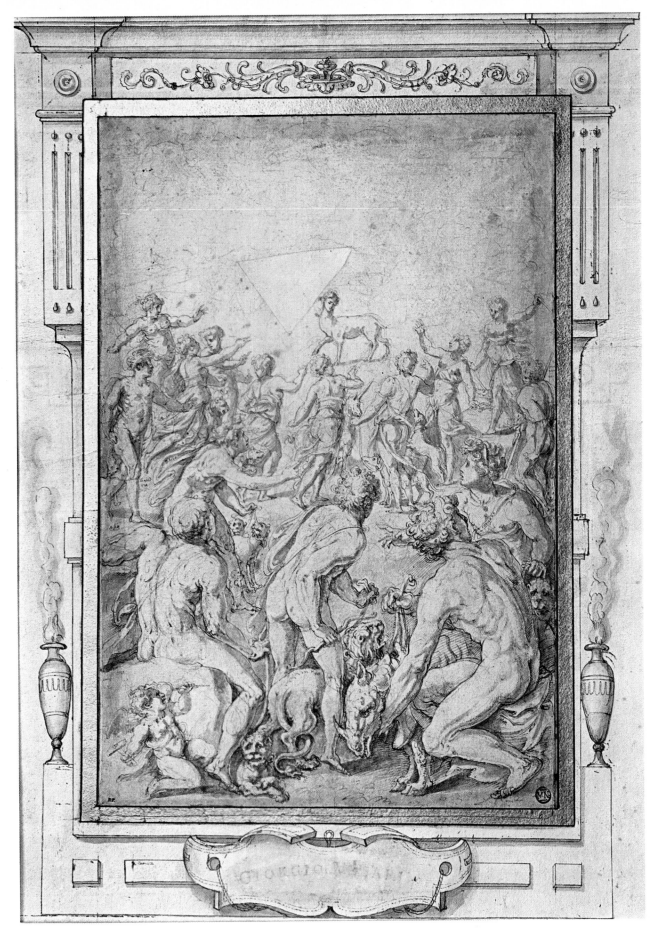

Giorgio Vasari
Arezzo 1511 - Florence 1574

The Hunt of Love.
Paris, Musée du Louvre, no. 2169.
Pen and brownish watercolor over
traces of black pencil; 17 × 11⅝ in.
(42.5 × 29 cm).

Provenance : Colls. G. Vasari ;
E. Jabach.

Bibliography : Barocchi, 1964, ill. 99 ;
Mostra Giorgio Vasari, 1965, no. 35.

Vasari here illustrates an elaborate
conceit proposed by the young prince
Francesco de' Medici. Beauty, as per-
sonified by a doe with the head of a
lovely woman, is surrounded by the
Virtues, with Chastity (indicated by her
attribute, the unicorn) at the center of
the group. In the foreground are the
Vices, who are seen striving to capture
Beauty with a pack of menacing beasts
they hold back on reins. Vasari himself
has framed this drawing with an ele-
gantly executed architectonic enclosure,
at the sides of which decorative perfume
burners send up fragrant vapors.
Within a cartouche at the bottom, the
artist inscribed his name prominently.

3

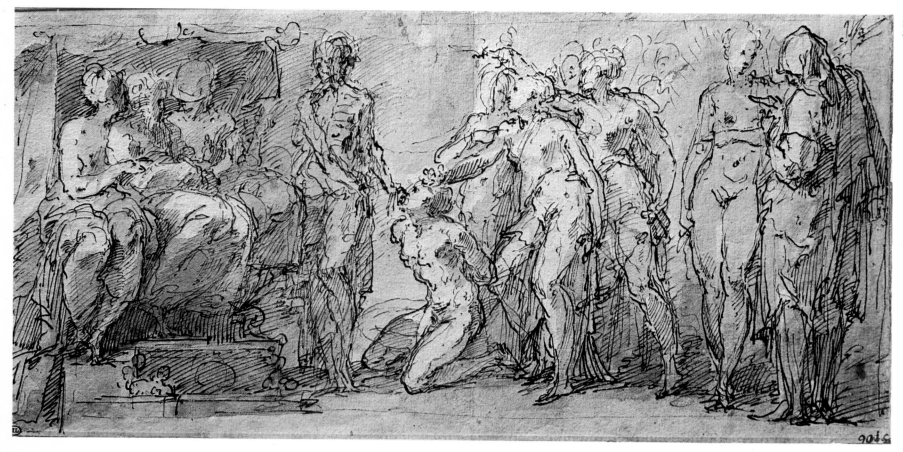

Niccolò dell'Abate

Modena c. 1509/12 - Fontaine-bleau (?) 1571

4

The Calumny of Apelles, 1552-1556.

Musée du Louvre, Inv. no. 5877. Pen and ink, with wash of India ink and bister and white heightening; 6⅜ × 14 in. (15.9 × 35.5 cm).

Provenance : Coll. Crozat ; entered the Louvre collections before 1827.

Bibliography : Dimier, 1900, p. 456 ; Sylvie Béguin, *L'École de Fontaine-bleau,* Paris, 1972-73, cat. no. 10. p. 13

A highly gifted, eclectic master who came to Fontainebleau from Bologna in 1552, Niccolò dell'Abate brought with him a vivid understanding of Parmigianino's art that was to provide the basis for the style of the French court in this era. As noted by Sylvie Béguin, Niccolò's exquisitely varied technique seems to " write " figures across the paper in a frieze-like fashion that reminds one of the delicate classicism which was to come much later, in the eighteenth century.

This highly complex classical subject was popular in the fifteenth and sixteenth centuries, when it was viewed as a tribute to the artist's independent intellectual, literary, and dramatic authority and prerogatives.

Threatened by a rival's false charge that he was plotting to overthrow their mutual patron King Ptolemy Soter of Egypt, the Greek painter Apelles devised an elaborate figural composition

personifying the danger of his situation. In it, Calumny was portrayed as a beautiful, agitated woman who is seen dragging an abject, innocent youth before a ruler, whose Midas-like ears indicate a readiness to hear the worst. Other figures in this shrewd personal allegory represent Jealousy, Deception, Repentance, and Truth. Apelles' masterpiece is described by Lucian in his *Imagines* (2-5, *"Calumniae Non Temere Credendum"*).

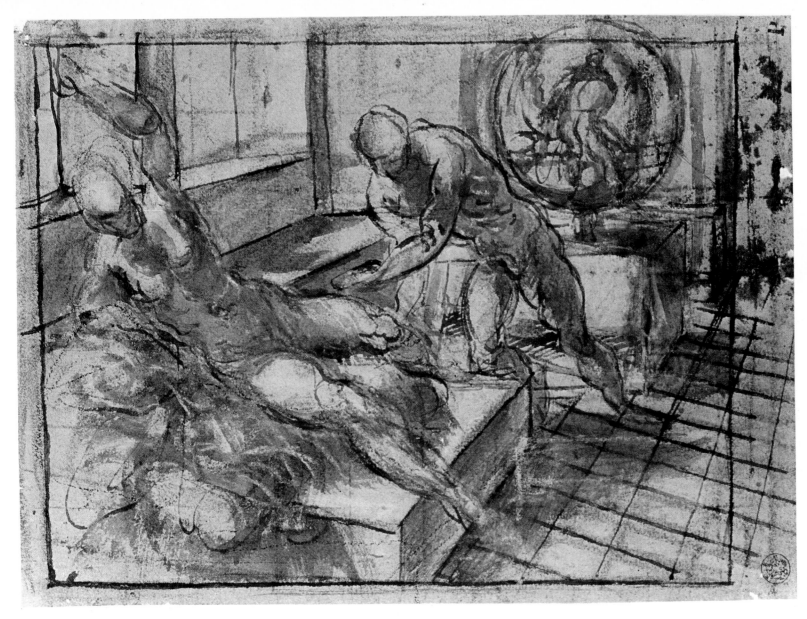

Jacopo Tintoretto (Jacopo Robusti)
Venice 1518 ? - 1594

5

Venus and Vulcan.
West Berlin, Staatliche Museen, no. 4193. Pen and brush, black ink and wash, heightened with touches of white, on blue paper; 8¼ × 11 in. (20.4 × 27.3 cm).

Bibliography : Hadeln, 1922, p. 32 ; Tietze, 1944, no. 1561.

Venus, the goddess of love, who reclines in the foreground, is approached by her nude, lame husband Vulcan, the celestial metalworker and son of Jupiter and Juno. His lumbering body is also seen from the back, as reflected in a large, fixed circular mirror. This is one of the very few complete working drawings by Tintoretto, prepared for his painting of about 1550 (Munich, Alte Pinakothek). Rarely has an artist's mastery of compositional means been more readily apparent than in this study, with its dynamic contrast between the space-creating rectilinear grid and the strong curves of the figures and circular mirror. This latter form is like a great inorganic eye whose reflection adds another, voyeuristic dimension to our perception of the love life of the gods. So convincing and authoritative are such images that for centuries they have haunted the imaginations of both the creative and the passive viewer as the definitive portrayals of the denizens of Mount Olympus.

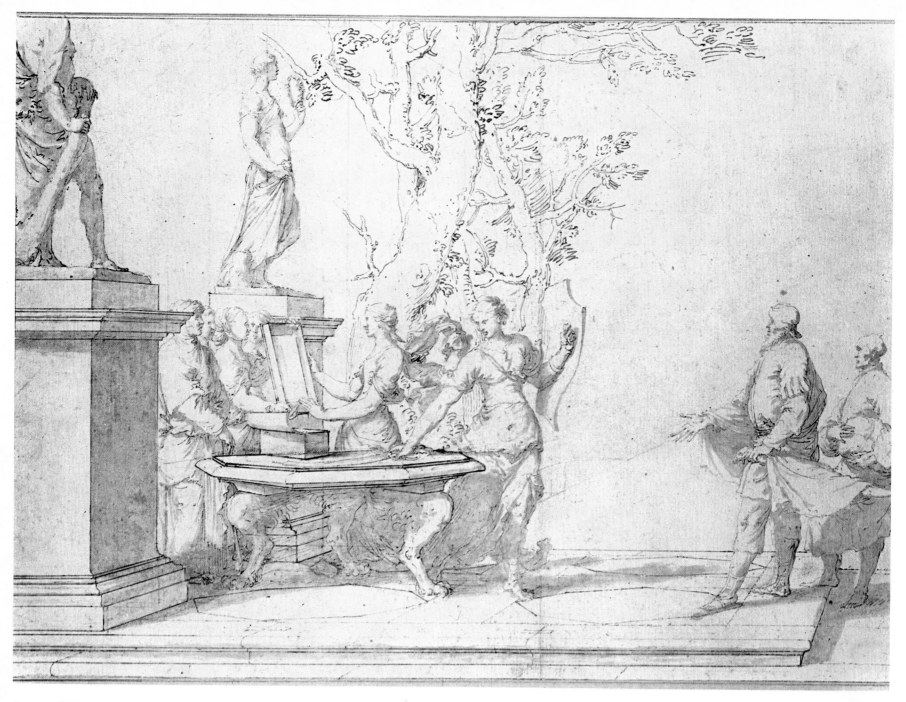

Jusepe Ribera
Játiva (Valencia) 1591 - Naples 1652

6

Achilles among the Daughters of Lycomedes.

Haarlem, Teylers Museum, K. II. 58.
Charcoal, pen and ink, and watercolor ;
10 ¾ × 15 ⅜ in. (26.9 × 38.4 cm).

Provenance : Colls. Queen Christina of
Sweden ; Odescalchi.

Bibliography : Van Regteren Altena,
1966, p. 117 ff. ; *Master Drawings,*
IV, 1966, p. 304.

This delicate, almost Mozartean work,
probably a study for a theatrical presen-
tation, shows a little-known aspect of
Ribera's brilliant draughtsmanship —
a welcome and far cry from the murky,
lurid scenes of martyrdom that issued in
endless numbers from the artist's Nea-
politan studio. Here Ribera depicts the
discovery of Achilles among the
daughters of Lycomedes by Odysseus.
Knowing her son was fated to die if he
went to Troy, his mother Thetis had
Achilles reared as a girl at the faraway
court of Lycomedes. Odysseus, after
cleverly leaving feminine trinkets and
a spear and shield at Lycomedes' palace,
recognized Achilles when the hero
instinctively selected a warrior's arms
over the girlish baubles (Ovid, *Meta-*

morphoses, XIII, 162 ff.). The Neapo-
litan master stages this mythological
episode in a baroque garden, with classi-
cal statues of Hercules and Hygiea in
the background and a handsome Tuscan-
style table providing a focus for the
figure group. The figures are done in
pale washes, while the trees, furnish-
ings, and architectural elements are
outlined in darker strokes of the pen.

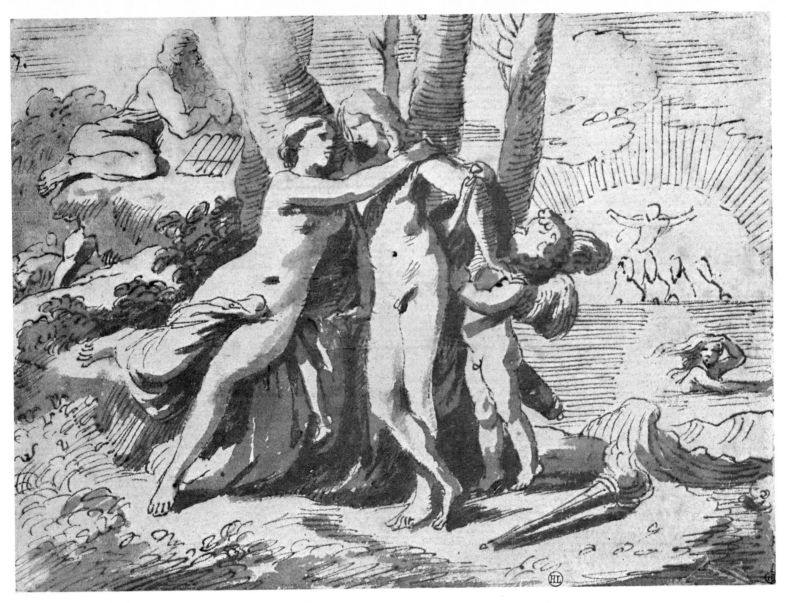

Nicolas Poussin
*Les Andelys (Normandy) 1594 -
Rome 1665*

7

Acis and Galatea.
Chantilly, Musée Condé. Pen and bister
over black chalk ; 7¼ × 5¼ in.
(18 × 13 cm).

Provenance : Colls. Mariette ; Law-
rence ; His de la Salle ; Reiset.

Bibliography : Malo, 1933, no. 28 ;
Friedländer-Blunt, 1953, III, no. 215.

The nymph Galatea, ignoring the mons-
trous Polyphemus, serenading her as
he crouches dejectedly on a cliff to the
left of the drawing, embraces Acis
while a cupid is disrobing him. Apollo's
sun chariot is visible on the horizon.
Infuriated by Galatea's rejection of his
suit, Polyphemus killed her lover Acis,
whose blood the distraught sea nymph
then turned into the Sicilian river flow-
ing at the foot of Mount Etna and bear-
ing his name. Poussin presents this
tragic myth with grandeur and force-
ful restraint. The whole scene is suffused
with an almost Venetian light. The
glow of the cupid's torch contrasts
with the sun's brilliant reflection on
the water, as the fleeing figure of
Galatea is shown again in its path.

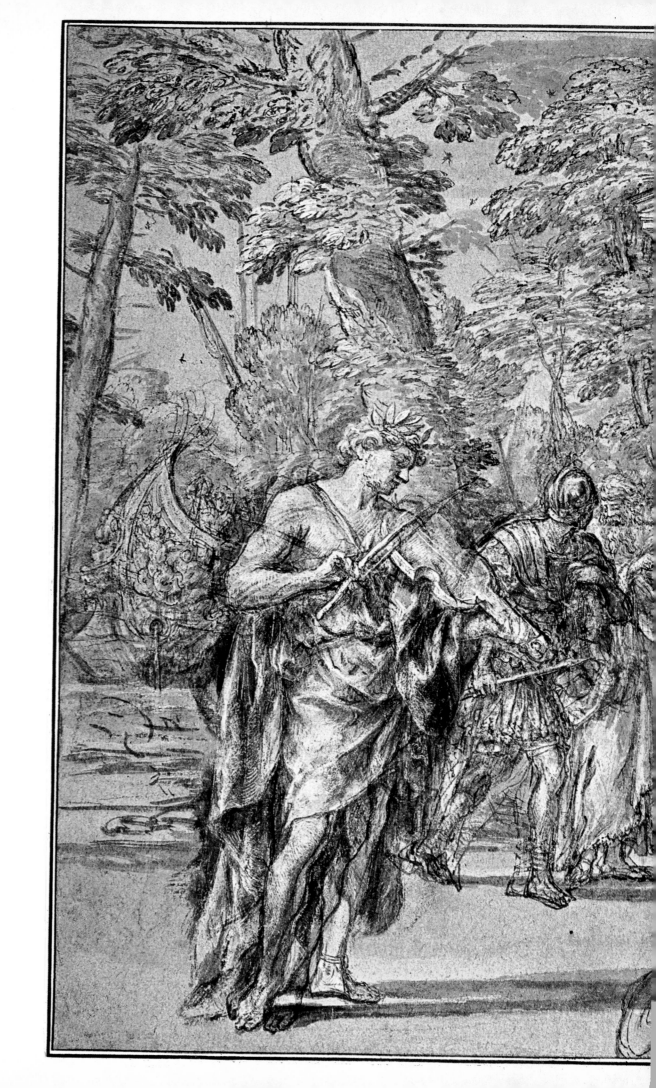

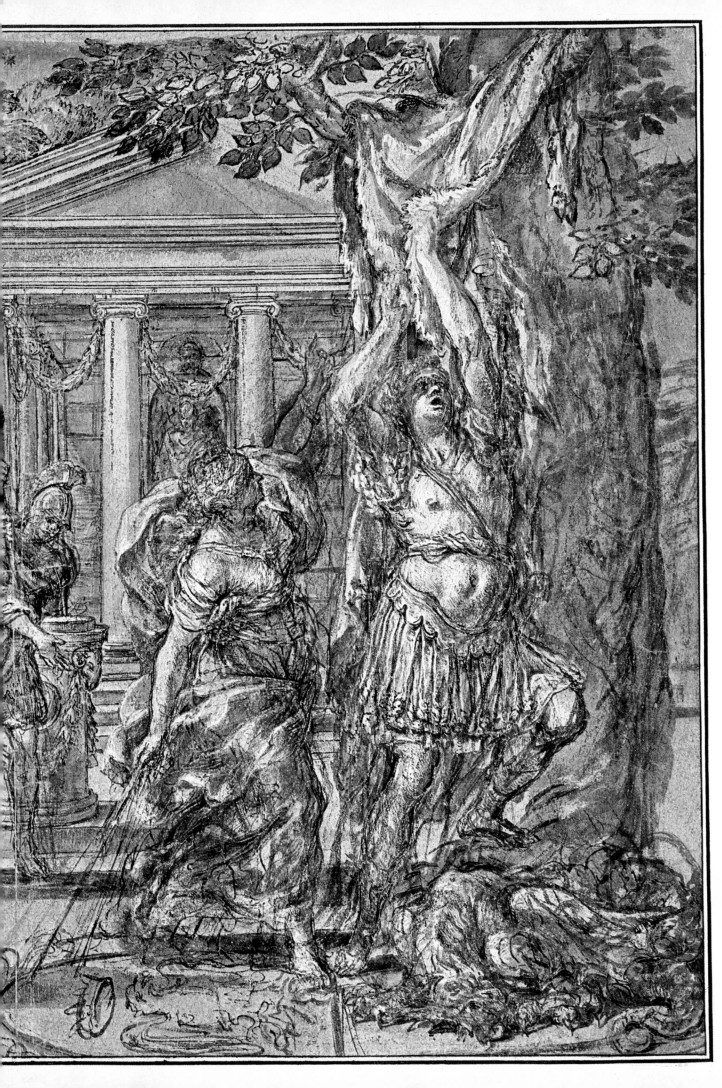

**Pietro da Cortona
(Pietro Berrettini)**
Cortona 1596 - Rome 1669

Jason and the Golden Fleece.
London, British Museum, no. 1941.
11.8.16. Charcoal, pen, watercolor,
and white-lead highlights ;
16 × 21⅜ in. (39.9 × 53.4 cm).

Bibliography : Briganti, 1962, p. 305.

Jason, the leader of the heroic band
of the *Argo* (the boat seen at the far
left), has finally found the Golden
Fleece in a great tree guarded by a
dragon (far right). The giant serpent has
been lulled to sleep by a potion from
Jason's bride, the sorceress Medea,
who is seen standing to the left. Apollo,
shown playing his viol at the far left
of the scene, may also have helped
soothe the fearful guardian of the
Fleece. Drawn about 1630, this work
was later dedicated in print form to
Cardinal Mazarin in a publication of
the Abbé Le Bouthillier in 1658. The
arms displayed at Medea's feet in the
drawing — belonging to a Borghese
cardinal — were replaced with Maza-
rin's emblem in the print, by the en-
graver Charles Audran. This is one
of Pietro da Cortona's most highly
finished graphic works, elaborately
detailed to guide the printmaker's hand.

8-9

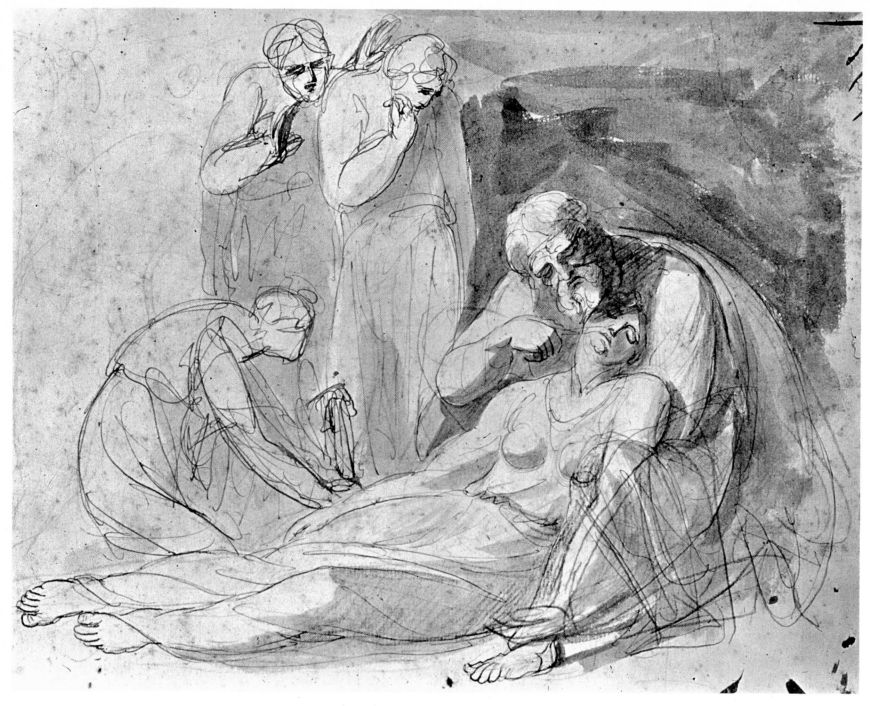

George Romney
*Dalton-in-Furness (Lancashire) 1734 -
Kendal (Westmorland) 1802*

10

**Lear Mourning the Dead Corde-
lia,** 1775 - 1777.
Washington, D.C., Folger Shakespeare
Library. Charcoal, pen and ink, with
gouache ; 12 × 16 in. (30 × 40 cm).

Bibliography : P. M. Henderson,
George Romney, Milan/London, 1966,
Pl. IV.

Michelangelesque in its drama, recalling
the fiery fresco of the Pauline Chapel,
Romney's gripping study of Shake-
speare's Lear shows the old king
poignantly embracing the dead body of
his beloved daughter Cordelia in *Pietà*-
like fashion. Although his major source
is Michelangelo, Rommey has turned to
other sixteenth century masters for the
group of figures on the left, which stem
from delicate aspects of Mannerism.
In Romney's day, England was
flooded with the greatest drawings of
the Renaissance — thus making it
almost too easy for the artist to adapt
motifs from the past, instead of giving
himself the opportunity to work out
his themes more independently.

In the late eighteenth and early
nineteenth century Shakespeare rose to
new heights of popularity, after a
period of decline during the reign of the
more "modern" Restoration drama,
when the great Elizabethan dramatist's
works were found somewhat crude and
distastefully larger-than-life. Romney's
and succeeding generations reveled in
the proto-Rodinesque splendor and
intensity suggested by the Bard's
magisterial repertoire, as seen in this
passionate sketch.

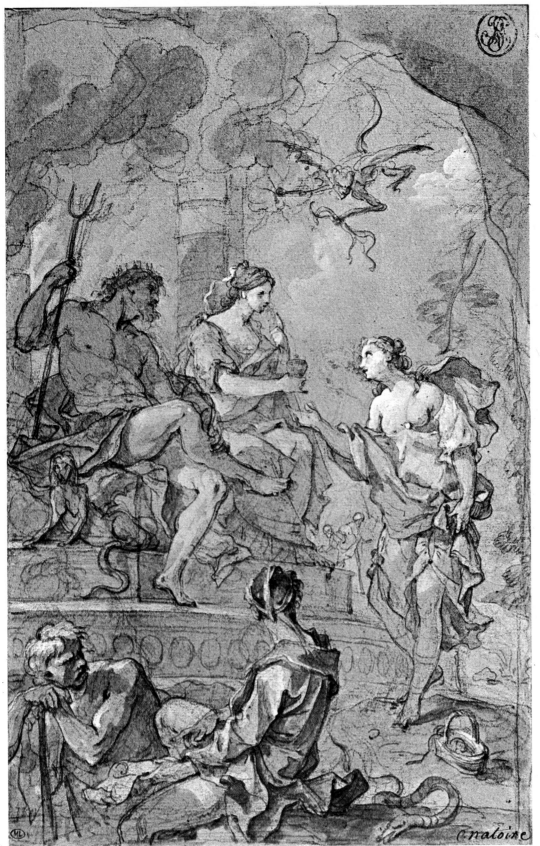

Charles Natoire
Nimes 1700 - Castel Gandolfo 1777

Psyche in the Underworld.
Louvre, Cabinet des Dessins, no. 31 416.
Black crayon, brown wash, with white
lead highlights, on blue paper ;
12¾ × 8⅓ in. (32.8 × 21.3 cm).
Provence : Chateau d'Orsay.

Bibliography : Boyer, 1949, n. 480, p. 88.

An unrealised project for the oval saloon
of the Hôtel Soubise, Paris, which
Natoire was requested to make for the
architect, Boffrand, between 1737 and
1739. The subject was taken from the
" Story of Psyche ", and shows Psyche in
the underworld, standing before Pluto
and Proserpine, and pleading for the elixir
of beauty demanded by Venus. Boyer
catalogues another three studies of this
subject. The drawing is signed in ink on
the right : *C. Natoire.*

11

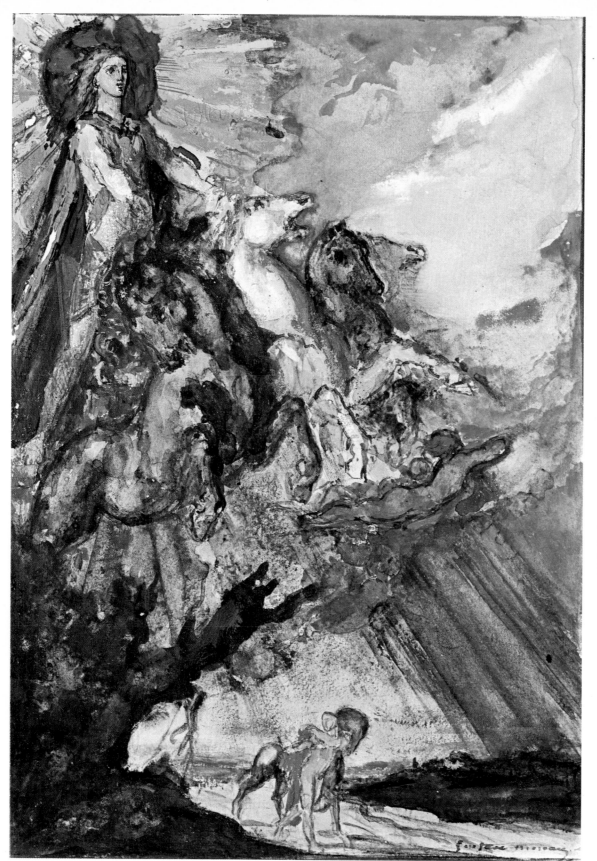

Gustave Moreau
Paris 1826 - 1898

Apollo.
Paris, Musée Gustave Moreau, Cat. no. 482. Watercolor with white-lead heightening over traces of black chalk and black ink, on gray-blue paper ; 12 × 8½ in. (29.9 × 21.1 cm). Signed at the lower right : *"gustave moreau."*

A resplendent Apollo, with golden rays streaming from his head like a halo, rides across the sky in the sun chariot. Moreau prepared this radiant watercolor as one of sixty-three illustrations for the *Fables* of La Fontaine, commissioned by Antony Roux about 1880. Here the sun-god challenges the wind-god Boreas to a contest involving the smaller-scale horseman seen below. Apollo, of course, wins. Redon's art affords a last rich pre-Freudian mystic symbolism, an uninhibited abandon to a fiercely androgynous world, without the prurient self-consciousness and tiresome anti-quarianism that tends to confuse so many of his contemporaries' works. As with much of Delacroix's *œuvre,* there is an implication of *Gesamtkunstwerk* in his follower Moreau's as well — incorporating all the arts, musical as well as visual. One can almost hear a sonorous poetic text spoken against the sensual, elusive sound of Fauré-like organ music as clouds of incense and heady perfumes scent the air.

12

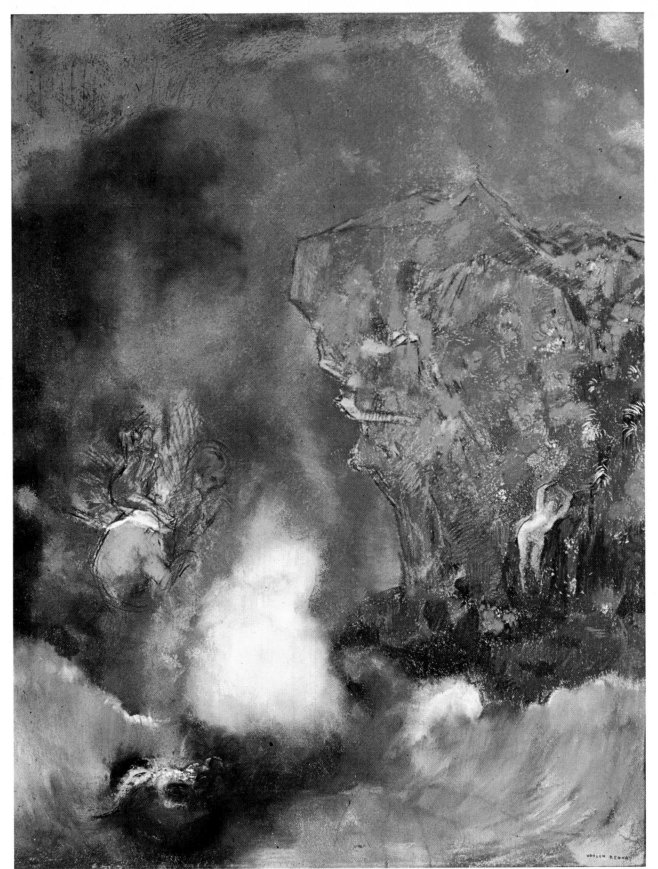

Odilon Redon
Bordeaux 1840 - Paris 1916

Roger and Angelica, c. 1910.
New York, Museum of Modern Art
(Gift of Lillie P. Bliss). Pastel on paper
laid over canvas ; 36½ × 28 in.
(91.2 × 69.8 cm). Signed in lower-
right corner : *"Odilon Redon"*.

Bibliography : *Odilon Redon, Gustave
Moreau, Rodolphe Bresdin,* 1962,
pp. 43, 84.

Angelica, Queen of Cathay, was res-
cued by the Saracen knight Roger from
her bondage on the Irish shore, cap-
tive of the detestable bird Orc. Riding
his hippogriff, Roger is seen vanquish-
ing Orc, shown faintly at the lower left.
Romances of the time of Charlemagne,
which had long been popular, were
drawn upon by Redon for his fabulous,
evocatively hued rendering of Angelica's
deliverance. The skull-like cliff and
turbulent waters breathe a spirit of
mystical agony and virtuous conquest.
The smoldering pastels suggest a world
of content beyond the nebulous forms,
an almost hallucinatory and endless
metamorphosis that looks forward to
the richly abstract but equally gripping
fantasies of Kandinsky and the best of
the Abstract Expressionists. It is fitting
that Redon, a consummate master of
black-and-white in his incomparable
lithographs and pastels, there limited to
two " colors ", should reveal an unpa-
ralleled mastery of subtle gradation in
his use of the total palette.

13

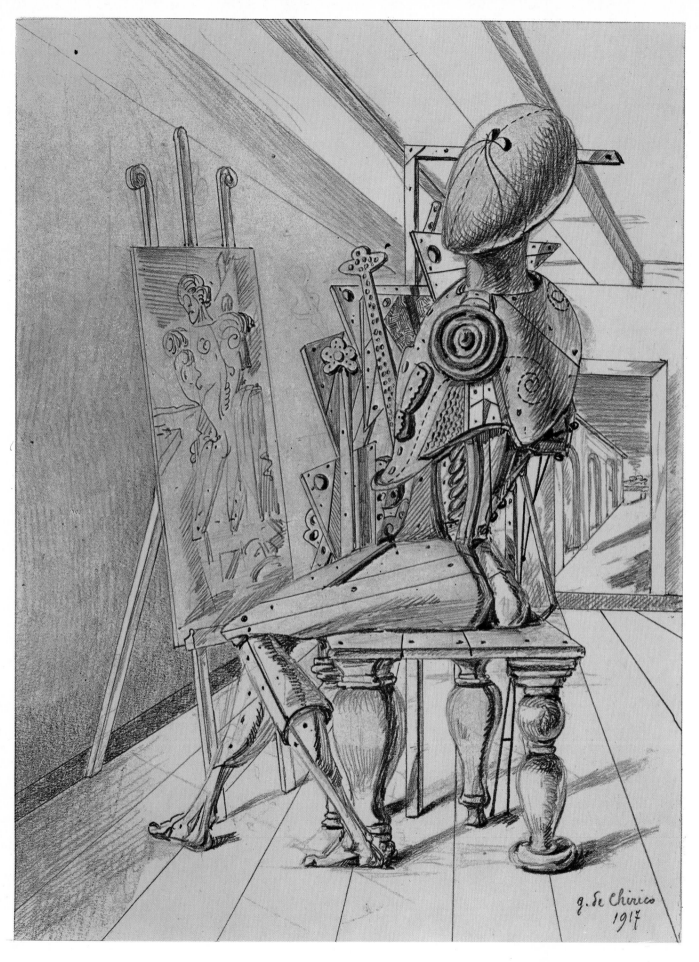

Giorgio de Chirico
Volos (Greece) 1888 -

The Mannequin Artist, 1917.
Milan, Private collection. Pencil and
black chalk. Signed and dated at lower
right: *"G. de Chirico 1917."*

Artist becoming mannequin becoming,
in turn, painter working on a self-
portrait. This wryly cyclical metamor-
phosis is rationalized through image
realization, or realized through image
rationalization. Surrealism, in the hands
of this Italian Metaphysical painter,
dissolves the barriers between and fuses
the possible and the impossible through
its assured command of both poetic
imagination and artful illusionism. De
Chirico may be pointing out how all
art starts and ends with its creator's
sense of self, regardless of his subject.
Strange juxtapositions and plunging,
contradictory perspectives create an
airless and disquieting ambience for
this artist's model model-artist.

14

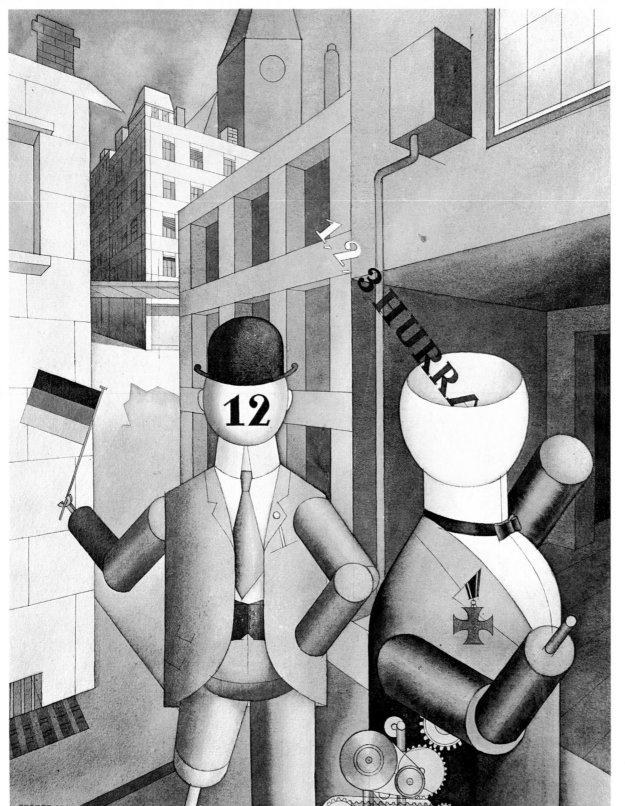

George Grosz
Berlin 1893 - 1959

Republican Automatons, 1920.
New York, Museum of Modern Art,
Acc. no. 120.46 (Purchase, Advisory
Committee Fund). Watercolor ;
23⅝ × 18⅝ in. (59.1 × 46.6 cm).
Signed with signature stamp.

Provenance : Coll. Dr. William Landman.

Bibliography : G. Grosz, *A Little Yes
and a Big No : The Autobiography of
George Grosz,* New York, 1946 (with
original illustrations by the author) ;
H. Bittner (ed.), *George Grosz,*
New York, 1960, p. 47, no. 30.

Grosz' sterile cityscape, with remini-
scences of De Chirico's Metaphysical
canvases in its neatly angular, vaguely
classical vista, is populated by a pair of
faceless veterans of World War I, two
maimed survivors of the Wunderwerk-
schaft. Here, restored to bourgeois pros-
perity, if not quite to humanity, they
continue to wave the flag of German
nationalism and assume a belligerent
fencer's stance, seeming only too ready
to have history repeat itself. Literally
empty-headed in Grosz' sarcastic render-
ing, these "republican" automatons
with gears for vital organs can only be
activated by regimental cheers. The
emblematic Iron Crosses and flags are
more individual than their mindless,
heartless wearers. In keeping with this
anonymous, mechanized theme, Grosz'
name is deliberately stamped, not hand-
signed, in blocky letters like those
issuing slogan-like from one robot's
perfectly spheroid but empty skull. Their
impersonal modular forms are close to
the austere aesthetic of the Bauhaus
and Léger, as well as the schematic
figures of Oskar Schlemmer. Here a
Cubist infatuation with numbers and
pure geometric definition is applied to
caricatural antimilitaristic ends. Robot-
like in style as in theme, this drawing
suggests a programmed construction
by compass and ruler, as predetermined
by a geometric dictatorship without
human recourse as are the depressing
"lives" it delineates.

15

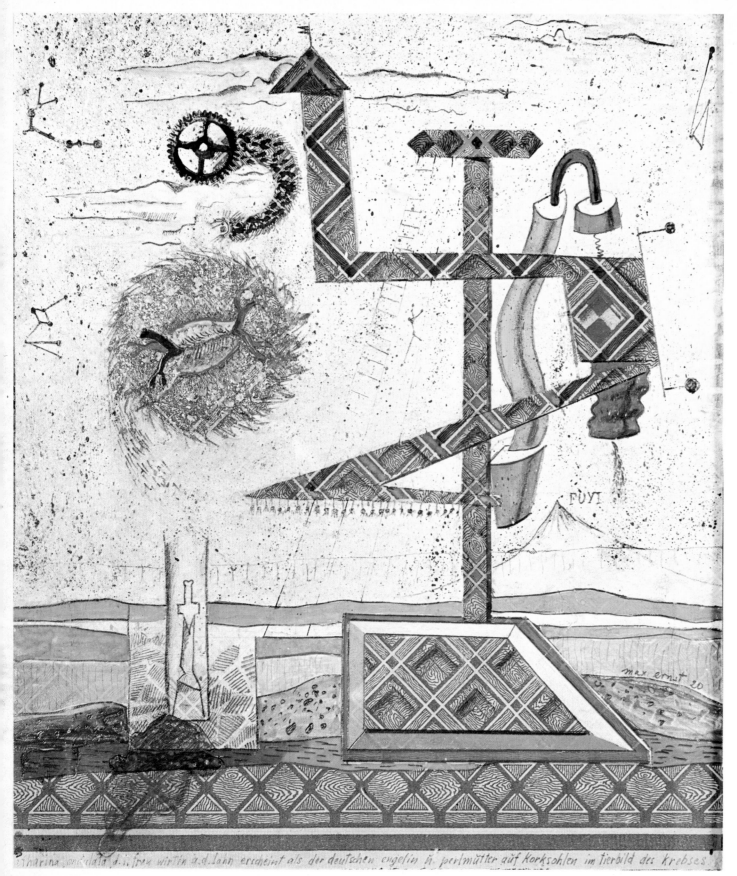

Max Ernst
Brühl (near Cologne) 1891 -

Katharina Ondulata, 1920.
London, Coll. Sir Roland Penrose.
Gouache and pencil, with printed wallpaper ; 12 × 10 in. (30 × 24.8 cm).
Signed and dated at lower right : *"max ernst 20".* Inscribed at bottom :
"Katharina ondulata d.i. frau wirtin a.d. lahn erscheint als der deutschen engelin n, perlmutter auf Korkschlen im tierbild des Krebses." ("Undulating Katherine is the tavernkeeper on the Lahn appearing as the German angel of mother-of-pearl on cork soles under the Sign of Cancer.")

Bibliography : J. Russell, *Max Ernst,*
New York, 1967, p.

Dada's perpetual sexual labyrinth, suspended on and terminated by universal symbols of male and female, is explored by the greatest master of that movement in a characteristically intricate, erotic voyage. Ernst charts the erogenous terrain of earth (a sketchy contour labeled "Fuyi" — Mount Fuji) and heaven (the Sign of Cancer), with a swastika-like phallic automaton signaling between, and joining, the two. Patches of wallpaper provide a stabilizing, prosaic element of *collage,* a note of down-to-earthness in this fantasy landscape of profoundly cosmic carnal knowledge.

16

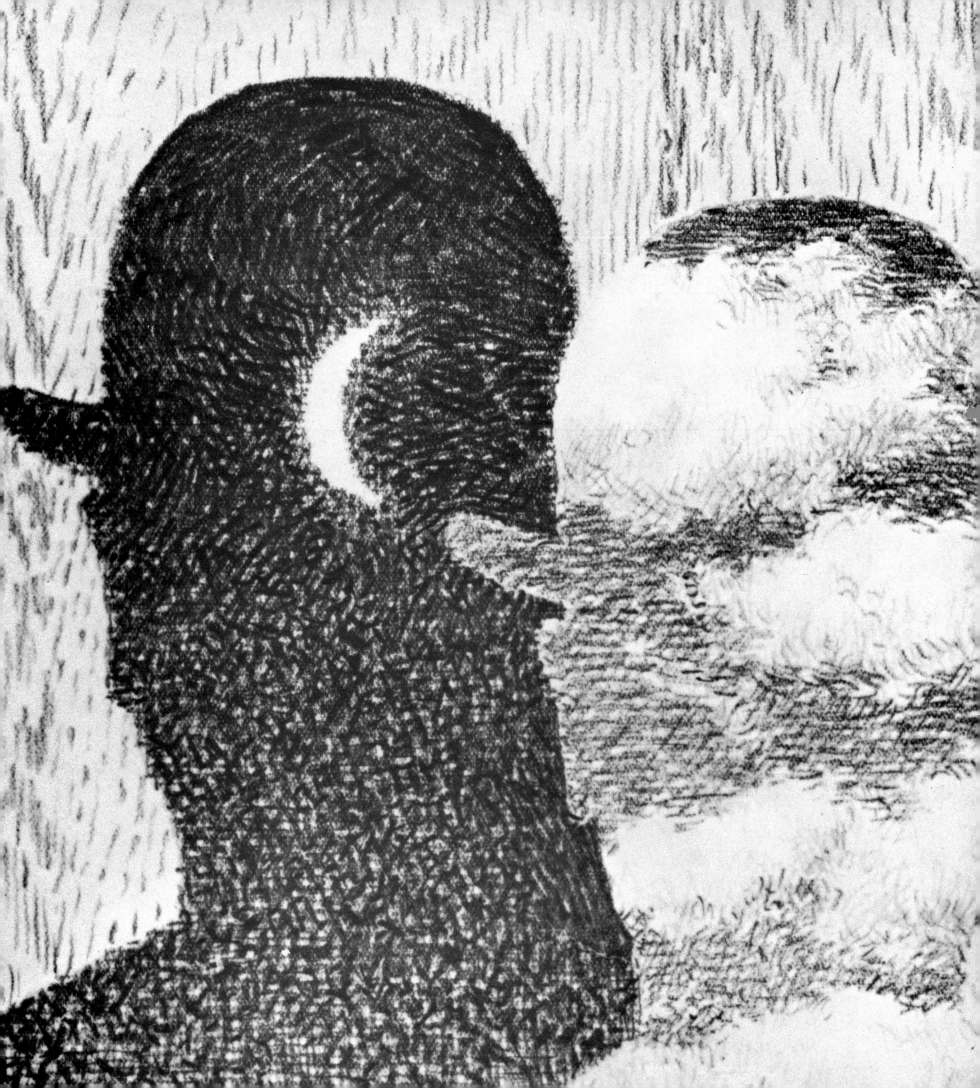

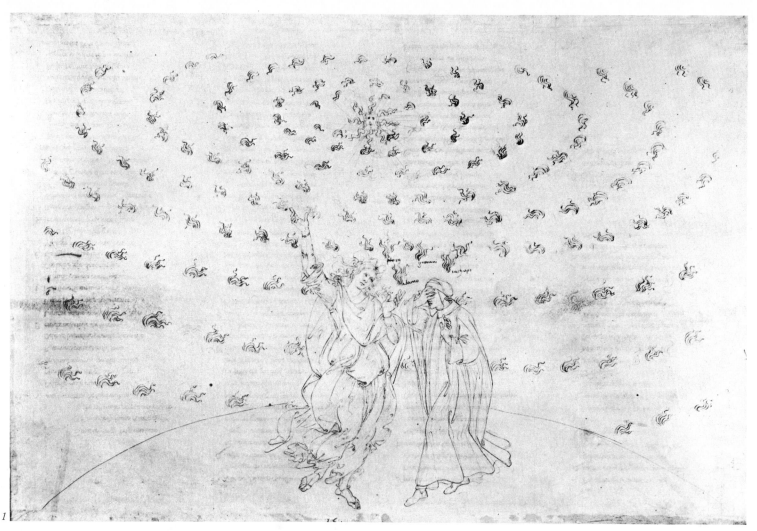

Sandro Botticelli (Alessandro di Mariano Filipepi) F. 1
Florence 1445 - 1510

Dante and Beatrice (illustration for the "Divine Comedy", Paradiso, Canto XXVI), c. 1490 - 1500.
East Berlin, Staatliche Museen. Silverpoint and lead pencil on parchment ; 12 ¾ × 18 ¾ in. (32 × 47 cm).

Leonardo da Vinci F. 2
Vinci 1452 - Amboise 1519

Marine God in Chariot Drawn by Seahorses, 1503 - 1504.
Windsor, Royal Library, no. 12570 (by permission of Her Majesty Queen Elizabeth II). Black chalk on white paper ; 10 × 15 ¾ in. (25.1 × 39.2 cm).

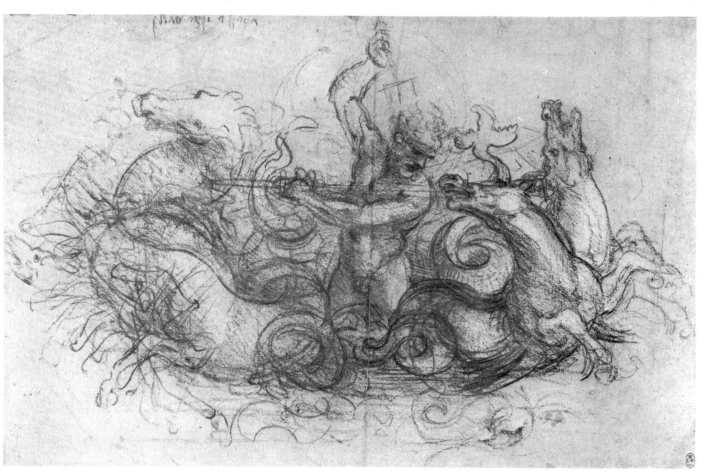

Correggio F. 3
(Antonio Allegri)
Correggio c. 1489 - 1534

Allegory of Vice,
c. 1532 - 1533
London, British Museum,
no. 1895.9.736. Red
chalk ; 11 × 7 ¾ in.
(27.4 × 19.4 cm).

Luis Paret y Alcazar
Madrid 1746 - 1799 F. 4

The Glory of Anacreon,
c. 1770
Madrid, Biblioteca Nacional,
no. 1421. Pen and ink on
yellowish paper ;
17 ¾ × 14 ⅜ in.
(44.4 × 35.9 cm).

Pierre Brebiette F. 5
*Mantes (Seine-et-Oise) 1598 -
c. 1650*

**The Mourning of
Phaeton.**
Paris, Musée du Louvre,
Inv. no. 25048. Red chalk ;
9 ½ × 7 ¼ in.
(23.5 × 18.3 cm).

Henrick Goltzius F. 6
*Mühlbrecht (Venlo) 1558 -
Haarlem 1616*

**Bacchus, Venus, and
Ceres, with Self-portrait
of the Artist,** 1604.
Leningrad, The Hermitage,
no. 18983. Pen, brush, and
bister on tinted canvas ;
91 ¼ × 68 in.
(228 × 170 cm).

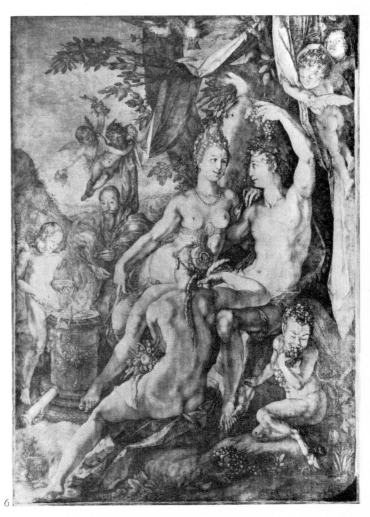

Gian Antonio Guardi ▪ F. 7

Vienna 1699 - Venice 1760

The Triumph of Martial Virtue.
Venice, Museo Civico, no. 8221.
Black chalk, pen and brush, with sepia
ink ; 11 ½ × 16 ¼ in.
(28.7 × 40.8 cm).

Peter Paul Rubens F. 8

*Siegen (Westphalia) 1577 -
Antwerp 1640*

The Death of Hippolytus, 1608 -
1612.
Bayonne, Musée Bonnat, no. 1441.
Pen and India ink, with wash, on two
sheets ; 8 ¾ × 12 ¾ in.
22 × 32.1 cm).

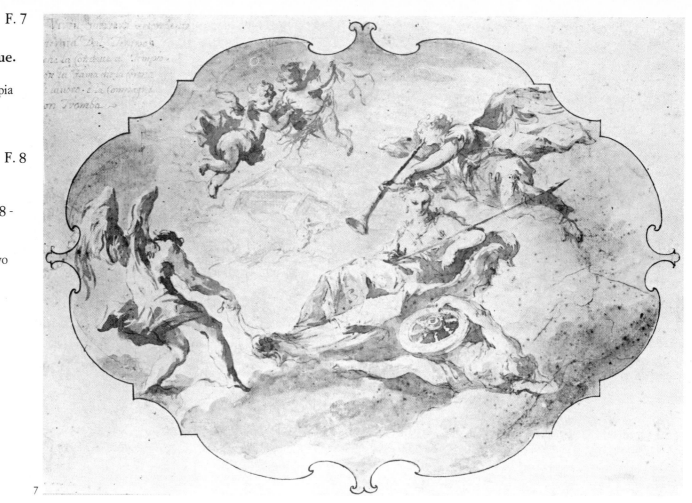

7

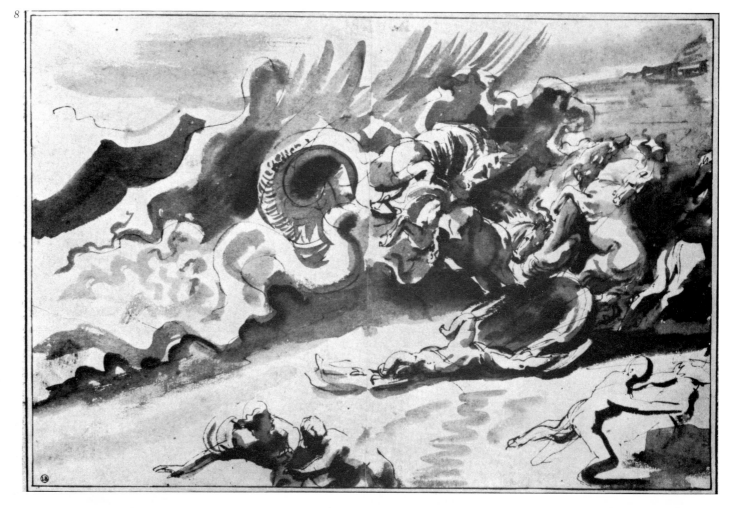

8

Dante Gabriel Rossetti F. 9
London 1828 - Birchington 1882

Lancelot's Vision of the Holy Grail (study for cycle of wall paintings, Oxford Union Library), c. 1857.
Birmingham (Eng.), City Museum and Art Gallery, no. 272.04. Pencil, pen and brown ink ; 9 ½ × 7 in. (23.8 × 17.5 cm).

Henry Fuseli F. 10
(Johann Heinrich Füssli)
Zurich 1741 - Putney Hill (Eng.) 1825

Brunhilde Contemplating Gunther, Hung from the Ceiling in Chains (illustration for the *Nibelungenlied*), X, 648-650, 1807.
Nottingham, City Museum and Art Gallery, no. 90.133. Pencil, pen and ink, with sepia wash ; 19 ¼ × 12 ¾ in. (48.3 × 31.7 cm).

George Romney F. 11
Dalton-in-Furness (Lancashire) 1734 - Kendal (Westmorland) 1802
The Origins of Painting.
Princeton (N. J.), Princeton University Art Museum, Acc. no. 47.28. Ink and wash ; 20 ¾ × 12 ¾ in. (52 × 32 cm).

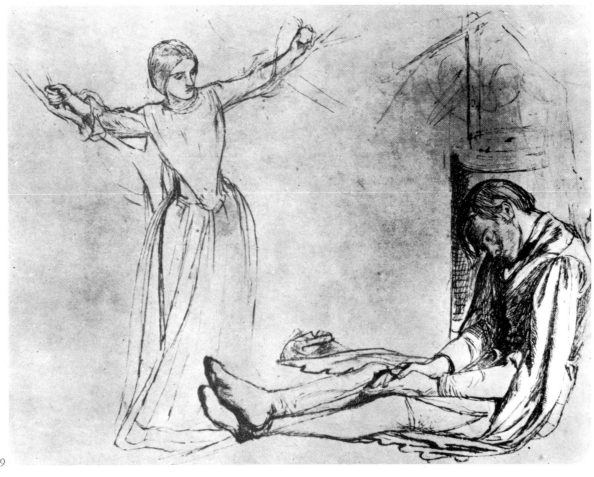

9

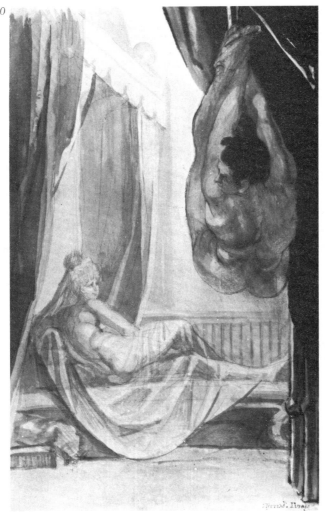

10

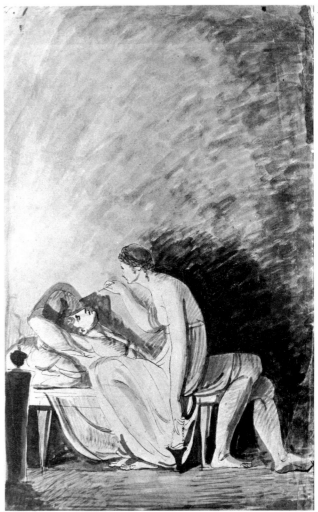

11

David Humbert de Superville
The Hague 1770 - Leiden 1849

The Flood. F. 12
Leiden, University of Leiden Prentenkabinet. Watercolor ;
26 ¾ × 40 ¼ in. (66.9 × 100.6 cm).

William Blake F. 13
London 1757 - 1827

The Ghost of a Flea.
London, Tate Gallery. Pencil ;
7 ⅜ × 6 ⅜ in. (18.5 × 15.9 cm).

Victor Hugo F. 14
Besançon 1802 - Paris 1885

The Dream.
Paris, Musée Victor Hugo. Pen and
black ink, with black wash ;
11 × 6 ½ in. (27.3 × 16.4 cm).

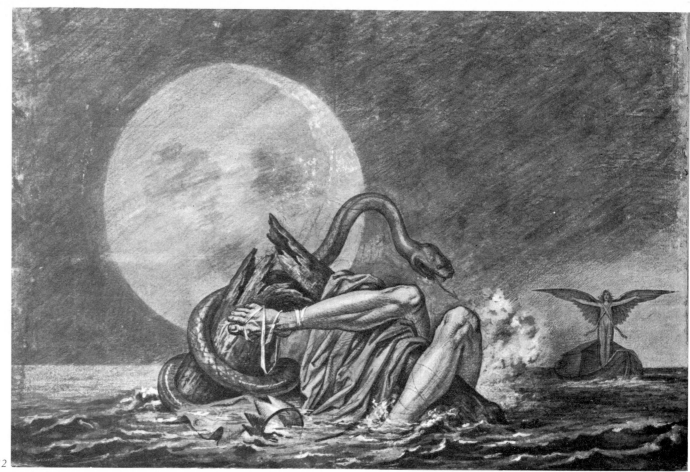

12

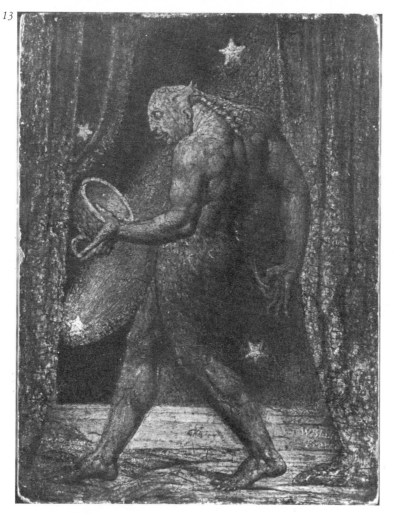

13

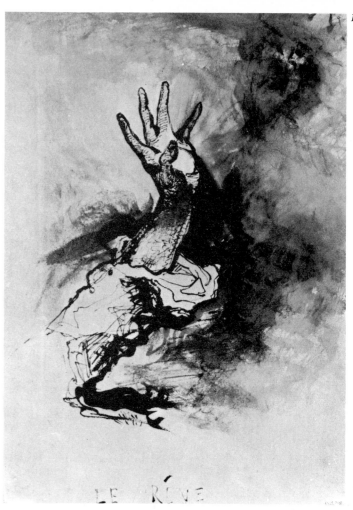

14

Yves Tanguy F. 17
Paris 1900 - Woodbury (Conn.)
1955

Joan Miró
Montroig (Catalonia) 1893

Max Morise
Kirchbichl (Austria) 1921

Man Ray
Philadelphia 1890

Cadavre Exquis (composite figure drawing), 1926 - 1927.
New York, Museum of Modern Art, Acc. no. 260.35. Color crayon, pencil, pen and ink ;
14 1/4 × 9 in. (35.6 × 22.5 cm).

René Magritte F. 18
Lessines (Belg.) 1898 -
Brussels 1967

The Thought Which Sees,
1965.
New York, Museum of Modern Art (gift of Mr. and Mrs. Charles B. Benenson), Acc. no. 261.66. Graphite ;
15 3/4 × 11 3/4 in.
(39.5 × 29.5 cm).
16

Pablo Picasso F. 15
Málaga 1881 - Mougins 1973

Composition, 1933.
Formerly collection of the artist.
India ink ; 16 × 20 1/4 in.
(40.2 × 50.6 cm).

Roberto Sebastian Matta Echaurren F. 16 17
Santiago (Chile) 1912

Composition.
Bergamo, Coll. Davide Cugini.
Pastel ; 26 1/2 × 20 in.
(66 × 50 cm).
15

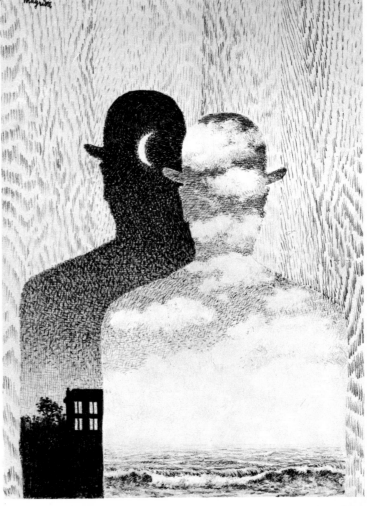

18

Religious Subjects

Courbet is said to have said, "Show me an angel and I'll paint one." The medieval artist, less limited to and by the literal approach, accepted his major role as that of realizing the Gospel—turning word into image. His patron saint, the Evangelist Luke, was thought of as a painter and a gifted, vivid draughtsman who essayed even the likeness of the Virgin. Luke was often portrayed in this role in painted panels to be set up on guild altars; in these scenes, Mary appears before the saintly artist as a placid model or heavenly vision, posing patiently as an angel guides Luke's stylus, so that the silverpoint drawing may be a work not only of divine inspiration but also of divine fabrication. Delineating religious subjects was itself an act of devotion, an endeavor to externalize Holy Writ—faith made manifest.

Christianity was first drawn out on the walls of the Roman catacombs, in sixty-mile-long subterranean funerary art galleries of divine truth, where at least half a million tombs have been excavated. Sketched in coarse lines, usually in red or orange and black (very like the purplish *sinopie* beneath fourteenth-century frescoes, meant to guide the painter in his work), these schematic drawings laid out a system of faith for this world and the next. Often combining classical and Christian motifs in a manner replete with abbreviation, these drawings reduced the architectural splendor and richly evolved imagery of Roman tradition to scant yet pungent lines.

After having first visualized the Word, the draughtsman also accompanied it in the religious comic strips of the late Middle Ages known as "Bibles of the Poor." Directed toward a semiliterate audience, these books of copious, rather coarse drawings presented the sacred text in a direct, unforgettable fashion. Their narrative was set forth in a crude but effective journalistic mode, drawn in a style of graphic economy. Dependent upon newly available supplies of cheap paper, these fifteenth-century works were a prelude to the elaborately illustrated printed publications of the sixteenth century and succeeded the medieval courtly tradition of richly hand-illuminated texts, most stirringly exemplified in the Utrecht Psalter. In this Carolingian masterwork the artist's drawings trace the imagery of each of David's songs with such spontaneity that the myriad short brushstrokes constituting the forms seem magnetized by some force beyond both themselves and human control, as if delineating the images with earthly ink but through an exercise of divine will.

Jan van Eyck's infinite patience for microscopic vision and his genius for making it larger than life characterize his drawings as well as paintings. In his drawing of Saint Barbara, the patroness of builders is seated demurely and reflectively before her identifying tower (symbol of her martyrdom as well as of the Church itself) and is rendered in thousands of pen strokes. The landscape background and tower seem almost infested with insect-like masons and laborers. The artist draws in color toward evolving form, and his restraint of size and palette works inversely to take on the miraculous aura of an icon.

Just as the Quattrocento arrived at the astonishingly refined, illusionistic *sfumato* technique of Leonardo, in drawing that had become a smoky blending from which form arose like a mystical revelation, some of his most gifted contemporaries rejected this subtly modeled *chiaroscuro* in favor of rigorously pure line. Botticelli elected to illustrate Dante's visions in the *Divine Comedy* in line as austere as fine handwriting. Only the graphic combination of profiles and contours makes recognition possible in this scarcely drawn, most spiritual of all worlds.

Religious Subjects

Sixteenth-century religious thought and art was divided between the public and the private, between public piety and personal devotion. Just when the vision of the Church had been realized with unrivaled splendor in the art of the High Renaissance, European unity of religious faith was forever broken by the newly emergent Protestant conscience. The harmony of man in his world had already been dealt a mortal blow by Michelangelo's perspective, in which man's body could be counted upon to reflect each and every aspect of divine Creation. Isolating corporeality and advancing it as a metaphor for all grace, the sculptor-painter led generations of artists to convey divine sentiment through the body alone, sometimes shown in moods and movements of anxiety, as if this troubled mortal vessel could never encompass the heavenly message. Such isolation of man from materialist fetters worked well with Counter-Reformation spiritual tenets, that dogmatic return of the Church to the most rigorous "old-time religion" and art in order to combat the new Northern fundamentalism.

Aspects of Andrea del Sarto's art in Florence, along with that of Pontormo and Bronzino, of Perino del Vaga and Salviati in Rome and Genoa, and of Rosso and Primaticcio at Fontainebleau, all dedicate their fine-spun line and sinuous contours to the new Mannerist introspection. This often encompassed the profane as well as the sacred in the curiously intellectual, pessimistic way in which even the most libidinous subjects were rendered.

Northern draughtsmen were rarely severed from medieval cosmology completely. They could not, or would not, isolate themselves from nature as a work of the Lord and an image of divine revelation. Even at their most abstract, such sixteenth-century limners as Étienne Delaune or Antoine Caron could not resist reference to organic growth, to plant and vegetal energy informing their most academically Italian exercises. Protestant art leaned toward that of the schoolroom, relentlessly didactic and a little dry. Moral lessons drawn from daily life brought welcome dashes of keen observation, as well as humanly bad and good humor, to "This Is Your Life" and "It Better Be Good."

With the burgeoning of the Jesuit Order, Catholic religious art assumed a new, enlightened worldliness and naturalism. Propaganda Fide led to a new missionary concept in which almost anything, including "show biz" and ethnology, was given license in the quest for salvation.

A new ecstatic graphism of trembling lines and blots, of whiplash calligraphy, with an impetuosity and immediacy almost like spirit-writing, swept through Western European devotional and other draughtsmanship. It was shared by Ribera, Salvator Rosa, and Strozzi, by Rembrandt and Van Dyck. The Venetians, never trapped by the restrictions of theory, already enjoyed the benefits of this spontaneity in the sixteenth century, as seen in Veronese's small brown-ink studies and in Tintoretto's rushing line and mysterious light transcribing nature into art on every level. Religious works of the Baroque, so often mistakenly associated exclusively with huge Rubensian machines decorating the Church of the Jesuits in Antwerp or the earlier and still more revolutionary effect of the Gesù in Rome, also operated on a miniature scale. In tiny projects designed for the printmaker, ant-like figures populate the lives of martyrs—a Passion drawn by and on a metaphorical pin.

Rubens and Rembrandt are the two sides of the Baroque coin: one Catholic, the other Protestant; the first oriented to classical Italy, the second turned toward a

Religious Subjects

native heritage of realism (though deeply admiring the South). Rubens, the elder, still recalled the Mannerist experience; the younger Rembrandt moved toward a more personal, objective style. They provided the twin bases for the art, especially the religious art, of the eighteenth century, because their *oeuvres* were so huge and well known throughout the West. Northern Catholic commissions for ecclesiastical art dwindled, since so much had already been built and decorated in the seventeenth century. Moreover, the Academy was especially interested in the Old Testament and assigned the most *recherché* subjects—some never before illustrated in the long history of religious art.

Religious themes abound in the eighteenth-century art of Italy, Spain, and southern Germany. These areas shared the new Rococo style, with its vocabulary of perpetual change. Such metamorphosis was ideally suited to the devotional repertoire and experience of Incarnation, Resurrection, Ascension, and Assumption, accompanied by a heavenly chorus of angelic singers or avengers in an endless traffic between heaven, earth, and hell. Never before did rebellious angels have so far to fall, or beatific spirits such a deliciously cloud-cushioned rise, as they did in the century which invented upholstery. Colored papers, myriad pastels, new use of watercolors, and the effect of the *trois-crayons* technique enlivened the works turned out by Rococo draughtsmen, in a divinely inspired visual litany of the seemingly endless varieties of spiritual experience.

Mystical communion between religion and nature, the manifestation of the art of God in his earthly creation, was common to the spirit of much early-nineteenth-century art, reflecting the pervasive new transcendentalism. Goethe's penciled skies, Ruskin's leaf in the rock, and Turner's luminous mountains, none overtly religious in intent, share a sense of revelation in reality, of an informing spirit in all nature.

The German Romantic religious imagery of the Nazarenes led to the modestly inspired art of Schnorr von Carolsfeld, with its dim but reverent echoes of the art of the fifteenth century. Much French academic religious art in the nineteenth century—whether by Ingres or Bouguereau—was so profoundly, if unknowingly, dedicated to materialism that it now proves theologically embarrassing and artistically absurd.

Most later nineteenth-century religious art is either forward or backward in style and spirit; whether forward-looking or rear-guard, it anticipates or reiterates the worst features of either tendency. Manet's infrequent Christian images seem like gutless Velázquez; Eakins' *Crucifixion*, some rejected flat for De Mille's *King of Kings*. Trapped between conflicting tides of neo-orthodoxy and New Objectivity, there was nowhere for religious art to go. Obsessed with the literal under the impact of the first photographic age, artists found religious imagery hard going and were defeated by their misguided desire to "document" the miraculous. Often these artists offer excessive assurance of their own faith in drawings more illuminated by the flashbulb than by the Light of the World. It is mystics such as Gustave Moreau and Odilon Redon, rather than academicians, who capture religious feeling and a sense of awe in their works.

Eroticism—through its affirmation or denial—always plays a lively role in religious thought, pulsating in the art of the Pre-Raphaelites and only a little less apparent in that of the Symbolists. The Italo-English movement of painter-poets enjoyed a built-in *ut pictura poesis*, redrawing the Bible in a graphic style recalling the

Religious Subjects

fifteenth century, infusing the Passion with their own, abounding in drug-ridden, artistically fertile morbidity. The Symbolists seized upon Delilah, Herodias, and Salome and on suffering saints such as Sebastian, Anthony, and Cecilia: tempted and tempting, swirling within octopus-like strands of desire, martyr and torturer both victims alike, all preying. Redon evolved the richest *chiaroscuro* ever known. In his pastels and lithographs, the full range of black, blacker, blackest assumed new graphic dimensions of expressivity.

Eccentrics such as Elihu Vedder in the United States or Thorn Prikker in the Netherlands, totally committed to their own visions of the divine, produced drawings more convincing of the depth and immediacy of religious experience than could many of their more avowedly orthodox contemporaries. Van Gogh, himself a minister but rarely drawn to conventional religious subjects, imbued his *oeuvre* with a constant sense of divine wonder. His very blackest scenes suggest a special comprehension of enlightenment withheld. The Dutch painter's friend Gauguin and his fellow artists at Pont-Aven, the Nabis, crucified Christ in Brittany and depicted a Magdalen who brought to mind nothing so much as a goose girl whose beauty had gone to her empty head.

New currents of experimental art allowed a resurgence of convincing devotional subjects. Expressionism, with its emotionally charged content of medieval force and austerity, provided a powerful sense of the passion and glory of faith in drawings by Kirchner, Schmitt-Rottluff, and Rouault. The Surrealist imagination, profoundly concerned with change, also allowed for a drawing with a highly efficacious sense of religious experience. Sheer acts of will seem to change the very fiber of being in the drawings of Ernst, Magritte, and Dalí and to realize the miracle in process.

The magical aspect of the Passion was realized with characteristic perspicacity by Picasso in a drawing of the Crucifixion he kept in his own collection till his death. Picasso's rendering of Calvary reduces all participants, human and divine, to skeletal form, re-creating the Biblical event as a kind of paleontological happening.

The experience of Jewish life in Eastern Europe, hovering between the spiritual and communal planes and stimulated by forced exclusion from the general society, was eloquently delineated by the young Marc Chagall. Unlike his later works, which exude a more commercial sanctity, these early religious drawings of Chagall are stirring in their quiet, wondering warmth and modesty, showing a touching, Arcadian dream of daily life with direct pipelines to Heaven.

The twentieth-century draughtsman closest to a vein of mystical revelation is Paul Klee, master of his own theology. This Swiss artist not only drew his own angelic messengers but seems to have told them what to say as well. Both evangelist and artist, he has spun out delicate lines of personal revelation, tightropes for angelic acrobatics in this newest testament of salvation.

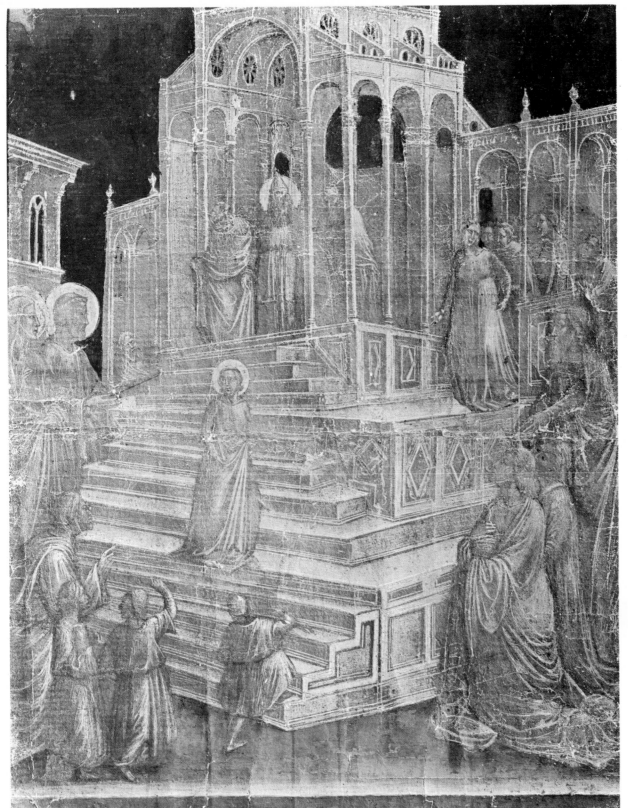

Taddeo Gaddi
Florence c. 1300 - 1366

The Presentation of the Virgin.
Paris, Musée du Louvre, Inv. no. 1222.
Brush, black and green-blue water-color, heightened with white on prepared green paper, with touches of gold on haloes and traces of sketching with a stylus; 14½ × 11⅜ in. (36.4 × 28.3 cm).

Provenance: Coll. Baldinucci.

Bibliography: Berenson, 1938, no. 758; Oertel, 1939-40, V, pp. 236-239; Bacou-Bean, 1959, no. 1; Degenhart-Schmitt, 1968, no. 22.

Perhaps the first drawing on paper securely attributable to the circle of a major Italian master, this study may have been done after, rather than preparatory to, the Baroncelli Chapel frescoes in the Church of Santa Croce in Florence, which were begun in 1332. Based on the work of Giotto's closest follower, *The Presentation* suggests relief sculpture rather than painting in effect, with its emphasis on a prismatic definition of form through manipulation of light. Such highly finished drawings of so early a date — works that cannot be confused with manuscript illuminations — are extremely rare. Whether it was prepared as a patron's spiritual memento or as the artist's working "account" of a major achievement, *The Presentation* affords a uniquely detailed insight into Trecento art.

1

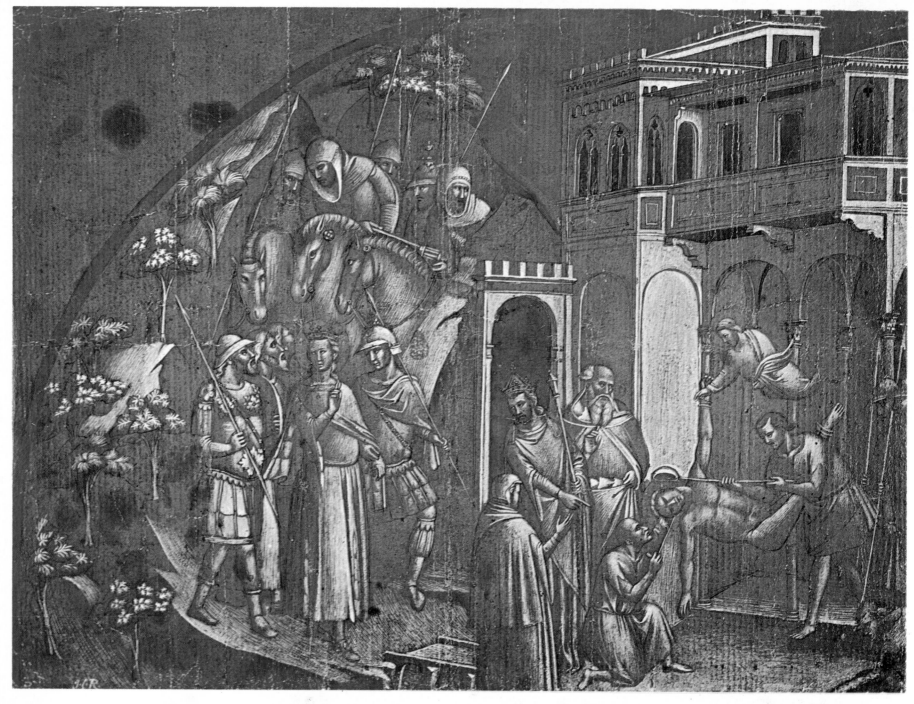

Master of the circle of Orcagna
Active in Florence c. 1350 - 1375

2

The Martyrdom of St. Miniatus.
New York, Pierpont Morgan Library.
Pen and ink, with wash and traces
of gold and white heightening, on pre-
pared dark-red paper; 11⅝ × 15⅞ in.
(29.2 × 39.7 cm).

Provenance: Colls. Skene; J. C. Rob-
inson; C. Fairfax Murray.

Bibliography: Fairfax Murray, 1905,
no. 1; Berenson, 1938, no. 2756 C;
Degenhart-Schmitt, 1968, no. 30.

The Armenian knight Miniatus is
visible in the custody of soldiers at the
left, as he is about to cross the bridge of
life to his own martyrdom, which is
depicted on the right, with the Emperor
Decius as witness. Bearing the victorious
symbol of a palm branch, Christ is
seen hovering above the agonized saint
as he undergoes excruciating tortures.
The curved confines suggest that this
was a preparatory drawing for a fresco
or panel to be placed above a doorway,
probably as part of a cycle dedicated to
the saint's life and possibly intended to
adorn the church which bears his name,
high above the Arno banks where
Miniatus was buried. Tinting paper the
rich dark red evident here, as prac-
ticed by fourteenth-century Florentine
artists, is described by Cennino Cennini
in *Il Libro dell'Arte* (Chapter XVIII).

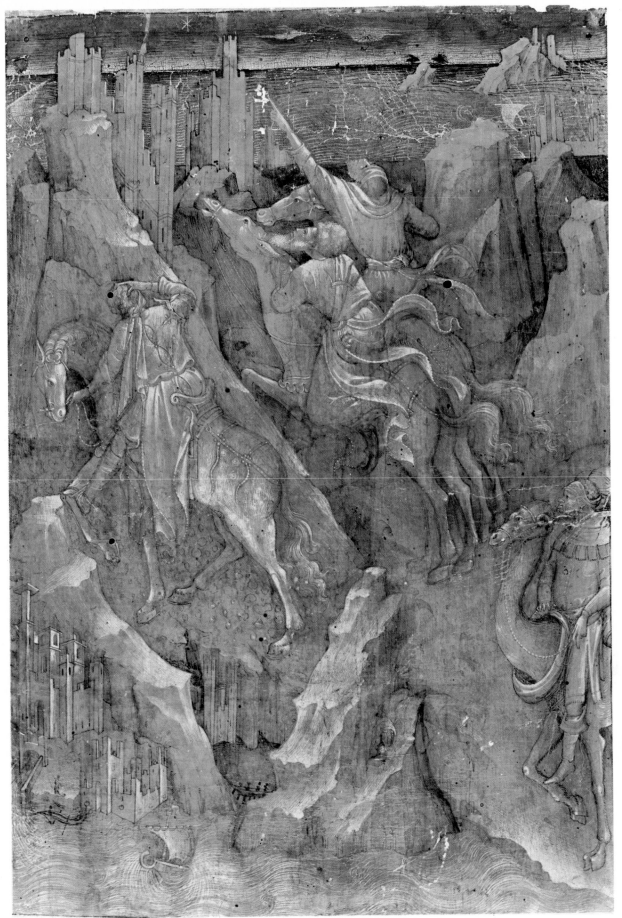

Lorenzo Monaco (Piero di Giovanni)
Siena 1370 - Florence (?) c. 1425

The Quest of the Three Magi,
c. 1420.
West Berlin, Staatliche Museen, no. 609. Pen and black ink, heightened with white lead and blue, green, and orange-hued tempera, on parchment; 10 ¼ × 7 ¼ in. (25.7 × 18.1 cm).

Bibliography : Sirén, 1905, p. 101 ; Berenson, 1961 (1938), I, p. 24, note ; Degenhart-Schmitt, 1968, no. 172.

Intensely delicate, this drawing is distinguished by the vibrant white lines coiling around or hatched within the main darker outlines. All the components seem to strive upward, with an elegant vertical elongation, as if following the Magus's arm that points at the guiding star. With its companion piece, *The Visitation* (also in West Berlin), this drawing epitomizes the forceful refinement of the International Style in the Late Gothic era. Its subject symbolizes the worldly domain, as indicated by its material rulers, the three kings, who seek salvation by searching for the newborn King of Kings.

3

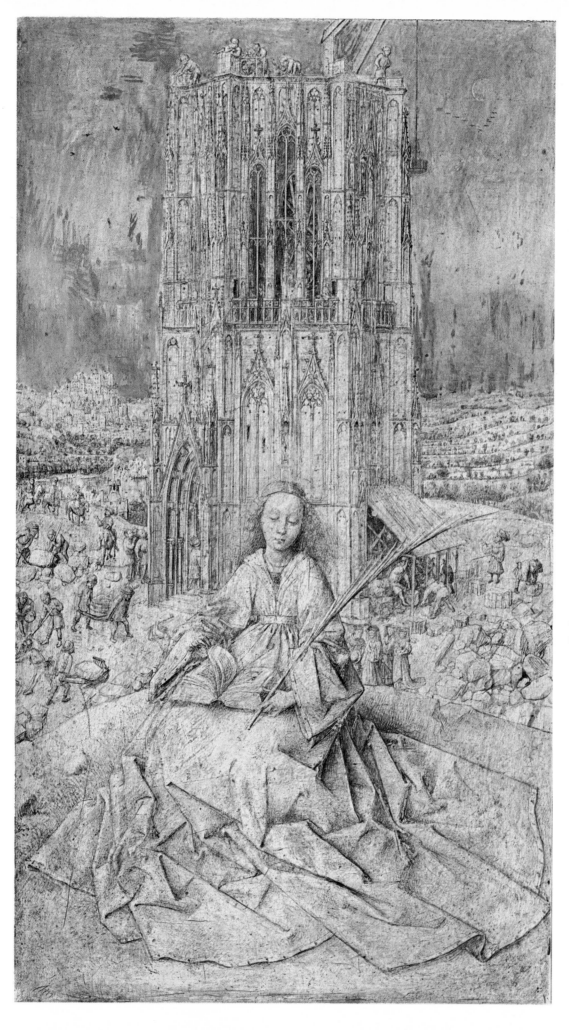

Jan van Eyck
Maastricht (?) c. 1380/90 - Bruges 1441

St. Barbara, 1437.
Antwerp, Musée des Beaux-Arts, no. 410. Brush, tempera(?), and oil on wood panel ; 12¾ × 7⅜ in. (32 × 18.3 cm). Signed and dated on the frame : *"Johes de Eyck me fecit 1437."*

Provenance : Colls. Lucas de Heere(?) ; J. Enschedé ; J. C. Ploos van Amstel ; Van Ertborn.

Bibliography : Friedländer, 1924, I, p. 62 ; H. Beenken, *Hubert und Jan van Eyck,* Munich, 1943, no. 107.

Drawn by brush within an engaged frame, on a gesso-coated panel, this exquisite preparatory rendering was probably meant to be covered with thin layers in oil, before being completed as a painting. Either artist or patron (possibly one and the same person in this instance) decided to stay the finishing hand, along with the usual coats of jewel-like glazes, so taken was he by the richness and delicacy of the drawing. At a later date, some philistine seems to have attempted to "complete" the panel, but happily he soon desisted, so that this loveliest of Van Eyck's drawing remains visible for posterity. Similar, though perhaps less highly developed, *grisaille*-like renderings must underlie most of the Flemish master's paintings. Thus, this amazingly detailed drawing has revealed, fortunately for us, yet another of the myriad dimensions of Van Eyck's superb art.

4

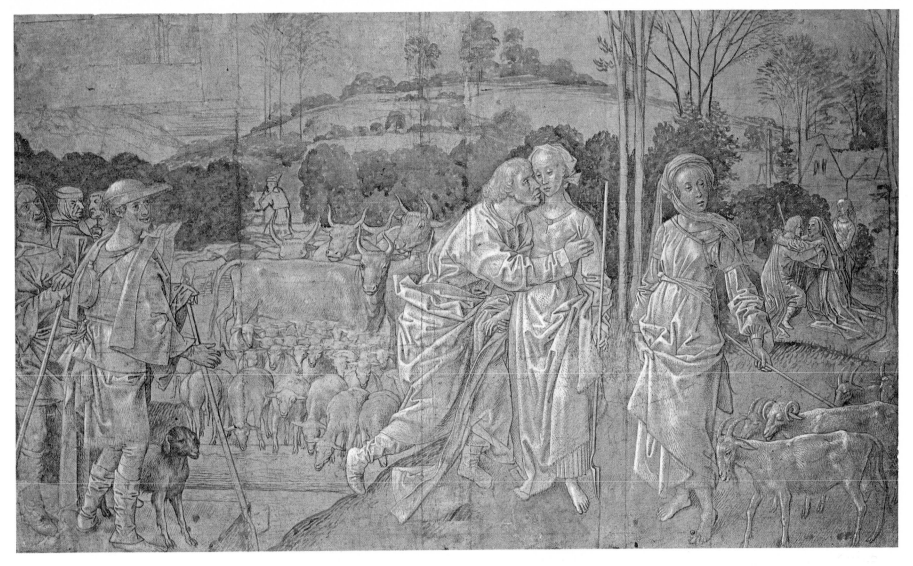

Hogo van der Goes
Ghent(?) 1439/40 - Brussels 1482

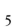5

The Meeting of Jacob and Rachel, c. 1470 or later.
Oxford, Christ Church Library Collections. Pen and bister, heightened with white lead, on gray-tinted paper ; 13⅝ × 22¾ in. (34 × 57 cm).

Provenance : Coll. Guise.

Bibliography : Friedländer, IV, 1924, p. 62 ; Van Puyvelde, 1942, p. 9, no. 1.

The only drawing surely executed by the greatest Northern master of the late fifteenth century, this beautiful sheet is both a major artistic document and an invaluable indication of new tendencies in Western landscape painting. Arranged in a frieze-like composition, the Old Testament narrative is beautifully balanced. Van der Goes's drawing is close to the art of the Venetian Renaissance toward the end of his century, with its reinterpretation of biblical history in a contemporary setting, projected through the new medium of the oil technique and informed by a new, more psychological interest in the world of appearances.

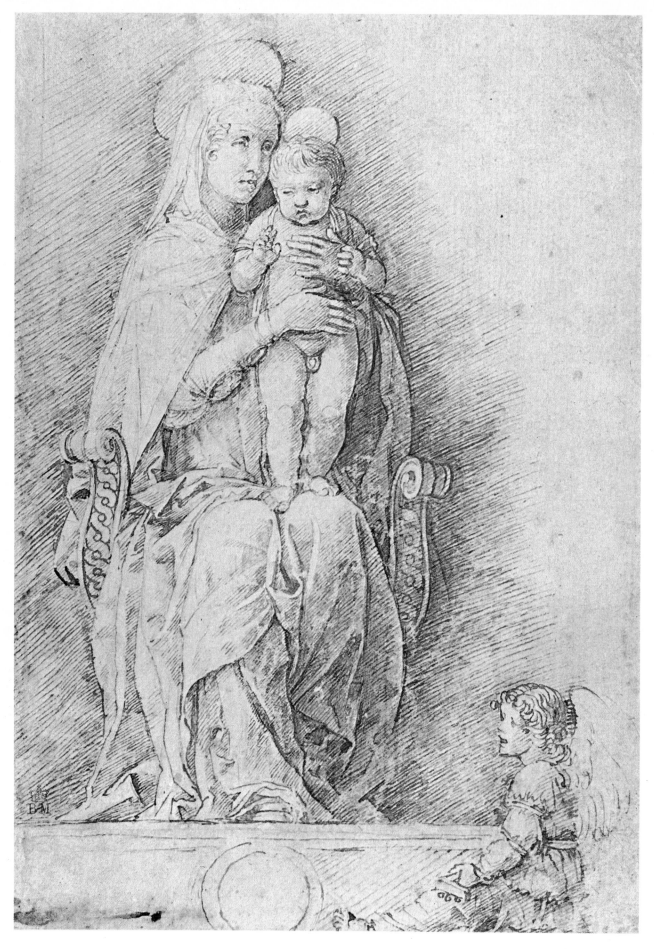

Andrea Mantegna
Isola di Carturo 1431 - Mantua 1506

Madonna and Child, c. 1495.
London, British Museum,
no. 1858.24.3. Pen and brown ink ;
7⅞ × 5⅝ in. (19.7 × 14 cm).

Provenance : Coll. Barck.

Bibliography : Morelli, 1891, p. 233 ;
Popham-Pouncey, 1950, p. 99, no. 159.

A stoical Virgin and Child, statue-like
in their seated frontal placement on an
altar, are adored by a music-making angel
below. Mantegna's "chiseled" style of
draughtsmanship is close to the
engraved lines of early Tuscan print-
makers. He was the first Renaissance master
to maintain a workshop to reproduce
his own paintings in engraved form,
and in this way made his works known
throughout Western Europe. Close in
date to his *Madonna della Vittoria*
(1495-1496 ; Paris, Louvre), this page
shows Mantegna's mature yet inten-
sely personal classicism, verging on
that of the High Renaissance. The
austere clarity of the Mantuan mas-
ter's graphic style was to appeal to
other great draughtsmen as widely
separated as Dürer and Ingres.

6

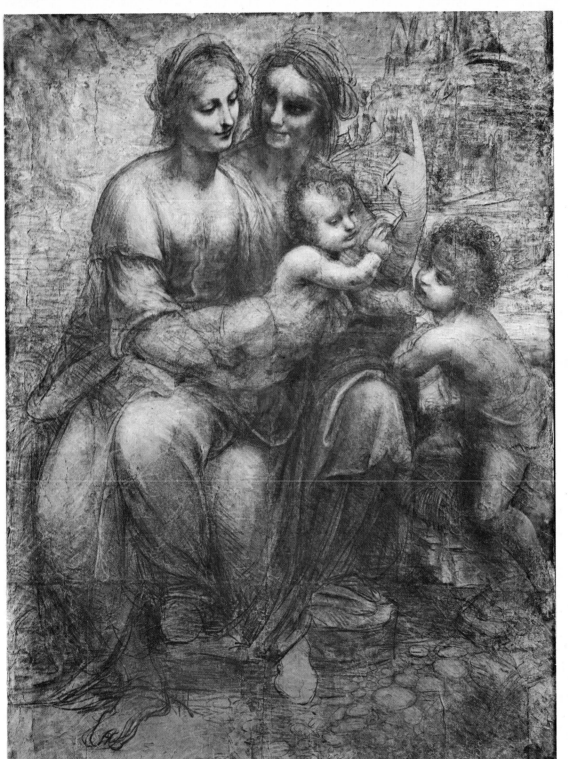

Leonardo da Vinci
Vinci 1452 - Amboise 1519

Virgin and Child with St. Anne and St. John, c. 1500.

London, National Gallery (acquired 1962). Charcoal with white-lead highlights, on reddish prepared paper mounted on canvas; 56⅜ × 41⅝ in. (141 × 104 cm).

Provenance : Royal Academy (unknown before 1771).

Bibliography : Berenson, 1938, no. 1039 ; Popham 1946, no. 176 ; *Commissione Vinciana,* VI, 1928-1952, 236 ; *National Gallery Acquisitions 1953-62;* London, 1962 ; Pedretti, 1968, p. 22.

Leonardo's *sacra conversazione* between the Virgin and her mother, in the presence of the infants Jesus and John the Baptist, typifies the Renaissance master's endlessly complex line and thought, his rich *chiaroscuro* and involved *contrapposto.* Mary is balanced on St. Anne's knee, while Jesus, lying across both women, seems about to swim toward John, as he appears to chuck him under the chin with one hand and bless him with the other. The winding rocky landscape at the upper right echoes the participants' serpentine arrangement. This very large drawing is a cartoon, possibly prepared in Milan and the same size as the painting for which it was drafted as a preliminary study. As inventive in technique as in concept, Leonardo's intricate figural composition has the graphic illusionism often captured in *grisaille* and creates a full-bodied relief that seems to come slowly to life before one's very eyes.

7

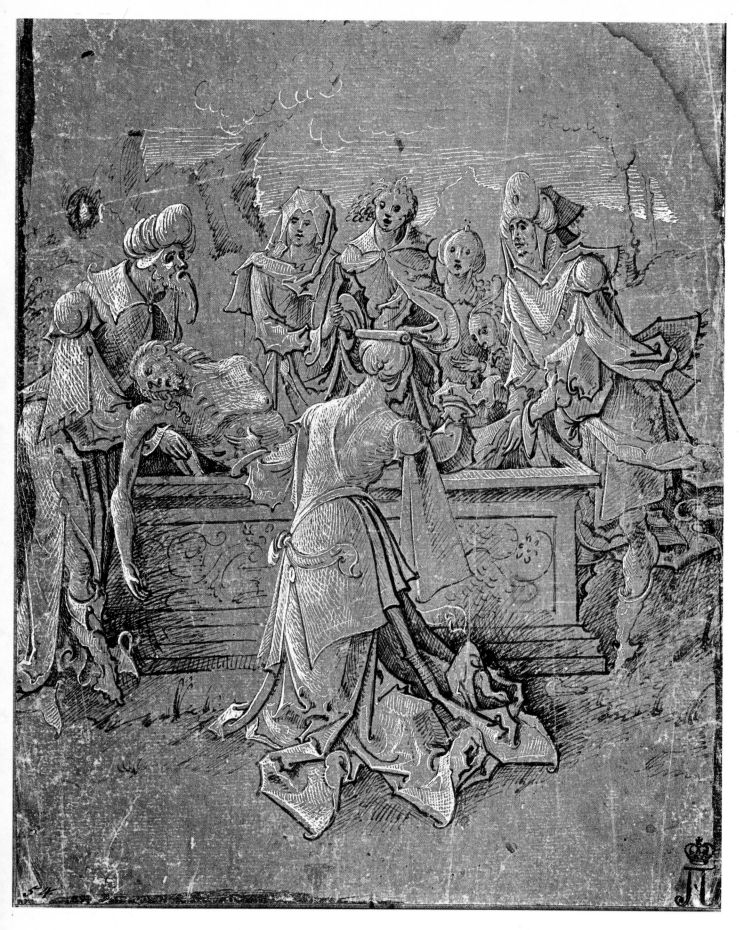

Cornelis Engelbrechtsz. (attrib.)
Leiden 1468 - 1533

The Entombment of Christ.
Leningrad, The Hermitage, no. 48.
Pen and India ink, heightened with
white lead, on gray-tinted paper ;
9⅝ × 11⅞ in. (24.1 × 29.8 cm).

Provenance : Coll. Cobenzl (Brussels).

Bibliography : *Selected Drawings from
The Hermitage, Cobenzl Collection,*
1969, no. 89.

Crisply rendered and decorative in
detail, this Netherlandish drawing sug-
gests the closing moments of a ballet or
stage tableau, rather than the sorrowful
climax of the Passion. The artist's
briskly mannered renewal of traditional
Northern forms came just before a
deluge of Italian stylistic influences
saturated the Low Countries. Close to
the so-called Antwerp Mannerists, Cor-
nelis developed a new vocabulary of
primitivistic surprise, designed to move
the viewer to spiritual response.

8

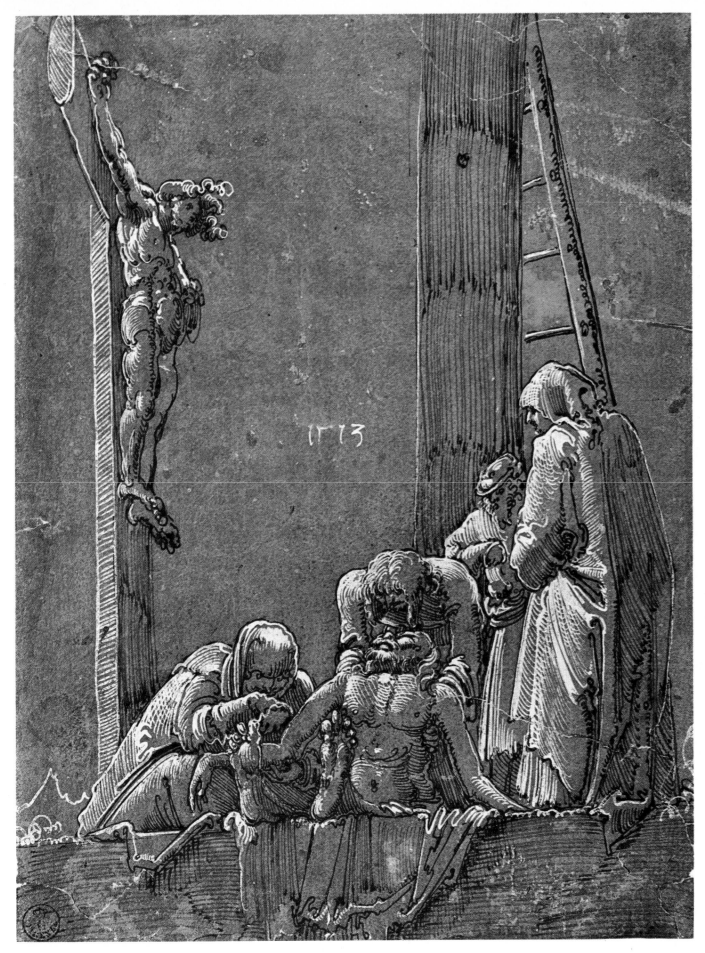

Albrecht Altdorfer

Before 1480 - Regensburg 1538

The Lamentation of Christ, 1513.

Florence, Uffizi, no. 1054. Pen and black ink, heightened with white lead, on prepared reddish-brown paper ; 8⅝ × 6¼ in. (21.5 × 15.5 cm). Inscribed at center : *"1513."*

Bibliography : Tietze, 1923, pp. 80-81 ; Becker, 1938, no. 36 ; Winzinger, 1952, no. 45.

Masters of anguish, German artists of the early sixteenth century presented the episodes of the Passion with an unparalleled horror and immediacy. Influenced by Mantegna's art, Altdorfer intensified the emotional confrontation by using dramatic foreshortening in the dead Christ's body and other bold perspective devices such as the low horizon line. But the artist maintained a medieval approach to the body — so that it is a man, not an idealized classical god, who suffers.

9

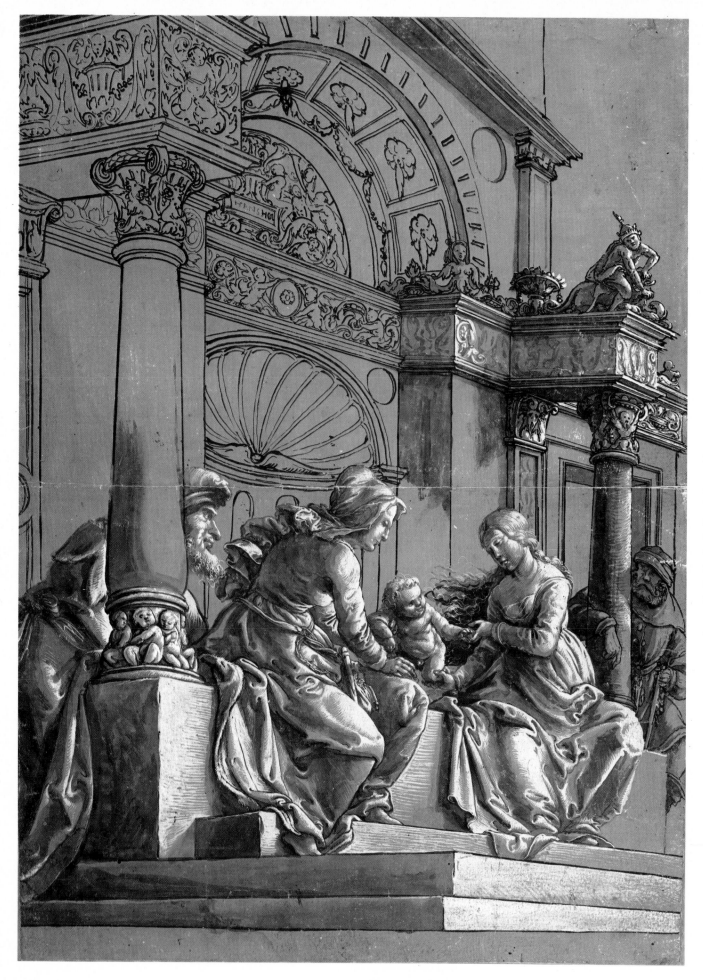

Hans Holbein the Younger
Augsburg 1497/98 - London 1543

The "Large" Holy Family,
c. 1520-1521.

Basel, Kunstmuseum, no. 1662.139.
Pen and black ink, gray wash, heightened with white lead, on prepared reddish-brown paper ; 17 × 12⅜ in. (42.5 × 30.8 cm). Spurious inscription : *"Hans Hol."*

Bibliography : Ganz, 1907, II, p. 51 ; Ganz, 1937, no. 106 ; Überwasser, 1947, pl. 18.

The Virgin Mary and St. Anne, with their husbands visible behind columns to the right and left, are grouped before a niche under a triumphal arch celebrating the victory of Christ. The Christ Child is shown as a rollicking, rather Herculean infant at the very center of the composition. A statue of Samson overpowering the lion, above an architrave at the upper right, prefigures Christ's divine strength. This drawing, with its handsome architectonic setting, reflects Holbein's Italian journey, the figures and architectural motifs showing a Lombard complexity and rich decorative style. The German master's virtuoso technique, allowing him to spin out his brilliantly illusionistic ensemble of forms with unprecedented authority, carried Northern graphism from Dürer's still medieval-oriented art toward a more cosmopolitan and fashionable style.

10

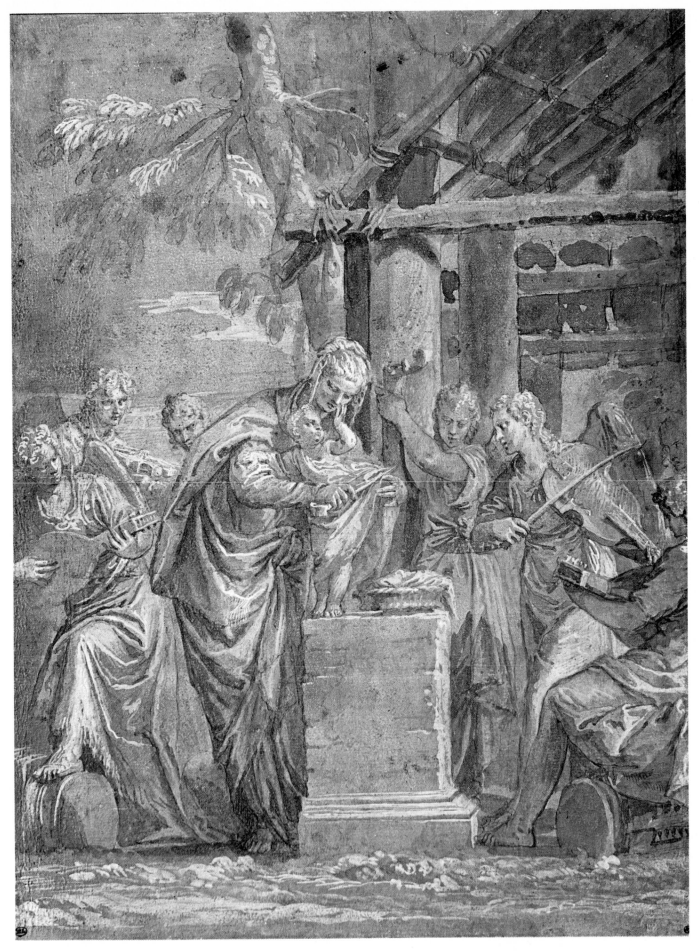

Paolo Veronese (Paolo Caliari)
Verona c. 1528 - Venice 1588

Madonna and Child with Angels.
Paris, Musée du Louvre, Inv. no. 4666. Brush, gray and white tempera, on violet paper ; 15⅛ × 11½ in. (37.7 × 28.9 cm).

Provenance : Coll. Mariette.

Bibliography : Hadeln, 1926, fig. 57 ; Tietze, 1944, no. 2135.

The most subtle of the great Venetian draughtsmen, Veronese tinges his ravishing drawings with the same silvery quality found in his painting. While perhaps to be considered an independent work, this sheet was probably one of the *modelli a chiaroscuro* the artist is known to have prepared for prospective patrons and collectors. The six angels' stringed instruments seem to accompany and orchestrate the complex emotional interplay between Mother and Son in this decorous, reserved yet eloquent page. A muted landscape is suggested with the sparest of background detail.

11

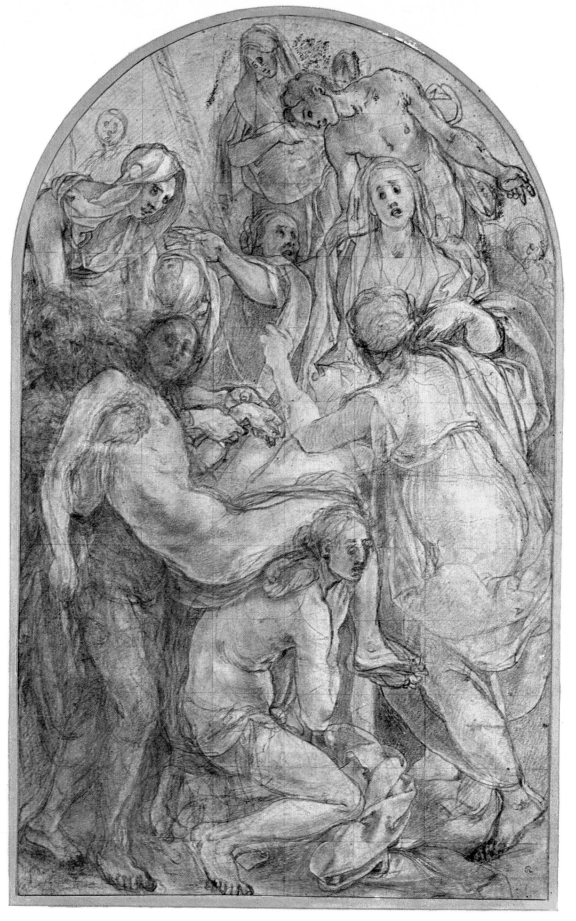

Jacopo Pontormo (Jacopo Carucci)
Pontormo 1494 - Florence 1556/57

The Deposition of Christ.
Oxford, Christ Church Library, no. F. 68. Black chalk, bister wash, heightened with white lead and touches of pen in the upper segment ; 17 ¾ × 11 in. (44.5 × 27.6 cm).

Bibliography : Cox-Rearick, 1964, no. 272.

Both Late Gothic and classical in derivation, Pontormo's art was inspired by that of Dürer as well as by his great Florentine predecessors. This drawing of an intertwining figure group, squared for transfer to a larger scale, is a preparatory study for the Altarpiece of Sta. Felicità (c. 1528). The artist endows a deeply felt religious experience with an undercurrent of spiraling eroticism through his *figura serpentina* composition. The simultaneous raising and lowering of Christ's dead body by its two angelic bearers is paralleled in the liturgical elevation of the Host, prior to its sacramental consumption.

12

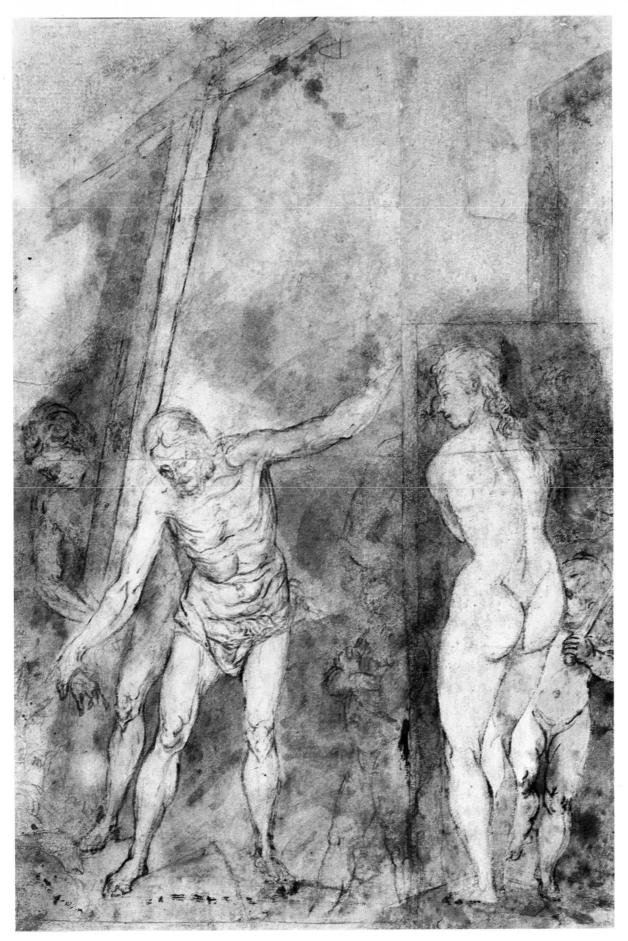

Alonso Cano
Granada 1601 - 1667

Christ in Limbo.
Madrid, Real Academia de Bellas Artes de San Fernando, no. 114 ; Black chalk, pen and ink, bister and red tempera, on yellowish paper ; 10⅞ × 7⅝ in. (27.2 × 19.2 cm).

Bibliography : Velasco, 1941, nos. 112, 114 ; Wethey, 1956, p. 20 ; Angulo, 1966, p. 10, no. 7 ; Pérez Sánchez, 1967, p. 36.

Perhaps the closest compatriot of Velázquez in his similarly graceful command of Italian art and a silvery style, Alonso Cano made this drawing as a preliminary study for his masterpiece now in the Los Angeles County Museum. His sources may have included North Italian prints of the late fifteenth century. Cano uses his cut-and-pasted figure-strewn page — clearly meant as a worksheet — to propose alternative solutions and varying modes of rendering, as a graphic shortcut toward arriving at his definitive painted statement.

13

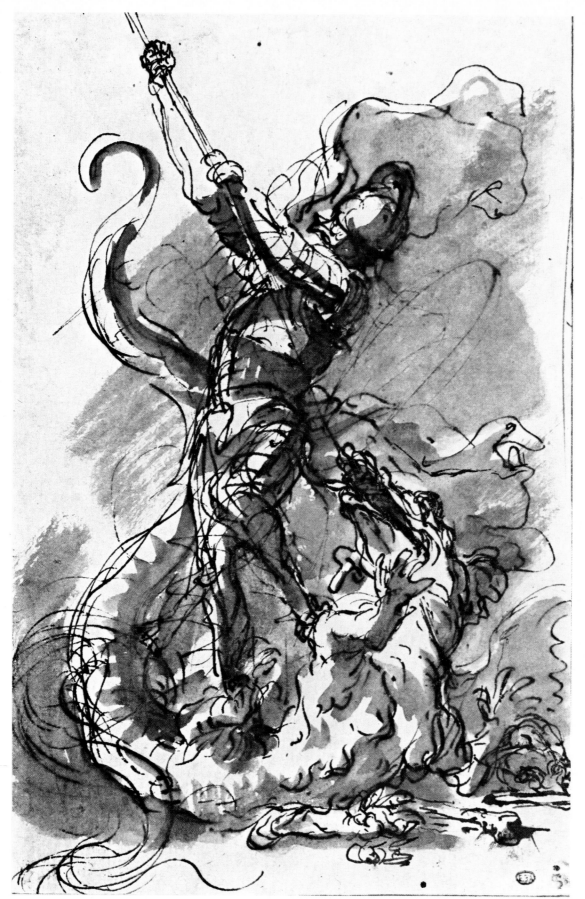

Salvator Rosa
Naples 1615 - Rome 1673

St. George Slaying the Dragon,
c. 1668.
Paris, École des Beaux-Arts, no. 335.
Pen, ink, and watercolor ;
9 × 5⅞ in. (22.4 × 14.7 cm).

Provenance : Colls. Spencer ;
Thibaudeau.

Bibliography : Ozzola, 1925-1926,
pp. 29ff.

With his swirling, expressionistic line
and washes, Rosa continues the free,
coloristic graphism by then character-
istic of artists in Naples, Venice, and
Bologna — further enriched by a new
dramatic intensity found in Rembrandt's
etchings. Rosa's evocative, romantic
drawings such as this, admired equally
by Gainsborough and Fragonard, were
hugely popular throughout Europe and
contributed to the emergence of a new
"International Style" in the late eighteenth
and the nineteenth centuries.

14

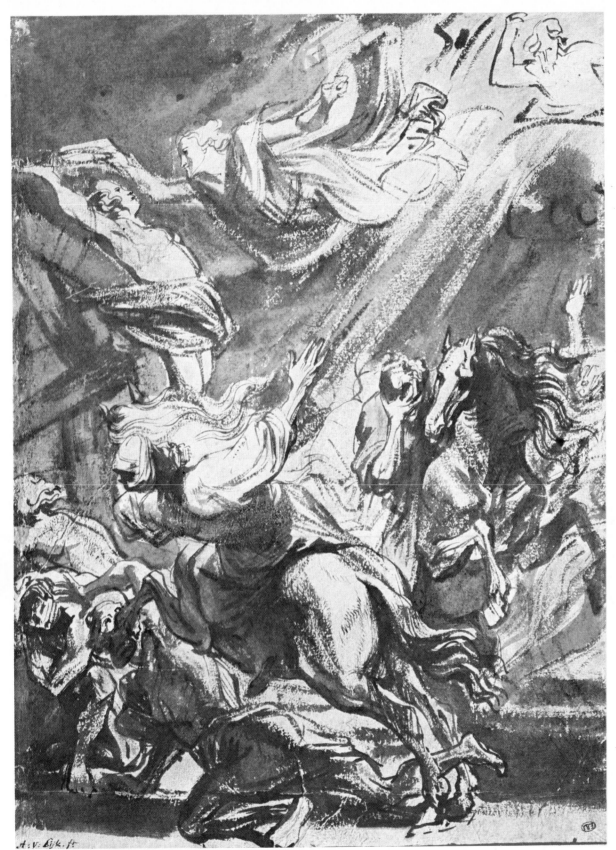

Anthony van Dyck
*Antwerp 1599 - Blackfriars
(London) 1641*

Martyrdom of St. Catherine.
Paris, École des Beaux-Arts,
no. 34.582. Pen and bister ink, water-
color, and carbon black ; $11^{3}/_{8} \times 8^{3}/_{8}$ in.
(28.5 × 21 cm). Inscribed in lower-
left corner : *"A. V. Dijk ft. "*

Provenance : Colls. Schneider (1820
sale) ; A. Armand.

Bibliography : D'Hulst-Vey, 1960,
no. 30 ; Vey, 1962.

Typical of the young Van Dyck's
brilliant draughtsmanship, with its
amazing combination of rigor and strik-
ing virtuosity, this dramatic study was
engraved later in the seventeenth cen-
tury as a work by Rubens, with whom
Van Dyck had collaborated in his
youth. It was Rubens who evolved this
combination of slashing line and bold,
theatrical washes, which creates an
emotionally charged atmosphere suitable
for the tragic, more agitated narrative
episodes of religious lore or classical
mythology. Drawings of this same
theme which are now in Brunswick,
Dijon, and Paris would indicate that
Van Dyck was working on a painting
of the subject, but no such finished
canvas is known today.

15

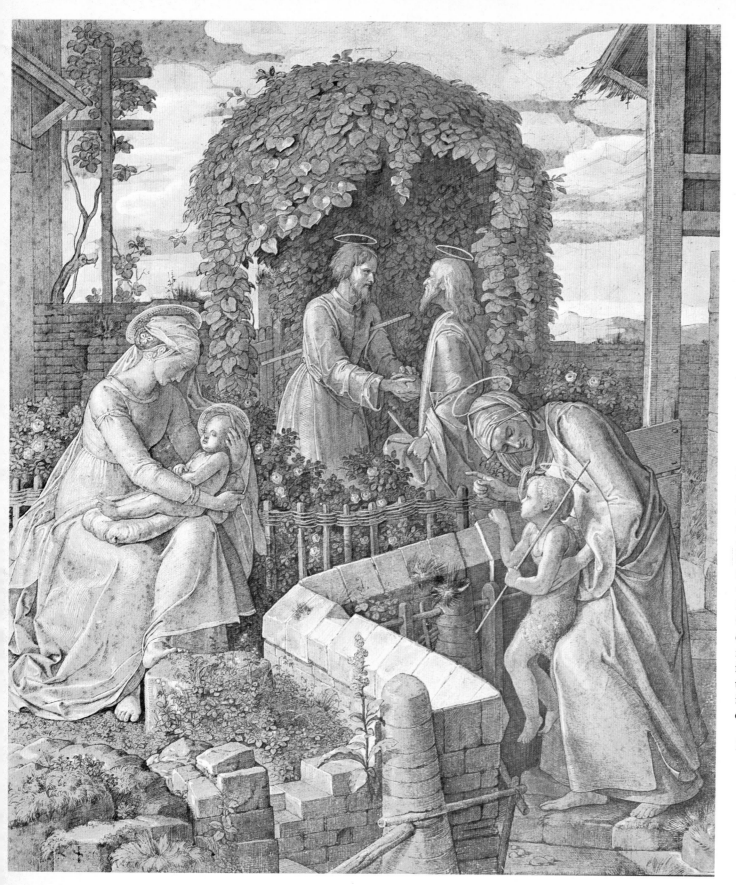

Julius Schnorr von Carolsfeld
Leipzig 1794/95 - Dresden 1872

The Holy Family Visiting the Family of St. John the Baptist, 1816.

East Berlin, Staatliche Museen. Pen and brown ink, with white and gold heightening ; 14¾ × 12⅝ in. (36.8 × 31.5 cm).

Bibliography : H. W. Singer, *Julius Schnoor von Carolsfeld,* Leipzig, 1911.

After a long Italian sojourn, Schnorr von Carolsfeld returned to his native Germany in 1827, where he entered the service of Ludwig of Bavaria and taught at the Munich Academy. From 1846 till his death he was director of the Dresden Academy. In this work of his youthful Italian period, the German master has redrawn the Gospel according to the venerable Mantegna. Nonetheless, this meeting of the Holy Family with St. Elizabeth, her husband, and their son John the Baptist resembles nothing so much as a bourgeois family reunion in a rustic Teutonic setting. Other than the haloes, only the "disguised" symbolism of the cross-shaped trellis behind the Virgin and Child and their pictorial isolation in an enclosed garden of medieval Marian purity disclose the scene's sacred import. By reviving the graphic styles of the fifteenth century, the artists in Schnorr von Carolsfeld's circle — known as the Nazarenes — sought a more sober Christian spirit, free of the pagan classicism of the academies which had invaded religious art since the Renaissance. A few decades later, the Nazarenes were to be followed by the Pre-Raphaelites in this return to the spiritual "good olde days" of the Quattrocento.

16

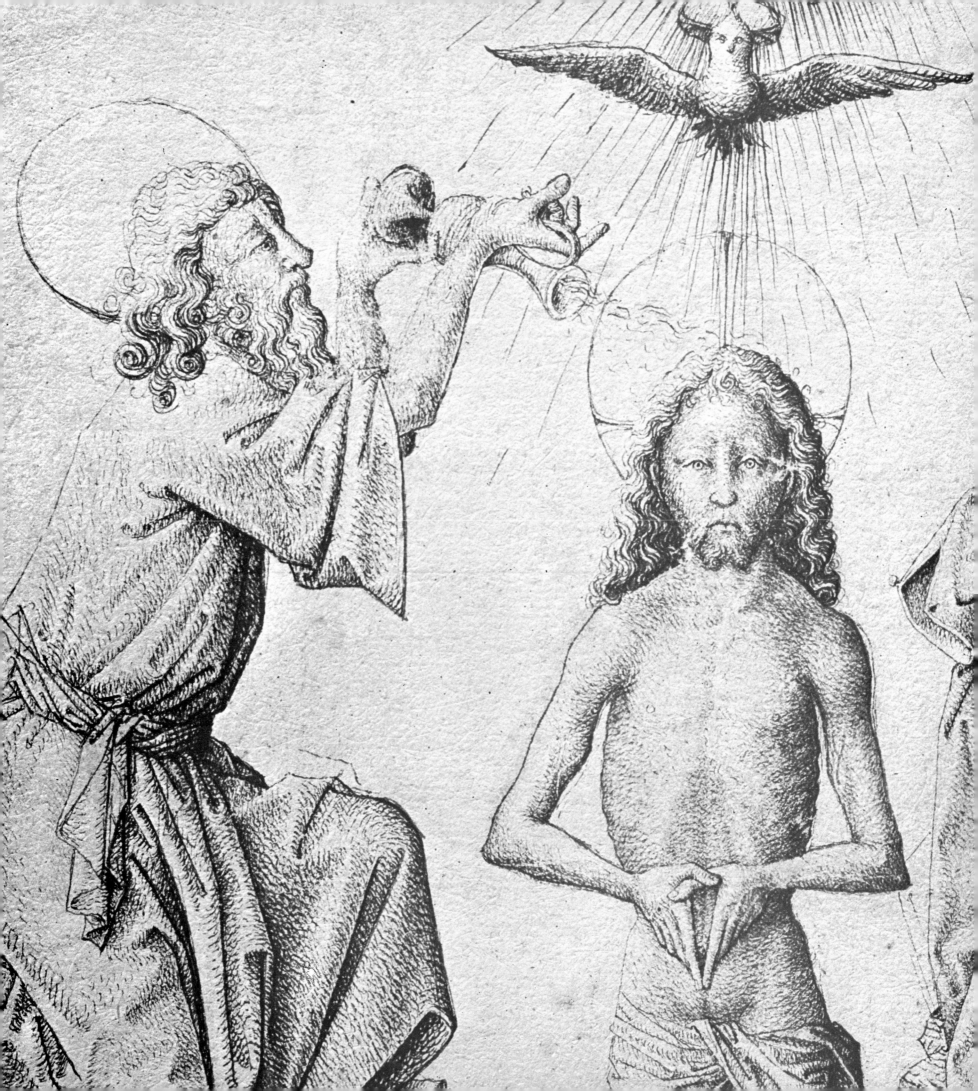

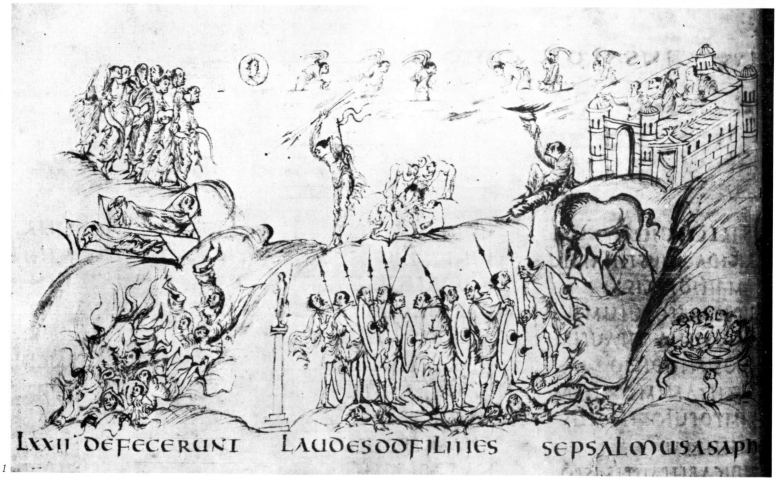

LXXII DEFECERUNT LAUDESOOFILIIES SEPSALMUSASAPH

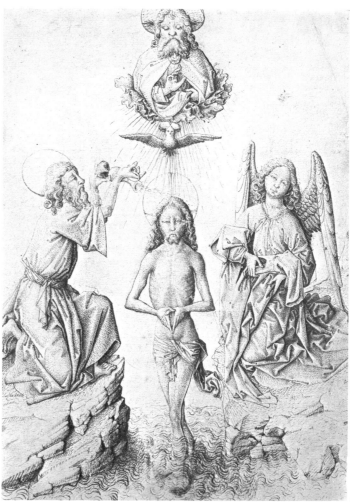

Anonymous Master F. 1
Active c. 820 - 830

The Utrecht Psalter, Psalm LXXII.
Utrecht, Utrecht University Library Ms. 32, fol. 41v. Pen and brown ink on vellum ; 4 ½ × 8 ½ in. (11 × 21 cm).

Albrecht Dürer F. 2
Nürnberg 1471 - 1528

The Nativity.
West Berlin, Staatliche Museen. Black pen and ink ; 11 ⅓ × 8 ⅓ in. (28.8 × 21.3 cm).

Master E. S. F. 3
Active c. 1450 - 1467

The Baptism of Christ.
Paris, Musée du Louvre, no. 18838. Pen and black ink ;
11 ½ × 8 ½ in. (29 × 21.1 cm).

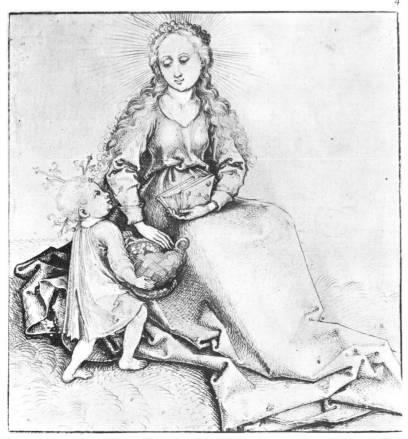

4

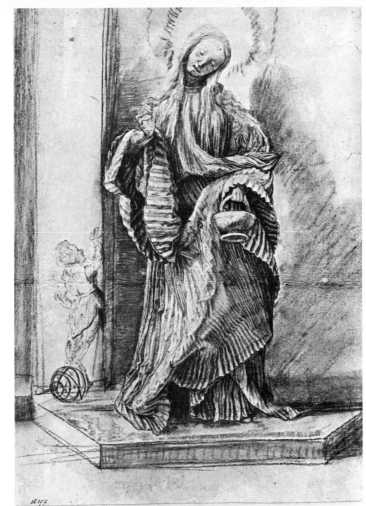

5

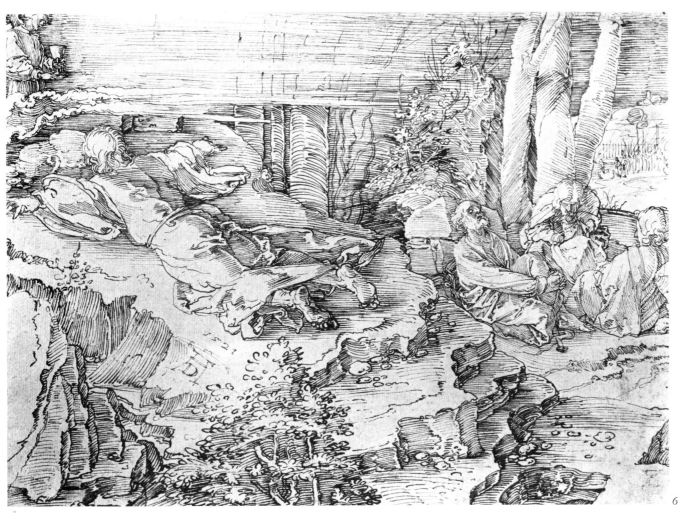

6

Martin Schongauer F. 4
Colmar c. 1445/50 - Breisach 1491
St. Dorothy.
West Berlin, Staatliche Museen,
no. 1015. Pen and grayish-brown ink ;
7 × 6 ½ in. (17.6 × 16.5 cm).

Mathias Grünewald F. 5
*Würzburg c. 1470/80 - Halle-an-der-
Saale 1528*
Study for St. Dorothy.
West Berlin, Staatliche Museen,
no. 12035. Pencil and gray watercolor,
with white highlights ;
14 ¼ × 10 ¼ in. (35.8 × 25.6 cm).

Albrecht Dürer F. 6
Nürnberg 1471 - 1528
**Christ Praying in the Garden of
Olives.**
Frankfurt-am-Main, Städelsches
Kunstinstitut. Pen and ink ;
8 ¼ × 11 ¾ in. (20.8 × 29.4 cm).

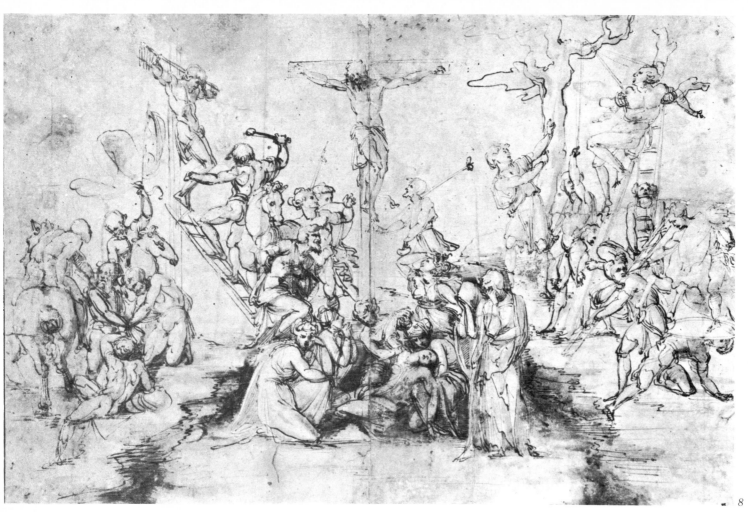

8

Domenico Ghirlandajo F. 7
Florence 1449 - 1494
Apparition of St. Francis in the Chapterhouse at Arles.
Rome, Gabinetto delle Stampe. Pen and ink, on white paper ;
7 ⅝ × 8 ¾ in. (19 × 22 cm).

Baccio Bandinelli F. 8
Florence 1488/93 - 1560
Crucifixion.
Vienna, Albertina, no. 14181. Pen and ink, with brown wash ;
15 ¼ × 22 in. (38 × 55.2 cm).

Raphael
(Raffaello Sanzio) F. 9
Urbino 1483 - Rome 1520
Study for the "Borghese Deposition", 1507
London, British Museum. Pen and black chalk ; 9 ¼ × 12 ¾ in. (23 × 31.9 cm).

7

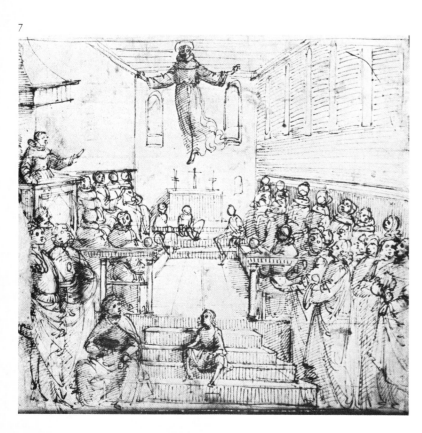

9

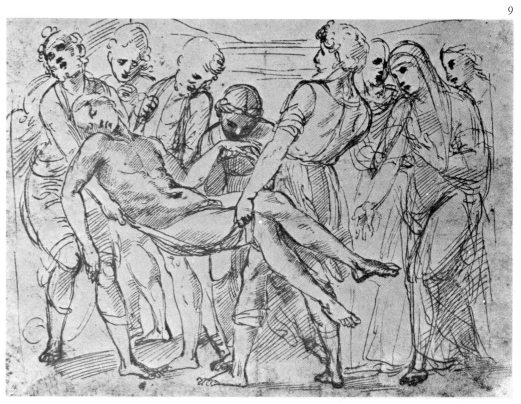

Rembrandt Harmensz. van Rijn
Leiden 1606 - Amsterdam 1669

Joseph's Brothers Beseeching Their Father to Allow Benjamin to Accompany Them into Egypt,
Amsterdam, Rijksmuseum, F. 10
no. A4518. Pen and bister ;
7 × 9¼ in. (17.6 × 23.1 cm).

Giuseppe Ribera F. 11
Játiva 1591 - Naples 1652

The Martyrdom of St. Sebastian.
London, Victoria & Albert Museum,
no. D. 610. Pen and ink ;
7½ × 10 in. (19.2 × 25.2 cm).

Antonio del Castillo F. 12
Cordova 1616 - 1668

The Beheading of John the Baptist.
Florence, Uffizi, no. 1715E. Pen and brownish ink on yellowish laid paper ; 13¼ × 9½ in (33.1 × 23.7 cm).

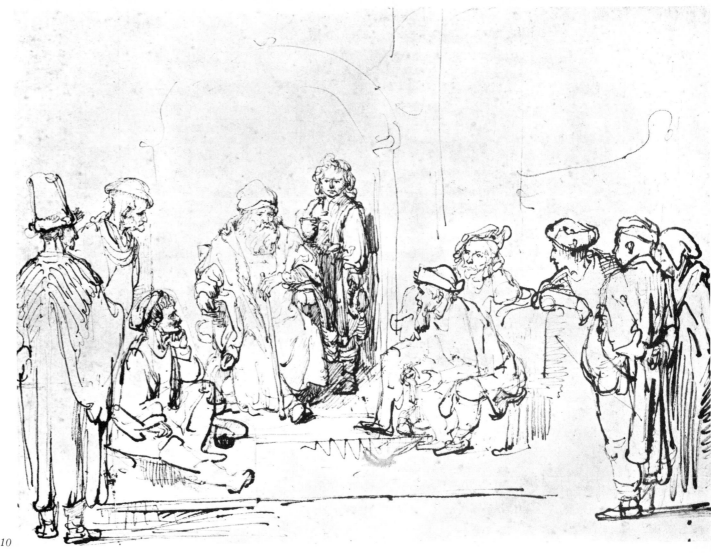

10

11

12

13

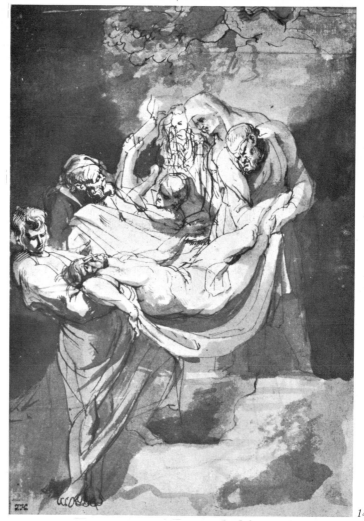

14

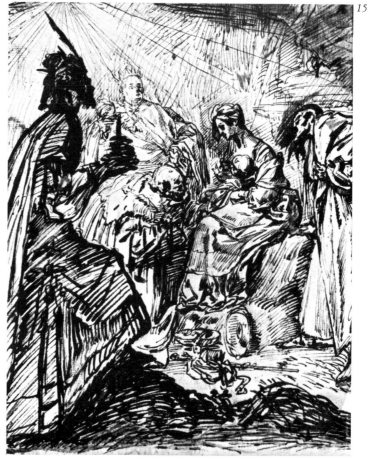

15

Simon Vouet
Paris 1590 - 1649

Study for "Christ on the Cross". F. 13
Montpellier, Musée Atger, no. D. 4944.
Black pencil with faint white-lead
heightening ; 16 ¾ × 10 in. (42 × 25 cm).

Peter Paul Rubens
Siegen (Westphalia) 1577 -
Antwerp 1640

The Entombment of Christ. F. 14
Amsterdam, Rijksmuseum,
no. A 4301. Pen and ink, with wash,
over black chalk ; 8 ⅞ × 6 ⅛ in.
(22.3 × 15.3 cm).

Claude Vignon the Elder
Tours 1593 - Paris 1670

The Adoration of the Magi. F. 15
Paris, Musée du Louvre, Inv. no. 22.196.
Pen and ink ; 9 ¾ × 8 in. (24.2 × 19.9 cm).

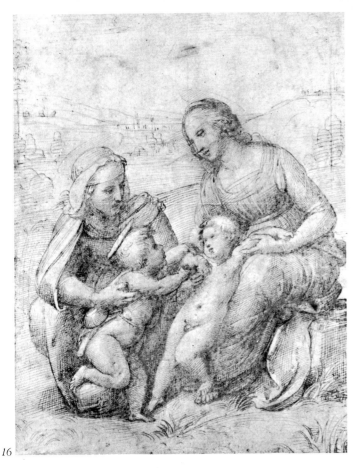

16

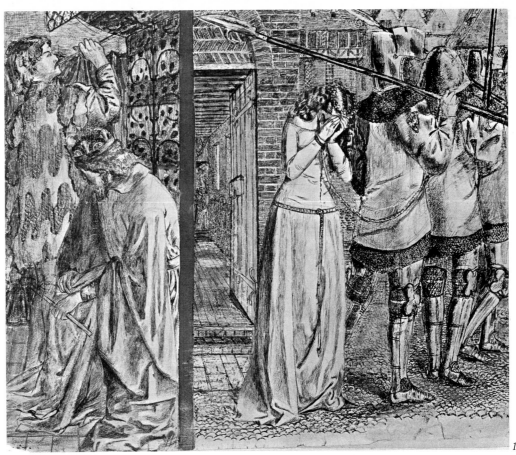

17

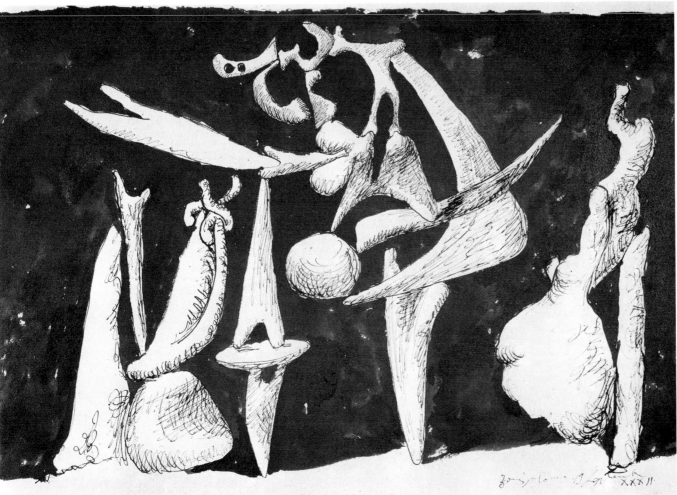

18

Raphael F. 16
(Raffaello Sanzio)
Urbino 1483 - Rome 1520

Virgin with Child Jesus, St. John the Baptist and St. Elizabeth.
Windsor, Royal Library, no. 12738
(by permission of Her Majesty Queen Elizabeth II). Ink with traces of black crayon on white paper ; 9 ¼ × 7 in. (23.4 × 18 cm).

William Morris F. 17
Walthamstow (Essex) 1834 - Kelmscott (Oxfordshire) 1896

Study for "The Legend of St. George" (decoration for a painted cabinet by Philip Webb).
London, Victoria and Albert Museum. Pen and black and brown ink.

Pablo Picasso F. 18
Málaga 1881 - Mougins 1973

Crucifixion.
Formerly collection of the artist. Pen and India ink, with wash ;
13 ¾ × 20 ¼ in. (34.5 × 50.5 cm)

Genre

The life we live, the styles brought to it in the past, as delineated in a somewhat documentary manner, are the essence of genre. Telling of the ways of coping with familiar exigencies, with pleasures and tears, love, sweat, and laughter, the draughtsman's narrative outlines these and many other episodes of existence. Reminiscent of the poignant bits and pieces of daily life uncovered at Pompeii, sketches of human beings in landscapes or interiors, amid flowerpots and bicycles, wine barrels and looms, provide unique insights not only concerning the artist's attitude toward the essentials of daily life but also a curious self-awareness imparted to the object itself, as though intensifying the nature of its being under the stimulus of artistic scrutiny.

Of all scenes of daily life, the most ancient and still popular cycle is that afforded by the calendar, with its special labors and pleasures for the months and seasons. From January's frozen wastes to the harvests of autumn the artist records the variation of activity and setting, defining life and time through changes, each holding promise of the next, in a cycle long equated with divine Providence. Sometimes realistic subjects show more than meets the eye, telling a story on two levels—a story that can tell more about the artist than about his subject and reveal his own perspective, be it cynical or sentimental.

Seventeenth-century scenes read today simply as charming drawings of rustic pursuits may delineate highly piquant proverbs or cloak in everyday garb a moral such as Christ's parables of the Mote and the Beam, the Wise and Foolish Virgins, or the Good Samaritan. "Pure genre" is as rare as pure thoughts. The artist, by isolating a motif—whether a broom in a corner, a woman feeding chickens, or visits to the doctor or milliner—by the very process of selection, says that this particular scene is going to tell you more than many others about the special nature of domesticity, agriculture, health, wealth, or fashion in his day.

Nothing ages quicker than the present, today becoming *passé* in art as well as in actuality, so that drawings of daily life fall rapidly into disfavor until rediscovered as souvenirs of the "good old days." Usually without the obvious preservative of redeeming social or religious value, the often humorous and unpretentious sketches are the first victims of changes in fashion, cut out of their frames or albums in favor of more up-to-date treatments of the same subjects. A monumental exception to this sad law is the *Housebook* of Schloss Wolfegg, a witty compendium of the constituents of life at a prosperous Northern provincial court of the late fifteenth century. Bathing, bickering, fishing, jousting, embracing, cooking, riding, building, boating, even reading and writing, the youthful participants share an exuberance, and perhaps even a sense of affectionate irony, with the artist who sketched them.

Earlier examples, such as the unforgettable twelfth-century scene of a disgusted scribe throwing a sponge at a rat, must have existed in considerable numbers, but this is a lonely survivor until the time when the large collections of drawings lumped under Pisanello's name in Paris and elsewhere were first drawn. Actually the work of many masters, including the artist's teacher Gentile da Fabriano, they present a corpus of studies after the antique, textile and medal designs, courtiers and riders—at once a patternbook, *National Geographic*, *Country Life*, *Vogue*, *Field and Stream*, *Time*, *Life* and *Fortune*.

Among the richest anthologies of genre are the drawn autobiographies of the Zuccari and the Carracci, some of them planned to be executed in fresco, to celebrato

the life and works of these great artists. Illustrated travel journals such as Dürer's sometimes tell one more than he cares to know about an artist's attitude to himself and his wife, his colleagues, and his expense account.

Genre can take you behind the scenes, raise the curtain, or open the door, thereby making the viewer privy to life without pose. Here no one poses stiffly or says some silly word to provide an empty smile for the recording eye and hand. Ideally the subject is caught unaware of the artist, pursuing the particular pattern of his own life, as delineated by the "candid-camera" eye of Parmigianino, the Carracci, Rembrandt, or Saint-Aubin. Such draughtsmen eternalize a "reflexive moment," one lived for itself, by itself, in itself. Their records of a fleeting experience, a transitory pursuit, or momentary perception are often moving. The artist seems to draw to and from himself, communicating the essence of his life and labor, or that of his family and friends, those among whom he is so fully accepted that his is an unseen hand delineating an essentially unseen sight, as much of a revelation to the draughtsman as it will be to the viewer in future times. That describes "ideal genre"—necessarily a contradiction in terms.

When meant as "too much for the better," genre goes sentimental and substitutes expectation for actuality, turning the present into what it ought to be rather than what it is. "Happy Peasant," "First Steps," "Modest Model," or "Tippling Priest" have all been popular themes since the sixteenth century, implicitly greeting-card-like and readily saleable. More recently there has been an equally predictable counter-sentimentality: life viewed as unrelieved Black Comedy, a vale of tears, with suitable type-casting. The greatest masters of genre, however, escape the traps of built-in captions, of predictable narrative, of instant message, by never losing sight of what they see before them. They respond so directly that for the moment the ideals of the academy or pulpit, propagandist or pornographer, cannot blind the communication of their instant response to what the Japanese call "pictures of the passing world," the unedited eye and hand. Ultimately genre becomes witness to itself. By sheer survival it symbolizes the past, accidentally invested with a far more forceful, dynamic significance than many a work specifically designed to commemorate the character or events of its moment in time. Sometimes more directly and instantly than the facts of our own lives, the ordinary life of bygone eras seizes our attention when drawn by those who see best or, conversely, when seen for us by those who draw best. Masters of genre capture the special choreography of each era, the changing space and grace of the experience of time, so different in Carpaccio's Venice from that of Guardi. The way people move and group, their sound and even their silence changes, all of this perceived in its particular essence by the astute and gifted artist-witness.

The draughtsman often counts on his public's "reading between the lines." This is especially true for genre, in which a certain amount of restraint speaks volumes. Just because the artist is drawing from his own world, he assumes a similar familiarity on the part of his public—if, indeed, he works with anyone else in mind. Those truths the daughtsman holds to be self-evident need not be long drawn out; that brevity which is the soul of wit can only be exercised on the common ground of genre.

Masters of genre delineate the different dances to the music of their time: those of life and death, ways of building up and grinding down. Local color in local line is the essence of this aspect of the draughtsman's recording role. Documentary though

Genre

it may be, genre is often tinged with irony and wit, yet with a sense of the way things really are as opposed to smug personal perspective. Witness from the wings, the artist can often combine the roles of journalist and editor, tempering the canonical "Who, What, Where, and When?" required for accurate, efficient reportage with a graphically understated "Why?" or "For whom?" or even "Since when?"—all of which may verge upon the caricatural.

Each area of life dictates its own drawings: law, fashion, travel, education, professions, and pleasures, the ways we love and the ways we love to kill. Social actions and transactions have to be perceived and re-created by draughtsmen, who quickly sketch in the essentials of the activity they will define as diarists or, occasionally, as publicists. For all its silent witness, genre often implies a scenario, with participants "visually taped" in a moment of verbal exchange, communicating the essence of their activity to one another so it may, in turn, be projected to the viewer. The eighteenth century, when the novel was born, is especially rich in such visual narrations by Hogarth, Tiepolo, Guardi, Greuze, and Chodowiecki. Italian masters of the preceding century, especially those active in Bologna and Rome, had already led the way to such representations, in series devoted to the many different street vendors and their cries, to regional costume, and to the world of actors and mountebanks, as done by Guercino. Highly autobiographical subjects drawn by members of the raffish Netherlandish artists' colony in Baroque Rome—the so-called Bamboccianti—bring to mind and eye the teeming streets and taverns, the urban squalor and splendor of the Eternal City. And the chroniclers of eighteenth-century Venetian society are among the most celebrated in all art.

With their passion for self-portraiture, the Dutch made thousands of drawings of every aspect of their society; scenes in interiors of tailor shops or near mills and cisterns, peasants plucking their own fleas or a dead ducks' feathers, fisher boys and girls, laundresses and striving apprentices, and sauntering assistants were all recorded with lively objectivity by Buytewech, Rembrandt, and many others.

Unquestionably the greatest single genre series ever undertaken was the illustrations for the *Enciclopédie*. Tens of thousands of preparatory studies (mostly lost) were prepared by Diderot's draughtsmen to convert all knowledge of long-secret manufacturing techniques, medicine, and the sciences into that most comprehensive of "Whole Earth Catalogues." It might be said that the very success of this immense project was to contribute to the killing of genre, since the invention of photography, like so many other scientific advances of the early nineteenth century, stemmed from the French Encyclopedists' comprehensive grasp and dissemination of the sum total of man's knowledge in almost every sphere.

Instant nostalgia, a major by-product of the Industrial Revolution, then led to endless drawings of the "Goode Olde Days," preserving in art doomed ways of life and leading to a new, affectionate scrutiny of the agrarian past. From the 1830's onward, such works were soon complemented by those of the artist as realist, as socialistic *communard* like Courbet, who occupied himself with a perpetuation of man's hand labor before the encroachment of the capitalist machine as his chosen work. But other artists embraced the advances of industry and studied the steel and textile mill and the railroad as new, strategic elements in European and American life. Then, near the end of the nineteenth century came a new Jamesian concern with the genteel

Genre

and with refined pursuits. Artists scrutinized the soon-to-be-extinct aristocratic splendors and life of Trouville and Newport, as recorded in drawings by Dewing, Gibson, Tissot, and Sargent.

New meeting places such as the café and dance hall, circus and theatre, provided the Impressionists with their own material for genre. They welcomed the flickering light of the railroad station or a greenhouse, stage illumination for the ballet, bright skies with whisps of clouds over boating ponds, and the quiet lamps of domestic life as inspiration for drawing a new public and private intimacy. These masters of the late nineteenth century enjoyed the informal encounter, depicting the overtaxed dancers and weary waitresses, laundresses, and seamstresses, or not-too-naughty children and prim nursemaids on a flower-dotted embankment. They drew a dining, dancing, boating, swimming middle class with a certain matter-of-factness, with occasional hints of romanticism but rarely with criticism.

The intimacy of the world shown by Sickert, Vuillard, Bonnard, and Lieberman, still taking comfort in the bourgeois credo that a man's home was his castle, was soon shot down by such prophetic expressions of anxiety as Munch's drawings of the misery of marriage and the German and Austrian Secessionists' studies of the corruption of nature and man by threatening forces within and without.

From the First World War until very recently, artists took a somewhat dim view of genre, of drawing the mirror of daily existence, which they considered a form of reportage best left to the camera. Few draughtsmen dared face the challenge of recognizable personal intimacy or of modern-day political and economic challenges. With few exceptions, genre fluctuated between caricature and corn. Matisse and Picasso, as they grew older, became increasingly responsive to the familiar underplayed drama of domesticity. Kollwitz and Barlach, Grant Wood and the American artists of the Public Works Administration, these artists seldom lost sight of human interchange, although their styles and sentiments were far apart.

In a headlong social context, the way it *is* is ever more rapidly becoming the way it *was*. Genre offers the draughtsman access to instant history, which is becoming increasingly popular again. Dissatisfied by the restrictions of abstraction, artists are showing a renewed fascination with various aspects of realism and a concern with one of the most enigmatic yet basic creative roles—that of drawing the present.

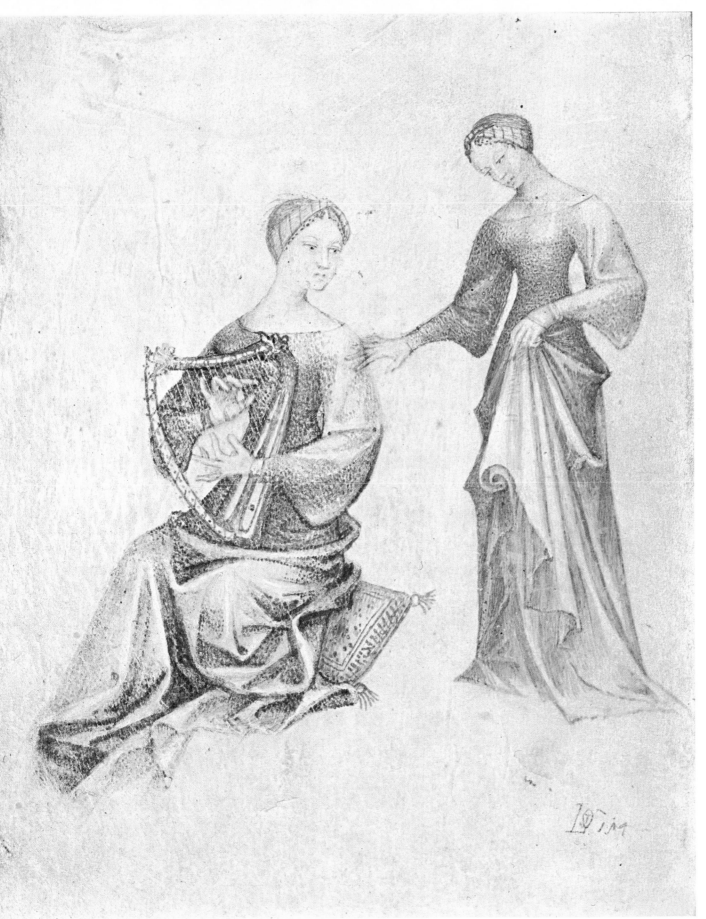

Giovannino de' Grassi
Active in Milan 1389 - 1398

Two Women Making Music.
Bergamo, Biblioteca Civica, Codex Δ
VII. 14, fol. 5 recto. Pen and ink with
watercolor, on vellum ; 10¼ × 7½ in.
(25.8 × 18.7 cm).

Provenance : Colls. Lotto ; Sillano
Licino ; Tassi ; Secco-Suardi.

Bibliography : Toesca, 1912, pp. 298-
306 ; Van Schendel, 1938, p. 60 ;
Scheller, 1963, p. 142, no. 21.

One of several pages in this manus-
cript devoted to the theme of courtly
music, this scene presents a seated
harpist approached by a graceful, seem-
ingly gliding companion, possibly a
singer or dancer. Both beautifully attired
ladies are delineated with a certain
formality, almost as if they were viewed
in slow motion. Their stateliness is
accentuated by the monumental sculp-
tural style of their drapery, which is
somewhat relieved by a pointillist treat-
ment of softhued stippling that lends
the duo lightness and movement.

1

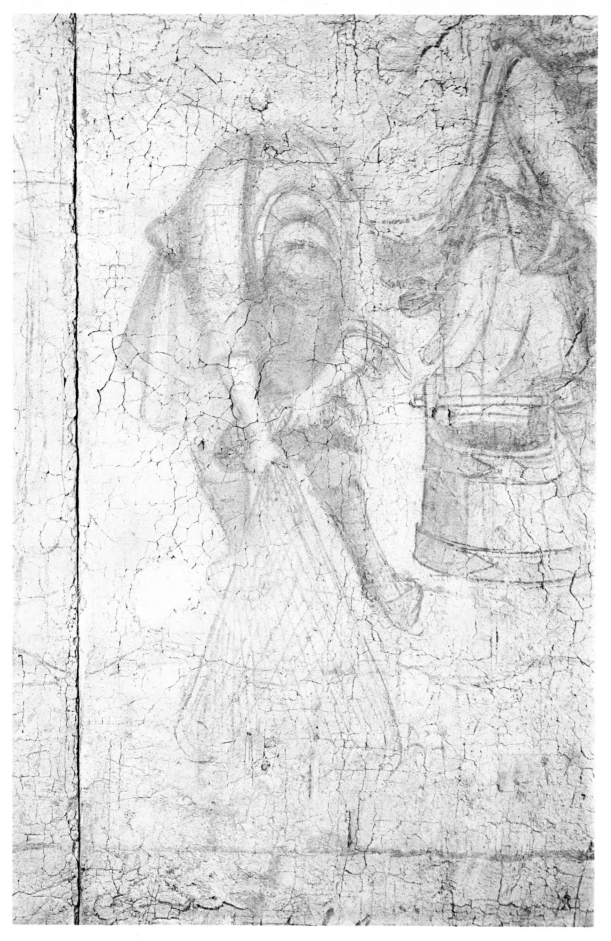

Master of the Triumph of Death
Active in Pisa mid-14th century

A Hermit Fishing, c. 1360.
Pisa, Camposanto Monumentale. Detail of sinopia from *The Life of the Hermits.*

Bibliography: Bucci-Bertolini, 1960, pp. 41, 45; Procacci, 1961, pp. 50-51, 236.

Michelangelesque in the forceful contours of its figures, this detail of the preparatory underdrawing for a fresco shows the immediacy and monumentality of the finest mid-fourteenth-century draughtsmanship. The artist, who painted three other large-scale frescoes at the same site *(The Last Judment, Scenes from the Life of Christ,* and *The Triumph of Death,* for the last of which he is named), is probably to be identified with the Pisan master Francesco Traini or with an artist from the Emilia region of Italy.

2

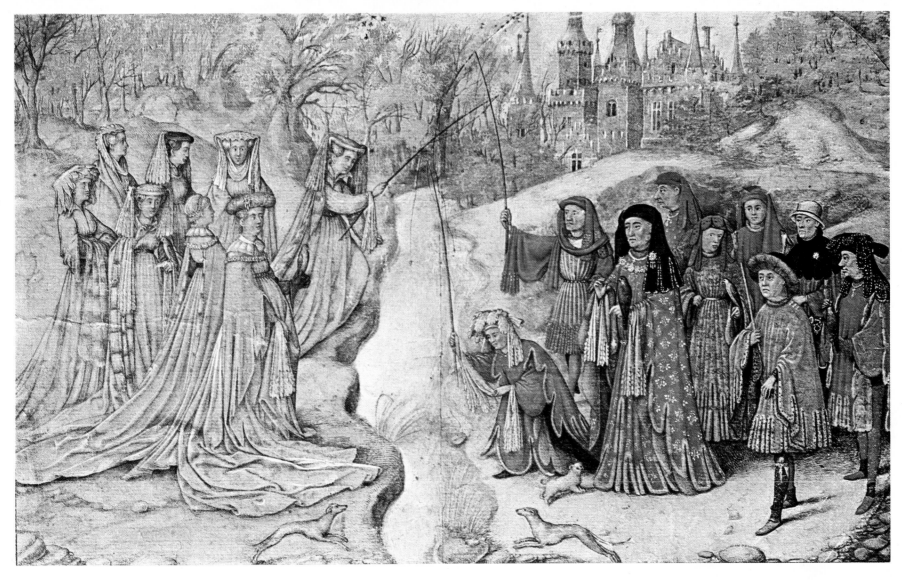

Manner of van Eyck
Flemish early 15th century

3

Fishing Party at the Court of William VI, Count of Holland, Zeeland, and Hainault.
Paris, Musée du Louvre, Inv. no. 20674. Watercolor, with white and gold gouache heightening, on wood; 9 ⅛ × 15 in. (22,9 × 37,5 cm).

Provenance : Owned by Emperor Matthias of Austria (inventory of 1619), remaining till the end of the 18th century in the Kaiserliche Gemäldegalerie, Vienna ; acquired by the Louvre in 1806.

Bibliography : Delaissé, 1968, p. 21 ; Lugt, 1968, no. 10.

Jacqueline of Bavaria is seen fishing with her ladies-in-waiting at the left of the scene. Across a downward-rushing stream she faces her father William VI, who seems to be pictured with all four of her husbands as well as her grandfather and two uncles. Whether the drawing dates from the early fifteenth century and is an authentic work of the circle of Jan van Eyck, or whether it is a fine copy from the next century, it is doubtless an accurate indication of the Flemish master's graphic style and approach to courtly subject matter. While outwardly a scene of princely pastimes, this intricate and highly detailed work may in fact present a complex biographical allegory, in which the artist has defied time by bringing together all the notable men in the princess' life, thus casting her in the emblematic role of a " fisher of fate ".

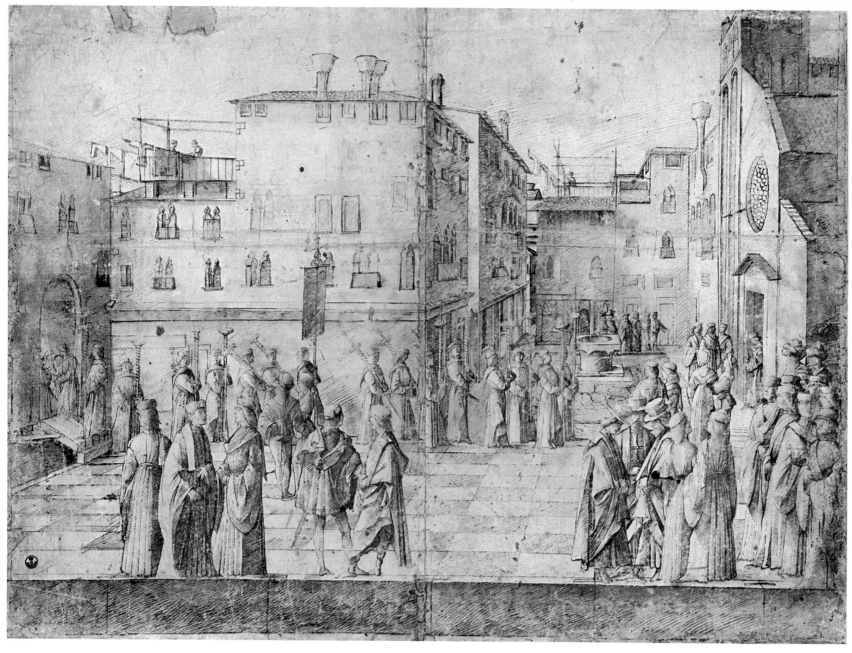

Gentile Bellini
Venice c. 1429 - 1507

4

Religious Procession in Campo San Lio, Venice.
Florence, Uffizi, no. 1293. Pen and brown ink ; 17⅝ × 23⅝ in. (44.2 × 59.1 cm).

Bibliography : Hadeln, 1925, p. 45 ; Tietze, 1944, no. 265.

Since Giovanni Mansueti, an undistinguished Venetian artist of the late fifteenth century, depicted the same scene as part of his cycle *The Miracles of the Relic of the True Cross* (Venice, Accademia), painted for the Scuola di San Giovanni Evangelista, he was long thought to have been the author of this crisp, prismatic drawing. Recently it has been recognized as the work of a slightly earlier, livelier hand — that of Gentile Bellini, who started and supervised Mansueti's series. As always, Venice's unique beauty and sense of mystery steals the scene from her players ; that matchless backdrop comes to the fore regardless of subject, sacred and profane alike. Theologically peculiar in never having produced a single saint for the Church's roster, Venice saw religion mainly in terms of holy days calling for elaborate processions and festivities of Byzantine splendor, punctuated by lavish fireworks and glorious music reverberating amid the many golden domes of St. Mark's.

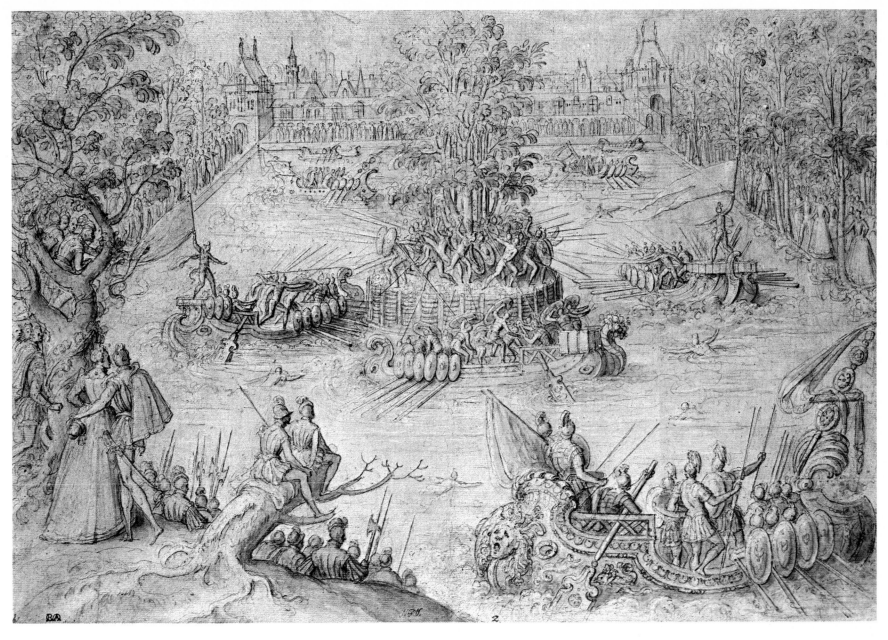

Antoine Caron
Beauvais c. 1525 - Paris 1599

5

Aquatic Fête at Fontainebleau.
Edinburgh, National Gallery of Scotland (acquired 1910). Pen and ink with watercolor, over preparatory drawing in black chalk, and with yellowish highlights; $12\frac{5}{8} \times 18\frac{3}{8}$ in. (31.5 × 46 cm).

Provenance: Coll. David Laing; Royal Scottish Academy.

Bibliography: Ehrmann, 1958, pp. 48, 53; Yates, 1959, pp. 3, 69; Béguin, 1970, pl. XXV.

Belonging to a series of six depictions of lavish fêtes at the royal court of Catherine de Médicis (others: Paris, Musée du Louvre; New York, Pierpont Morgan Library; two in the Witt Collection of the Courtauld Institute, London; Winslow Ames Collection, R.I.), these drawings were later reworked as tapestry cartoons by the Flemish artist Lucas de Heere. Glorifying the Valois family, the eight finished tapestries (Florence, Uffizi) stress royal portraiture and aristocratic life. Caron's scene shows an elaborate water battle staged at Fontainebleau in 1564, the myriad details are rendered in a sprightly miniaturist style. At once documentary and delicately romantic, this modest-sized drawing presents a subtle fusion of a festive event in court life with a prevailing chivalric perspective, in a manner very different from the pompous, overbearing "cult of personality" so evident in the propagandistic tapestry series it was to inspire.

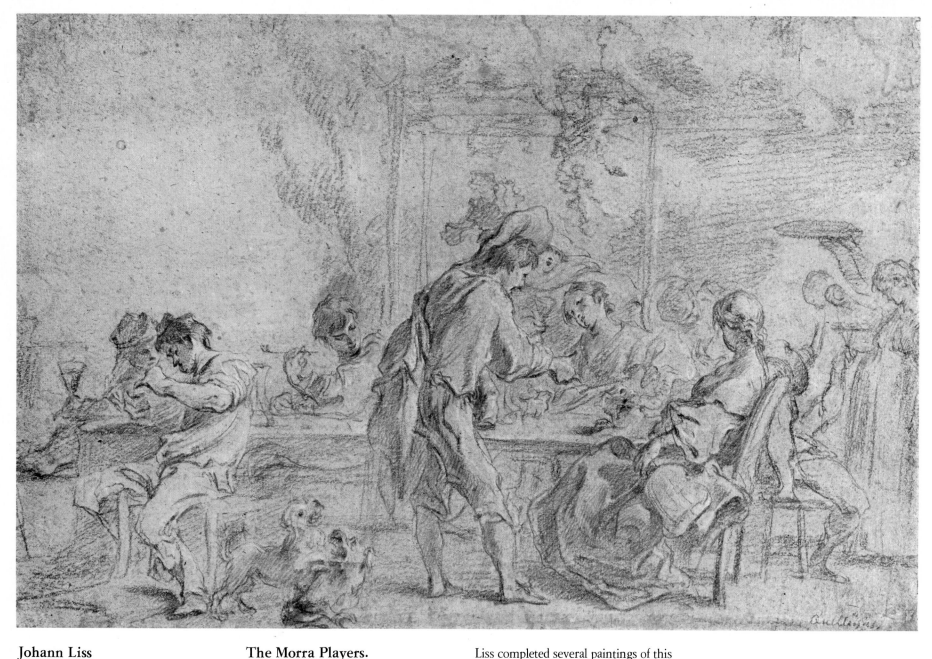

Johann Liss
Oldenburg (Holstein) c. 1597 - Venice 1629/30

6

The Morra Players.
Kassel, Staatliche Kunstsammlungen, no. 1375. Black lead pencil and charcoal, heightened with white lead, on gray paper ; 9 × 13 ⅝ in. (22.4 × 34.2 cm).

Provenance : Colls. Weigelt ; Habich.

Bibliography : Steinbart, 1940, p. 63 ; Pignatti, 1959, no. 35.

Liss completed several paintings of this playful theme (now in collections in Kassel, Bremen, and elsewhere). Like his Italian contemporary Domenico Feti, the German master perfected a relatively small number of subjects. His early death precluded the full development of his widely recognized and much-imitated work. Liss' decorative, picturesque motifs and spontaneous manner seem to anticipate the sparkle of Fragonard, another Northerner whose art was to ripen on encounter with Italy. This sketch is Gainsborough-like in its freely drawn, effective realization of a casual atmosphere of rustic pleasures.

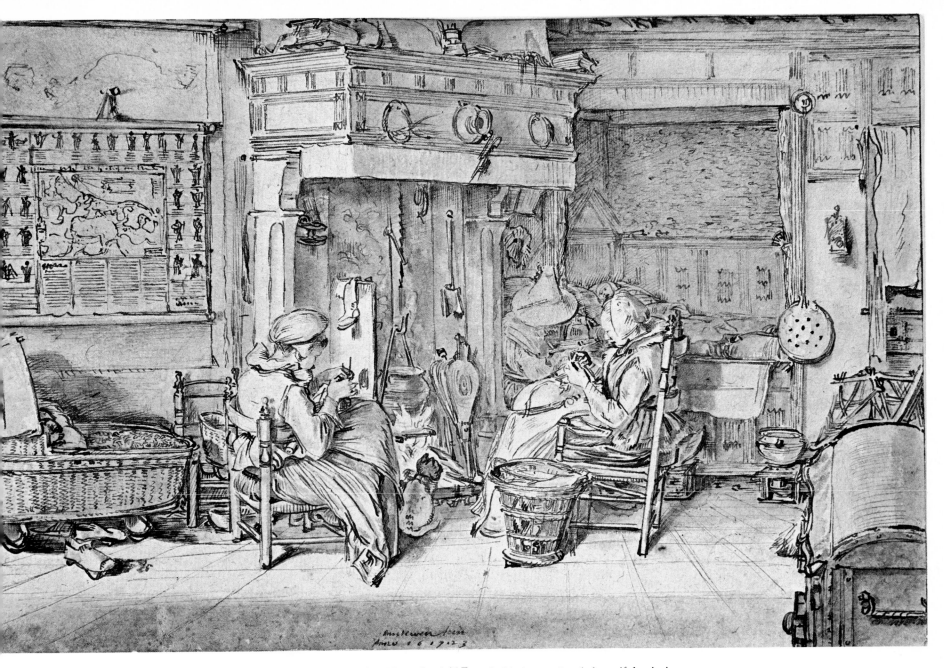

Willem Buytewech
Rotterdam 1591 - 1624

7

Needlework by the Hearth, 1617.
Hamburg, Kunsthalle, no. 21773. Pen
and India ink, brush and bister wash ;
7½ × 11⅝ in (18.8 × 29 cm). Verso
signed and dated : *"buutewech fecit
anno 1617.2.3 "* (most likely denoting
February 3 or March 2 of that year).

Provenance : Colls. V. Rover ; Goll van
Franckenstein ; E. Harzen.

Bibliography : Haverkamp Begemann,
1959, no. 37.

In his innovational, beautiful paintings
and drawings of a variety of domestic
subjects Buytewech, a great master of
genre, broadened the range of themes
acceptable for serious works of art. His
early death resulted in a small, too-
little-known *œuvre.* Buytewech's lumi-
nous yet intimate approach to rendering
figures in space influenced Rembrandt
and, by way of the younger artist's
etchings, much subsequent art. This
same interior appears in more summary
form in a Buytewech drawing now in
Berlin (Staatliche Museen, no. 4609).
The map of the Low Countries visible
at the left is found again in many Ver-
meer interiors.

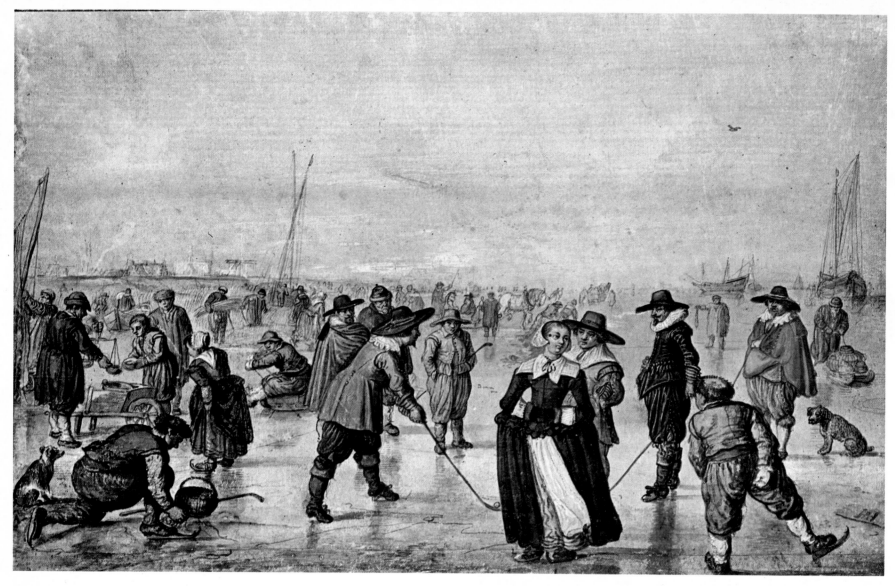

Hendrick Avercamp
Amsterdam 1585 - Kampen 1634

8

Skating Scene.
Haarlem, Teylers Museum. Watercolor ; 7⅝ × 12⅜ in. (19 × 31 cm).

Bibliography : Welcker, 1933, no. 144.

No other people ever enjoyed contemplating the labors and pleasures offered by their land, under broad and ever-changing skies, so much as the Dutch. Reveling in the wintry weather, Avercamp's skaters present a Breugel-like panorama of age and physical variety — an innocent human comedy on ice. Very detailed and highly finished in technique, this watercolor was meant for sale as an independent work of art. Avercamp also did similar scenes as panel paintings, and he may have based the elaborate completed works in both media on series of sketches drawn in situ, as a sort of figural data bank from which he then carefully selected and reassembled components for his deceptively casual tableaux. Such scenes could also be combined in series (one for each season) tracing the year's passage through a cycle of four genial pleasures or social pastimes among everyday folk, just as the Labors of the Months had recorded passing time in earlier works of art.

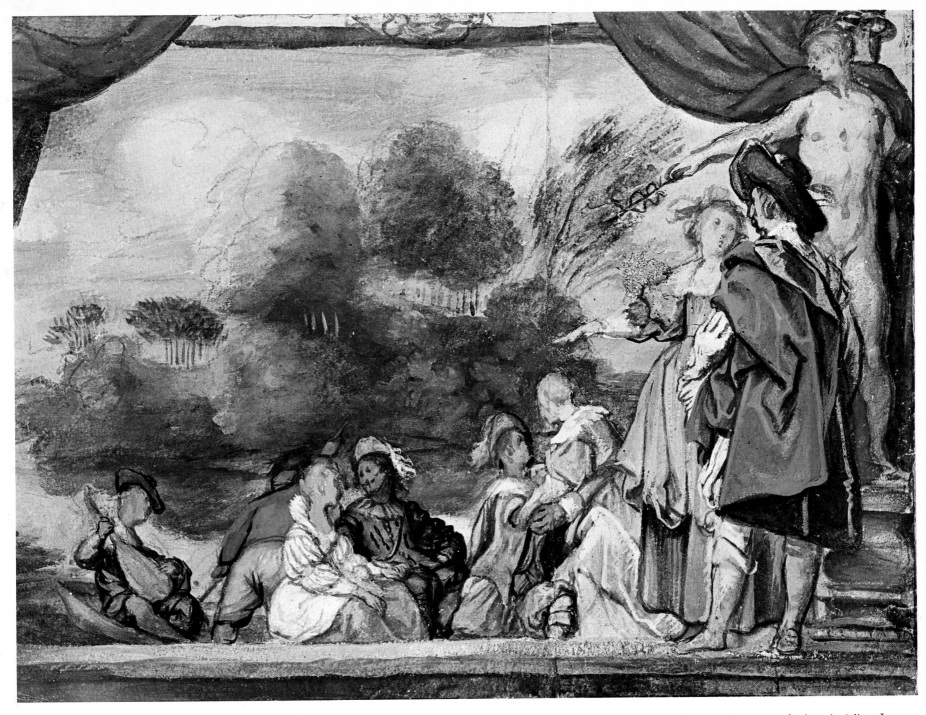

Jacob Jordaens
Antwerp 1593 - 1678

9

Boating Party.
London, British Museum, no. 1885.7.
11.268. Watercolor and gouache, over
charcoal sketch ; 11¼ × 15¼ in.
(28 × 38.1 cm).

Provenance : Coll. W. Russell.

Bibliography : D'Hulst, 1956, pp. 168-
169, 181, 340, no. 49 ; Jaffé, 1968,
no. 173.

Moving back and forth between art and
nature, like a *tableau vivant* presenting
the romantic pleasures of a court that
never was, Jordaens' sketch suggests a
tapestry design in its decorative
approach to narrative. The subject, a
landscape with waterborne lovers, calls
to mind Watteau's celebrated *Embark-
ation for Cythera,* that most tender of
amorous voyages. Watteau, drawn to
the art of seventeenth-century Flanders
and himself of Flemish birth, may well
have had images such as the *Boating
Party* in mind while preparing his own
glorious canvas. Better known for his

rustic scenes of robust joviality, Jor-
daens shows here that he could, when
he wished, rival Rubens's evocations of
idyllic pleasure gardens and other lyrical
settings for love.

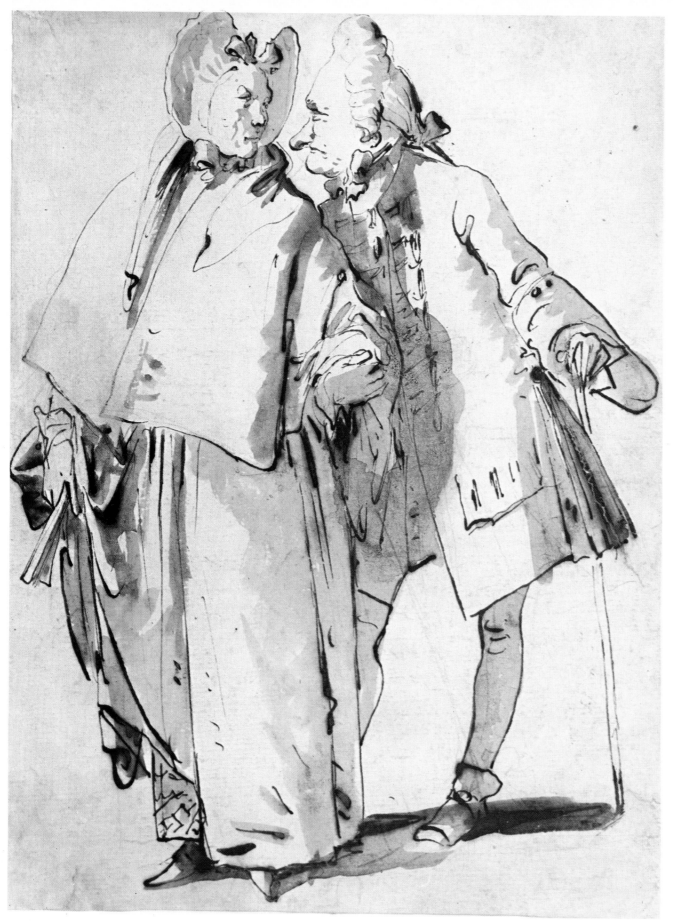

Giovanni Battista Tiepolo
Venice 1696 - Madrid 1770

Elderly Couple Strolling.
New York, Metropolitan Museum of Art, no. 37.165.8. Pen and brush, with brown ink and wash; 8 ¼ × 6 ¼ in. (20.8 × 15.6 cm).

Provenance : Coll. Biron.

Bibliography : Benesch, 1947, no. 39 ; Bean-Staempfle, 1965.

The perpetual ascent of the middle classes — like the presence of the poor — may always be with us. No one knew this better than the Venetians, successful entrepreneurs of a thriving mercantile republic for centuries. Shorn of its worldwide power by the eighteenth century, this uniquely scenic floating city-state still evidenced a comfortable life-style. As satirized by G. B. Tiepolo in a caricatural yet affectionate depiction, the eternal *passeggiata* of the elderly Venetian haut-bourgeoisie bears witness to this conventional existence in what had by then become an " Amsterdam of the South".

10

Francisco Goya y Lucientes
Fuente de Todos 1746 - Bordeaux 1828

That's How They're Raping Her!
Madrid, Museo del Prado, no. 92.
Reddish tempera and wash, on yellowish
paper, 8 ⅛ × 5 ⅜ in. (20.3 × 13.5 cm).

Bibliography : Sánchez Cantón, 1949,
p. 72 ; López-Rey, 1953, I. p. 189 ;
Sánchez Cantón, 1954, I. pl. 7.

This preparatory study is for the seventh
of the eighty *Caprichos,* which Goya
etched between 1794 and 1797. Here
he merges the three protagonists of a
monstrous episode in such a way that
they resemble a pictograph for the letter
" M ", with the struggling victim and
her violators alike locked into a single
unit. Since the finished print has a darker
background, the writhing figure group
emerges more starkly than it does in the
preliminary study, and with still greater
dramatic force. For all its obvious crimi-
nality, this scene also partakes of a
certain picturesque convention that
seems to echo Goya's early years as a
tapestry designer. His experience with
the decorative arts is here transformed
into a harsh yet balanced, balletic tab-
leau — with Goya as the demonic
choreographer of silent violation.

11

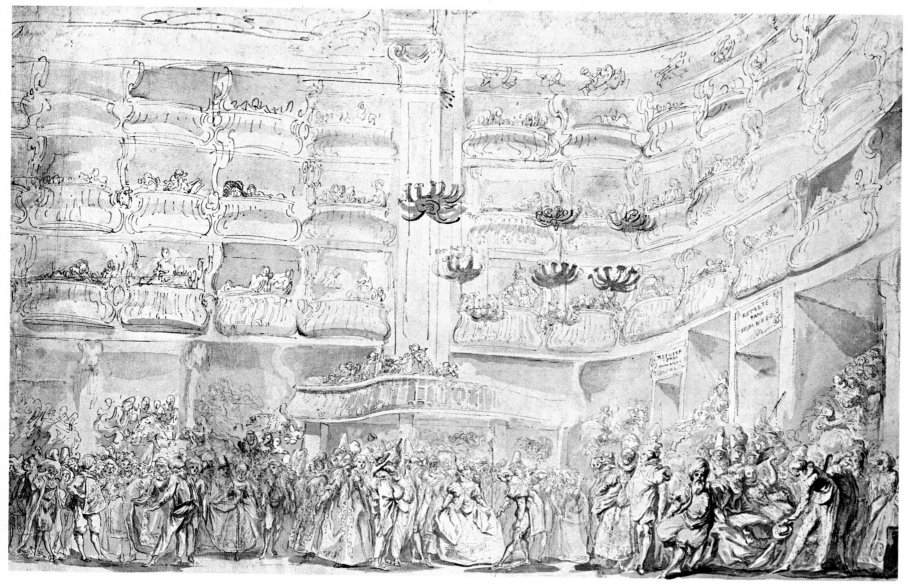

Luis Paret y Alcázar
Madrid 1746 - 1799

12

Masked Ball.
London, British Museum, no. 1890.
12.9.50. Pen and ink, bister and brown
tempera ; 12 × 20 in. (30 × 50 cm).

Bibliography : Mayer, 1915, no. 128 ;
Gradmann, 1939, pl. 23 ; Delgado,
1957, p. 265 ; Sánchez Cantón, 1963,
p. 488.

Astonishing for its scope and the scin-
tillating ambience created within such
modest scale, this drawing is fittingly
the work of a prodigy, done by Paret y
Alcázar at the age of twenty in prepa-
ration for his painting now in the Prado
(reproduced in a print by J. A. C. Car-
mona). So close in spirit and appearance
to the art of eighteenth-century France,
the style of this crowded, gala scene
shows its young artist's familiarity with
prints based on the drawings of Gillot
and Watteau, as well as with others
copied after later masters. Spain, as
shown here, remained sufficiently pros-
perous — still subsidized by the residue
of her colonial empire — to emulate
the follies of Louis XV's France.

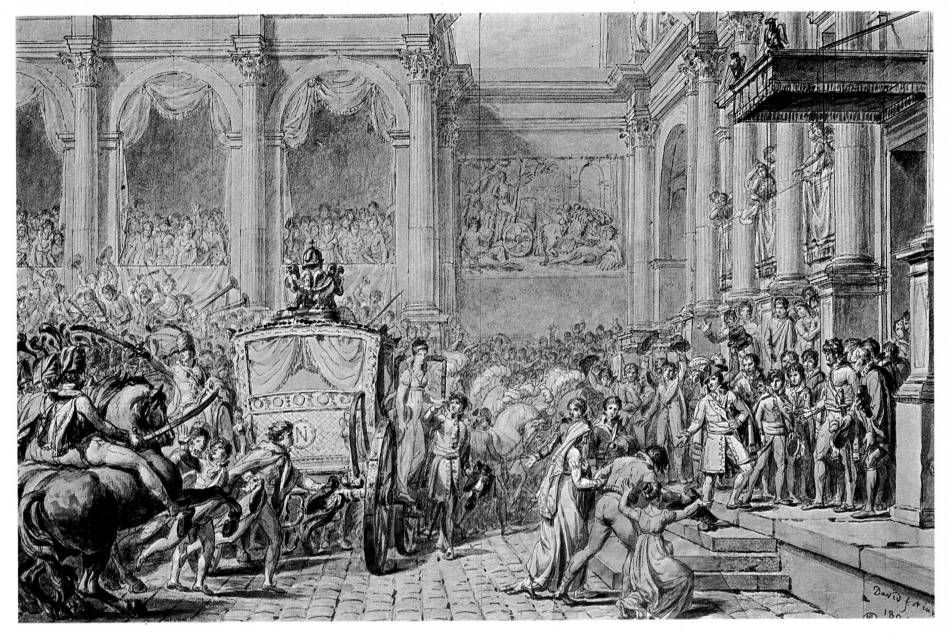

Jacques-Louis David
Paris 1748 - Brussels 1825

13

Napoleon Arriving at the Hôtel de Ville, 1805.
Paris, Musée du Louvre, Inv. no. 3206.
Pen and ink ; 10 ½ × 16 ¼ in.
(26.2 × 40.8 cm). Signed and dated at lower right : *"David f. et inv. 1805 ".*

Provenance : Coll. J.-D. Chassagnol.

Bibliography : Gonzalez-Palacios, 1967, pl. XXX.

Much as he disliked laboring over official narrative subjects such as this, David did them extremely well. Combining secure classical authority with romantic verve, the court painter could take ceremonial scenes of slight actual significance and convert them into impressive "instant history." This is one of a series of four grandiose Napoleonic episodes — the others being *Le Sacre* (1805-1807 ; Louvre), *The Distribution of the Eagles* (1810 ; Versailles), and *Napoleon Enthroned at Nôtre-Dame* (Louvre).

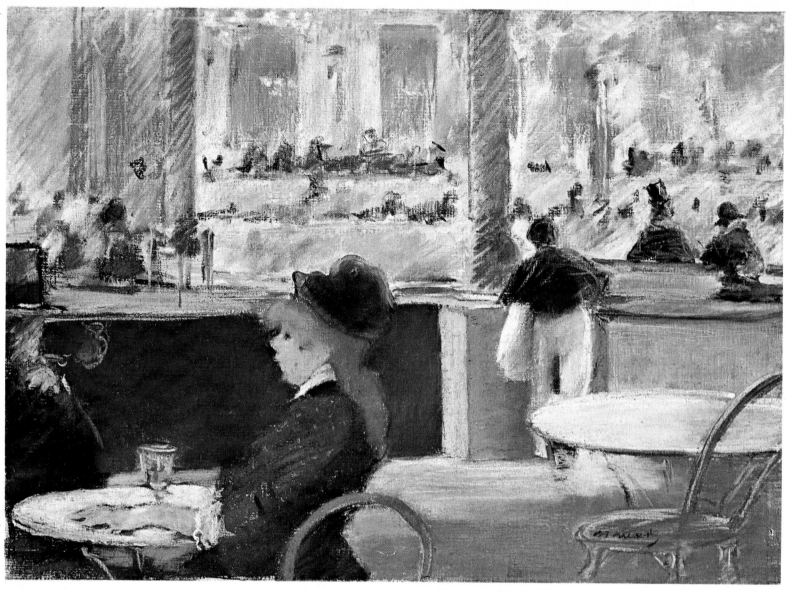

Edouard Manet
Paris 1832 - 1883

14

Café in Place du Théâtre Français, 1881.
Glasgow, Art Gallery. Pastel ;
13 × 18 ¼ in. (32.5 × 45.5 cm).
Signed in lower-right corner : *"Manet."*

Bibliography : A. Tabarant, *Manet et Ses Oeuvres,* Paris, 1947, no. 678, p. 432 ; A. de Leiris, *The Drawings of Edouard Manet,* Berkeley/Los Angeles, 1969.

The special intimacy afforded by the café, its neutral setting so conductive to quiet reflection or leisurely rendez-vous, appealed to the Impressionist painters. Many of Degas's, Manet's, and other French artists' finest works were staged in this peculiarly transient world, where it was the person — and not the locale — who established the protagonists' significance. Informal setting was mirrored by informal technique, as the fleeting vivacity of the café scene was captured by the swift passage of shimmering pastels.

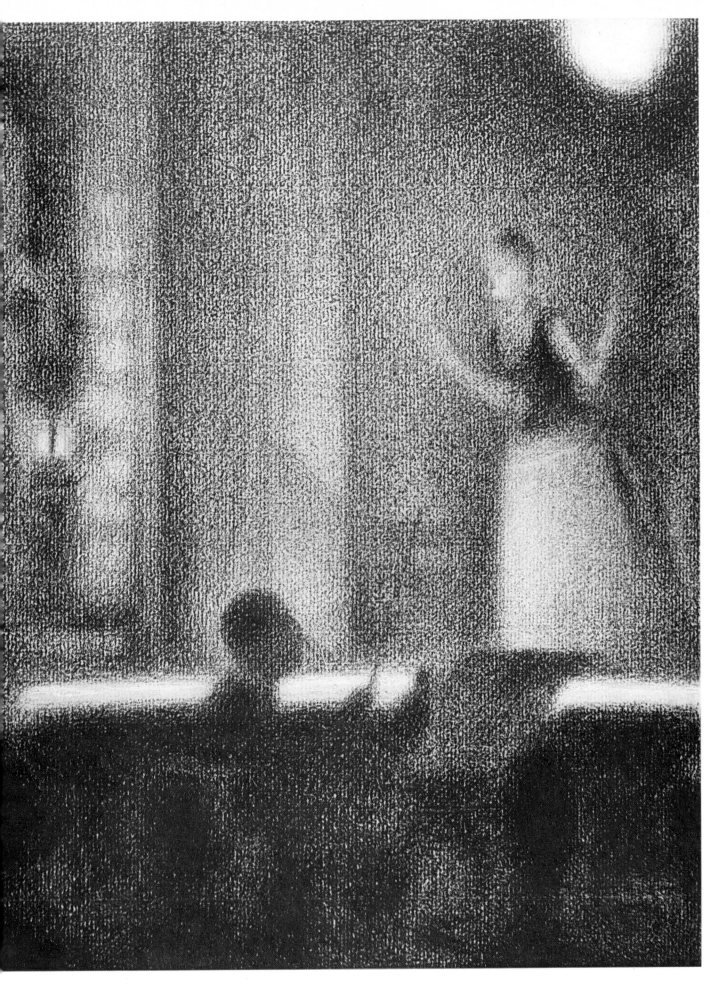

Georges Seurat
Paris 1859 - 1891

Café-Concert à la Gaieté, Roche-chouart, 1887-1888.
Providence, Rhode Island School of Design, Museum of Art. Conté crayon and gouache ; 12 ¼ × 9 ⅜ in. (30.5 × 23.3 cm).

Provenance : F. Fénéon ; De Hauke and Co. ; Mrs. Murray F. Danforth.

Bibliography : De Hauke, 1961, II, pp. 268-269.

The rich blackness of the crayon, caught on the ribs of a strongly textured paper, creates an effect of subtle luminosity, further enhanced by the application of white highlights in gouache. Despite the artist's austere means, Seurat has produced a remarkably evocative drawing, which continues the subject matter of Degas, but in more abstract fashion. Reclusive by nature, Seurat was especially sensitive to the underlying spirit of the " lonely crowd " and sometimes conveyed most perceptively the loss of individuality that is typical of many social situations in which people, by merely echoing one another, never quite hear themselves.

15

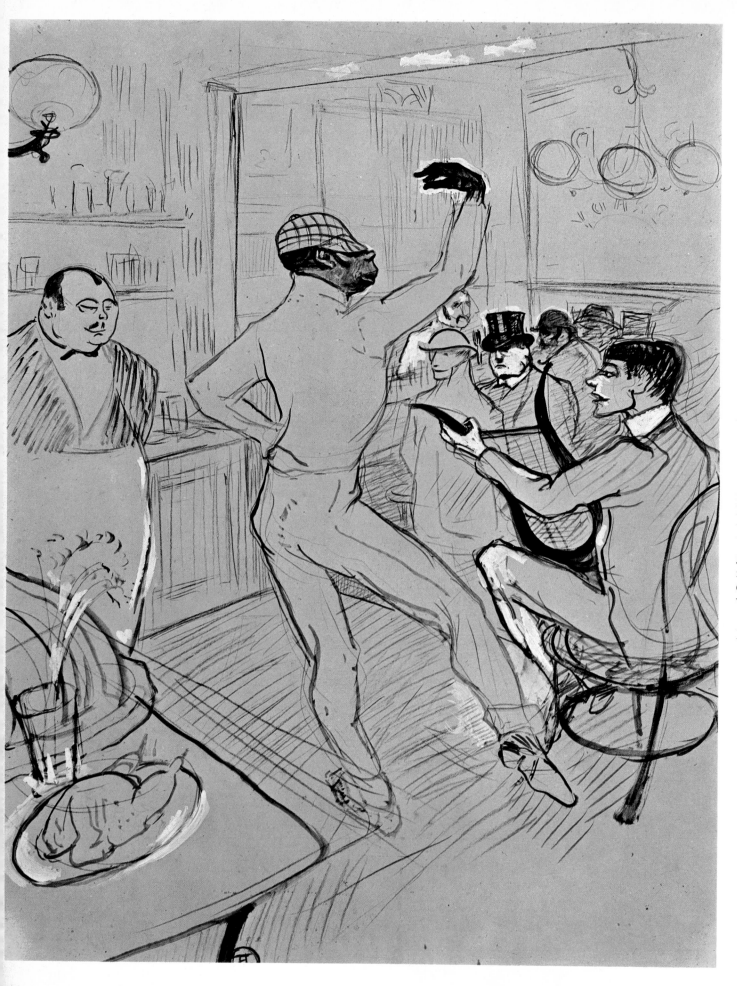

Henri de Toulouse-Lautrec
Albi 1864 - Malromé 1901

Chocolat Dancing at the Bar d'Achille, 1896.
Albi, Musée Toulouse-Lautrec. Brush and India ink wash, with blue chalk and Chinese white heightening ; 30 ¾ × 24 ⅜ in. (77 × 61 cm). Signed at lower left with artist's monogram : *"T-L."*

Bibliography : M. Joyant, *Henri de Toulouse-Lautrec,* II, *Dessins, Estampes, Affiches,* Paris, 1927, p. 219 ; G. Mack, *Toulouse-Lautrec,* New York, 1938, p. 164.

Insouciance — hallmark of the best American dancing — is here captured with characteristic verve, economy of line, and brilliance by Toulouse-Lautrec, the great chronicler of *fin de siècle* Paris nightlife. This sketch of a black dancer known as Chocolat, star of the Nouveau Cirque, was made as an illustration for *La Rire* (no. 73 ; March 28, 1896). Chocolat is shown dancing to the popular song "Be Good to Me, Lovely Stranger" (the caption in *La Rire*), which is strikingly close in mood and spirit, if not in sound, to Cole Porter's later hit "Lady, Be Good." The oblique viewpoint and sudden shifts in scale between the obtrusive table in the foreground and the background figures recall similar compositional traits in Oriental art, then much in vogue in Western Europe.

16

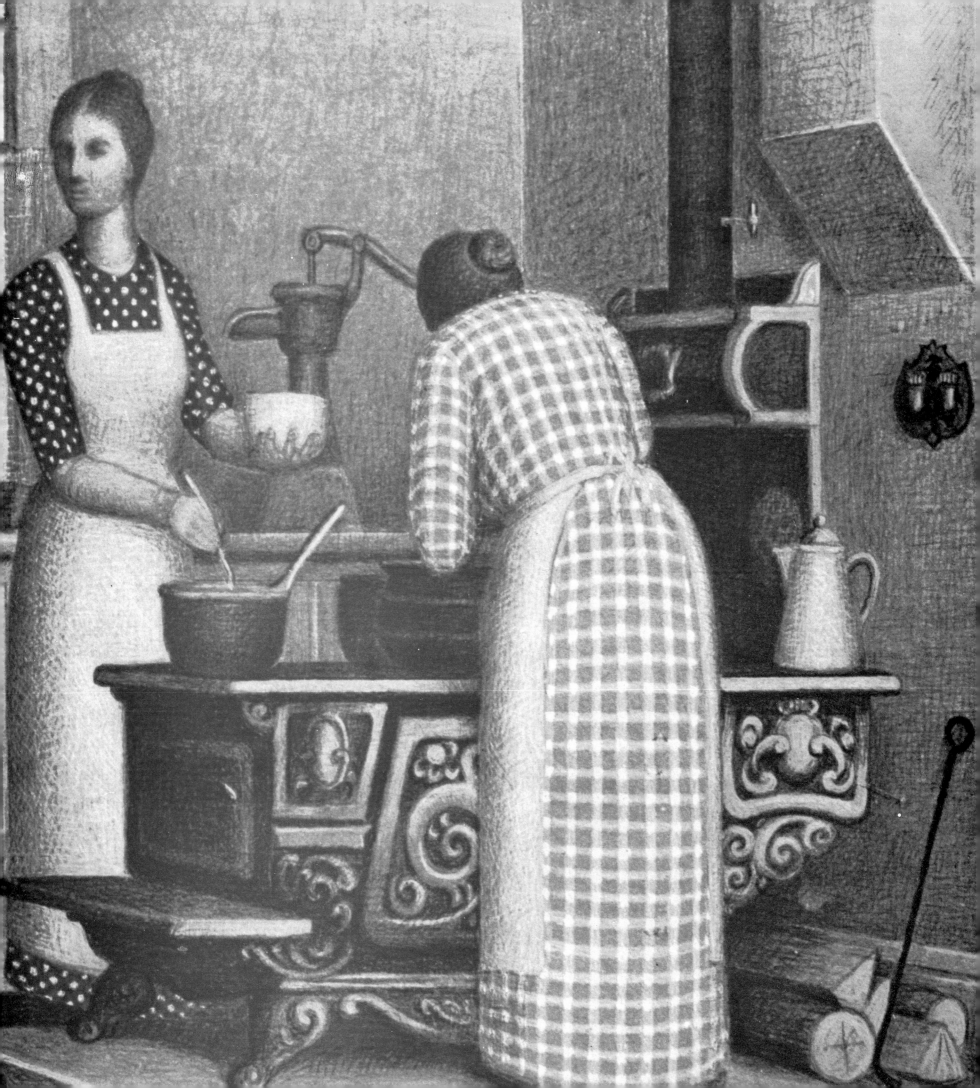

Master of the Housebook F. 1

Active late 15th century

A Bathhouse and Garden with Couples Conversing.

Waldsee (Württemberg), West Germany, Schloss Wolfegg, Coll. Fürst von Waldburg zu Wolfegg und Waldsee. India ink ; 10 ³/₈ × 14 in. (26 × 35 cm).

Bonifacio Bembo F. 2

Brescia c. 1420 - active until 1477 (Lombard school)

Tristan and Lancelot Playing Chess.

Florence, Biblioteca Nazionale Centrale ("Historia di Lancellotto del Lago", Codex Pal. 556, fol. 105). Pen and ink, with touches of silverpoint, on vellum ; 11 × 8 in. (27.5 × 20 cm).

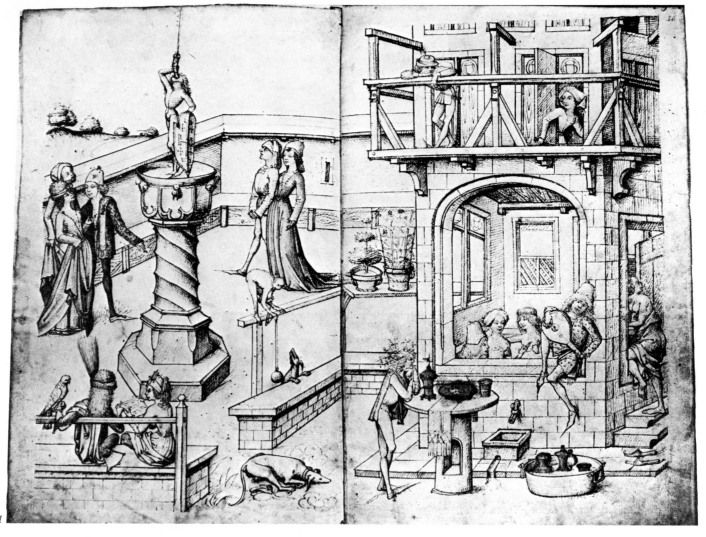

1

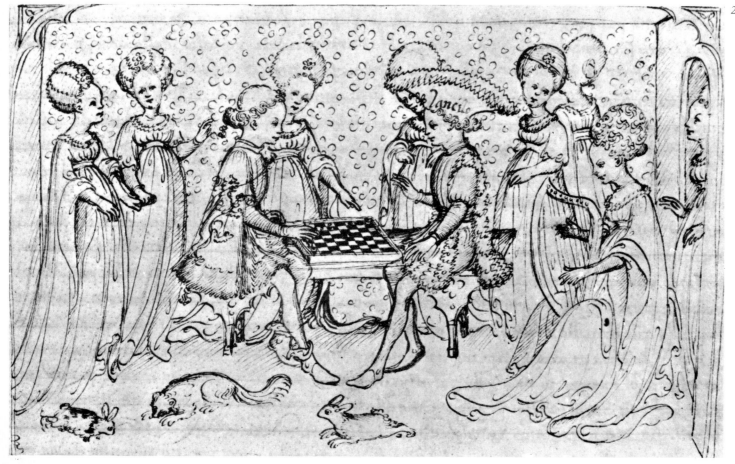

2

3

4

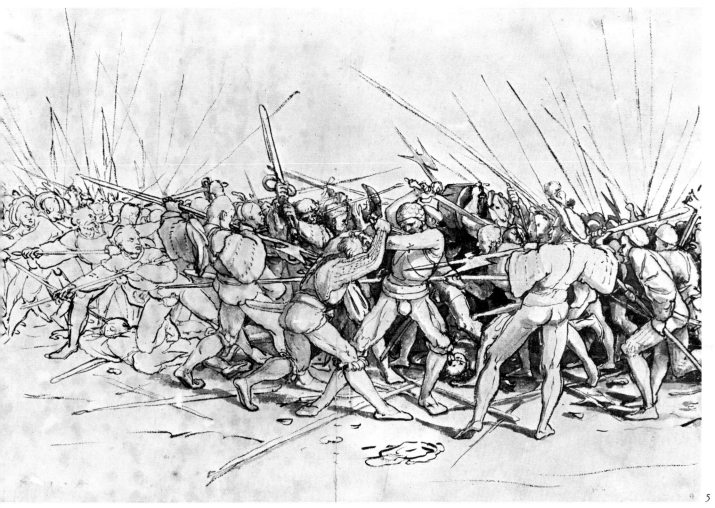

Jorg Breu the Elder F. 3
? 1475/80 - Augsburg 1537
Design for a Roundel - July.
West Berlin, Staatliche Museen. Pen
and black ink, with gray watercolor ;
9 ½ in. diameter (23.5 cm).

Bartolino de' Grossi F. 4
Active c. 1435 - 1464
Two Men on Ladders.
Milan, Biblioteca Ambrosiana, n.F.
261 inf. (Codex Resta, p. 4). Black
chalk, bister with pen and brush, on
unbleached paper ; 8 × 7 ¼ in.
(19.7 × 18.2 cm).

Hans Holbein the Younger F. 5
Augsburg 1497 - London 1543
Battle Scene.
Basel, Kunstmuseum, no. 1662.140.
Pen and ink, with gray watercolor ;
11 ¼ × 17 ¼ in. (28.4 × 43.4 cm).

5

Giovanni Battista Piranesi F. 6
Mogliano (Venice) 1720 - Rome 1778

Workshop at Pompeii.
Providence, R. I., Rhode Island School
of Design, no. 52.039. Pen and ink ;
16 ¼ × 21 ½ in. (40.7 × 53.8 cm).

Claude Gillot F. 7
Langres 1673 - Paris 1722

Acrobats.
Stockholm, Nationalmuseum, Coll.
Cronstedts, no. CC-2384. Pencil, pen
and brown ink, with brown wash ;
33 × 22 ½ in. (82.5 × 56.4 cm).

Giovanni Battista Tiepolo F. 8
Venice 1696 - Madrid 1770

**Group of Seated Buffoons
("Pulcinelli"),** c. 1755 - 1760.
London, Coll. P. Wallraf. Pen and
bister ink with sepia wash, over traces
of chalk ; 7 ¾ × 11 ⅜ in.
(19.4 × 28.5 cm).

6

7

8

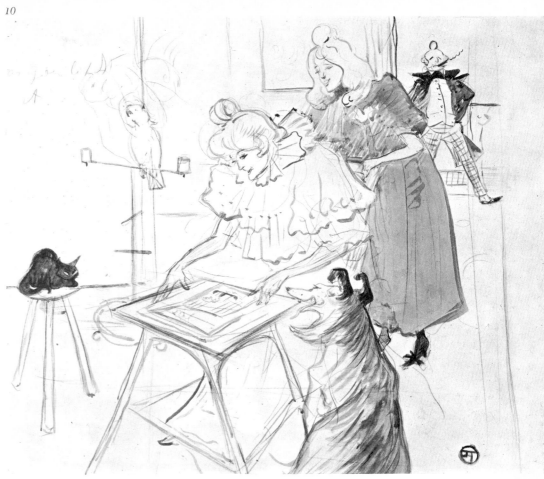

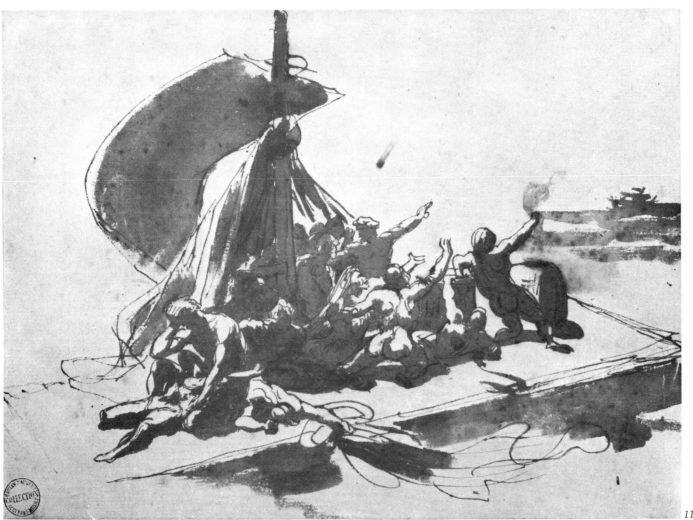

Jean-François Millet F. 9
Gruchy 1814 - Barbizon 1875

The Gleaners.
London, British Museum.
11 ¼ × 9 in. (28.3 × 22.4 cm).

Henri de Toulouse-Lautrec F. 10
Albi 1864 - Malromé (Gironde) 1901

The Motograph.
Paris, Private collection. Blue pencil
and India ink wash on cardboard ;
20 × 24 in. (50 × 60 cm).

Théodore Géricault F. 11
Rouen 1791 - Paris 1824

The Sighting of the Rescue Ship
(study for ''The Raft of the
Medusa'').
Rouen, Musée des Beaux-Arts, Cat.
no. 1385. Pen and ink, with sepia wash ;
8 ⅛ × 11 ¼ in. (20.6 × 28.6 cm).

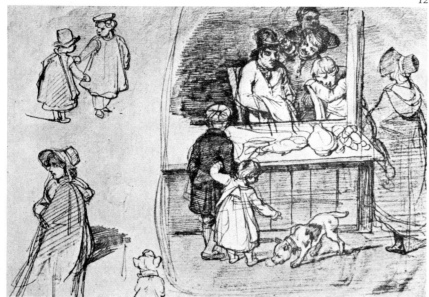

Théodore Géricault F. 12
Rouen 1791 - Paris 1824

The Sleeping Fishmonger.
Paris. Private collection. Pen and ink.

Charles-François Daubigny
Paris 1817 - Auvers-sur-Oise 1878

Episodes from a Journey in His Studio-Boat "Le Botin" (from a letter to Geoffroy-Dechaume, dated 28 October 1857).
Pen and ink ; c. 6.5 × 4.3 in. (16.3 × 11 cm). F. 14

Edvard Munch F. 13
Leyten 1863 - Ekely (Norway) 1944

Study for Ibsen's "Ghosts", 1906.
Oslo, Kommunes Kunstsamlinger Munch-museet, Inv. no. T. 1579. Pen and ink ; 10 5/8 × 8 3/8 in. (26.6 × 21 cm).

Claude Monet F. 15
Paris 1840 - Giverny 1926

Two Fishermen.
Cambridge, Mass., Fogg Art Museum, Harvard University. Black crayon on white scratchboard ; 13 1/2 × 10 in. (34.3 × 25.4 cm).

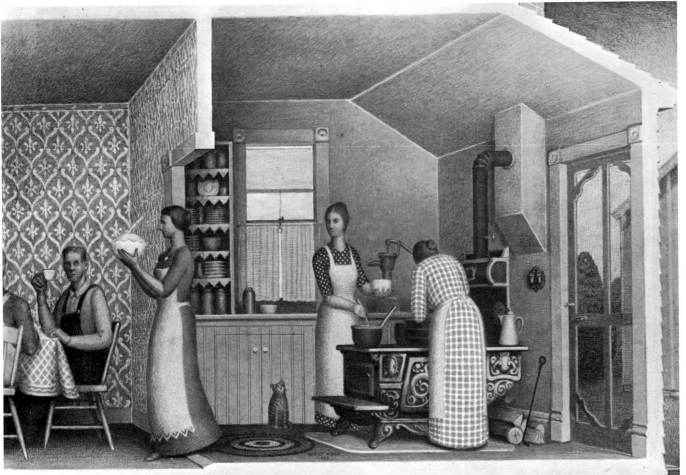

Winslow Homer F. 16
*Boston 1836 - Prout's Neck
(Maine) 1910*
The Last Boat In, 1885.
Andover, Mass., Addison Gallery of
American Art, Phillips Academy,
no. 1934.39. Charcoal ; 8 ¼ × 12 in.
(20.6 × 30 cm).

William J. Glackens F. 17
Philadelphia 1870 - New York 1938
Washington Square, 1914.
New York, Museum of Modern Art.
Pencil and wash, with touches of white
over blue crayon outlines ; 29 × 22 in.
(72.5 × 55 cm).

Grant Wood F. 18
Anamosa (Iowa) 1892 - Iowa City 1942
Dinner for Threshers (study for
right portion of painting), 1933.
New York, Whitney Museum of
American Art. Pencil on brown paper ;
17 ¾ × 26 ¾ in. (44.4 × 66.9 cm).

Still Life

Still life, beginning with its very name, is a paradox in every way; dead yet alive, it is at once among the most spiritual and most material, conventional and personal, abstract and realistic of art forms. Originally the anonymous masters of ancient funerary still lifes dedicated their works to the message "You *can* take it with you" and delineated a counterfeit world of endless provisions, an abundance of foodstuffs and personal items created to ensure man's needs in the everlasting. Thus the roots of still life are buried in ancient Roman depictions of the Seasons, showing a reassuring cycle of divine Providence in which the gods of spring, summer, and fall supply the staff of life in perpetuity. The fruits of man's labors, depicted on tomb walls and on the sides of the sarcophagus itself, affirmed this timeless bond between heaven and earth. As silent messengers of eternal truths, these renderings of loaves and fishes, water and wine, and grape clusters and wheat sheaves all conveyed the everlasting reward of a bountiful Promised Land to the devout worshipers in the Catacombs.

Nature morte ("dead nature," or dead life, if you will), the French term for this genre, indicates its major element—contrast. The deliberately inanimate choice of subject, sometimes further stressed by the presence of a predatory pet or a relentlessly ticking clock, gives this artistic type an inherent contemplative quality, a pervasive tone of quietistic scrutiny. The art of still life could never have developed without its silent sermon of *Ars longa, vita brevis*—Hippocrates' prescription to physicians to do what is best, for doctor and patient alike. This original message concerning physical care, an admonition of the short time available to the medical arts for healing, was to become a philosophical observation on the brevity of human life compared with the long life of art itself.

The quietest of still lifes, delineating abstract geometric shapes for art *and* science, first appeared with the early-fifteenth-century rediscovery of perspective in drawings by Paolo Uccello and Piero della Francesca. Their first renderings of the multifaceted hoops for headdresses *(mazzocchi)*, as well as of complex urns and vases, were reconstructed in the tranquillity of the draughtsman's formal analysis, as if inspired and activated by the subject itself. Object seemingly spoke to artist in a silent dialogue, guiding its transfer from three to two dimensions. This novel sense of studious contemplation, a kind of reverse flow of creativity, is a major basis of still life.

In Uccello's time, lesser artists already specialized in rendering still-life details, adding plants, animals, or elaborate accessories such as jewels and rich drapery to large works commissioned from a major master. Gentile da Fabriano, for example, may have employed Pisanello and Jacopo Bellini to animate his great *Adoration of the Magi* (Uffizi) by adding the veritable arks of animals and herbals of flowers which almost dominate the huge altarpiece, completed in 1423. Flowers capture its cathedral-like frame and peep through its Gothic interstices, lending it a sense of irrepressible life and organic growth. Raphael too had specialized studio assistants, such as Giovanni da Udine, who was well known for his brilliantly drawn birds, flowers, and fruit, which enlivened the Vatican Logge and the ornate walls of the Villa Farnesina.

The independent flower piece—no longer merely the verso decoration of a portrait, meant to recall life's brevity—began in the sixteenth century. Though for purely domestic consumption, such paintings echoed the "Nevermore" of the *vanitas*; in them, falling petals or nibbling beetles still paid dues to the ravages of time. Far-reaching exploration and trade brought precious exotic flowers from the East for

acquisition and close study. Great draughtsmen such as Jan Brueghel and, later, Jan van Huysum drew blockbusting *bouquets imaginaires* that magnificently combined flowers of all lands and seasons, first blooming together in the artist's fertile imagination in a sort of creative triumph over time and tide.

Although Italy produced more than its share of innovative, now largely neglected still lifes, Northern Europe predominated in that genre for quantity, if not consistently in quality. France, Germany, and the Netherlands issued the most numerous drawings of polished cutlery and urns, succulent oysters, lustrous sliced lemons, and fresh-caught fish with glittering eyes and satiny scales. This natural and man-made bounty was usually arranged in dramatic, mouth-watering disarray amid gorgeous napery and drapery and with the moralizing clock or hourglass in view, lest our greedy appetites forget the march of time. The focus shifted somewhat from these "operatic" productions in the eighteenth century, when Oudry and Chardin aimed mainly to entertain rather than to impress with their still life. Still-life drawings of this period fall into irregular decorative confines—the *vignette* and the *rocaille*—showing the highly cultivated rustic "informality" of vine and rock.

From the later seventeenth century on, painters had been able to survive on the production of *nature morte* alone, but this was not considered a very worthy artistic pursuit and was relegated to those unwilling or unable to pursue the glories of history painting. Such unambitious still-life masters were long excluded from the Academy, and their artistic associations were still tied to the limitations of the craft guild. On a practical level, there was far less money in drawing dead birds than in portraying live generals; and lifelike, luscious grapes on a plate couldn't pay the same bills as those enticingly dangled by a roistering Bacchus over a naughty bacchante.

Artists well known for grandiose official commissions, painters from Rubens to Adolph von Menzel, at times treasured the retreat and repose afforded by drawing still life, an intimate solace happily removed from the sterile pomp of court life, with its insatiable demand for propriety and flattery. Only the *nature morte* could so gratifyingly escape the bonds of style and go beyond the dulling restrictions of fashion. Here, then, a rose is a rose *is* a rose, and the animal *is* dead, with only perhaps a vegetable and a mirror attending its wake.

Many drawings of still-life elements were prepared for fashionable portrait studios, where assistants filled in acres of curtains, urns of flowers, carpets, shoes, gloves, belts, and jewels to create a lavish *mise-en-scène* that distinguished a Somebody from Everyman. In the eighteenth century, when the *nature morte* was brought to superb perfection, the sitter in such a portrait may at times become reduced—or elevated—to a static fixture of that genre, less a living likeness than a neutral repository for the arts of the jeweler, wigmaker, *visagiste*, embroiderer, ribbonmaker, tapestry and carpet weavers, *ébéniste*, decorator, gardener, architect, and florist. This impressive orchestration of detail could then be repeated at will, for standard repertories of drawings, down to every rosette and button hook, allowed for an almost programmed repetition of such portraits and figure groups, where only the faces varied just enough from a *beau idéal* to allow for the merest breath of individuality and recognition.

French eighteenth-century art was frankly committed to a lighthearted retelling of that of Venice and those Venices of the North, Amsterdam and Antwerp. Their

mercantile acquisition of the world's goods spoke volumes to Paris—as ever, the supreme consumer society and leader in both *haute cuisine* and *haute couture*. Still life now began to play a special role as a responsive vehicle for the new Western mania for exotic styles. In *chinoiserie*, *japonaiserie*, and *turquerie*, objects appeared in fancy dress; chairs, chandeliers, and chamber pots alike assumed foreign airs and graces. At once reticent, amusing, and reflective, still life provided a welcome pictorial outlet for the Rococo passion for an eclectic, exotic profusion of material possessions: figurines, porcelains, clocks, fans, corals and shells, and all sorts of *objets* from East and West lived graciously together in these silent peaceable kingdoms. The age of the Encyclopedia—first in England and then in France—brought with it a fascination for the comprehensive which extended to the still life as an attractive visual catalogue, a selective *Wunderkammer*.

As Diderot's enlightened materialism gave way to the classical pomp and emotional circumstance of the Romantic age, with its ambivalent strivings for the twin grandeurs that were Rome and Roman Catholicism, still life per se practically disappeared. With its sensitive and sensible limitations, it was drowned first in tidal waves of Napoleonic pictorial propaganda and then in the *propaganda fide* of the religious revivals. Except for the glorious flower pieces of Delacroix and Courbet and a few other rare instances, such as Millet and Manet's floral studies or Caspar Friedrich's plant studies, the major nineteenth-century achievement in still life lay in *trompe-l'œil*. Stimulated by early photography, artists in Düsseldorf and America produced illusionistic masterpieces rivaling those of antiquity. In these compositions the revelations of the camera eye permitted the artist an unending, almost Eyckian care with detail, and the finished painting's glossy surface seemed an astonishing mirror of flowers and fruit, old pipes and new tobacco, or paper, quill pens, and sealing wax.

This new, magical scrutiny and reproduction of nature was soon assimilated in art instruction founded on the conveniently immobile still life; its sentinel bottles and slowly rotting "odalisques" of fruit avoided the expense and distraction of live models. By the mid-nineteenth century, every drawing manual was filled with geometric shapes—unwitting forerunners of Cézanne and Cubism—which the young draughtsman copied with his needle-sharp pencil. As he explored the passage of light over a glass of water, he was expected to delineate contrasts of light and shade, hardness and softness, reflections and liquidity, convincingly with graphite alone.

The nineteenth century, even more than the preceding one, was a century for flowers, whether climbing over endlessly varied wallpapers or woven by the inventive looms of Lyons. Freed from rigorous Linnaean taxonomy, flowers gained in character as well as name as they sprang from herbaceous borders with compelling power first captured by the great draughtsmen for Thornton's *Temple of Flora* (1807). In such works, Linnaeus' "prose" was embellished by a Darwinian poetry in art. Half a century later, Baudelaire's *Fleurs du Mal* (1857) were to tend quite another garden, whose insinuating Gallic flowers came to haunting bloom in Redon's drawings, then later were rife in Art Nouveau design.

Flowers and fruit, as cut and arranged by such Impressionists as Renoir, Monet, Pissarro, and Sisley, blossomed anew in the late nineteenth century. Through a new use of color and brushwork, a novel perception and re-creation of optical experience, still life was realized afresh by them. Their deliberately artless paintings of middleclass

Still Life

domestic pleasures, of teacups or of field flowers in homely pots and crocks, may well have proved easier to sell to contemporaries than their more ambitiously naturalistic subjects did. Following Delacroix's brush, pen, and pencil, wise Impressionists saw still life as an appropriate vehicle for their curiously personal yet documentary approach. Van Gogh and the Symbolists also exploited the mysterious latitude of the genre; their spare and intense still-life arrangements proved that new potatoes and old shoes, as well as tropical fruit with mute idols, could convey moving lessons in religious justice and Oceanic mores. Their sensitive scrutiny of the emblens of poverty at home or of distant paganism were far more profound and arresting in a quiet way than were images of hungry peasants or exotic topless virgins.

But Cézanne stopped all that latent emotional communion. Be it in portraits, landscapes, or still life, the great Provençal master urged painters to "Treat nature by [according to] the cylinder, the sphere, and the cone." In this reverent harking back to the clarity of Poussin and Uccello, to an almost Pythagorean reading of creation in terms of the mysterious harmony of abstract form and number, Cézanne was reacting against the increasingly unstructured *oeuvre* of the late nineteenth century. This solitary master saw his subjects as if petrified, something to be rigorously analyzed and lovingly preserved by his pen and pencil, brush, watercolor, and oil. Such revelation of new-old truths in the geometry and poetic silence of inanimate objects was shared by Cubism. With their own formal fundamentalism, the Cubists searched for a new visual verity beyond the deceptive surface, perhaps toward some new *vanitas*.

The Fauves, followed by the Expressionists, found the language of flowers an essential element in a newly uninhibited vocabulary merging Golden Age and forest primeval. In their work the deliberately naïve—the delectable excitement of mastering the Academy and then leaving it behind—led to a "riot of color," to a dancing delineation of flowers and fruit vividly engaged in passionate encounter.

The loveliest still-life drawings respond without polemic to what the artist sees. Such diverse modern masters as Bonnard, Demuth, Sutherland, and Kelly have found in the mute object or silent nature a message, to be felt and traced. Thus, the most impersonal subject matter—through an art almost without ego—speaks directly to the viewer, as if the artist-intermediary, in transposing the object from actuality to the plane of art, were never there. Spectral tables set by Giacometti bear frugal repasts on which only his skeletal models could survive, suggesting a negative definition of sustenance as something that is not given sufficiently. Rising cliff-like from limitless tabletops, Morandi's bottles assume a special force, blown up beyond prosaic use into a realm of poetry, contemplative and monumental yet elusive in their subtle massing. Other modern still life is quite the reverse: Sutherland, for instance, seems to energize a boat-like vase of flowers into dramatic action, as if aggressively confronting their mirror image in a naval skirmish of rival narcissus.

Several twentieth-century masters—Matisse from early in the century, followed by Braque, Gris, and Picasso—revived the richly orchestrated splendors of the Baroque still life. Handsome classical busts, graceful china and silver, and choice fruit in elaborate settings all proclaimed peace and plenty, both art and artist in idyllic harmony with a Golden Age before the harsh reality of the Great Depression.

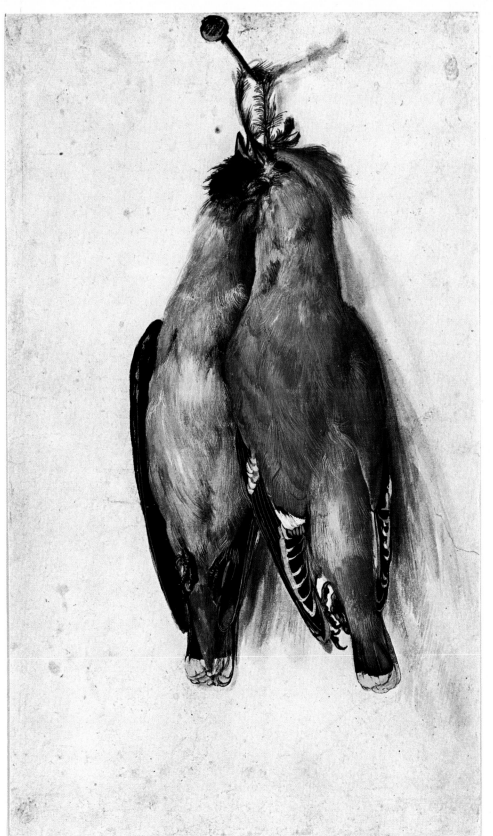

Lucas Cranach the Elder
Kronach 1472 - Weimar 1553

Two Dead Birds Hanging from a Nail, c. 1530.
Dresden, Staatliche Kunstsammlungen, no. C2179. Watercolor and gouache; 13⅞ × 8⅛ in. (34.6 × 20.3 cm).

Bibliography : Girshausen, 1936, p. 52, no. 73 ; Rosenberg, 1960, no. 69.

Rendered with *trompe l'œil* finesse, this study of dead partridges nails them to a wall with extraordinary verisimilitude, in one of the first such images since classical antiquity. It follows a model established by the Venetian master Jacopo de' Barbari, who went to Northern Europe and was active in the Netherlands and Germany in the early sixteenth century. Cranach's drawing captures the very essence of still life, or *nature morte* — dead nature — a segment of life that is arrested so it may be closely observed by the artist.

1

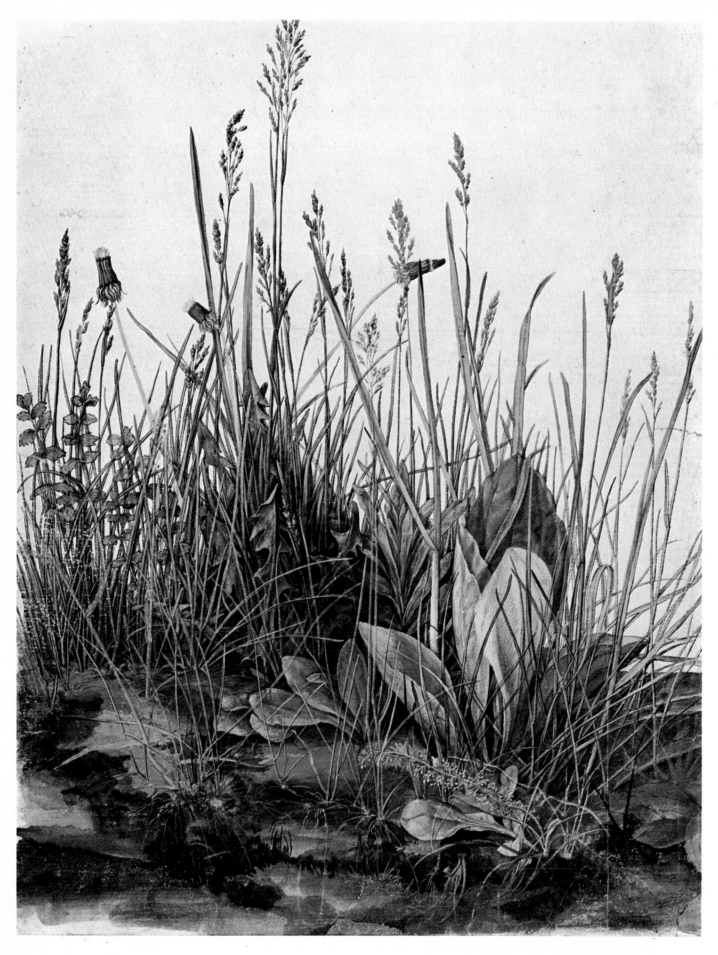

Albrecht Dürer
Nürnberg 1471 - 1528

The "Great" Turf, 1503.
Vienna, Albertina, no. 3075. Watercolor and gouache ; 16½ × 12⅝ in. (41.1 × 31.5 cm).

Bibliography : Flechsig, 1931, II, p. 366 ; Tietze-Benesch, 1933, no. 54 ; Winkler, 1939, no. 346 ; Panofsky, 1948, no. 1422 ; Winkler, 1957, p. 183.

One of a series of nature studies done in the years 1503-1505, this closeup of grasses and field flowers combines the objective descriptiveness of earlier herbal illustrations with the microscopic attention to detail first found in the art of Jan van Eyck. To these sources the young Nürnberg master added a strange sense of the monumental, a contradiction of scale that makes these meticulously observed blades of grass appear as if they were actually the size of giant redwoods. Probably intended for re-use as a small area of a painting, Dürer's remarkable study of turf asserts an almost cosmic independence ; so complete unto itself, this minute landscape is a part that impressively conveys the greatness of the whole natural realm.

2

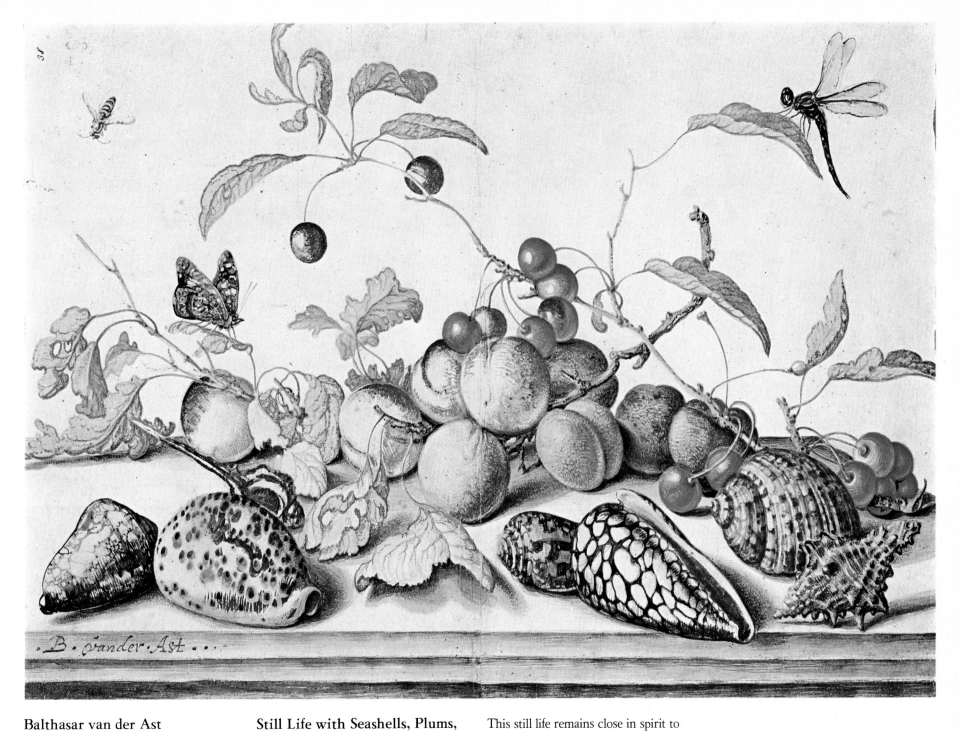

Balthasar van der Ast
Middelburg 1593/94 - Delft 1656/57

3

Still Life with Seashells, Plums, and Cherries.
London, British Museum, Ast no. 1.
Watercolor and pen ; 11⅝ × 16 in.
(29.1 × 39.9 cm). Signed in lower-left corner : *"B. vander. Ast. "*

Provenance : Coll. Sloane.

Bibliography : Van Gelder, 1958, no. 31

This still life remains close in spirit to the emblematic *vanitas* of the sixteenth century. Tender, vulnerable plums, peaches, and cherries contrast with the durability of the seashells and the masonry ledge they rest upon. The fruit is victim to insects (the fly, bee, and dragonfly are all signs of mortality and transience) and to the passage of time, while the rock-like shells of the *fruits-de-mer* remain immutable and timeless. The drawing probably reproduces a finished painting by Van der Ast ; it is close to a work he painted on metal, signed and dated 1628 (London, Alfred Brod Gallery), and another on wood (London, Koetser Gallery).

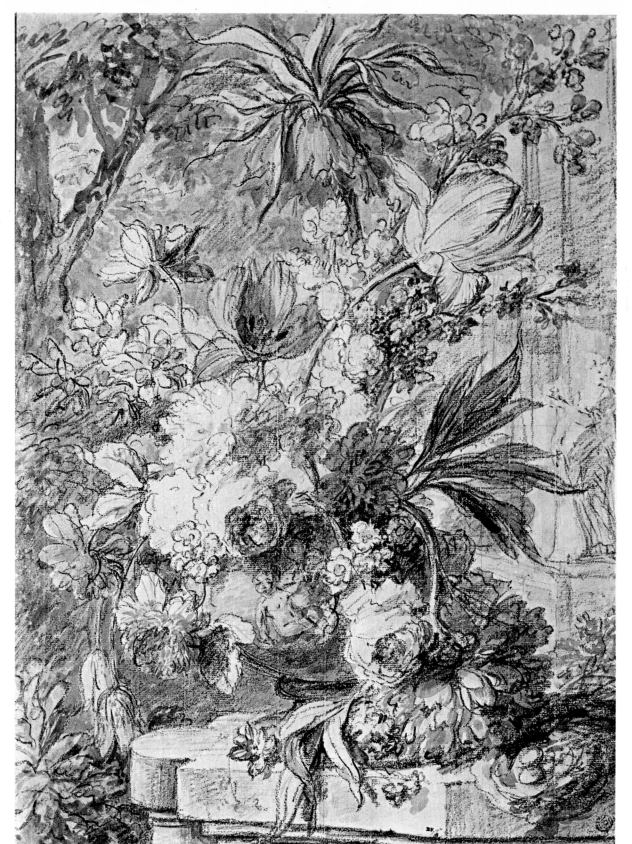

Jan van Huysum
Amsterdam 1682 - 1749

Urn of Flowers.
Paris, Musée du Louvre, Inv.
no. 22669. Black chalk and watercolor ;
19 × 14¼ in. (47.5 × 35.6 cm).
Bibliography : W. Bernt, *Nieder-
ländische Zeichner des 17 Jhr.,* I, 1957,
no. 317 ; White, 1964, p. 20, no. 109.

A great flourish of tulips, amaryllis,
roses, and other flowers overflows a
bronze urn embellished with *putti.* The
classical statue faintly visible on the
right seems to point at the artificially
arranged opulence of this impossible
floral display, in contrast to the natur-
alistic setting of trees and shrubs in
which it is placed. Such idealized mix-
tures of blooms, which existed in the
artist's mind rather than in nature and
which often bridged seasons and coun-
tries, were popular since Jan Brueghel's
influential floral pieces of the late six-
teenth century — an impressive tribute
to that painter's creative powers. This
sketch is for a painting dated 1726
(London, Wallace Coll., no. 149). There
are two additional drawings that were
probably for the same work : one earlier
(Haarlem, Teylers Museum, no, T. 12),
and another later (London, Lousada Coll.).

4

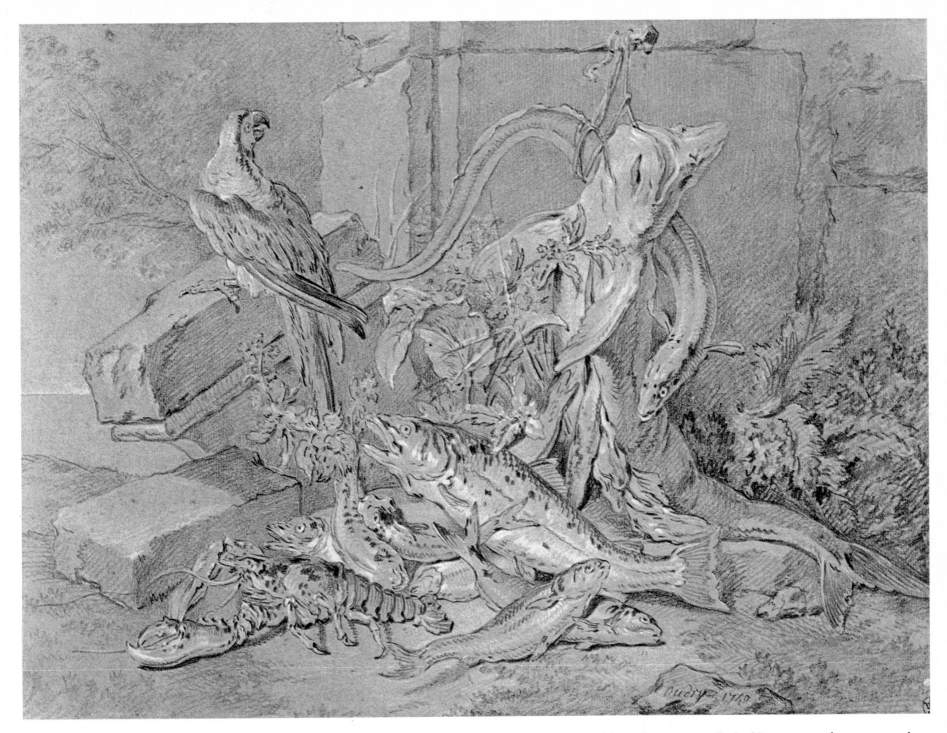

Jean-Baptiste Oudry
Paris 1686 - Beauvais 1755

5

Still Life with Parrot and Eel.
New York, Cooper-Hewitt Museum.
(Courtesy of the Cooper-Hewitt Museum
of Decorative Arts and Design, Smith-
sonian Institution). Black and white
chalk on bluish paper ; 12¼ × 16¼ in.
(30.5 × 40.8 cm). Inscribed at lower
right : *"Oudry 1740."*

Provenance : Coll. E. Hewitt (sale,
October 1938).

Bibliography : T. Vallery-Radot, *French
Drawings, from the 15th Century
through Géricault,* New York, 1962,
p. 72, pl. 40 ; R. P. Wunder, *Extra-
vagant Drawings of the Eighteenth Cen-
tury,* New York, 1962, no. 53.

This varied selection of *fruits-de-mer* —
lobster, eel, ray, and at least three
other varieties of fish — is arranged in a
carefully informal, decoratively irreg-
ular format similar to the *vignette* and
rocaille, fashionable groupings in the
first half of the eighteenth century.
Oudry employed these devices in his
designs for both the Beauvais and Gobe-
lins tapestry works during the 1730's.
The perishability of these tempting
edibles contrasts with the enduring rock
wall which serves as their backdrop.
Though the masonry may crumble into
picturesque disarray beyond man's
design, it will surely survive his human
appetites, as signified by the "bouquet"
of fish for *bouillabaisse* in the foreground.

Such oblique contrast between mortal-
ity and immortality is often found in
the still life or *nature morte,* its message
being that of *vanitas.* Oudry's wish for
enduring fame is suggested in the
artist's placing his name on a rough stone
in the foreground, while a parrot —
traditional emblem of artistic imitation
— perches at the upper right.

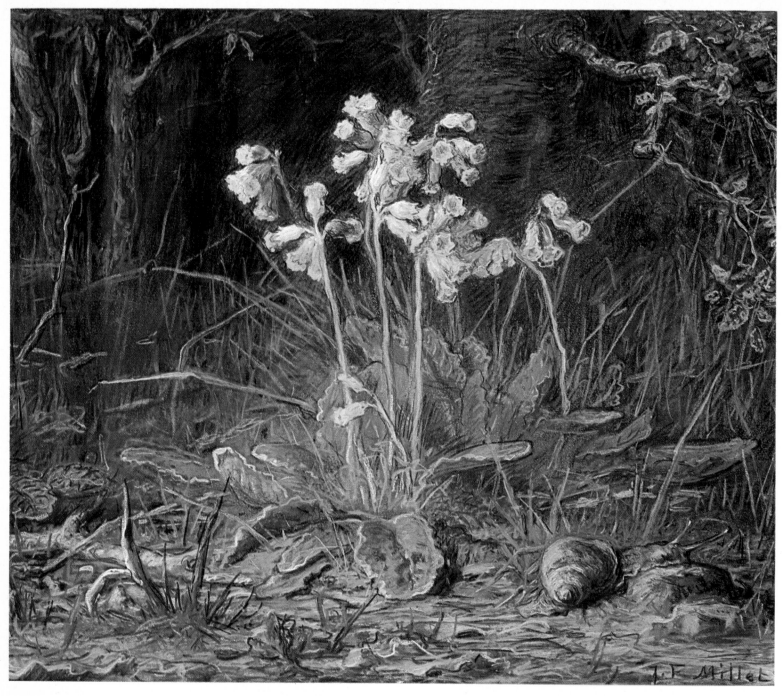

François Millet
Gruchy 1814 - Barbizon 1875

6

Primroses, 1868.
Boston, Museum of Fine Arts. Pastel;
16 × 19 in. (40 × 47.8 cm). Signed in
lower right corner: *"J. F. Millet."*

Bibliography: *Quincy Adams Shaw
Collection,...,*Boston, 1918, p. 93,
no. 49.

Millet's pastel primroses have a deli-
cately tinted freshness not usually found
in the darker, bleaker perspective of the
Barbizon School. These flowers are
first of all themselves, springing to life
through the artist's direct, delightful
realism, as they survive the slug's
appetite for another brief moment in
their frail, beautiful existence. Though
endowed with some of the moralizing
import of the *vanitas* (note the more
hardy snail in the right foreground) —
that is, suggestion of beauty's brief
bloom before an all-consuming death —
Millet's primroses anticipate the
Impressionist's sunnier outlook.

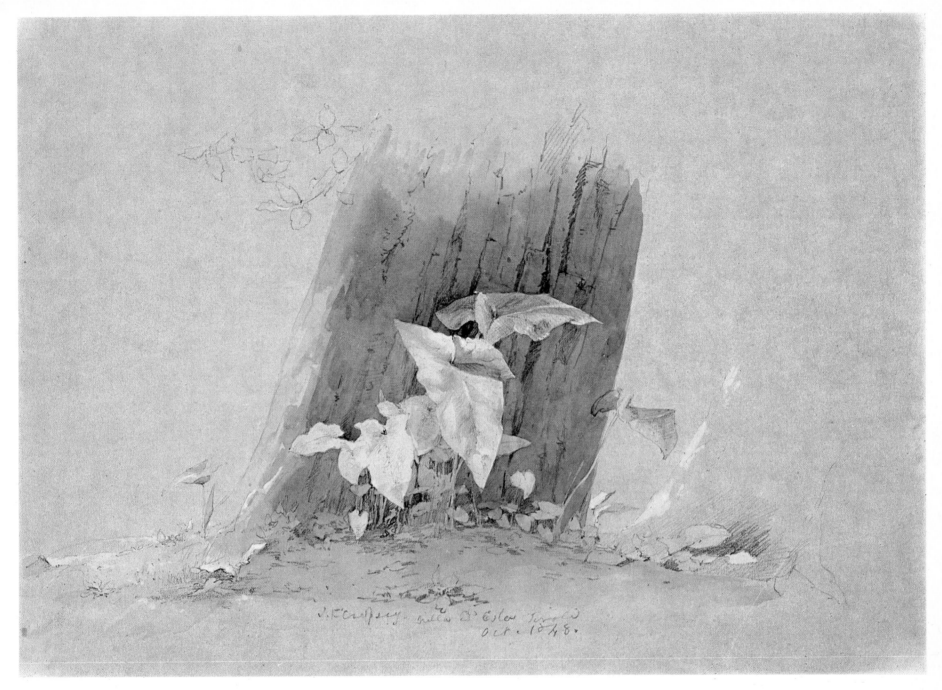

Jasper Francis Cropsey
Rossville (N.Y.) 1823 - Hastings-on-Hudson (N.Y.) 1900

7

Plants against Tree Trunk.
Boston, Museum of Fine Arts, M. & M. Karolik Coll., Acc. no. 54.1632. Pencil and washes ; $11\frac{3}{8} \times 15\frac{7}{8}$ in. (28.5 × 39.7 cm). Inscribed at lower center : *"J. F. Cropsey - Villa d'Este Tivoli - Oct. 1848."*

Provenance : M. & M. Karolik Coll.

Bibliography : *M. & M. Karolik Collection of American Water Colors and Drawings, 1800-1875*, Boston, I, 1962, pp. 124, 126, no. 200.

Drawn during the young American artist's honeymoon on his first trip to Europe, this study was made in the gardens of the Villa d'Este at Tivoli, outside Rome. Rather than record the abundant larger picturesque vistas afforded by this famous site, Cropsey preferred to render a few fragile leaves, against the foil of a protective yet somewhat forbidding tree trunk, as signs of emergent life and hope. In this, he shares the intensely romantic, intimate response to nature found in Friedrich's *Ferns* or in Wordsworth's "Daffodils".

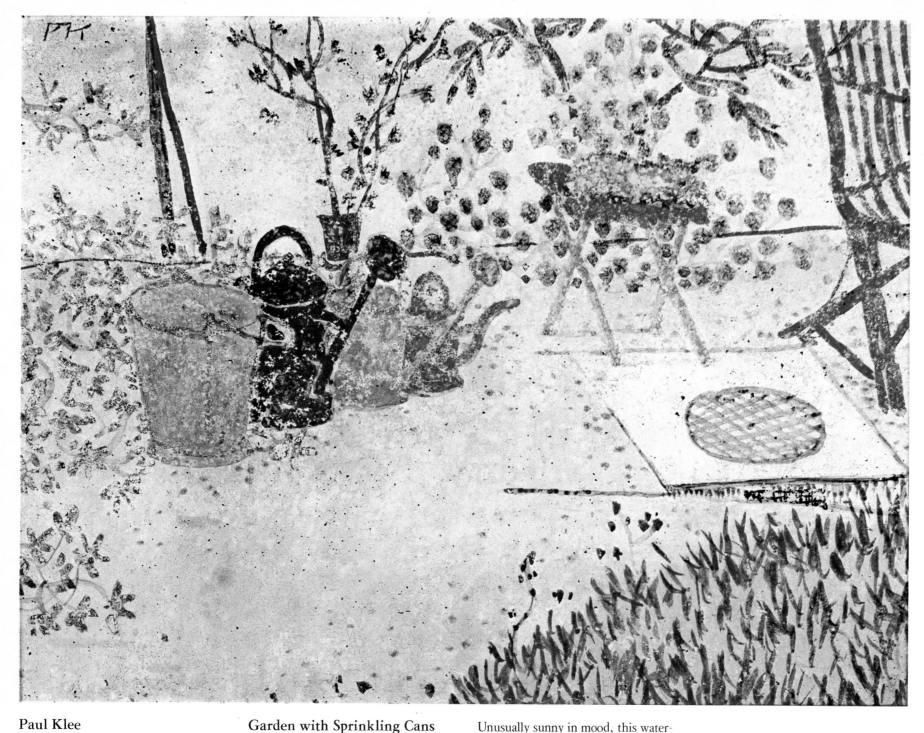

Paul Klee
Münchenbuchsee (Bern) 1879 -
Muralto (Locarno) 1940

8

**Garden with Sprinkling Cans
and Cat,** 1905.
Bern, Coll. Felix Klee, K. 1905/24,
Inv. no. 31. Watercolor; 5½ × 7⅜ in.
(14 × 18.5 cm). Inscribed in upper-
left corner : *"P K. "*

Bibliography : *Aus der Sammlung
Felix Klee,...,* Bern, 1966, p. 24,
no. 177.

Unusually sunny in mood, this water-
color reveals unexpected affinities bet-
ween Klee and Bonnard, in an intimate,
affectionate glimpse of unabashed domes-
ticity. Sprinkling cans are shown lined
up in single file with the same verve
and wit that characterizes eighteenth-
century *chinoiserie* panels of gardener's
accessories. Perhaps Chinese woodcuts,
as well as the neighboring art of France,
stimulated the Swiss artist to create
this enchantingly fresh vignette, in
which the file of sprinkling cans, the
crouching cat, and the garden furniture
all appear involved in an animated dia-
logue that is closer to a *tableau vivant*
than a *nature morte.*

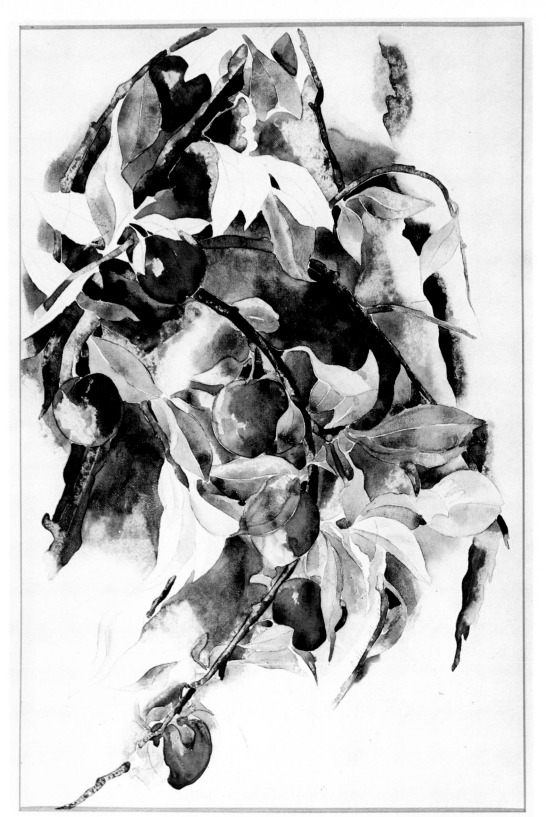

Charles Demuth
Lancaster (Pa.) 1883 - 1935

Plums, 1925.
Andover (Mass.), Addison Gallery of American Art, Phillips Academy. Pencil and watercolor ; 17½ × 11½ in. (43.8 × 28.8 cm).

Bibliography : A. C. Ritchie, *Charles Demuth,* New York, 1950 ; B. Hayes, *American Drawings,* New York, 1965, pl. 47.

In Demuth's hands, watercolor acquired an unprecedented prismatic power. This new architectonic quality was partly inspired by Cézanne and by post-Cubist developments in European art. Using such unorthodox means as razor blades and blotting paper to create new planar and surface effects, this delicate yet forceful master developed techniques which lent new drive to a medium that had **been** too long left to the amateur and wrongly restricted to capturing the transient scene alone.

9

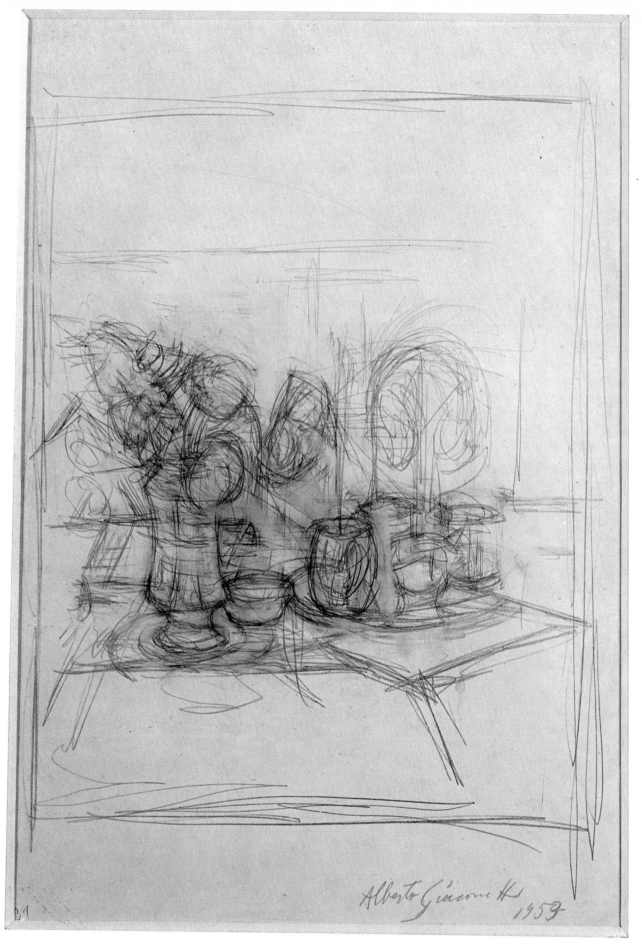

Alberto Giacometti
Stampa (Switz.) 1901 - Paris 1966

Still Life, 1959.
Milan, Private collection. Black chalk ;
18¾ × 13⅝ in. (47 × 34 cm). Signed
and dated in lower-right corner :
"Alberto Giacometti 1959."

Bibliography : Russoli, 1971, p. 85.

Despite its vase of flowers, Giacometti's
table is quite austerely laid, and he
presents it in a flurry of quickly defining
lines. Renouncing color, his creation is
in the *grisaille* tradition, dependent on
a subtle gray-on-gray manipulation and
lavenderish smudges to convey the
elegant simplicity of the artist's ascetic
setting, with only the barest suggestion
of a perspective frame given in a few
swift lines. Like his portraits, this sub-
dued still life takes on a spectral quality,
as if Giacometti were endowing the
inanimate with the possibility of death
(truly a *nature morte),* as well as resur-
rection, through his proficient drawing.

10

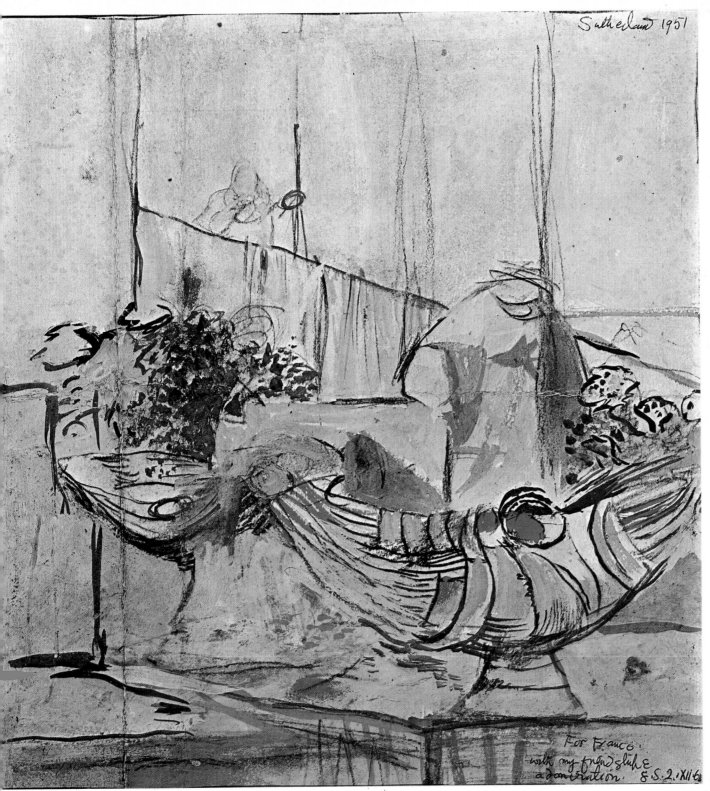

Graham Sutherland
London 1903 -

Composition, 1951.
Milan, Coll. Franco Russoli. Tempera and pastel ; 10¾ × 12 in. (27 × 30 cm). Signed and dated in upper-right corner : *"Sutherland 1951."* Dedication added later in lower-right corner : *"For Franco with my friendship & admiration. G.S. 2.XII.61."*

Bibliography : Russoli, 1971, p. 85.

Laden with greenery, Sutherland's footed basket, placed on a table, suggests a sense of motion and adventure contradicting the traditionally stable concept of the still life. Like venturesome frigates under full sail, these household vessels sally forth to conquer the ledge where they perch, in what may be an endless conflict generated by the mirror image. For all this modern British master's intelligent appreciation of Matisse, Sutherland's colorful, animated sketch reflects the considerable originality of an artist whose great gifts are still insufficiently recognized.

11

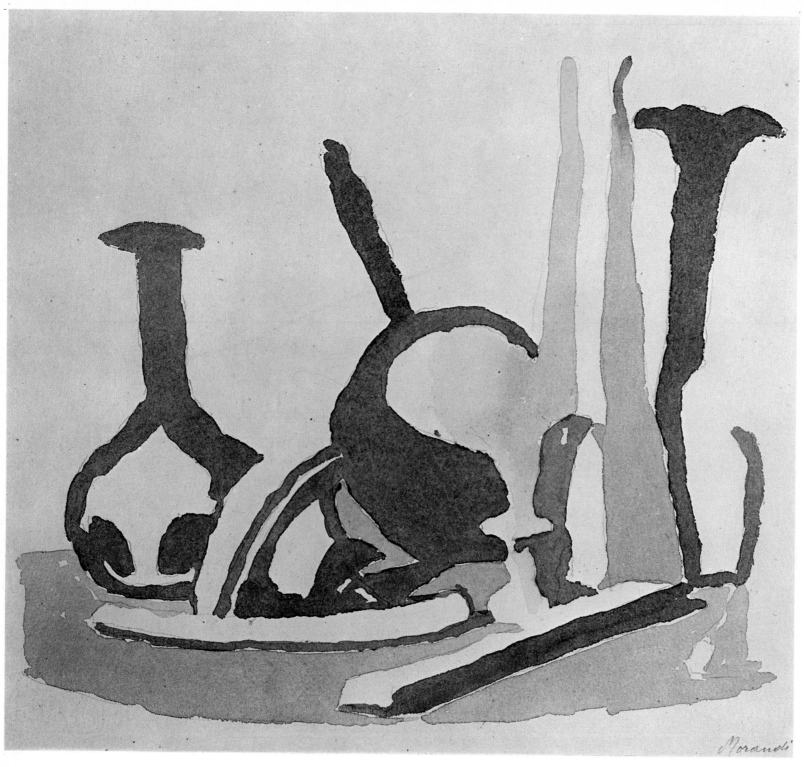

Giorgio Morandi
Bologna 1890 - 1964

12

Still Life, 1936.
Milan, Private collection. Pencil with watercolor; 13 × 9⅝ in.
(32.5 × 24 cm). Signed and dated in lower-right corner : *"Morandi 1936."*

Bibliography : *L'Opera di Giorgio Morandi,* Bologna, 1966, p. 78, no. 5 (exhibition catalogue).

With austere conciseness, this table setting is indicated as if by pictographs. With the greatest of linear economy, the artist spells out the bare essentials of each form, stopping just as soon as cognition is established and the object can be "sounded" in the mind. Written in a kind of shorthand rather than drawn, then, this still life shares the typical exquisite restraint of Morandi's art, much of which hovers tantalizingly on the brink of monotony. So often asserting its validity at the very last minute — visually speaking — his is a reserved and deeply contemplative art that sometimes barely escapes a sense of critical indifference and *déjà vu.*

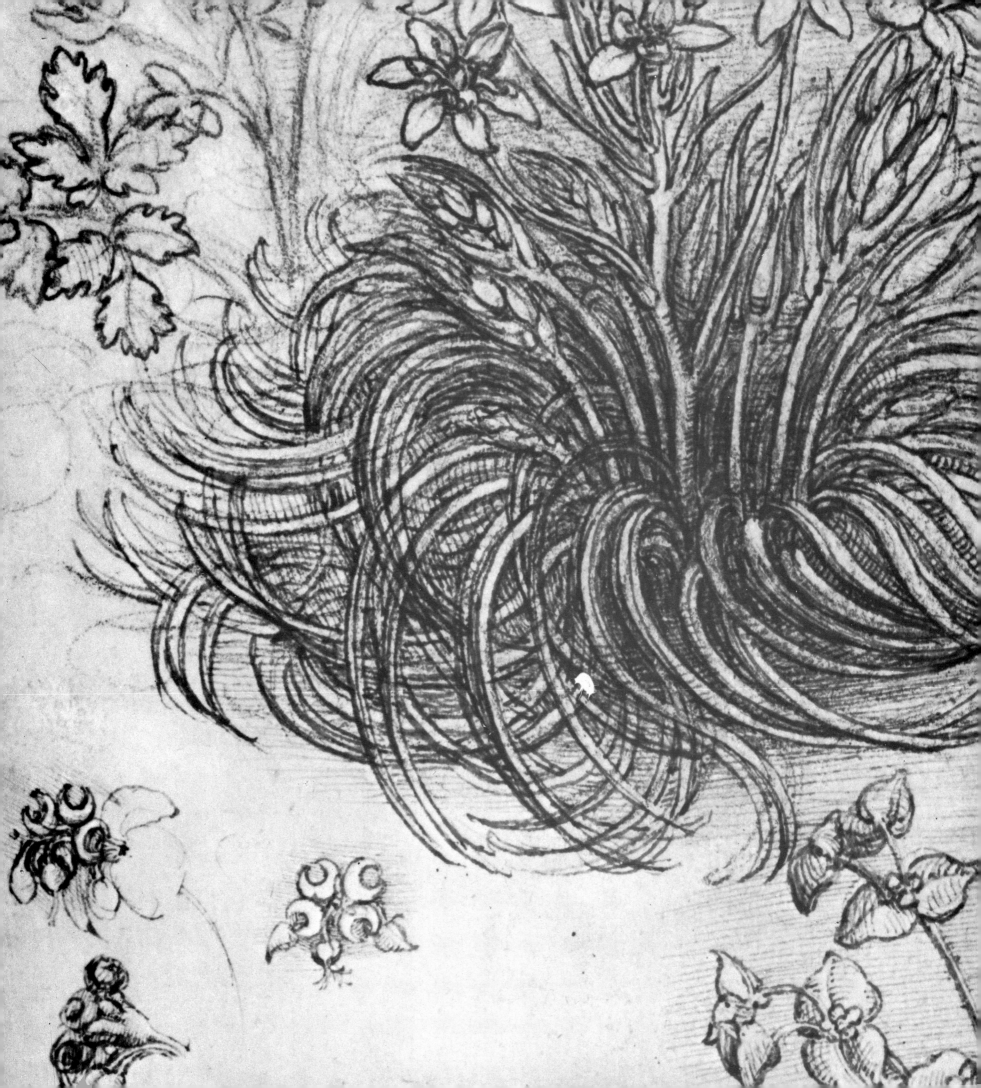

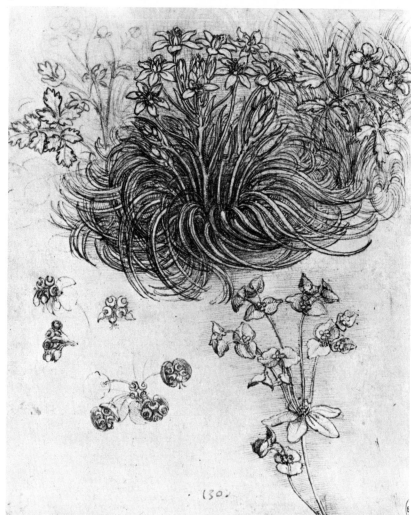

Unknown Artist F. 1

Active probably early 6th century

Bramble (Rubus fruticosus), from Codex Vindobonensis of Dioscorides.

Vienna, Nationalbibliothek, Codex Vindobonensis Medicus Graecus 1, fol. 83 recto. Watercolor; 14 1/4 × 12 1/4 in. (35.6 × 30.6 cm).

Leonardo da Vinci F. 2

Vinci 1452 - Amboise 1519

Star of Bethlehem and Other Plants.

Windsor, Royal Library, no. 12.424 (by permission of Her Majesty Queen Elizabeth II). Red chalk with pen and ink; 7 7/8 × 6 3/8 in. (19.8 × 16 cm).

Fra' Bartolommeo F. 3

(Baccio della Porta)

Florence 1475 - 1575

Study of a Tree.

Washington, National Gallery of Art. Pen; 11 1/3 × 8 1/2 in. (28.9 × 21.7 cm).

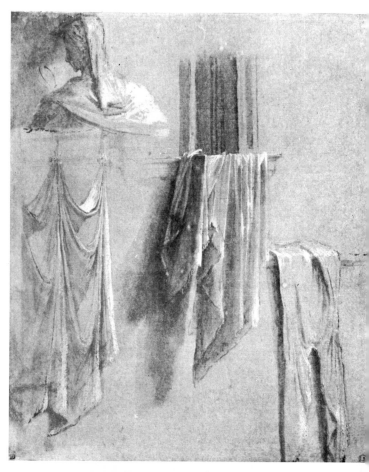

Jean-Baptiste Huet F. 5
Paris 1745 - 1811

Dead Hare Suspended by its Leg.
Montpellier, Musée Atger, no. 157. Watercolor ; 9 ¾ × 13 ½ in. (25 × 35 cm).

Albrecht Dürer F. 6
Nürnberg 1471 - 1528

Six Pillows.
New York, Metropolitan Museum of Art, Robert Lehman Coll. Pen and ink ; 11 × 8 in. (27.6 × 20.2 cm).

Anonymous F. 7
17th century

Trophy.
Düsseldorf, Kunstmuseum, no. F.P. 6943. Pen and ink, wash, white lead ; 10 ½ × 8 in. (26.6 × 20.7 cm).

Parmigianino F. 4
(Francesco Mazzola)
Parma 1503 - Casalmaggiore 1540

Linen and Garments Hung from Windows.
Bayonne, Musée Bonnat. Brush point with brown wash on brown paper, heightened with white ; 8 ½ × 7 in. (21.2 × 17.5 cm).

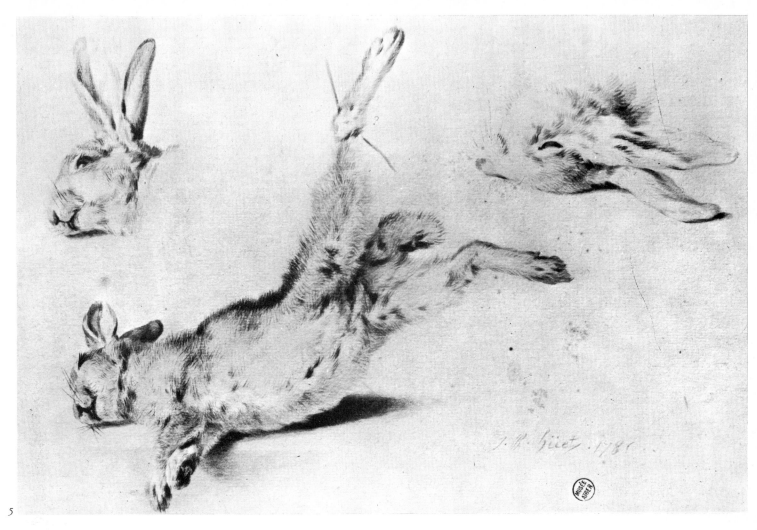

5

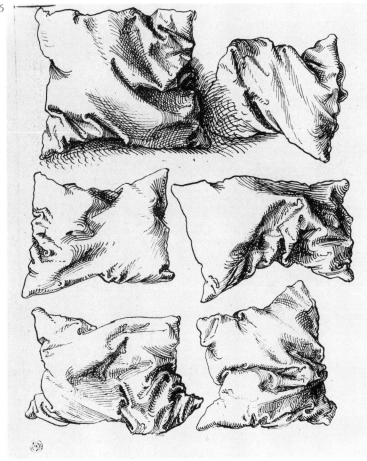

6

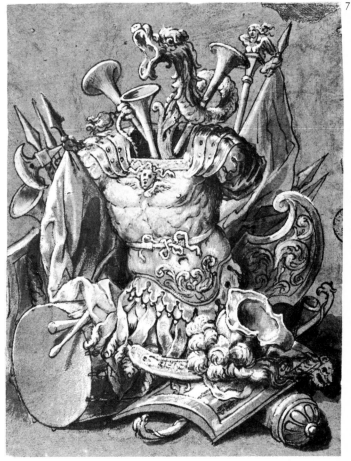

7

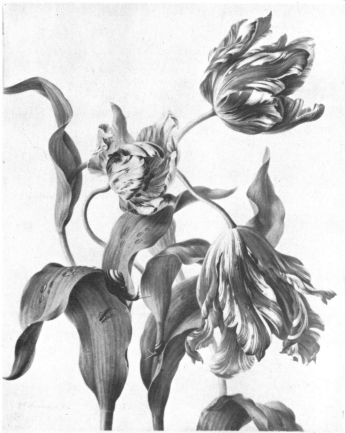

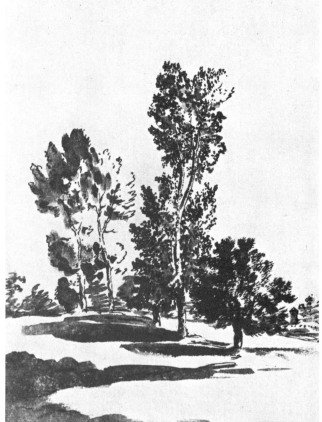

Herman Henstenburgh F. 8
Hoorn 1667 - (?) 1726

Parrot Tulips.
Haarlem, Teylers Museum. Watercolor on parchment ; 14 × 12 in. (37.5 × 31.0 cm).

Nicolas Poussin F. 9
1594 - 1665

Study of Trees in Early Light.
Paris, Louvre, Inv. no. 32-467. Pen and bister wash ; 9 ½ × 7 in. (24 × 18 cm).

Lorrain, Claude Gellee F. 10
1600 - 1682

Oak Trunk Covered with Ivy.
British Museum 00.7.224. Pen, bister, bister wash on white paper ; 12 ⅔ × 8 ¾ in. (33 × 22.5 cm).

Théodore Rousseau F. 11
Paris 1812 - Barbizon 1867

The Great Oak.
Basle, Private Collection. Graphite ; 25 × 19 ½ in. (64 × 50 cm).

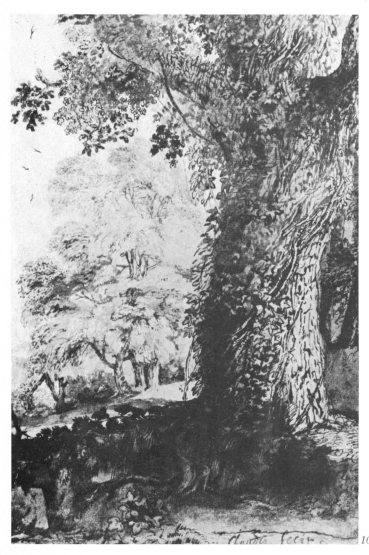

10

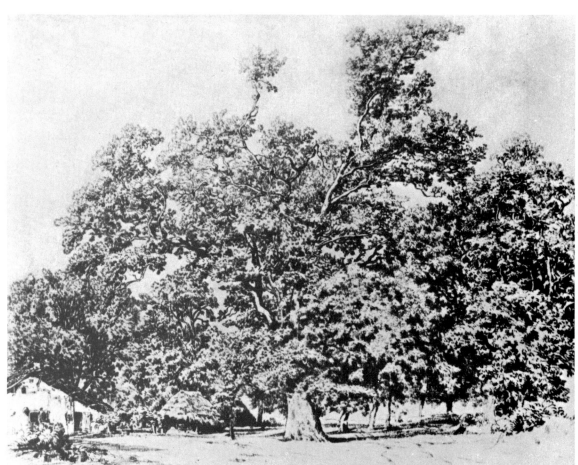

11

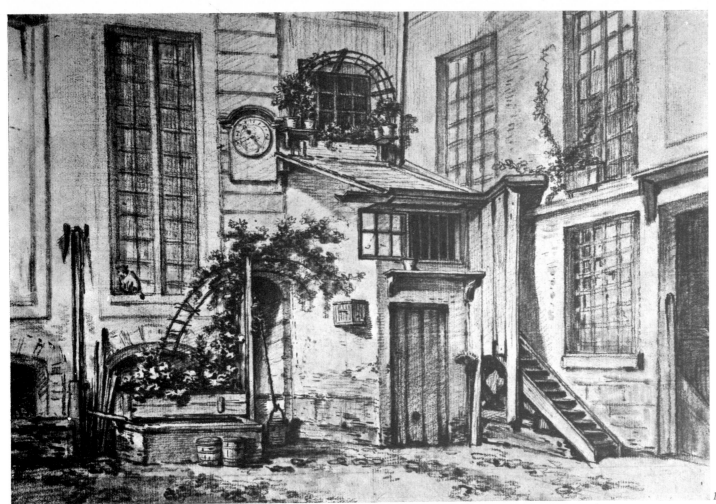

François Boucher F. 12
Paris 1703 - 1770

A Corner of a Courtyard.
Vienna, Albertina no. 12-190. Black
crayon ; 9 ⅓ × 13 ⅔ in.
(23.8 × 34.9 cm).

Caspar David Friedrich F. 13
Greifswald 1774 - Dresden 1840

Branch with Leaves.
Stuttgart, Graphische Sammlung
Staatsgalerie, no. c. 1928/44.
Pen and wash ; 14 ½ × 10 ¾ in.
(37.5 × 27.5 cm).

Georges Seurat F. 14
Paris 1859 - 1891

A corner of the Artist's Studio,
study for " Les Poseuses ".
Paris, Musée du Louvre, Inv. no. 362.
Conté crayon ; 9 ⅜ × 12 ¼ in.
(23.3 × 30.5 cm).

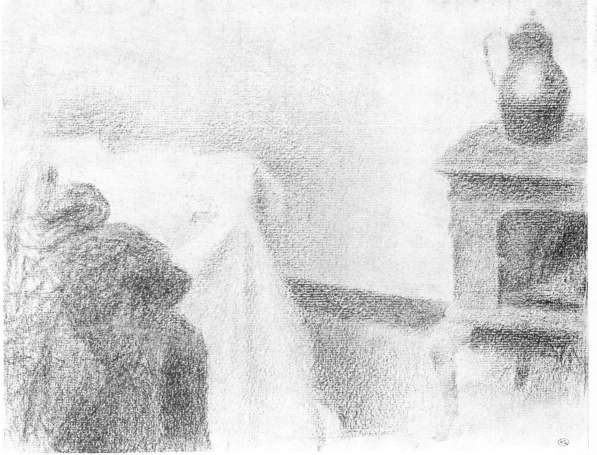

13 14

15

Thomas Eakins F. 15
Philadelphia 1844 - 1916

Perspective Drawing for "Chess Players".
New York, Metropolitan Museum of Art, no. 42.35 (Fletcher Fund, 1942). Pencil and ink on cardboard ; 24 × 19 in. (60 × 47.5 cm).

John Singer Sargent F. 16
Florence 1856 - London 1925

Study of a Motorcycle for the Road.
Washington D. C., in the collection of the Corcoran Gallery of Art. Pencil ; 6 ⁷⁄₈ × 4 ⁷⁄₈ in. (17.2 × 12.2 cm).

Charles Sheeler F. 17
Philadelphia 1883 - Irvington-on-Hudson 1965

Of Domestic Utility, 1933.
New York, Museum of Modern Art (gift of Abby Aldrich Rockefeller). Conté crayon ; 21 ¾ × 15 ⁷⁄₈ in. (54.4 × 39.7 cm).

16

17

18

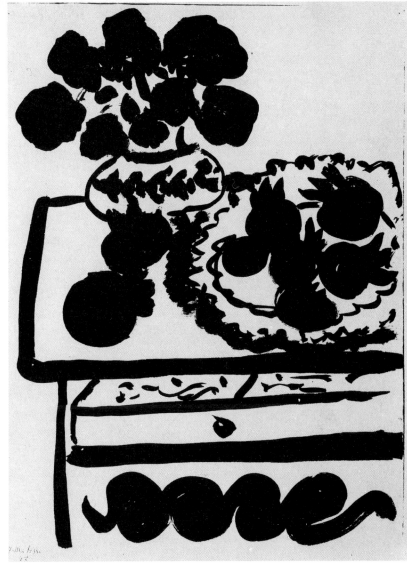

19

20

Georgia O'Keeffe F. 18
Sun Prairie (Wis.) 1887

Banana Flower, 1933.
New York, Museum of Modern Art.
Charcoal ; 21 ¾ × 14 ¾ in.
(54.4 × 36.9 cm).

Henri Matisse F. 19
*Le Cateau-Cambrésis 1869 - Cimiez
(Nice) 1954*

Dahlias and Pomegranates, 1947.
New York, Museum of Modern Art
(Abby Aldrich Rockefeller Fund).
Brush and ink ; 30 ⅛ × 22 ¼ in.
(75.3 × 55.6 cm).

Claes Oldenburg F. 20
Stockholm 1929

Hamburger (study for ''Dual
Hamburgers''), 1962.
New York, Museum of Modern Art
(Philip Johnson Fund). Lithographic
crayon ; 14 × 17 in. (35 × 42.5 cm).

Ornament
and Architecture

The comparatively recent divorce of the arts, their division into major and minor, is due to the isolation of artist from designer since the Industrial Revolution. Until then, almost all great draughtsmen were prepared to apply their special gifts to making designs to be followed by the craftsman—the armorer, cabinetmaker, tailor, ceramist, jeweler, or printer. Only when the West had little practical use for the artist was abandoned to follow his own unemployed star in the lonely, romantic pursuit of his genius. With a sense of design and a feeling for technique, the artist could extend his unique style from the monumental to the miniature, could bridge the gap between the solemn and the sumptuous. It was the court painter's major responsibility to produce a "total look," extending to all the arts. His task was to create a visual parallel of his royal patron's dominion, as a way of placing his regal imprint upon almost every material aspect of the ruler's domains, from tapestry to teaspoon, artistically reshaping the demimonde and demitasse alike. The designer-draughtsman was at once producer, director, prop and costume designer, and flat painter, besides being in charge of lighting and landscaping, devising the flow of fountains and the blaze of fireworks.

Among the earliest surviving drawings for the "applied arts" are late-medieval projects for the vast spires and clockworks rising from and ticking within the mother of the arts—the cathedral. Later, Pisanello's projects included both textile patterns and fashion design, as well as many beautiful medallic designs and other decorative schemes for the numerous courts of fifteenth-century Italy which depended upon that master's romantic *œuvre* to establish a sense of chivalric authority, a divine right of princeship with origins presumably lost in the mists of time. Preparation of tapestry and embroidery cartoons, paintings on biscuit boxes and hope chests, and carved, painted, or inlaid furniture: such furnishings and accessories employed the talents of all the major masters of the Renaissance. Their design and decoration involved preparatory drawing, often made directly on the surface of the gift tray or jewel casket.

The goldsmith's craft underlay the art of the Renaissance. Pollaiuolo, Verrocchio, Ghirlandajo, Perugino, Dürer, and countless others of the greatest draughtsmen in this era were first trained as workers in precious metals or were descended from families devoted to these craft skills for generations. Fidelity to the incised line, to the discipline of engraving, produced an unparalleled purity of graphic control. Apprenticeship to the metalworker's craft inspired so many Renaissance artists with a matchless sense of profile, sensitivity to dynamic definition of contour, and the presentation of space, movement, and emotion through eloquent line alone.

Drawings often provide our only detailed knowledge of the greatest extravagances of the metalworker's art, since so many of their costliest creations were destined for the melting pot as soon as new fashions came and old fortunes went. Fabulous silver services designed for the Gonzagas by Giulio Romano were wrought as if Nature, in a strangely cooperative mood, had entwined and silvered her leaves and flowers, transforming time into eternity and literally gilding her lilies, to function as dinner plates or sweetmeat dishes. Raphael and Holbein were also masterful designers of metalwork, of perfume burners and jewelry and table fountains. Dürer devised wildly improbable long-stemmed covered cups, the *pokals*, to be admired but not used—luxury items for conspicuous *non*-consumption to gleam in the midst

of many a groaning board. Monuments in miniature were designed to assert the proud possessor's affluence and enlightenment, giving testimony of the virtuosi attached to his court as designers and goldsmiths, able and encouraged to conceive and indulge in the most wildly *recherché* flights of unfettered imagination. Dalí's drawings for jewelry, such as his surreal brooches of ruby-edged lips with pearl teeth within, are but the last gasp of the drawn metaphor of the last of many Middle Ages.

The artist's serving as pageant master involved him to the fullest in the decorative arts, in devising the accouterments of ceremonies and processions, banquets and masques. From Jan van Eyck to Inigo Jones, Fouquet to David, the leading painters designed triumphal arches, banners, posters (broadsides), costumes, floats, lavish saddles and harnesses, and commemorative trinkets to celebrate the greater glory of their patrons, extending their sphere of influence throughout the visual world and leaving their imprint on every facet of the man-made milieu.

Some artists, such as Mantegna and David, evolved a formal classical style whose reference to imperial splendors of the past and present shed a seemingly eternal luster on the patron, whether a Gonzaga duke or a Napoleonic ruler. Ruben's and David's tapestry designs offered supreme witness to the undying glories of imperial rule, just as Raphael's huge tapestry cartoons presented the Acts of the Apostles with a special timelessness, forever woven into the very fabric surrounding the richly musical services in the Sistine Chapel. Works in silver and gold, wool and silk, pottery and porcelain, wood or steel or plastic echo an artist's style and can create a world of consistency and harmonious order, giving clear testimony to the overriding validity of one man's thought in art.

The early opera in the sixteenth century, along with the incredibly elaborate presentations of plays, religious dramas, and processions, also provided the artist with endless design opportunities and labors, which included drawings for everything from water ballets to ceremonial sleds and huge automata. Art and music went hand in hand, to delineate singing lines in sight as well as sound. Rubens, following Giulio Romano's activities in Mantua a little more than fifty years later, relished to the fullest the artist's participation in the ceaseless production that was courtly life when he worked out preparations for the grandiose festivities at the Hapsburg and Valois courts of the Baroque era. He was deeply concerned with architecture as well and made many drawings after Italian palace designs. Even men-of-war were embellished with richly carved sides, and their sculpted, gilded sides gleamed in the setting sun.

With the Western development of porcelain, new territory for artistic elaboration was opened to painters and sculptors, who designed figurines, huge table services in delicate relief, and splendid porcelain stoves. Previously artists had devised whole forests of leaf and flower patterns to paint over the broader, coarser surfaces of fired clay decorated with tin glazes—the greatly prized faïence and Delft ware.

Breaking down the heroic classical orchestration of Poussin and his monumentally oriented contemporaries into bite-size arpeggios, the masters of the early eighteenth century reduced the gap between naturalism and abstraction, between the decorative and the objective. The vignette and the cartouche, peepholes whose deliciously contrived frames were almost as arresting as their contents, confined nature to a scaleless, ageless world, in which eternally youthful lovers, shepherds, Pierrots and Pierettes were caught in attitudes of sophisticated innocence, knowledge-

ably unknowing in their thoughtfully upholstered rusticity. The great age of Meissen and Sèvres, of the *ébéniste* and the *doreur*, made all artistic masters think in terms of motifs, of working together with master craftsmen of the sumptuary arts.

Boucher, Tiepolo, Maulbertsch, and Kaendler created a new decorative synesthesia in which painted fresco merged with plaster relief, carved wooden walls, inset Gobelin tapestries, inlaid floors, and Aubusson carpets. The language of line, at its most eloquent, created a continuous chatter among the media, bringing them together in a relentlessly Rococo integration. In this era of high nonseriousness, one of the greatest draughtsmen of all time—Jean-Antoine Watteau—produced hundreds of drawings, none of which was much concerned with overtly philosophical, moral, or religious issues. It was a century of ubiquitous design activity. Saint-Aubin's dinner plates, Clodion's reliefs, Boucher's tapestries, Oudry's illustrations, Canaletto's topography, and Hogarth's narrative seem to flow from one to another in a truly international style of art for amusement's sake, in which the painter, the potter, the candlestickmaker, and all craftsmen are joined in a unique communion of comfort and pleasure, bearing a message of unprecedented enlightened materialism.

Such scintillating accord eventually had to go out of fashion, and so it did. With the excavation of Pompeii and the pomposity of Neoclassicism, medium and message were isolated, and decorative line became the monopoly of a few skilled masters such as Piranesi, David, and Rünge. Flaxman's austere outlines, elegantly but uncomfortably unbending, created a new ascetic purity in which the Grecian urn and its ornament dictated the profile of Western life. Napoleonic camp provided a Neo-Mantegnesque classicism in which the great emperor's snuffbox, tent, medals, and even night light all had to shine with a requisite imperial luster more *parvenu* than Hollywood's most extravagant aspirations.

Skilled renderings, both precise and illusionistic, were—and are—among the draughtsman's major responsibilities and rewards. Only the architectural assistant who is able to project the final appearance of the completed building, to share it with patron and designer, can point up design strengths and weaknesses and anticipate problems previously hidden from both. The draughtsman alone can deliberately disguise or accentuate, whether with brush or airbrush, and thereby convert the unsaleable into the sold-out. From Boullée to Sant'Elia, Sullivan, Le Corbusier, and Wright, many architects have been master draughtsmen, uniquely qualified to understand, capture, and convey the new directions of their works.

The Gothic and Rococo revivals, following each other posthaste during the first half of the nineteenth century, allowed the artist-designer considerable scope, but always in the language of the past. The new anonymity of the Industrial Revolution engendered endless repetition. Not until the revivalism of the Arts and Crafts Movement could artists participate directly in planning manufacture without lowering themselves in society's eyes. Significantly, however, their designs were not for the many, not something to be made by machines, but were mainly for those who could afford to acquire the conspicuously handwoven, handprinted, or handcarved and to eschew the convenience and economy of the machine-made.

The first original decorative vocabulary evolved for mass production came with Art Nouveau. Here the undulating qualities of cast metals and machine-bent wood and new techniques in lamination allowed the sculptor, the painter, the architect,

Ornament and Architecture

and the ceramist to work together in a shared language of motifs rivaling the currency of the Rococo. Great artists such as Klimt and Monet merged their worlds of human and natural experience within a total decorative continuity in which tables and chairs, china and silver, carpets and hardware could all extend, in inanimate yet expressive form, the new psychological and organic dimensions explored by the painter. William Morris, followed by such design movements as the Sezession, Wiener Werkstadt, De Stijl, the Bauhaus, and Art Deco, found a new unity between draughtsman and designer, who were creating worlds very different in appearance but similar in their concerted desire to have every aspect of an interior share the overall esthetic concerns and principles of the major masters. Throughout these styles we have the artist as interior designer or stage decorator.

Louis Sullivan's intricate, almost Gothic ornament and Sant'Elia's futuristic architecture both reflect the overriding interests of each architectural leader: the one recasting a mystical medievalism in new media, and the other objectifying a world of rapid projection, of transition beyond scale in the form of flight. Le Corbusier's drawings and illustrated letters show his great concern with his patron's understanding the scale and space of life which the architect was evolving to suit his individual client and to suit his own guiding ideals. The end product should be representative of the mind and style to which the patron was attracted in the first place.

Sets and costumes by Picasso and other major modern artists working for the Ballets Russes brought a brief sense of fusion between innovative art and its application on many levels. The same was true for creative work in the Soviet Union in the early post-Revolutionary years, when the Constructivists participated actively in poster, book, and stage design and briefly brought to the new state a parallel new look in art which, significantly, was not to last long.

Art Deco was an opulent adaptation of Cubism to those "best things in life" that are always far from free—high fashion, the motor car, the caviar bucket, and the *minaudière*. Whether meant for lipstick or the Empire State Building, the artist's design communicates the special character of his time, defining and recording the fugitive feeling for line-in-life and life-in-line that communicates the special rhythms which make every culture look the way it does.

Freud's century went on to strip its setting of fantasy, divorce life from dream, and split the organic unions of Art Nouveau. The subconscious was sterilized, isolated in a Surrealist entertainment and placed within a chaste museum ghetto. The *féérique* inventiveness of Louis Comfort Tiffany, turning day into night through inspired manipulation of metal, glass, and jewels, was shattered by his shamed heirs.

Only recently have artists realized how much they have lost in their exclusion from design. By embracing the banal and investing the anonymous with individuality, Pop Art reclaimed the long-lost patrimony of the painter—mastery of the scene from top to bottom, now reasserted by literally blowing up the mirror into major art. Handmade "photographs," living replications of soup cans, the apotheosis of the lipstick and the hamburger are sad yet witty attempts to reassert the artistic hegemony of the designing hand. And a lot of other things, too. . . .

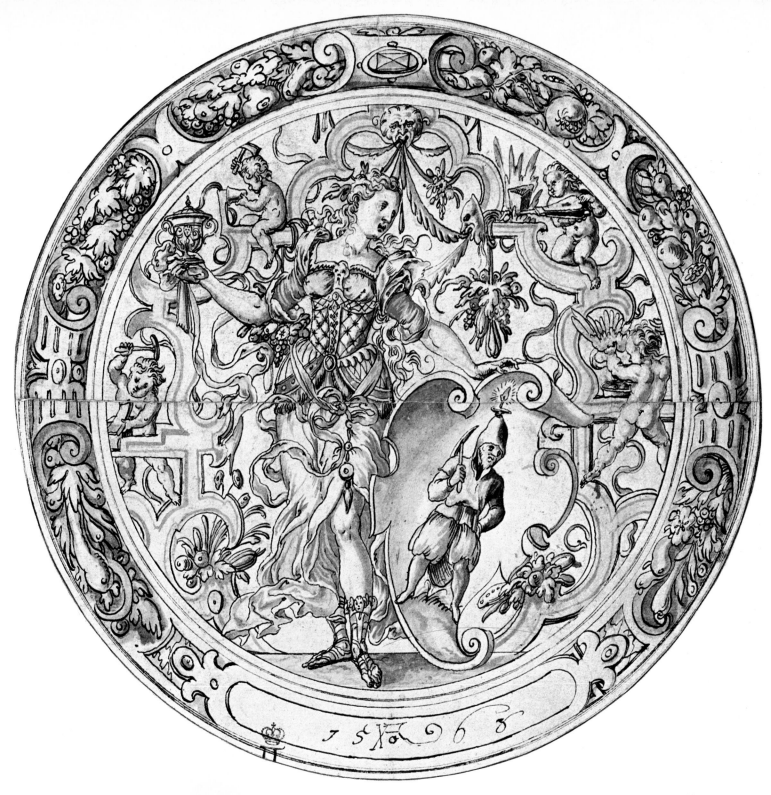

Jost Amman
Zurich 1539 - Nürnberg 1591

1

Design with Woman Holding a Shield and Cup, 1563.
Leningrad. The Hermitage, no. 35.
Pen and ink, with watercolor ;
10¼ in. (25.7 cm ; diameter). Signed with artist's monogram and dated at bottom.

Bibliography : Kamenskaja, 1937, no. 1.

A prolific popular printmaker, Amman made numerous woodcuts and etchings for book illustrations and ornament designs, besides executing portrait commissions. These extensive print series provide valuable source materials for studying the customs and dress of his time. One such project was an abundantly illustrated book on arts and craftsmen, on which he collaborated with the poet Hans Sachs. Here a classical-inspired goddess symbolizing the miner's and metalworker's craft — possibly Venus in her role as Vulcan's

bride and attendant at his forge — is the focus of a highly decorative tondo. In one hand she raises the product of Vulcan's craft : a finely wrought covered metal cup. Her other hand supports a shield indicating the metal's source — a miner holding a pickaxe and with a candle on his head. Within the drawing's circular border are shown infant genii working away at the cup's manufacture : fanning hot coals at the far right ; above, melting an ingot and using bellows on the fire ; and hammering out the cup at the left.

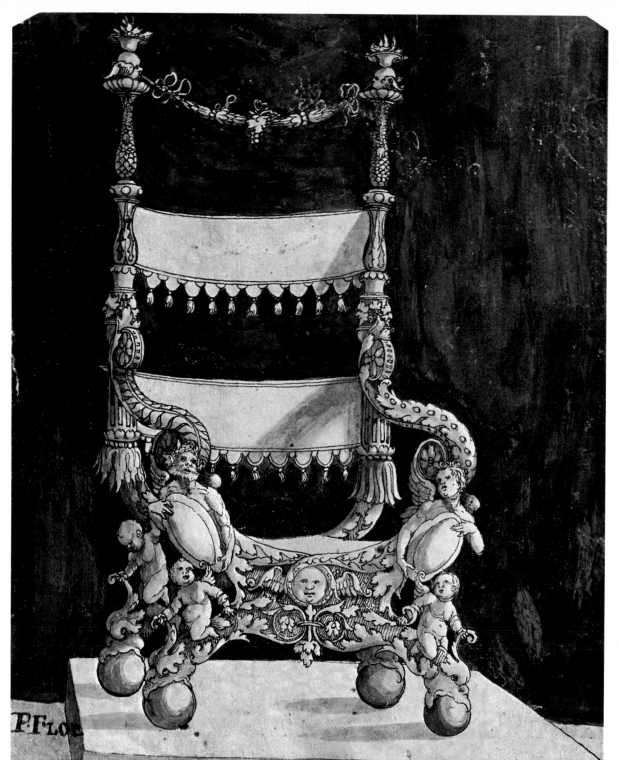

Peter Flötner
Thurgau c. 1485/95 - Nürnberg 1546

Sketch for an Ornate Chair,
shortly after 1520.
West Berlin, Staatliche Museen,
no. 390. Pen and brown ink, with
brown and black wash; 7½ × 6¼ in.
(18.6 × 15.6 cm). Signed at the lower
left: *"P. Floe."*

Bibliography: Friedländer-Bock, 1921,
p. 42; Bange, 57, 1936, pp. 177-178,
191, no. 6.

Flötner, who worked as a woodcarver
and decorator-sculptor, had traveled
extensively in Italy, where he took par-
ticular interest in ornamental motifs.
His own designs, prepared subsequently
for application to all media, are note-
worthy examples of the German
approach to decorative arts in the later
Renaissance. Flötner's project for a
handsome bronze or wooden throne,
perilously poised on four orbs that seem
about to be swallowed up by fierce-
looking eagles with *putti* astride, dis-
plays the endless inventiveness and
studied instability so typical of Manner-
ist ornament. The eventual owner's
identity would be indicated by engrav-
ing his coat of arms on the blank shields
held by a satyr and an angel who sup-
port the armrests. This intricate design,
with its rampant use of classical
motifs, dates from the German artist's
first Nürnberg period.

2

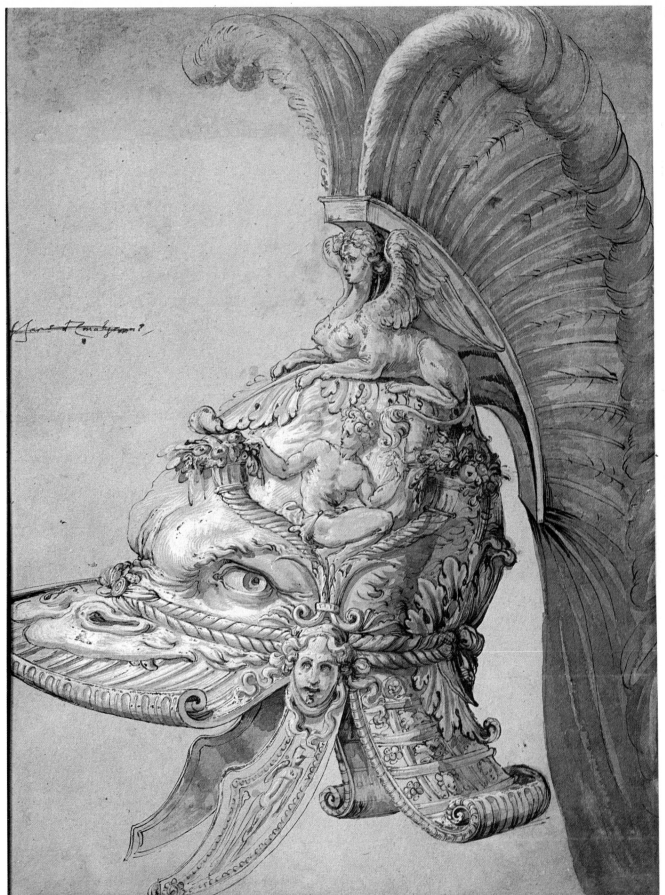

Francesco Salviati
Florence 1510 - Rome 1563

Study for a Plumed Helmet.
Paris, Musée du Louvre, Inv. no. 6126.
Pen and ink with brown wash, heightened with white, on gray-green paper ;
19¾ × 18⅞ in. (49.4 × 47.1 cm).

Provenance : Coll. E. Jabach.

Bibliography : *Le XVIe Siècle Européen*,
1965, illus. 207.

Intended more for parades than for
battlegrounds, this elaborate helmet
was designed in the antique fashion by
the Florentine Mannerist Salviati. The
crowning winged and plumed sphinx,
symbolizing timeless wisdom, subjugates the monster of the lower passions
which forms the major portion of the
protective bronze head covering.
Through its terrifying eyes the soldier
may even have looked out, should he
have cared — or been able — to lower
his visor. Athletic youths alluding to
manly virtue are seated between twin
branching cornucopias of peace and
plenty. Similar figures reappear on the
sidepieces which help to keep the helmet
on its wearer's head, and originally
protected his ears. Seen from the front,
an advancing warrior wearing this
imposing headgear might appear as if
emerging from a fearsome monster's
jaws, with an intimidating effect.

3

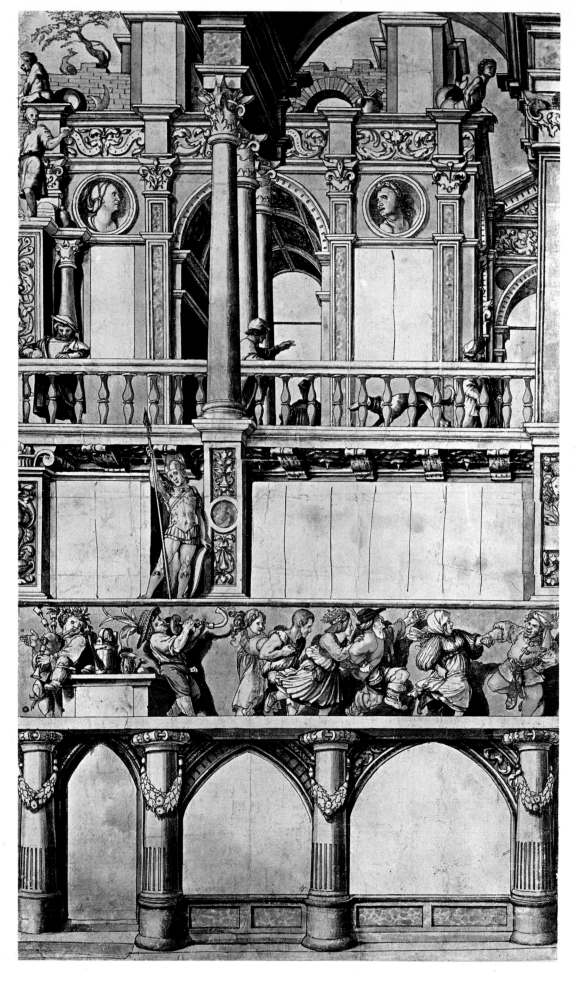

Hans Holbein the Younger
Augsburg 1497/98 - London 1543

Sketch for Façade of the "Dance House" on the Eisengasse, Basel, 1520-1522.

West Berlin, Staatliche Museen, no. 3104. Pen and ink, with watercolor; 22⅞ × 13½ in. (57.1 × 33.9 cm).

Bibliography: Friedländer-Bock, 1921, p. 54; Ganz, 1937, no. 113; Ganz, 1950, no. 162.

Designed both to disguise and to enhance the late-medieval façade of a Basel goldsmith's house, Holbein's project begins on its lowermost level with pointed arches and garlanded columns to frame the Gothic windows set within. Then, proceeding upward from the lively frieze of dancing peasants (which gave the house its popular name), the elaborate design becomes increasingly dignified. Splendid Italianate loggias disclosing Renaissance figures and deep perspectives alternate with classical relief ornament in the painter's ingenious decorative compartmentalization of the older façade. The very highest level gives illusionistic glimpses of stonework against a vista of open sky. The whole scene is enlivened by random figures and animals.

4

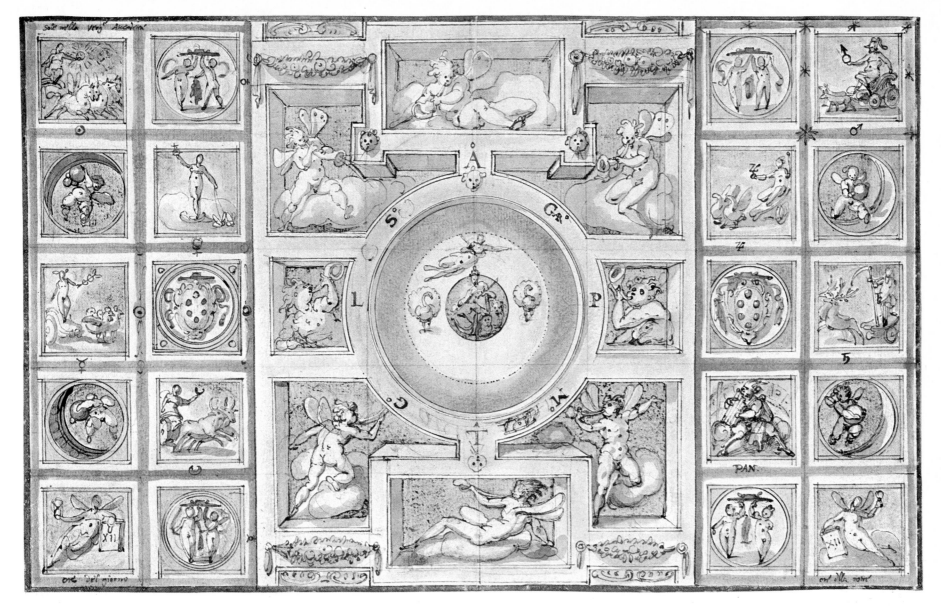

Jacopo Zucchi
Florence 1541 - Rome or Florence 1589/90

5

Project for a Ceiling.
London, British Museum, no. 1877.8.8.3. Pen and ink, with watercolor; 8½ × 13¾ in. (21.2 × 34.4 cm).

Bibliography: Barocchi, 1964, fig. 112; Pillsbury, 1969, p. 64, no. 21.

Neatly boxed emblems abound in this wittily designed astrological ceiling prepared by Zucchi for Cardinal Ferdinando de' Medici, who founded the Villa Medici and embellished the Palazzo di Firenze while residing in Rome. Six of the flanking roundels bear either the Medici arms or a cardinal's hat, placed within an elaborate see-through grouping of celestial allusions that were shrewdly planned by Vasari's gifted associate to flatter the fortunes of his great ecclesiastical patron.

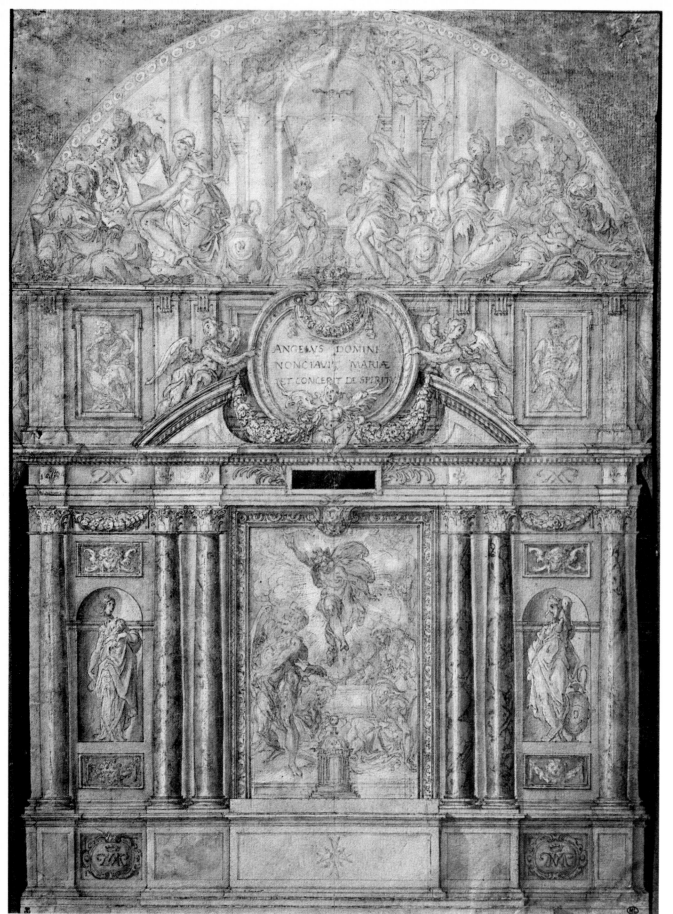

Martin Fréminet
Paris 1567 - 1619

Design for High Altar in the Chapel of the Trinity at Fontainebleau, c. 1610-1615.

Paris, Musée du Louvre, Inv. no. RF. 2361 bis. Black chalk preliminary drawing, with pen and ink and wash, heightened with white lead and watercolor; 18¾ × 13⅝ in. (46.8 × 34 cm).

Provenance: Colls. Kaieman; C. Gase; Marquis de Chennevières.

Bibliography: Béguin, 1963, no. 3, pp. 30, 34; Béguin, 1964, p. 98, note 78.

This lavish altar ensemble includes an Annunciation scene flanked with Silbyls and other figures in a lunette at the top, Old Testament prophets and female allegorical figures below, with the Resurrection as the central subject, placed over a Eucharistic tabernacle. The whole was brilliantly planned by Fréminet for the Chapel of the Trinity at Fontainebleau. His ambitious project unites the late Mannerist tradition with a sense of balanced opulence that is close to the Baroque. The Holy Ghost, shown in the vault of the triumphal arch above the Annunciation, is referred to again in the central panel of the altar table by the emblem of the Order of the Holy Ghost, which is set between cartouches with the monograms of Marie de Médicis and King Louis XIII. Though designed between 1610 and 1615, the project was not carried out until 1633, more than a decade after Fréminet's death.

6

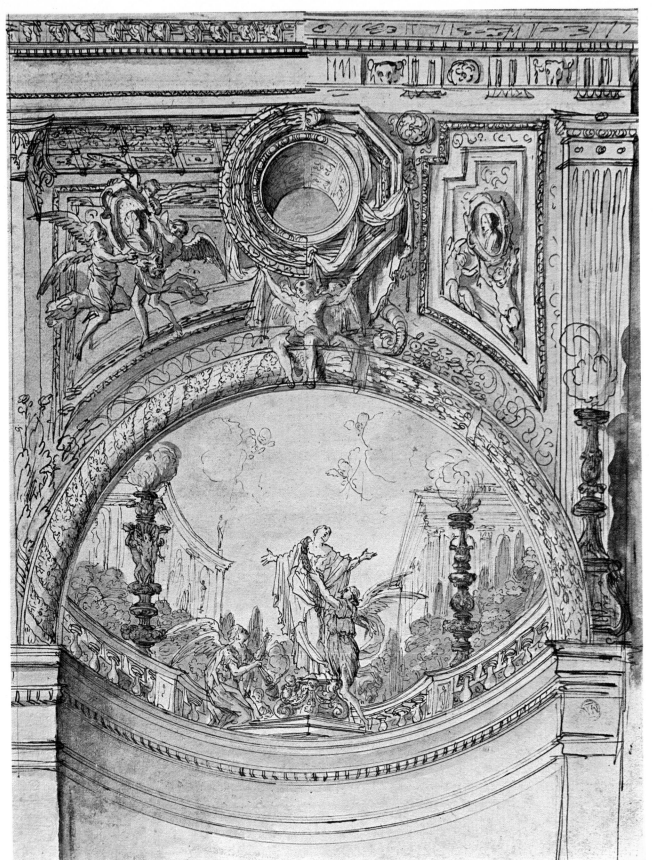

Thomas Blanchet
Paris 1614 - Lyon 1689

Project for Church Decoration.
Paris, Musée du Louvre, Inv.
no. 23.784. Pen and bister wash, with
red chalk and watercolor tints;
16 × 12¼ in. (40 × 30.7 cm).

Provenance : Coll. Mariette.

Bibliography : Bacou-Bean, 1960,
cat. no. 66.

Trained in Paris in the atelier of the
sculptor Jacques Sarrazin, Thomas
Blanchet lived in Rome during his
early maturity, from 1649 to 1653,
before settling in Lyon — where he
was to become, one might say, the
official painter in residence. His Italian
sojourn seems to have been decisive
for Blanchet's drawing style. Late in
life, in 1676, he was inducted into the
French Academy — an event indicating
the importance of French provincial
artist activity during the seventeenth
century. Blanchet's proposed decora-
tive scheme may have been for an enti-
rely illusionistic wall painting, or could
also have followed the lines of a real
niche to contain a side altar dedicated to
some patron saint. The alternate arran-
gements and decorative motifs presented
here show the artist in the role of inte-
rior designer, prepared to leave final
decisions be settled with his client.

7

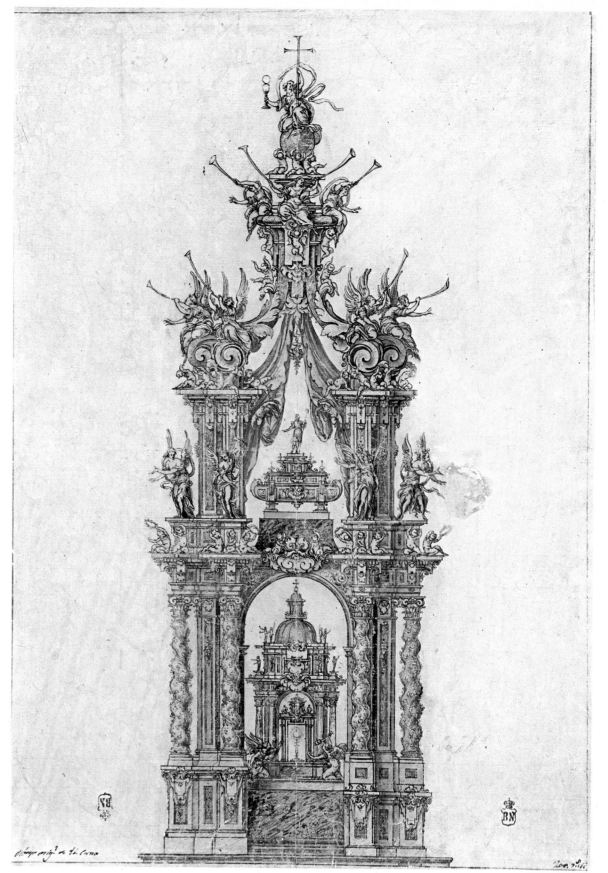

Sebastian de Herrera Barnuevo
Madrid 1619 - 1671

**Tabernacle of St. Isidore
Agricola,** 1659.
Madrid, Biblioteca Nacional, no. 403.
Pen and ink, with bister and yellow
tempera, on yellowish paper ;
16 ¼ × 11⅜ in. (40.8 × 28.5 cm).

Bibliography : Barcia, 1906, no. 403 ;
Sánchez Cantón, 1930, V, no. 363 ;
*Exposicion de Dibujos de Antiguos
Maestros Españoles (Siglos XVI al
XIX),* Madrid, 1934, no. 78 ; Wethey,
1956, figs. 11-13.

Clusters of agitated and trumpeting
angels, theatrically arranged amid *putti,*
drapery, and architectural elements,
celebrate the eternal victory of Faith,
who is personified in the figure seated
on a globe at the very top and holding
a chalice, Host, and cross. The central
reliquary and monstrance below con-
tain and display relics of St. Isidore
Agricola. This highly embellished altar
project for the Church of San Andrés in
Madrid was rejected in favor of a more
restrained and conservative model. The
design is based on Bernini's for St.
Peter's burial place, where the great
serpentine columns were believed to
have come from the biblical Temple of
Solomon. Here that great Baroque pro-
gram is reduced to a series of fussy
decorative conceits, nearer the sugary
ornament on a wedding cake than to
Bernini's imposing bronze monument.

8

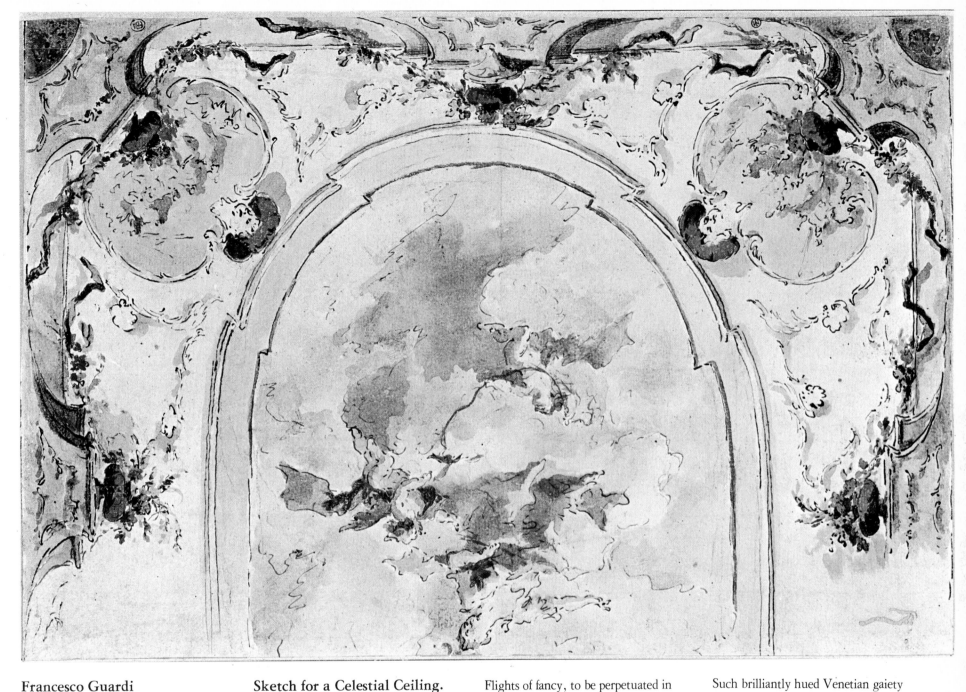

Francesco Guardi
Venice 1712 - 1793

9

Sketch for a Celestial Ceiling.
Paris, École des Beaux-Arts. Pen and
sepia ink, with brown wash and water-
color; 10¾ × 15¾ in. (27 × 39.5 cm)

Bibliography: Fiocco, 1948, p. 5;
Pignatti, 1965, p.128

Flights of fancy, to be perpetuated in
fresco or on canvas, animate this airy
Venetian Rococo ceiling project. Part of
the ornament included here may have
been sketched for modeling in stucco
relief. The beige cartouches at the cor-
ners were probably meant to contain
narrative scenes. The goddess in pink,
set in a central oval of open sky, is
perhaps an overdressed Venus. One of
her attendant Cupids holds a bird on a
string, symbolizing the human spirit
enslaved by love. This is probably a
late work of Guardi; other drawings
of the same series are now in Plymouth
and in the Museo Civico Correr, Venice.

Such brilliantly hued Venetian gaiety
was popular throughout Europe, for the
travels and commissions of Tiepolo and
Sebastiano Ricci carried this style to
France, Spain, Germany, England, and
even eastward to Poland.

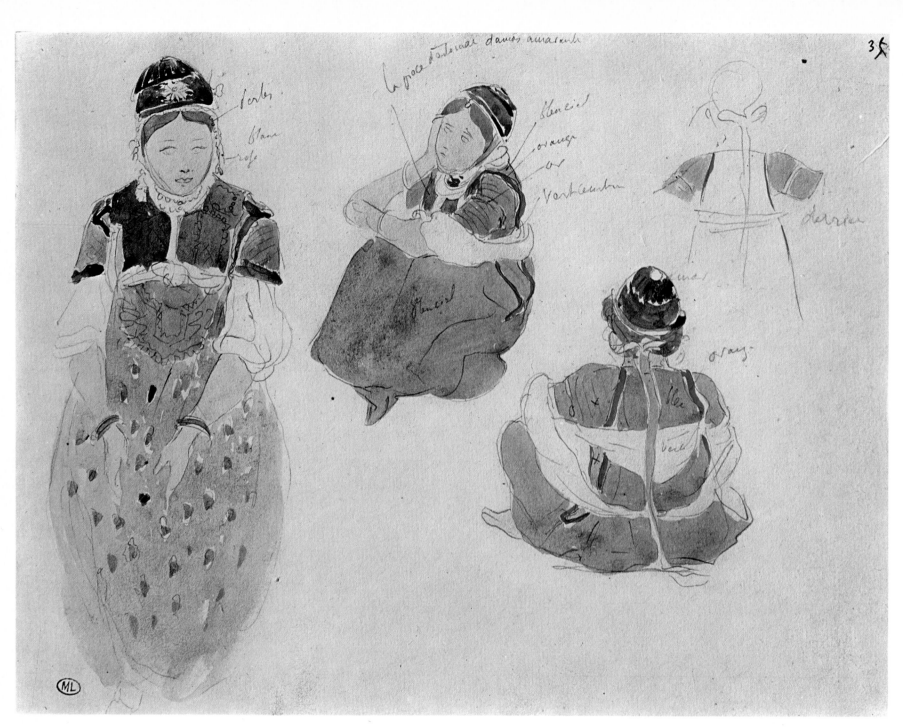

Eugene Delacroix
*Charenton Saint Maurice 1798 -
Paris 1863*

10

Study of Arab Women.
Paris, Louvre, n. R.F. ; 9154.
Watercolor over graphite, 6¼ × 8⅓ in.
(15.8 × 21.3 cm).
Provenance : Gift of Etienne Moreau-
Nélaton, 1927.

Bibliography : Sérullaz, 1963, n. 159.

During his travels in Morocco and Spain
in 1832, when he accompanied the
diplomatic mission of the Count de
Mornay, Delacroix filled his sketch-
books with local scenes. The album from
which this drawing was taken includes
sketches, watercolors, and pastels made in
North Africa and Spain, and the subjects
consist of landscapes of the Spanish coast,
Algiers, and Mers-el-Kebir, inter-
spersed with moorish interiors and studies
of local figures. This journey was to have
the utmost importance to the develop-
ment of Delacroix's art, fascinated as he
was by these countries which seemed to
contain a living vision of the past, and
scenes washed by a light that exalted and
transformed the colors. This sketch is

marked so as to fix the the visual image
for the artist : *perles, blanc, rose, la pièce
d'estomac damas amarante, bleu ciel,
orange, or, vert, derrière, amar...,
orange, bleu, vert.*

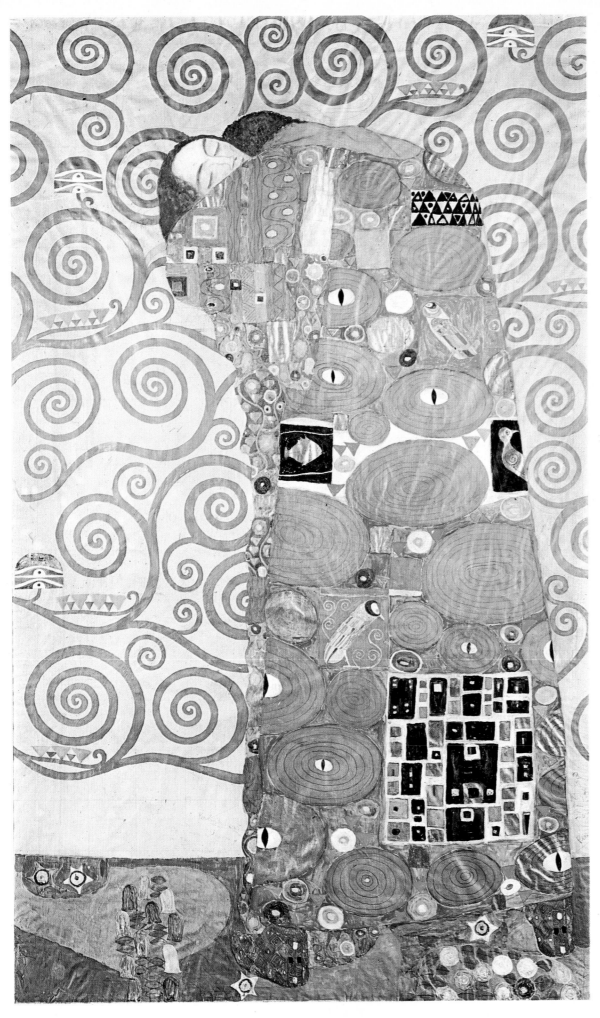

Gustav Klimt
Baumgarten 1862 - Vienna 1918

**Mosaic Design for the Stoclet
Residence, Brussels,** 1905-1909.
Vienna, Österreichisches Museum für
Angewandte Kunst. Mixed media on
panel ; 77¾ × 48½ in.
(194.6 × 121.3 cm).

Provenance : Coll. S. Primavesi.

Bibliography : J. Dobai, *Gustav Klimt,*
Vienna, 1959, no. 148 ; Solomon
R. Guggenheim Museum, Gustav
Klimt and Egan Schiele, New York,
1965, no. 7-1 (exhibition catalogue).

Klimt's stylized lovers embrace a world
of design references as well : they
present a mysterious marriage of the
English Arts and Crafts movement to
the style of the Vienna Sezession. The
Austrian master unites the patchwork
quilt effect of bold contemporary wall
hangings with the assumed, mannered
austerity of Aubrey Beardsley. Only
Klimt's eclectic genius could so effec-
tively join the erotic vocabularies of the
Pre-Raphaelites to those of Japanese
art, resulting in works that are breath-
taking in their seductive, surprising,
and ultimately original beauty.

11

Antonio Sant'Elia
Como 1888 - Carso (Monfalcone) 1916

Project for a Terraced Apartment House with External Elevators, 1913.

Como, Villa Olmo (Permanent Exhibition of Sant'Elia's Works). Pencil; 8½ × 8⅝ in. (21.3 × 21.5 cm). Dated at right: "2 agosto 1913."

Bibliography: U. Apollonio and L. Mariani, *Antonio Sant'Elia,* Milan, 1958; L. Caramel and A. Longatti, *Antonio Sant'Elia: Catalogo della Mostra Permanente,* Como, 1962, no. 95.

This bold yet meticulous rendering by the Italian architect-draughtsman Sant'Elia shows a residential building capped with a lighted advertising sign and an antenna which resembles a miniature Eiffel Tower. It has much of the dynamism and drama associated with Futurist art and design, rooted in the architectural work of Auguste Perret. Anticipating the sets for Fritz Lang's classic *Metropolis,* Sant'Elia's prophetic building also foreshadows the coolly elegant excitement of Art Deco or some of its most exuberant architectural heirs in Hollywood, Miami, and Las Vegas. The designer's special sensitivity to subdued decorative motifs, to surface effect as well as structural inventiveness, makes such a drawing — like the building which inspired it — a striking independent work of art.

12

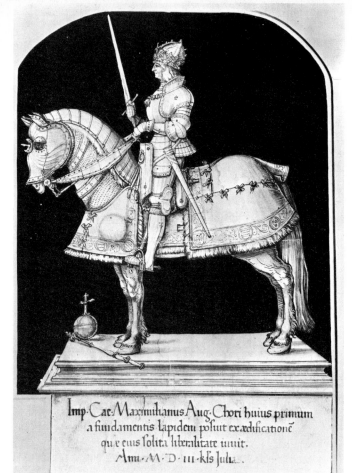

1

2

3

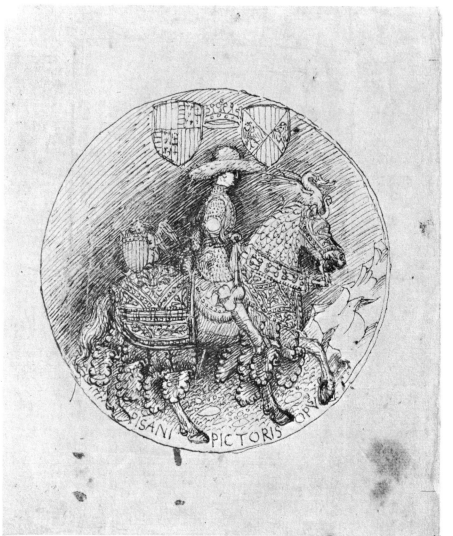

Hans Burgkmair the Elder F. 1
1473 - 1531

**Design for a Monument to the
Emperor Maximilian.**
Vienna, Albertina no. 22.447. Brown-black
ink, grey wash ; 17 × 11 ¼ in.
(43.3 × 28.0 cm).

Etienne Delaune F. 2
Orléans c. 1518 - Strasbourg 1583

Design for a Plate.
Paris, Musée du Louvre, no. 26193. Pen and
dark brown ink, with brown wash, on
vellum ; 10 ⅞ in. diameter (27.2 cm).

Pisanello F. 3
Pisa 1395 - ? 1455

**Design of Horseman for the Reverse
of a Medal.**
Paris, Louvre, Cabinet des Dessins,
no. 2486. Pen and ink on white paper ;
6 ½ × 5 ½ in. (16.5 × 14.2 cm).

4

5

6

Guido Reni F. 4
Bologna 1575 - 1642

Coat-of-arms of Cardinal Sforza.
London, British Museum,
no. 1862.7.12.523. Pencil, red chalk,
and watercolor ; 7 1/4 × 9 1/2 in.
(18.3 × 23.7 cm).

Niccolo Tribolo F. 5
Florence 1500 - 1550

Design for a Fountain in a Niche.
Paris, Musée du Louvre, no. 49. Pen
and brown wash, over black pencil ;
12 × 9 in. (30 × 22.6 cm).

Marco da Faenza F. 6
(Marco Marchetti)
Faenza (?) - 1588

Study of a Pitcher.
Oxford, Christ Church Library, no. 887.
Pen and ink, with brown wash ;
14 1/2 × 8 in. (36 × 20.2 cm).

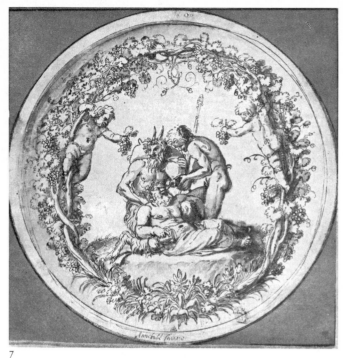

7

Annibale Carracci F. 7
Bologna 1560 - Rome 1609

**Design for the Farnese
Silver Salver,**
1597 - 1599.

New York, Metropolitan
Museum of Art,
no. 1972.133.4.
Pen and brown ink, with
brown wash, over traces
of black chalk and stylus ;
10 ⅛ in. (diameter 25.5 cm).

Pellegrino Tibaldi F. 9
Bologna 1527 - Milan 1596

**Design for a Frieze of Putti with
Heraldic Emblems.**
Windsor, Royal Library, no. 10908 (by
permission of Her Majesty Queen
Elizabeth II). Pen and ink, with brown
watercolor and white-lead highlights ;
7 ¼ × 16 in. (17.8 × 40.2 cm).

Perino del Vaga F. 8
(Piero Buonaccorsi)
Florence 1501 - Rome 1547

Design for a Chapel Wall.
Budapest, National Art Museum,
no. 1838. Pen and ink, brown wash ;
16 ½ × 11 ¼ in. (42.0 × 28.3 cm).

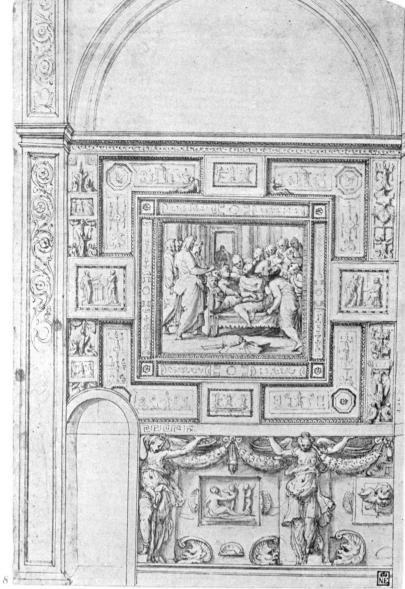

8

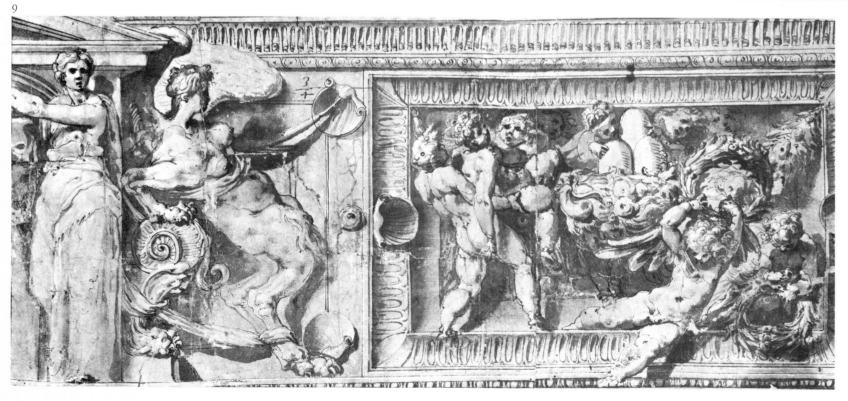

9

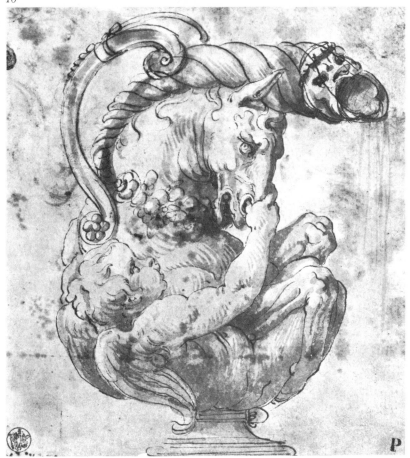

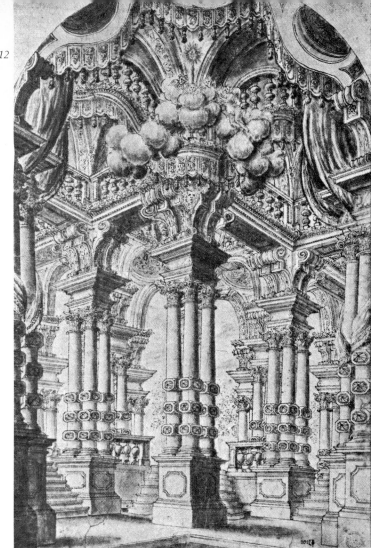

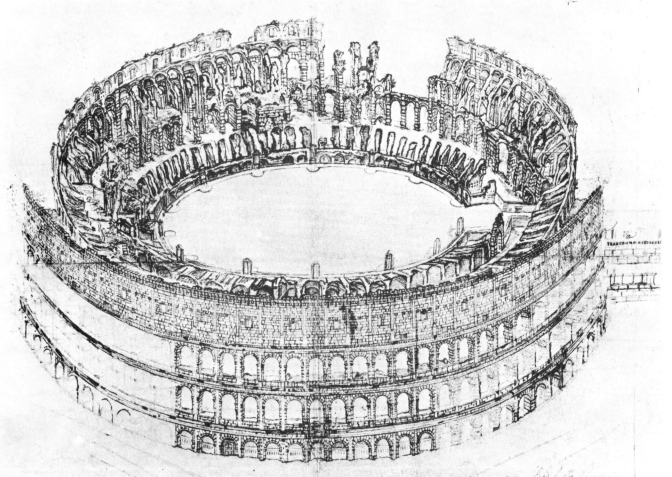

Francesco Salviati F. 10
Florence 1510 - Rome 1563

Study for a Piece of Jewelry.
West Berlin, Staatliche Museen. Pen and ink with brown wash ; 7 1/3 × 6 1/2 in. (18.7 × 16.7 cm).

Giovanni Battista Piranesi F. 11
Venice 1720 - Rome 1778
Bird's Eye View of the Colosseum.
West Berlin, Staatliche Museen, no. 4475/3940. Pen and ink ; 20 × 29 1/2 in. (51 × 75 cm).

Ferdinando Galli Bibiena F. 12
Bologna 1657 - 1743

Stage Design for a Royal Palace.
Naples, Museo di San Martine. Pen and bister ink, with pale blue and bister wash.

Filippo Juvarra F. 13
Messina 1678 - Madrid 1736

Architectural Stage Design.
Turin, Museo Civico. Pen and sepia ink, with pale blue wash.

Gian Lorenzo Bernini F. 14
Naples 1598 - Rome 1680

Project for a Fountain with a Giant and an Obelisk.
Rome, Biblioteca Vaticana (Codex Chigi, p. VIIg, fol. 129(89). Pen and wash over chalk, on white paper ; 11 ¹/₈ × 8 ¹/₈ in. (27.8 × 20.4 cm).

Pieter Jansz. Saenredam F. 15
Assendelft 1597 - Haarlem 1665

Interior of the Groote Kerk at Alkmaar.
Vienna, Albertina, no. 15129. Pen and bister, India ink, brush and watercolor ; 9 ¹/₄ × 13 ³/₄ in. (23.5 × 35.2 cm).

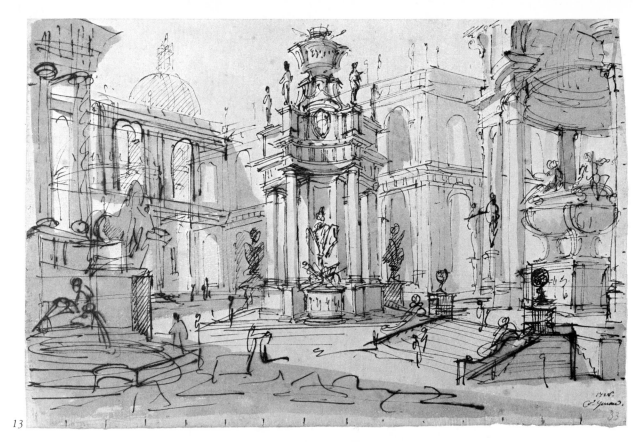

13

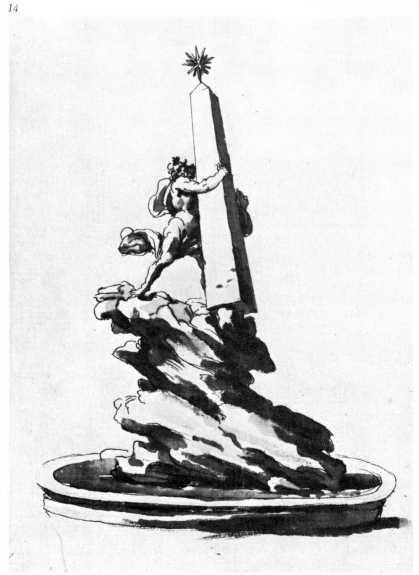

14

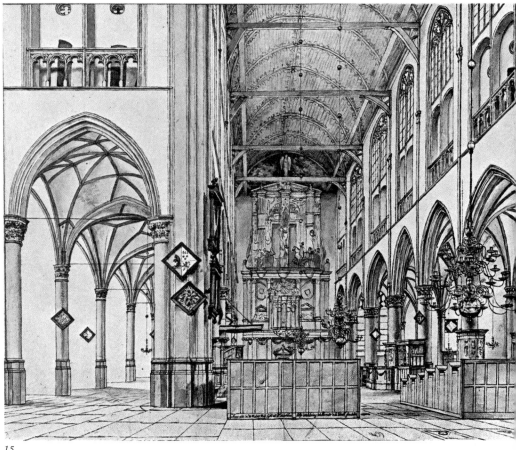

15

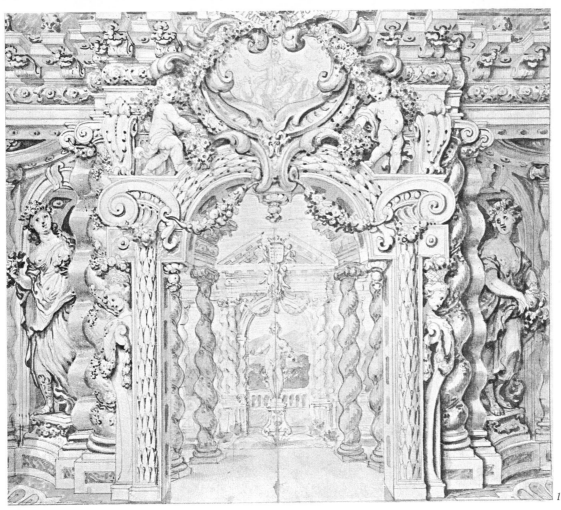

16

Francisco Rizi F. 16
Madrid 1608 - 1685

Decoration for a Royal Festival.
Madrid, Biblioteca Nacional, no. 458.
Pen and ink, colored temperas, on
yellowish paper ; 13 × 14 ¾ in.
(33.2 × 37.9 cm).

Claudio Coello F. 17
Madrid 1624 - 1693

Ceiling with Flora.
Madrid, Prado no. F.D. 405. Pen and
ink, bister wash, white paper
9 ¾ × 6 ⅔ in. (24.7 × 17.2 cm).

Charles Rennie Mackintosh F. 18
Glasgow 1868 - London 1928

Sketch for a Mirror.
Glasgow, Mackintosh Coll., University
of Glasgow, no. 23a. Watercolor and
pencil ; 12 ⅜ × 12 ⅞ in.
(31.5 × 32.7 cm).

17

18

A note on graphic techniques and conservation

Among the first drawings in the modern sense of the word were the Italian *sinopie*, preparatory underdrawings of frescoes and mosaics to guide the painter or mosaicist in applying his colors. Self-liquidating in purpose, these drawings were completely effaced by the fresh layer of plaster and the pigments or tesserae placed over them. Sometimes there were as many as three separate layers of such *sinopie*—so named because the last step in their making used a red earth pigment which came from Sinope, a town on the Black Sea.

In late medieval times, with the development of new papermaking techniques, the use of metal point as a graphic medium became increasingly common. The hardness of this new medium, a pointed stylus, provided a uniquely uniform breadth of line. The stylus was usually made of silver, but occasionally was of lead, copper, or gold. The paper was first covered with chalk, bone dust, or white lead (sometimes powdered egg was used), and the surface was burnished before the silverpoint was applied. This technique is especially effective on light-tinted papers, pale lavender, blue, green, or gray, which provide a perfect foil for the finespun silverpoint line, with its light-reflecting surface, to convey subtle contrasts of texture. Although it was less popular after the early 1500's, metal point continues to appear irregularly through the present day and is regarded as the ultimate challenge to graphic mastery.

The light-hued papers mentioned above provide an invaluable shortcut to illusionism. Their subtly tinted surfaces are marvelously responsive to any suggestion of light or space. First employed in the fourteenth century, such papers reached a peak in coloristic variety during the sixteenth century, after which shades of pale blue, green, beige, and gray predominated. Black papers drawn on with white or blue and green sheets used with varicolored chalks were particularly effective in conveying space, color, and atmosphere. Among the Italian artistic centers, as might be expected, it was Venice that adopted these colored backgrounds most notably, as if reluctant to abandon the rich sustenance of color for even the most tentative paper projects.

Pen drawing is found more than any other medium in the graphic *œuvre* of the last six centuries. Watrous credits the supreme popularity of this intrument to its amazing "adaptability in creating forms which meet the varied stylistic requirements of every art epoch and of almost every master." [1] Earliest in use were reed pens cut from the stems of bamboo-like grasses. Later, beginning in the fifteenth century, quills obtained from the wing feathers of swans, geese, and other birds were variously cut to produce blunt, medium, or fine points or to form broad chisel-like nibs. The primary advantage of the quill was the great ease with which it responded to the individual touch and graphism of each master, becoming a sort of organic extension of his hand and allowing for direct transmission of every gestural nuance to the paper. Lacking the uniformity and unyielding precision of the steel nib, the quill gives flexibly as the hand moves, thereby laying ink on paper in a more personal, varied stream. In its linear progress over the irregular, varyingly absorbent surface of rag papers of earlier times, the quill responded sensitively to this unevenness—widening and narrowing, darkening and lightening, according to the pressure of the artist's hand and the texture of the sheet.

Perhaps most dramatic of all the draughtsman's instruments is the reed pen, so forceful and urgent in effect. The blunt reed seems to compel progressive abstraction of a motif, at times to the point of becoming ideographic. To achieve more precise detail or illusionistic effect, the reed pen must be combined with an instrument of greater ductility, such as the quill or some other pen or brush.

[1] James Watrous, *The Craft of Old-Master Drawings*, Univ. of Wisconsin Press, Madison, 1957, p. 44.

The so-called black "lead" pencil, probably the most common drawing instrument in later periods, was not widely adopted until the late seventeenth century. Despite its familiar name, it is actually made of graphite. The very best grade of graphite came from a lode at Borrowdale in Cumberland, England, discovered in 1560. This was employed for the most part by architectural draughtsmen, in the form of a narrow stick set into a *porte-crayon*, so that it could be sharpened when needed. In the nineteenth century, these graphite sticks were firmly embedded in wood—much the type of lead pencil we know today. Artists often sketched out their composition first in graphite, then added inks, washes, or chalks to finish the drawing.

Charcoal was also employed with increasing frequency in the sixteenth century and later, as the price of paper decreased and larger sheets, on which it showed to best advantage, became more conveniently available. Besides for drawings on paper, it was used for direct preliminary roughing out of panel paintings and mural compositions, to be covered by the final layers of oil, tempera, or fresco. Made of compressed burnt willow or other twigs, charcoal encourages a swiftly executed line, interestingly varied in intensity and breadth, as well as highly poetic shading. Though less stable than other media, charcoal makes up for this impermanence with its extraordinary graphic thrust.

Some drawings, in their method, should be thought of almost as reliefs. Unlike silverpoint, ink, or watercolor renderings, where line or wash rests evenly across the surface and is absorbed at a relatively uniform level, such more perceptibly layered works realize their images by an interaction of the medium (or media)—chalk, charcoal, pastel, Conté crayon—with the paper's irregular texture (known as *tooth*). Some of these media are water-soluble, and the draughtsman may go over them with brush and water to create more softly modulated transitions; others are made of ground pigment held together with a fatty or oily adhesive that gives the surface a slightly glossy, light-reflecting appearance.

The first natural chalks were taken from the earth in pure white, black, or colors and were held together by a clay binder. Red chalk, long a popular medium, is often referred to as sanguine, from its blood-like coloring; or as hematite, after the mineral from which it is extracted. This warm-hued medium, with a kind of implicit organic reference in its color, was often preferred for nude studies. Many of the most beautiful drawings of Leonardo, Andrea del Sarto, and Michelangelo, among other Renaissance masters, were made in red chalk; the relatively broad line, pulsing with life, suggests both flesh and sinewy muscle. Laid on thinly over blue or other toned papers, red chalk allows the tint of the paper to show through and enhances the atmospheric, form-building effect. The slightly blurred contours in this medium give a vague suggestion of motion and an impressionistic play of illumination. These distinctive qualities were used to good advantage by such sixteenth-century master draughtsmen as Barocci. When sanguine is worked together with black and white chalk, a still richer and more complex resonance occurs. This *trois crayons* technique, first employed in northern Italy during the sixteenth century, can achieve a colorism approaching the oil sketch.

Such Venetian masters as Tintoretto and Bassano turned to chalks or pastels as the quickest, broadest (and perhaps cheapest) way to capture initial pictorial concepts in figure and landscape studies. Perhaps what is now loosely termed "modernism" began with these painterly Manet-like sketches in which the viewer's eye was meant to add to the graphic realization by the artist's hand. Fresh strokes of color, quickly set down with a deceptive informality on tinted paper, demonstrated a radical break with the meticulous goldsmith's line of the late Middle Ages and Early Renaissance. No longer a finespun pattern in itself, the drawing now recorded the creative impulse of its maker with an unmannered spontaneity. Still, neither Italy nor the North ever entirely jettisoned the finely wrought goldsmith's line. In the South, many artists alternated between a more conservative, carefully hatched mode and a bolder,

freer approach that was often associated with a relaxed classicism. In the North this second mode tended toward an expressionistic style characterized by a more erratic, almost Late Gothic line. While Bosch was dashing off his mordant, vigorous sketches of moralizing rustic scenes or Biblical subjects, his contemporaries such as Gossaert were forging an union between medievalizing craft traditions and the new freer graphism of Rome.

In the late sixteenth century, versatility in graphic technique became part of a more considered academic approach with the Carracci in Bologna. Located between Venice and Florence, this great center for painting appropriated the best from two pre-eminent schools of Italian art: Florentine precision and intellectualism and Venetian colorism, relaxed classicism, and sweeping grandeur. Bolognese artists practiced the drawing techniques of both these schools. Use of tinted papers and a free, engagingly spontaneous graphism from Venice were combined with a rigorous Tuscan sense of method and tenacious grasp of *disegno*. This virtuoso fusion of color and line, so masterfully achieved by the Carracci and their followers, led to the dissemination of a new graphic style throughout Europe.

This development was most important for Flanders, as seen in Rubens' art, and for the towering Dutch genius of the next generation, Rembrandt, with his incomparably versatile handling of expressive line. Rubens' headlong, voluptuous figure studies would be inconceivable without the Bolognese precedent. And Rembrandt's stirring, suggestive reed-pen line could never have been realized without the prior experiments in this austere yet curiously rich medium by the Carracci. Significantly, both of these Northern masters had great collections of Italian art.

Rembrandt, perhaps the most daringly experimental of all master draughtsmen, was fond of combining diverse techniques. A single sheet of his may employ dry and moistened natural red chalk, quill pen and bister ink, yellow ocher, processed chalk, and semiopaque whites applied with a brush. His drawings present an exceptionally variegated array of graphic media, and occasionally involve students' hands as well as his own. A variety of inks, sometimes set down with different kinds of pens, can be identified in the same drawing. For example, in one study Rembrandt used iron-gall and carbon inks, quill and reed pens, besides applying carbon-black and bister inks with a brush as grayish and brown washes. Using the warmer, more changeable iron gall for finer lines, he saved the reed pen and carbon-black ink for the broadest, most dramatic contours.

In the seventeenth century, when trade links to the East were established to a greater extent than ever before, Chinese and Japanese brushwork, with its calligraphic abstraction and suggestive power, began to attract many European artists. Rembrandt also used Oriental papers, and possibly inks, for some of his finest drawings and prints. He made drawings after Indian manuscripts and the other Oriental works of art in his vast personal collection. Eastern influences in graphic and other arts became still stronger in the eighteenth and nineteenth centuries. In the late 1800's, the Impressionists responded to the vivacious linear economy and arresting perspective of Japanese prints and drawings, adapting these distinctive traits in their own Parisian equivalents of the "Pictures of the Passing World".

Watteau, another consummate draughtsman who was of Flemish origin, was uniquely suited to blend the art of Rubens and his source, the Venetian masters. While living in Paris in the great drawing collector Crozat's household, Watteau studied the financier's seemingly endless treasures just at the time he also enjoyed special access to one of the Baroque master's finest achievements, the Marie de Médicis series, whose curator was the young Watteau's friend. Stripping the art of the preceding century of its grandiose rhetoric, Watteau made a little line and a little color zero in on the subtlest, most fleeting and peripheral expressions and emotions. His graceful yet speedy graphism coined a new vocabulary of physiognomy, and he raised the *trois crayons* to an unrivaled degree of sensitivity. He often sketched the model from different angles on the same sheet, producing an effective "in the round" anthology with breathtaking dexterity and insight. Watrous has noted Watteau's masterly combination of manufactured black chalk with natural red chalks of varying hue, from vivid blood red to cooler and brownish earth reds. Sometimes, in such features as the eyes, the artist moistened his chalk patches to darken them and create a sense of sparkle and depth.

With the noteworthy exceptions fo the eccentric eighteenth-century Swiss master Liotard, whose highly finished pastel studies rank among the greatest in this technique, and the talented Rosalba Carriera (another protégé of Crozat), all the leading masters of pastel crayons were French, as evidenced particularly in La Tour's admirable portraits. Even Chardin, who left no securely identified drawings in any other medium, executed a number of pastel portraits. The semimonopoly exercised by France in this popular medium goes back to the fifteenth century, when it is thought to have originated, before it was taken over by Leonardo and his circle, later to be employed extensively in France again by the Clouets for their numerous aristocratic portraits. Holbein and Cranach also seem to have used pastels in some of their works. Adding traces of pastel, hints of soft color about the eyes and cheeks and lips or casual strokes on a bodice to suggest texture and pattern, François Clouet capitalized on the new graphic discoveries of the North.

Centuries later, with the revival of the evocative chiaroscuro of Leonardo and Correggio, pastel enjoyed new popularity in the work of Prud'hon and other Neoclassic artists. Later in the nineteenth century Degas, Puvis de Chavannes, and Redon, among many others, worked in varicolored pastels, taking superb advantage of the unique layered shadings possible in this delicate medium, combining warm and cool tones. One might almost say that Redon's haunting works in black and white chalk or in very dark pastels were even more stunningly coloristic than his bright-hued flower pieces. The French master's infinitely graded blacks bear out the theory that all other colors lie within them.

A greasy black chalk, Conté crayon, was much used by nineteenth-century artists (Seurat). One of its special qualities was that it attached itself quite tenaciously to the irregular surface of handmade papers, creating a hazy suffusion of light and dark almost like mezzotint. This medium was first developed in the late eighteenth century when chalks were impregnated with fatty substances to produce a rather waxy effect; known as crayons, these were employed with distinction by Fragonard and Greuze. Crayons combine a shiny, luminous quality with a sense of solidity that communicates form rather more readily than chalk. Later, Ingres combined black crayon and graphite to strengthen the modeling in some of his studies.

Though long sought, a metal pen that would remain pointed without the repeated sharpening and recutting necessary for reed or quill was not perfected until the early nineteenth century, only then made possible by the technical advances of the Industrial Revolution. Gold, silver, and brass had all been experimented with, but these trial materials eventually gave way to mass production of stamped, bent, and ground steel blanks. While some artists held onto quill and reed pens for their varied tonal effects, many illustrators welcomed the steel pen, with its capacity to provide clean, sharp contrast between line and paper, a keenly defined black-on-white pattern that lent itself exceedingly well to mechanical reproduction of graphic works.

As Watrous observed, "Today artists depend for the most part upon two kinds of ready-made inks, drafting or India ink, made of carbon black and water, and a brown ink commonly called sepia. Earlier draughtsmen had recourse to a much richer variety, including carbon black of unchanging color and iron gall 'black,' whose color and value underwent very considerable change during and following preparation." Two kinds of brown ink were most frequently used: bister, which Watrous characterized as chromatically strong but very transparent; and sepia, far more transparent and used for the most part as a wash. It is difficult if not impossible to

differentiate between watercolor and many so-called inks (often the reds, blues, and browns) used for pen and wash drawings, since the preparation and pigments of both, made from mineral colors and vegetable or chemical dyes, are so much alike.

Papermaking in the West only began on a large scale in the late fourteenth century; before then, most drawings were done on parchment. Early paper was made of linen and cotton rags reduced to a pulp, with fibers of great strength and durability. In the mid-eighteenth century, the great English printer John Baskerville changed the surface of paper by replacing the pronounced "chain" and "laid" lines of older papers with a perfectly even, fine wire mesh. This new paper, called woven paper, was first made in 1750. With the discovery of chlorine in 1774, it became possible to lighten the color of paper and achieve the most-prized white surface from cheap rags that formerly would have produced only an undesirable grayish shade. The best rag paper is never bleached. Chlorine or similar agents, if not completely rinsed out of the pulp, have a distinct weakening effect that sometimes is not noticeable till long after the paper is made. With the increased demand for paper in the sixteenth century, fermenting agents were introduced to accelerate the pulping process of rags, to speed up the disintegration of the fibers. Lime water or similar agents, in accelerating fermentation, also tended to weaken the paper's structure and sometimes contributed to a yellowing effect as well. Rust-colored spots known as *foxing* also were likely to appear in such paper, from the use of fermenting agents after 1500.

A device known as the Hollander, having metal beaters to break up rag fibers more effectively than the older wooden stampers, was invented in 1680 and remained in use until the early nineteenth century. While it speeded up papermaking, it also deposited minute quantities of iron filings in the paper as the teeth of the beaters began to be worn down, and these metal bits led to the appearance of rust spots in the paper if subjected to moist air at a later time. Metal beaters also shortened the fibers to a greater degree than

wooden stampers, thereby weaking the paper's fabric.

The earliest papers have an uneven surface because the felts separating individual sheets impressed themselves on the paper. In the sixteenth century, with interest in more even-textured surfaces, paper was pressed over and over again ("sweated") to achieve the smoothest effect. It was also burnished with a smooth stone after it had been sized with animal glue to create a surface with reduced absorption, to gain maximum effect from the artist's media. This glue, actually a gelatin, was kept in baths; the sheets of paper, after their first drying, were dipped in the solution and hung up again for drying. Poor-quality sizing could lead to discoloration of the paper when exposed to light; all organic sizing is hazardous since it can "feed" bacteria, leading to mold and brown stains. Significantly, discoveries speeding up production and reducing the cost of paper took place just before the Industrial Revolution, in the final decade of the eighteenth century, with the invention of paper presses and early experimentation with use of wood pulp in paper manufacture. Extensive bleaching, requiring the addition of alum (which is slightly acidic) and the use of a rosin, built in self-destructive factors that led to serious problems in paper preservation. Weaker in structure than hand-made paper, the product of the Foundrinier machine of 1807 lacked the inner strength of cross-laid fibers in rag paper. Any leftover chloride bleaches, together with the presence of too much alum, could led to a potential "self-destruct" undreamed of by the papermakers or users of the day. Fillers of chalk, china clay, or gypsum added to paper to increase its weight and solidity (because paper was sold by weight) also undermined its structure.

Poorly preserved drawings, unlike damaged paintings and prints, can rarely be treated in a way to disguise rather than merely minimize or arrest their losses. A seemingly brilliantly preserved drawing cannot be worked up from a wreck, as is sometimes the case in other media. Skillful restoration can employ photography and other techniques to improve the quality of an engraving or etching, to hide tears in the paper, to wash

and bleach the paper to remove spots or other discoloration, primarily because printer's ink is a relatively stable compound. Drawings present far greater problems, for the medium is often water-soluble; but newly discovered gas bleaches and other techniques are sometimes used with a degree of success. Lines can be worked over or "strengthened" to give greater vitality and contrast to a faded drawing. Color, always in demand, was sometimes added later to works in monochrome to make them more attractive to the purchaser.

Atmospheric acidity due to gasoline pollution and sulfur dioxide in smoke are major sources of damage, especially to drawings of the nineteenth and twentieth centuries, if the paper is made of wood pulp whose bleaching agents were not completely rinsed out at the time of manufacture. Air conditioning does much to prevent these injurious substances from reaching the drawing, as does a tightly sealed frame. If need be, drawings can be deacidified through the penetration of the paper with an alkaline substance which neutralizes the acid, leaving enough alkali in the paper to combat any further return of acidity. Applicable in either a gaseous or aqueous state, it can be used even if the drawing medium is water-soluble.

Exposure of fine drawings to the ultraviolet and infrared rays of strong sunlight or powerful electric light should always be avoided. Paper subjected to relative humidity above 70 percent can suffer irreparable harm from mold growth. Excessive humidity will also act on the minute particles of iron and other matter occasionally found in old paper, leading to rust spots and other discoloration. Extreme dryness can be equally injurious, causing progressive dehydration that will make it shrink and become brittle. Therefore drawings should not be hung against warm walls or near heating units and hot-water pipes. All mats and other mounting material or backing should be checked to determine whether they are of rag paper, so that the mounts cannot discolor or otherwise adversely affect the drawing. If it is purchased already framed, its backing should be removed to inspect the mat and ensure that no cellophane or other tape is holding the

drawing in place, since these would soon discolor and destroy the surface underneath. Any such adhesive must be removed by an expert paper conservationist.

Papers which have become discolored through rust spots or bacterial growth can be lightly cleaned by placing them in a cabinet containing thymol crystals that are mildly heated. Such treatment, best done by a paper conservationist, kills any bacteria present in the paper and has a lightening effect that will remove most of the colored spots.

In the later nineteenth century, artists often worked on cheap wood-pulp paper to produce their rough compositions or first studies, using costlier paper for more finished works. Many preliminary studies so executed proved unstable, especially when subjected to the high humidity and excessive central heating in American buildings. These cheap papers were not employed out of economy alone, since some had a rough grey or buff texture that made them especially suitable for preparatory studies exploiting the warm coloration of the background. Impressionists and Postimpressionists such as Toulouse-Lautrec liked the uneven, mottled surface of these pulpy cardboards.

Pastel and charcoal drawings should not be exposed to vibration, and the effectiveness of their fixatives should be checked regularly. Sometimes it is advisable to reapply fixative, but this must be done with great care and by an experienced conservator to avoid darkening the surface. Sixteenth-century and later drawings were often given zinc white highlights to increase the illusionism of the surface, and this treatment lent a relief-like look to the study. Such additions tend to oxidize and darken in time, an effect that can also be reversed by a skilled paper conservator. If there is no graphite or other material that could be disturbed in the process, skillful use of a fine brush or gum eraser by a paper expert can do much to remove decades or centuries of dirt from the drawing's surface.

Bibliography

Barocchi, P., *Il Rosso Fiorentino*, Rome, 1950.

Barocchi, P., "Precisazioni sul Primaticcio," *Commentari*, II, 1951, pp. 203-223.

Barocchi, P., *Vasari Pittore*, Florence, 1964.

Bean, J., and F. Staempfle, *The Seventeenth Century in Italy: Drawings from New York Collections*, New York, 1965 (exhibition cat.).

Becker, H. L., *Die Handzeichnungen Altdorfers*, Munich, 1938.

Béguin, S., "Two Projects by M. Fréminet for the Chapel of the Trinity at Fontainebleau," *Master Drawings*, I, no. 3, 1963, pp. 30-34.

Béguin, S., "Toussaint Dubreuil, Premier Peintre de Henri IV," *Art de France*, IV, 1964, pp. 86-107.

Béguin, S., *Il Cinquecento Francese* ("I Disegni dei Maestri"), Milan, 1970.

Benesch, O., *Venetian Drawings of the Eighteenth Century in America*, New York, 1947.

Benesch, O., *The Drawings of Rembrandt*, London, 1957.

Benesch, O., *Meisterzeichnungen in der Albertina*, Salzburg, 1964.

Berenson, B., *The Drawings of the Florentine Painters*, Chicago, 1938 (expanded ed., *I Disegni dei Pittori Fiorentini*, Milan, 1961).

Bernt, W., *Die Niederländischen Zeichner des 17. Jahrhunderts*, I, Munich, 1957.

Blunt, A., and E. Croft Murray, *Venetian Drawings of the XVII and XVIII Centuries . . . at Windsor Castle*, London, 1957.

Hadeln, D. von, *Venezianische Zeichnungen des Quattrocento*, Berlin, 1925.

Hadeln, D. von, *Venezianische Zeichnungen der Spätrenaissance*, Berlin, 1926.

Haverkamp Begemann, E., *Willem Buytewech*, Amsterdam, 1959.

Heinzle, E., *Wolf Huber, um 1485-1553*, Innsbruck, 1953.

Held, J., *Rubens; Selected Drawings*, London, 1959.

Held, J., "The Early Appreciation of Drawings," *Acts of the XXth International Congress of the History of Art*, III, Princeton, N.J., 1963, pp. 72ff, 84.

Hess, T. B., *Drawings of Willem de Kooning*, Greenwich, Conn., 1972.

Huyghe, R., and P. H. Jaccottet, *Le Dessin français au XIXe Siècle*, Lausanne, 1948.

Jaffé, A. M., *Jacob Jordaens*, Ottawa, 1968 (exhibition cat.).

Kamenskaja, F. D., *Watercolors of the 16-19th Centuries in the Hermitage*, Leningrad, 1937.

Ketterer, R. N., *Lyonel Feininger, Gemälde, Aquarelle, Zeichnungen, Graphik*, Campione bei Lugano, 1965.

Koch, C., *Die Zeichnungen Hans Baldung Griens*, Berlin, 1941.

Kusenberg, K., *Le Rosso*, Paris, 1931.

Monbeig-Goguel, C., *Giorgio Vasari, Dessinateur et Collectionneur*, Paris, 1965 (exhibition cat.).

Moreau-Nélaton, E., *Chantilly, Les Crayons français du XVIe Siècle*, Paris, 1910.

Moreau-Nélaton, E., *Les Clouet et leurs Émules*, Paris, 1924.

Morelli, G., *Kunstkritische Studien über italienische Malerei . . .*, II, Leipzig, 1891 (Eng. trans., *Italian Painters, Critical Studies of Their Works*, II: The Galleries of Munich and Dresden, London, 1892-1893, p. 177).

Oettinger, K., and K. A. Knappe, *Hans Baldung Grien und Albrecht Dürer in Nürnberg*, Nürnberg, 1963.

Oertel, R., "Wandmalerei und Zeichnung in Italien . . . ," *Mitteilungen des Kunsthistorischen Instituts in Florenz*, V, 1939-1940, pp. 217-314.

Ozzola, L., "Pitture di Salvator Rosa Sconosciute o Inedite," *Bollettino d'Arte*, 1925-1926 (July), pp. 29-41.

Pallucchini, R., *I Disegni del Guardi al Museo Correr di Venezia*, Venice, 1943.

Panofsky, E., *Albrecht Dürer*, Princeton, N.J., 1948.

Parker, K. T., *The Drawings of Antoine Watteau*, London, 1931.

Parker, K. T., *Catalogue of the Collection of Drawings in the Ashmolean Museum*, II: *Italian School*, Oxford, 1956.

Popham, A. E., and Pouncey, P., *Italian Drawings in . . . the British Museum: The Fourteenth and Fifteenth Centuries*, London, 1950.

Pouncey, P., *Lotto Disegnatore*, Venice, 1964.

Procacci, U., *Sinopie e Affreschi*, Florence, 1961.

Reznicek, E. K. J., *Die Zeichnungen von Hendrick Goltzius*, Utrecht, 1961.

Roethlisberger, M., *Claude Lorrain, The Drawings*, 2 vols., Los Angeles, 1968.

Rosenberg, J., *Martin Schongauers Handzeichnungen*, Munich, 1923.

Rosenberg, J., *Die Zeichnungen Lucas Cranachs d. A.*, Berlin, 1960.

Rosenberg, P., *Disegni Francesi da Callot a Ingres*, Florence, 1968 (exhibition cat.).

Russoli, F., *Il Novecento* ("I Disegni dei Maestri"), Milan, 1971.

Sánchez Cantón, F. J., "Los Dibujos del Viaje a Sanlúcar," *Boletín de la Sociedad Española de Excursiones*, Madrid, 1928.

Sánchez Cantón, F. J., *Dibujos Españoles*, 5 vols., Madrid, 1930.

Sánchez Cantón, F. J., *Los Caprichos de Goya y sus Dibujos Preparatorios*, Barcelona, 1949.

Sánchez Cantón, F. J., *Los Dibujos de Goya*, Madrid, 1954.

Sánchez Cantón, F. J., *Museo del Prado, Catálogo de las Pinturas*, Madrid, 1963.

Sanminiatelli, D., *Beccafumi*, Milan, 1967.

Scheller, R. W., *A Survey of Medieval Model Books*, Haarlem, 1963.

Sérullaz, M., *Mémorial de l'Exposition Eugène Delacroix organisée au Musée du Louvre à l'Occasion du Centenaire de la Mort de l'Artiste*, Paris, 1963.

Sérullaz, M., "La Donation de la Baronne Gourgaud," *La Revue du Louvre et des Musées de France*, XVI, 1966, pp. 96-105.

Shearman, J., *Andrea del Sarto*, Oxford, 1965.

Sirén, O., *Don Lorenzo Monaco*, Strasbourg, 1905.

Slive, S., *Drawings of Rembrandt, with a Selection of Drawings by His Pupils and Followers*, New York, 1965.

Stechow, W., "Drawings and Etchings by Jacques Foucquier," *Gazette des Beaux-Arts*, XXXIV (July 1948), pp. pp. 419-434.

Steinbart, K., *Johann Liss*, Berlin, 1940.

Stix, A., and L. Fröhlich-Bum, *Die Zeichnungen der Venezianischen Schule*, Vienna, 1926.

Van Regteren Altena, J. Q., *Jacques de Gheyn, An Introduction to the Study of His Drawings*, Amsterdam, 1936.

Van Regteren Altena, J. Q., *Les Dessins italiens de la Reine Christine de Suède*, Stockholm, 1966.

Van Schendel, A., *Le Dessin en Lombardie jusqu'à la Fin du XVe Siècle*, Brussels, 1938.

Velasco, M., *Catálogo de la Sala de Dibujos de la Real Academia di San Fernando*, Madrid, 1941.

Venturi, A. (with G. Guiffrey), *Gentile da Fabriano e Pisanello da "Le Vite" di Vasari*, Florence, 1896.

Venturi, L., *Cézanne, Son Art, Son Œuvre*, Paris, 1936.

Vey, H., *Die Zeichnungen Anton van Dycks*, Brussels, 1962, I, p. 129, no. 61.

Vey, H., and X. de Salas (eds.), *German and Spanish Art to 1900*, New York, 1965.

Von Sick, I., *Nicolaes Berchem, ein Vorläufer des Rokoko*, Berlin, 1930.

Weinberger, M., *Wolf Huber*, Leipzig, 1930.

Welcker, C. J., "Hendrick en Barent Avercamp," in *Schilders tot Campen*, Zwolle, 1933.

Wethey, H. E., "Decorative Projects of Sebastián de Herrera Barnuevo," *Burlington Magazine*, XCVIII, no. 635 (February 1956), pp. 40-46.

Miscellaneous Exhibition Catalogues

Amis et Contemporains de P.-J. Mariette: Dessins français du XVIIIe Siècle, Paris, 1967.

Exposition Hubert Robert, 1773-1808, Paris, 1933.

Exposition P.-P. Prud'hon (Palais des Beaux-Arts), Paris, 1922.

France in the Eighteenth Century, London, 1968 (with introduction by D. Sutton).

"Hamburg Exhibition": *Spanische Zeichnungen von El Greco bis Goya*, Hamburg, 1966.

Hollandse Tekeningen uit de Gouden Euw . . ., Brussels, 1961 (Fr. trans., *Dessins hollandais du Siècle d'Or: Choix de Dessins provenant de Collections publiques et particulières néerlandaises*, Brussels, 1961).

Honderd Twintig Tekeningen . . . uit Verzameling van de Koniglijke Musea voor Schoone Kunsten van Belgie, Brussels, 1967.

Jan Gossaert genaamd Mabuse: see above, Pauwels et al.

Le XVIe Siècle européen: Dessins du Louvre, Paris, 1965 (Louvre exhibition organized by M. Sérullaz and R. Bacou).

"Mostra Giorgio Vasari": see above, Monbeig-Goguel.

"Rotterdam Exhibition": *Le Dessin italien dans les Collections hollandaises*, Rotterdam/Haarlem/Paris, 1962.

Selected Drawings from the Hermitage, Cobenzl Collection (1763), Leningrad, 1969.

Velázquez y lo Velázqueño, Madrid, 1960-1961.

Vingt Ans d'Acquisitions au Musée du Louvre, 1947-1967, Paris, 1967-1968.

Printed in Italy
by F.lli Fabbri Editori, Milan